FUGITIVE TESTIMONY

FUGITIVE TESTIMONY

On the Visual Logic of Slave Narratives

JANET NEARY

Fordham University Press

NEW YORK 2017

Fordham University Press gratefully acknowledges financial assistance provided for the publication of this book from the Offices of the Provost and the Dean of Arts & Sciences, Hunter College, City University of New York.

Fordham University Press has no responsibility for the persistence or accuracy of URLs for external or third-party Internet websites referred to in this publication and does not guarantee that any content on such websites is, or will remain, accurate or appropriate.

Fordham University Press also publishes its books in a variety of electronic formats. Some content that appears in print may not be available in electronic books.

Visit us online at www.fordhampress.com.

Library of Congress Cataloging-in-Publication Data available online at http://catalog.loc.gov.

Printed in the United States of America

19 18 17 5 4 3 2 1

First edition

To
Lindon Barrett
and my family

Contents

The distance from Tuckahoe to Wye river—where my old master lived—was full twelve miles, and the walk was quite a severe test of my young legs. The journey would have proved too severe for me, but that my dear old grandmother—blessing on her memory!—afforded occasional relief by "toting" me (as Marylanders have it) on her shoulder. . . . She would have "toted" me farther, but that I felt myself too much of a man to allow it, and insisted on walking. Releasing dear grandmamma from carrying me, did not make me altogether independent of her, when we happened to pass through portions of the somber woods which lay between Tuckahoe and Wye river. She often found me increasing the energy of my grip, and holding her clothing, lest something should come out of the woods and eat me up. Several old logs and stumps imposed upon me, and got themselves temporarily taken for wild beasts. I could see their legs, eyes, and ears, or I could see something like eyes, legs, and ears, till I got close enough to them to see that the eyes were knots, washed white with rain, and the legs were broken limbs, and the ears, only ears owing to the point from which they were seen. Thus early on I learned that the point from which a thing is viewed is of some importance.

—Frederick Douglass, *My Bondage and My Freedom*

Introduction: Representational Static

*[Future] literary history will engage in radical strategies to hear the silence of
the narratives. It will attend to the gaps, the elisions, the contradictions, and
especially the violations. It will turn original purposes on an angle, transform
objects into subjects, and abolish the abolitionists. The slave narrators were
feeling their way through strange fields in the dark, Arna Bontemps once wrote.
When they found light or a break in the fences, they ran on. Abolitionist nar-
ratives, for one large instance, are critiques of certain aspects of America. A
subgroup of those, in turn, are critiques of critiques.*
—JOHN SEKORA, "BLACK MESSAGE/WHITE ENVELOPE: GENRE, AUTHENTICITY,
AND AUTHORITY IN THE ANTEBELLUM SLAVE NARRATIVE"

*Each 'now' is the now of a particular recognizability. In it, truth is charged to
the bursting point with time. . . . It is not that what is past casts its light on
what is present, or what is present its light on what is past: rather, image is
that wherein what has been comes together in a flash with the now to form a
constellation.*

—WALTER BENJAMIN, *THE ARCADES PROJECT*

In 1993 visual artist Glenn Ligon debuted *Narratives*, a series of prints us-
ing eighteenth- and nineteenth-century slave narrative title pages as tem-
plates for ironic commentaries on contemporary American race relations.
Reproducing the baroque form and syntax of the genre's titles and typog-
raphy but substituting his own autobiographical details in place of those
of the ex-slave narrator, Ligon creates large mock-ups of imagined title
pages, which provocatively link the conditions of contemporary African
American art production with that of the literary production of fugitive
slaves. One of the prints in the series, for example, "The Life and Adven-
tures of Glenn Ligon, A Negro, who was sent to be educated amongst
white people in the year 1966, when only about six years of age, and has
continued to fraternize with them to the present time," sends up viewers'
potentially inflated notions of racial progress by confronting them with
the unexpected collision of nineteenth-century literary conventions and
late-twentieth-century autobiographical disclosure (Figure 1).

THE

LIFE AND ADVENTURES

of

GLENN LIGON

A NEGRO;

WHO WAS SENT TO BE EDUCATED AMONGST
WHITE PEOPLE IN THE YEAR 1966 WHEN
ONLY ABOUT SIX YEARS OF AGE AND HAS
CONTINUED TO FRATERNIZE WITH THEM
TO THE PRESENT TIME.

———

NEW YORK
PRINTED BY BURNET EDITIONS
corner of Greenwich and Desbrosses Streets

———

1993

FIGURE 1. Print from Ligon's *Narratives* series. Courtesy of Regen Projects, Los Angeles, © Glenn Ligon. "The Life and Adventures of Glenn Ligon, A Negro, who was sent to be educated amongst white people in the year 1966, when only about six years of age, and has continued to fraternize with them to the present time" (1993).

Using anachronism to open a space between Ligon-as-object (the "Negro" of the title) and Ligon-as-subject (the artist and subject of the auto-biographical disclosure), *Narratives* challenges viewers' expectations of black art and life, skewering the ways black cultural production has been consistently constrained and commodified to fit a market that does not always reflect the goals of black artists or writers themselves. By rigorously maintaining the formal elements of slave narrative title pages but supplying a contemporary subject and modern intertextual references, *Narratives* is a sly critique of the very notion of authenticity as it has been unequally applied to black artists and writers. Ligon's historical displace-

ment creates a frisson of competing expectations that operates as both punchline and rebuke, reducing the black post–Civil Rights era subject and the ex-slave narrator to type. In the competing discourses of authenticity on display it becomes impossible to locate the "real" Ligon. Rather than "the unvarnished truth" (as it might have been called in the antebellum period), or a "confession" (as it might have been called in the post–Civil Rights era), the subject of *Narratives* is the discourse of authenticity itself.[1]

Ligon's recovery of the publication conventions of slave narrative title pages allows him to critique contemporary constraints on African American artists while locating his art within a history of attenuated African American cultural production. Just as the ex-slave narrator entered into negotiation with white amanuenses or abolitionist editors and publishers, presenting his or her narrative to an overwhelmingly white readership, Ligon must weigh the benefits and constraints inherent in producing art in a gallery system dominated by historically white liberal institutions.[2] *Narratives* illustrates the historical legacy of the negotiations the contemporary African American artist undertakes with the gallery and the public, drawn by Ligon as consumers of black distress.

Although *Narratives* presents us with, perhaps, the most explicit example, a diverse cadre of visual artists turned to slave narratives as fertile ground for contemporary cultural critique at the end of the twentieth century. In addition to Ligon, Kara Walker, Ellen Driscoll, Reneé Green, David Hammons, Isaac Julian, Kerry James Marshall, Lorna Simpson, and Fred Wilson have all produced what I call "contemporary visual slave narratives" at the end of the twentieth century: works that combine nineteenth- and twentieth-century practices of visual representation with conventions of slave narration to question the historical threshold of legibility for the black subject.[3] While extremely varied in art historical terms, these works form a distinct archive that challenges traditional understandings of what is meant by "black art" and reveal the continuing role that a speculative or objectifying gaze has played in the long history of racial capitalism both before and after the end of legal slavery. In their explicit focus on exchange (historical, generic, and speculative), contemporary visual slave narratives demand a shifting gaze that unsettles the unidirectionality of the white subject gazing on a black object.[4] Employing what art historian Darby English has referred to as "strategic presentism," contemporary visual slave narratives exploit a series of historical dislocations—the contemporary artist often adopts the subject position of the fugitive slave narrator, for example—to call attention to and dismantle a set of racial protocols from the inside.[5] By highlighting

the contradictory or incongruous visual and linguistic codes denoting the black body or black experience at different moments in time, these artists force the viewer to recognize the discursive production of race in place of the icon of the black body. When one looks to these works for a representation of blackness, one sees only a particular angle of cultural vision reflected back.[6]

While modern viewers and critics have often privileged the ironic stance of the contemporary artist's pose, suggesting for example that the cleverness of Ligon's *Narratives* exists in contrast to the "straight," raw material provided by the original literary narratives, this perspective overlooks the ways ex-slave narrators themselves manipulated visual rhetoric to evade the assumption of an essential blackness thrust upon them by the abolitionist editors and publishers who sponsored their texts. Ligon himself emphasizes the conventions of authentication over ex-slave narrators' inventive responses to them. While he is perhaps best known for his early text-based works, he became increasingly ambivalent about using literary source material in his art, stating that literature has been "a treacherous site for black Americans because literary production has been so tied with the project of proving our humanity through the act of writing."[7] Confronted by and often acutely aware of the skepticism directed at black narrators, ex-slave narrators developed sophisticated and resourceful ways of satisfying the authenticating conventions of the genre while undermining the underlying racial implications and motivations of those conventions. Addressing a readership that *saw* them as objects, ex-slave narrators appropriated visual discourse to re-signify the terms of their disenfranchisement and call attention to the inextricability of visual material from its discursive context. Thus, ex-slave narrators' strategic deployment of visual discourse intensifies rather than wanes after abolition, amplifying a rhetorical element of antebellum narratives as former slaves were no longer contending with the *legal* perpetuation of slavery but were still subject to social and economic containment based on their racial designation. For example, in her narrative *The Story of Mattie J. Jackson* (1866), published at the close of the Civil War, Jackson skillfully turns the potentially objectifying narrative gaze from her own abused body onto white Northern readers' practices of looking.[8] Relating her experiences during the war, when Union troops entered her neighborhood and established themselves at a nearby arsenal, Jackson describes appealing to the Union forces for aid on two separate occasions. On the first, she and a fellow servant are turned away from the arsenal gates without being acknowledged. A few weeks later, after suffering a brutal beating at the hands of her master, Jackson makes a second attempt. She is immediately

admitted into the arsenal and granted temporary protection. Aware of the effect her injured body has on both Southern and Northern white onlookers, Jackson first refuses to change her clothes when her master demands that she do so (shifting the shame of abuse from the locus of her body to that of his offended gaze); then she deliberately wears her stained, bloodied clothing to obtain help from the Union soldiers. Jackson's actions reveal her awareness of the requirement that she provide visual evidence of her abuse if her request for aid is to be taken seriously; moreover, she manipulates the requirement that she put her injured body on display such that she gets the help she needs and exposes the limits of Northern sympathy in both soldiers and readers.[9]

This book takes as its starting point the evocation of the slave narrative in late-twentieth-century visual art and uses the representational strategies of these artists to decode the visual work performed in the original literary slave narratives. Reading backward from contemporary visual slave narratives, the book shows that the tactics of resistance or critique employed by current-day visual artists, in which visual and literary discourses of race are regularly juxtaposed to reveal their discontinuity—a strategy I term *representational static*—can be found in the work of ex-slave narrators themselves. Signifying the vibrational dynamics between authenticating strategies, representational static is a form of resistance to the speculative gaze.[10] It comprises the unruly narrative gestures embedded in texts, which initially appear to merely present race and racial relations as fixed forms. Emphasizing representation as mediation, representational static draws attention to the forces that produce and transmit images of enslavement and their authenticating infrastructures. Magnifying the dissonance between textual and visual discourses of authenticity by proliferating sometimes incommensurate rhetorics of authenticity, representational static disrupts while satisfying the conventions of authentication found in the slave narrative, exploiting the problematic nature of an abolitionist movement that "reduc[ed] the body to evidence in the very effort to establish the humanity of the enslaved."[11]

Gathering an archive of ante- and postbellum literary slave narratives, visual art, and graphic narrative, this book makes a case for an expanded notion of what have been called, alternatively, "neo-slave narratives" or "contemporary narratives of slavery" to include works of visual art and argues that, rather than postmodern pastiche or an aspect of post-soul aesthetics, contemporary artists' production of representational static is an extension or amplification of the rhetorical strategies developed by ex-slave narrators themselves to undermine the very conventions of authentication that structure the slave narrative when they did not have complete

control over their literary production.[12] In light of these shared rhetorical strategies, I argue that the slave narrative's conventions of authentication become a prime site of meditation, parody, and appropriation for contemporary artists not because we have come so far, but rather because similar problems of white patronage and institutional control, combined with the ongoing spectacularization of the black body, continue to plague relationships between black artists and exhibition institutions today.[13] As a political aesthetic adopted by both twentieth-century African American visual artists and nineteenth-century ex-slave narrators, representational static unsettles the equation of blackness with enslavement and calls attention to blackness as a discursive formation.

My analytic focus on representational static anchors and enables the transhistorical and intermedial scope of the study and is central to my understanding of literature itself as a form of visual culture. Simultaneously connoting noise and disruption as well as stasis and continuity, representational static captures the contradictions endemic to employing slave narratives as—to echo Sekora in the epigraph shown earlier—critiques of critiques. In addition to its antilogy, the term has a synaesthetic quality that directs our attention to disruption, misdirection, and in-between spaces. Recalling the black-and-white snow on a fritzed-out television screen, the noise in the fallow spaces between radio stations, as well as the electric charge produced by friction—one sees that static is both insurrectionary and obscuring, charged, interrupting our reception of clearly-defined images and sounds with clean edges. As such, it calls attention to representation and authentication as mediation, asserting the precarity of reception over the verisimilitude of narrative depiction, as well as the priority of enslaved experience over white abolitionist authority or witnessing.

In this multivalent sense, then, my notion of representational static shares much with Anne Elizabeth Carroll's understanding of the "abrupt juxtapositions" in early-twentieth-century black cultural productions such as *The Crisis*, though I trace the phenomenon to an earlier period. I understand the strategy as a hallmark of slave narratives' status as negotiated texts riven with tensions between white editors (or curators and critics) and black writers and artists. Both representational static and abrupt juxtapositions are aesthetic, political tools that help writers, narrators, and artists navigate hostile terrain while spurring readers and viewers into a less passive position. Carroll describes how these elements work in tandem: "It is possible . . . that the discomfort created by a juxtaposition of disparate items motivates a reader toward action. . . . Artists who created collages, for example, often viewed the abrupt juxtapositions

between individual elements 'as a means of undermining conventional associations and shocking the viewer into a new perception of a new reality—social, political and psychological, as well as aesthetic.'"[14] Darby English uses the term "representational miscegenation" to describe a similar strategy he has identified in Ligon's work: Ligon's "mix[ing of] impulses and means regarded as mutually exclusive."[15] Noting the contradictions maintained by Ligon's 1998 *Untitled (I Am a Man)*, which reinterprets the now familiar iconography of the signs carried by protesters during the Memphis Sanitation Strike of 1968, English argues "We might mistake [the work] for a quintessentially postmodernist appropriation if Ligon had not elected to reposition the sign by constructing it into a sumptuous oil painting."[16] Similarly, as the example from his *Narratives* series shows (Figure 1), Ligon relishes and dwells on the historical dislocation he performs. Contemporary visual slave narratives move beyond appropriation by working inside of the very terms and modes of that which they appropriate.

Employing an interdisciplinary lens borrowed from the primary texts themselves, the book's primary contention is that by resurrecting in principally *visual* terms the central contradiction negotiated in the *written* slave narrative, contemporary artists reveal the persistent objectification of blackness via a speculative gaze. By reconceiving the slave narrative as a mode of cultural critique that exceeds the political mandates of abolition and the historical episode of racial slavery, *Fugitive Testimony* offers new insights for scholars of African American literature, visual studies, and American and Atlantic studies, and presents the form as a key site in African American cultural producers' challenge to the organization and logic of racial capitalism. In identifying an insurrectionary visual subtext embedded within the slave narrative that counters the textual mechanisms of containment, this book also claims a more prominent place for postbellum slave narratives—in multiple mediums—in the slave narrative tradition.[17]

As recently as 2011, Stephen Best argued that the visual archive of slavery is characterized by absence and lack. Lamenting the dearth of visual material produced by slaves, Best claimed that "[t]here are no visual equivalents of *Incidents in the Life of a Slave Girl*," a claim that overlooks *Incidents'* own significance within mid-nineteenth-century visual culture.[18] While the recent explosion of critical work on African Americans and nineteenth-century visual culture has made Best's assertion increasingly difficult to support, it speaks to a series of critical binaries that have limited our understanding of the ways African Americans generated,

adapted, and transformed the technologies and terms of a visual culture that has continued to disproportionately affect their lives.[19] By contending that images and iconography alone constitute the visual, or by treating African Americans as *either* the object or subject of a visual archive, critics misapprehend the scope and operation of visual culture and perpetuate stark divisions between object and subject, as well as image and word, which former slaves have been contesting in their narratives since the late eighteenth century.

Sarah Blackwood's review essay on four recent books on African American visual culture elegantly defines the contours of the burgeoning field of nineteenth-century African American visual culture studies. Regarding the 2012 edited volume *Pictures and Progress: Early Photography and the Making of African American Identity*, Blackwood writes that it "display[s] an agile sense of 'visual culture'—a culture expressed as much by Douglass's speeches and slave narratives as by actual photographs."[20] Similarly, in her work on the inextricability of American print and visual culture in the mid–nineteenth century, Marcy Dinius notes that "America's initial encounter with daguerreotypy was textual rather than visual," and argues that "[r]ecognizing language's role in structuring the practice of photography makes the two cultures—print and visual—visible as one."[21] Maurice Wallace also insists on the imbrication of print and visual discourse, making a case for the "visual grammar" of the photographic archive, arguing that "the American Civil War archive is a class of photographic portraiture visually approximating the verbal chiasmus, and its underlying logic of binary opposition, made famous in African American abolitionist discourse by Frederick Douglass, a figure not at all untutored in what W.J.T. Mitchell has called 'picture theory.'"[22] In 2002, P. Gabrielle Foreman demonstrated how a variety of discursive contexts condition our readings of the frontispiece engravings included in the textual apparatus of slave narratives, such as the engraving of Louisa Picquet in Hiram Mattison's *The Octoroon* (1861) or that of Ellen Craft as "Mr. Johnson" in the Crafts' *Running a Thousand Miles for Freedom* (1860).[23] My argument builds on these theorists' identification of the inextricability of print and visual culture, though it focuses primarily on the textual visuality integral to slave narratives, rather than the intertextual, semiotic traffic between images and text. While I agree with Dinius that we need to understand the discursive production of "what has become almost an instinctive way of seeing photography," my object in this book is to recognize African American writers' awareness of and response to the pervasive *mis*understanding of technologies of visual culture such as the daguerreotype and photograph as unmediated records of truth.[24] My

contention is that African Americans were *both* savvy participants in *and* objects of nineteenth-century visual culture and used the highly negotiated platform of the slave narrative to deliberately contest their experience of visual objectification.

While the most well-known slave narratives prominently engage visual discourse to undermine the power relations they are subject to both in slavery and within abolitionist discourse (think of Frederick Douglass's chiasmus, "You have seen how a man was made a slave; you shall see how a slave was made a man," or Harriet Jacobs's "peeping" on her master), critics have principally focused on the role of literacy within the slave narrative and have only glancingly addressed the significance of ex-slave narrators' engagement with visual discourse.[25] In attending to these textual aspects of visual culture, a focus on representational static exposes the depth and breadth of slave narrators' interventions into visual culture and articulates the profound challenge they present not only to the justifications for racial slavery—interrupting the association of blackness with illiteracy, for example—but also to a broader understanding of visual culture that would separate the imagistic from the discursive. I argue that ex-slave narrators reject not only the political and moral justifications for racial slavery but also the speculative gaze directed at them by slaveholders and abolitionists alike by seizing control of visual discourse in the same way they seized control of literacy.

Although the slave narrative has been understood and mapped according to its literary proximity to or distinction from other genres such as spiritual autobiography, captivity narrative, and autobiography, what remains consistent across the broad range of texts that have come to be called slave narratives are the conventions of authentication, which structure the texts.[26] Several textual elements motivated by the author/narrator's race—including the author portrait; title page boasting the claim "Written By Himself"; editorial assertions, testimonials, prefaces, and introductions vouching for the trustworthiness of the narrator; first sentence beginning "I was born . . ."—distinguish the slave narrative from other forms of autobiography and are designed to lend an aura of verifiability to the narrative. As early literary critics of the genre have shown, these formal conventions preceded the anti-slavery goals of slave narration and developed in response to the skepticism of a white reading public toward black-authored texts and black humanity more generally. In early-eighteenth-century slave narratives, for example—such as those by Briton Hammon or George White—slavery is almost incidental to the narrative, while the conventions of authentication are paramount; this suggests that the conventions of authentication are a response to the author/narrator's

race, rather than a function of anti-slavery polemic.[27] Before the black subject could speak, he or she must be legitimated by white authority in the form of prefaces, letters of recommendation, or historical documentation verifying the subject's story, causing John Sekora to refer to the slave narrative as a "black message in a white envelope." These conventions, which rely on fixed notions of "black" and "white," have the corollary effect of making race legible in the very structure of the text. Thus, to enter into the slave narrative is to enter a site of racial constraint; the ex-slave narrator must explicitly engage the logic of racial slavery while implicitly critiquing its philosophical presumptions, specifically, the presumption that the black subject at the center is less than human.[28]

My analysis of the slave narrative examines ex-slave narrators' response to the central contradiction produced by the conventions of authentication—the objectification of blackness at the very entry-point of an individual black subject—and reveals a sustained strategy of resistance shared across the many incarnations of the slave narrative. My contention is that visual tropes and discourse within slave narratives offer a critical access point for understanding how ex-slaves negotiated these structuring contradictions, specifically the requirement that the ex-slave narrator provide evidence of his or her humanity to controvert the "evidence" of black skin. Both the narrators of the literary texts and the "narrators" of contemporary visual slave narratives critique fixed ideological conceptions of blackness by juxtaposing visual and literary racial codes within the narrative or overproducing competing claims to authenticity to undermine the authority of authenticating conventions and interrupt the racial logic of the form. This strategy allows ex-slave narrators to argue strongly for abolition without staking it as the ultimate liberatory goal.[29] To return briefly to Mattie Jackson's example, she no longer needs to provide evidence of the cruelties of slavery for the purpose of abolishing it, a fait accompli in 1866, but her largely conventional portrayal of the abuse she suffers smuggles in a critique of abolitionists' treatment of the enslaved or formerly so, as well as a critique of this narrative convention. While appearing to simply present the quotidian violence slaves were subjected to, Jackson subtly challenges the way white Northerners see former slaves: not as equals whose word should be taken at face value, but rather as objects of abuse or protection whose word must be corroborated by physical (read: visible) evidence. The difference between these two positions is captured in Sekora's observation that "[m]ost white sponsors of slave narratives from 1760 to 1865" (and, I would argue, long after) "seem to have believed that all important aspects of a slave life could be told by recounting what was done to him or her."[30] In short, the ex-slave narra-

tor faces a rhetorical situation in which the authenticating requirements of the slave narrative and the justifications for enslavement spring from similar assessments of blackness.

The discovery of a rich visual imaginary within the slave narrative re-animates our understanding of ex-slave narrators' response to this central contradiction recognized and outlined by the genre's earliest literary critics—William Andrews, Robert Stepto, John Sekora, James Olney, Valerie Smith, Harryette Mullen, and Hazel Carby.[31] Furthermore, in reading contemporary visual slave narratives alongside ante- and postbellum slave narratives, representational static presents visuality as a complication in the staged conflict between white literacy and black orality, taken to be the foundational scene of an African American literary tradition in, for example, Henry Louis Gates, Jr.'s analysis of the trope of the talking book. In this recurring scene, symbolizing the conflict between oral and written cultures in many early slave narratives, the narrator recounts his experience of overhearing his master read aloud for the first time; misunderstanding what he sees and believing the book to be talking to the master, the enslaved man later picks up the book himself, holds it expectantly to his ear, and is dismayed to find that for him the book remains silent.[32]

Recognizing the importance of literacy to white Western notions of humanity, ex-slave narrators themselves privilege literacy, often presenting their first encounter with literacy as a key turning point in their lives.[33] From early slave narratives featuring the trope of the talking book to Frederick Douglass's depiction of his first, aborted reading lesson, literacy operates as a symbolic boundary within the slave narrative.[34] Before the abolition of slavery, literacy is presented as a prohibition or exclusion connected to systems of white power, but also as an entry-point into abstract thought, a sign of freedom from embodiment.[35] In his 1845 *Narrative*, for example, Douglass calls literacy the "pathway from slavery to freedom" and represents his transition from object to subject within his narrative as a transformation from purely bodily existence to symbolic presence enacted by his acquisition of literacy.[36] But, as Valerie Smith argues, literacy is an ambivalent mechanism of self-authorization in Afro-American narrative; to value its symbolic power is to "pay homage to the structures of discourse that so often contributed to the writer's oppression."[37] On the one hand, rehearsing the scene of literacy "grants [the narrators] significance and figurative power over their superordinates, [and by] their manipulation of received literary conventions they also engage with and challenge the dominant ideology."[38] On the other, the stress placed on the scene of literacy as the key to freedom has the counter-effect of suggesting that "without letters, slaves fail to understand the full meaning of their

domination."[39] Smith resolves this dilemma by expanding our under-standing of literacy to include oral culture; however, the expansion leaves the structure and function of literacy as prohibition/arrival intact.[40] By contrast, ex-slave narrators' deployment of visual discourse interrupts the authenticating force of literacy within the narrative and challenges literacy as a symbolic boundary between black and white. For example, in her depiction of a reading lesson in *Behind the Scenes*, a scene I read more fully in this book's second chapter, Elizabeth Keckly shows how an illustration meant as a reading aid in a literacy primer actually misleads the student.[41] Her ironic treatment of literacy instruction casts doubt on the self-evidence of systems of racial classification based on physical or visible signs such as blackness or whiteness and undermines the symbolic function of literacy in the slave narrative—as a sign of reason and there-fore a symbol of the narrator's humanity. Keckly's production of represen-tational static scuttles the symbolic power of both literacy and images as signifiers of humanity and allows Keckly, like Mattie Jackson and Glenn Ligon, to turn the objectifying gaze directed at a former slave back on her audience. When read in conjunction with the narrative's deployment of visual discourse, literacy operates not as a neutral sign of reason that can be appropriated by white and black alike, but rather as a highly subjective discursive formation whose significance is shaped by the visual logic of race. In other words, if an ex-slave narrator must demonstrate literacy to prove her full membership in the human community, the production of representational static allows her to present this evidence while rejecting it as "proof" of humanity.

Fugitive Testimony's unique focus on the recursive nature of the slave narrative form unifies what have been three distinct phases of the genre's criticism within the academy—historical, literary, and cultural studies approaches—and contributes to the historiographical contours of Atlan-tic studies. Drawing on literary analysis, art history, and visual theory, this book connects vital early literary critical accounts of the slave nar-rative that examine the genre's conventions of authentication and issues of literacy with later cultural studies approaches, including those by Lin-don Barrett, Saidiya Hartman, Fred Moten, Daphne Brooks, and Michael Chaney. In so doing, this book examines the power relations that under-gird these conventions as well as ex-slave narrators' aesthetic responses to them. Bringing visual theory to bear on the central problematic of the slave narrative, this book captures the animating force and form of the gestures, exchanges, and transfers at the heart of what Hartman calls

"scenes of subjection," while accounting for the symbolic role literacy and other authenticating conventions play within the narratives.[42]

To address the lacunae between these distinct phases of slave narrative criticism, as well as the lacunae between literary and visual culture within the critical discourse, I understand the slave narrative to be an emblematic form productive of what Chaney calls "meditative spaces that exceed the bounds of print or illustration alone, exhausting to the point of collapse the modes and technologies common to antebellum representations."[43] However, while Chaney's approach is fundamentally interartistic, "analyz[ing] images of slavery alongside and against corresponding literary texts," *Fugitive Testimony* shows how ex-slave narrators challenge the dominance of the "pictorial domain" through visual cultures of text within slave narratives themselves.[44]

Because the slave narrative is both a highly negotiated literary production and a text that continually refers to and mediates a set of power relations beyond the frame of representation, I have found it useful to refer to the slave narrative as a form rather than a genre. If genre implies a set of conventions, which inhere in literary narratives, form addresses those same conventions while making visible certain structural elements that supersede the literary but are registered there as well. In the case of the slave narrative, the conventions of authentication, which give the slave narrative its formal distinctiveness and coherence, both reflect and deflect the cultural logics of racial slavery and abolition, but they also operate according to a binary logic of race that produces blackness and whiteness as the symbolic bearers of ideological value. It is this aspect of the form that is most insistently addressed by contemporary visual slave narratives. Calling for "a more rigorous historicization of racial desire," Robert Reid-Pharr appropriately cautions us against conflating the "'blackness' described by the fugitive slave and the 'blackness' proudly articulated by the radical memoirist of the 1960s," or, we might add, the "blackness" of the radical artist of the 1990s.[45] I want to be clear that in identifying a formal analogy across time I am not suggesting "the inevitability of a specifically black tradition" or a static racial identity across periods; rather, I want to show that ex-slave narrators themselves resisted the notion of "black art" and the ways blackness itself was consolidated. Moreover, ex-slave narrators, like the contemporary artists under consideration, used the negotiated form of the slave narrative—specifically its racial protocols—as a platform to contest this racial consolidation.[46] Following Lloyd Pratt's recent meditation on "the nature of form," the formalism I employ here is "a comparative process that permits us to identify

the components of a given logic such that the repetition of those components, or their differentiation, becomes visible across ostensibly separate fields of experience."[47] This shift in critical perspective allows us to see important continuities between eighteenth- and nineteenth-century literary narratives and contemporary visual slave narratives produced at the close of the twentieth century and after, continuities that a strict literary history has no way of recognizing or accounting for.

One of the earliest critics to make a case for what he calls the "strategies of form" in the African American slave narrative was Raymond Hedin, who argued in 1982 that the disjointed nature of the slave narrative was an expression of the dislocated and dislocating nature of slave life:

> The disconnectedness of slave life—the jarring dislocations that resulted from the owner's power to buy and sell at whim, the slave's consequent inability not only to control his movements but even to predict them or to keep track of separated friends and family members—was one of the cruelest and most pervasive aspects of slavery; to expose it accurately was one of the narrator's purposes. The narratives are therefore filled with loose ends, with incidents whose outcomes remain unknown.[48]

Hedin's argument is one of the first to allow for the literary self-determination of the ex-slave narrator, and he does so through an analysis of form; however, his analysis implies a degree of formal control that overlooks the negotiations and concessions slave narrators had to make to editors and publishers who had often occasioned the written narrative for their own purposes in the anti-slavery movement. By contrast, James Olney, John Sekora, and Robert Stepto all offer compelling formal readings of the slave narrative that insist on the extra-textual and extra-literary power dynamics that shape the slave narrative's unique formal structure. Stepto, in particular, lays out a formal schema that classifies slave narratives into three different "phases" based on the calculus of the degree of control the narrator exerts in his tale relative to the authenticating conventions that threaten to overwhelm his voice.

Like Olney, Sekora, and Stepto, my understanding of the slave narrative form insists on the recognition of the extra-textual power relations that shape the narratives; however, it differs from these accounts—and Stepto's in particular—in that I do not see the slave narrative (or African American literature more generally) as a teleological progression in which texts dominated by authenticating devices and strategies are considered relatively artless in relation to more "sophisticated" works in which authors and narrators had a greater degree of control.[49] In fact, as I hope this book

demonstrates, I believe some of the most interesting and sophisticated narratives are those that are most apparently dominated by their authenticating strategies, such as Solomon Northup's narrative *Twelve Years a Slave* (classified by Stepto as an "integrated narrative," indicating that the corroborating documents and testimonials are integrated into the tale rather than appended to the narrative) and Henry Box Brown's *Narrative of Henry Box Brown* (1849), which one critic has called "a casebook study of the erasure of black subjectivity in the fugitive slave narrative genre."[50] Rather than thinking of the slave narrative by the rubrics of the singular author, I understand *racial negotiation* to be the defining characteristic of the slave narrative. It is only from this vantage that one can see the rhetorical and narrative strategies ex-slave narrators developed to interrupt the racial logic of the form.

One of the goals of this book is to map the efflorescence of the slave narrative at different moments in time in relation to contemporaneous developments in racial capitalism, demonstrating how the slave narrative has been a key site in which African American cultural producers challenge the organization and logic of racial capitalism.[51] The slave narrative emerged as a response to a regime of racial slavery organized by capital; however, abolition marked neither the end of the slave narrative nor the end of racial capitalism. The reemergence of the slave narrative within visual art at the end of the twentieth century speaks to the continued traction of the form as a mode of cultural critique. The book addresses itself, then, not only to the visual dynamics of the auction block—in which enslaved people were both the subject and object of a speculative gaze—but also to the visual dynamics that characterize what Saidiya Hartman calls the "afterlife of slavery":

> Slavery has established a measure of man and a ranking of life and worth that has yet to be undone. If slavery persists as an issue in the political life of black America, it is not because of an antiquarian obsession of bygone days or the burden of a too-long memory, but because black lives are still imperiled and devalued by a racial calculus and a political arithmetic that were entrenched centuries ago. This is the afterlife of slavery—skewed life chances, limited access to health and education, premature death, incarceration, and impoverishment.[52]

The endurance of the slave narrative points to the ongoing role of racial speculation in organizing social relations. My argument here is that the reemergence of the slave narrative at later moments of history is not simply an appropriation of an earlier form out of historical context, but,

rather, a contemporary response to racialized conditions that continue to haunt social, economic, and cultural relationships in the present.

In his book *Specters of the Atlantic*, Ian Baucom provides a useful model for thinking about "what it might mean to suggest that the present is more than *rhetorically* haunted" by the past.[53] Following Walter Benjamin, he argues that the reemergence of particular logics of representation at later moments in history indicates the advancement of the logic contained in the original form. Thus, for Walter Benjamin, allegory— the dominant mode of representation in the seventeenth century— becomes the "the phenomenology of the entire social-material world" in the nineteenth century because of "the essentially allegorical nature of that process by which capital produces exchange values and, hence, commodities."[54] Similarly, Baucom argues that the key to understanding the current dominance of finance capital, which characterizes the long twentieth century, is a reading of the value form that emerged in an earlier period of speculation and produced value in anticipation of any actual exchange: the insurance contract. Specifically, Baucom reads the 1781 insurance contract taken out on the slave ship *Zong* and the 440 slaves on board as both an inaugural moment in the history of finance capital and an emblematic episode of the system of finance capital with us at the present moment. The shift from exchange value toward anticipated, imagined, or virtual value, which is the basis of finance capital, is bound up with modern notions of race, which become similarly abstracted from actual bodies and circulate as ideological values. What makes the insurance contract on *The Zong* particularly significant is the captain's decision to throw 122 enslaved people overboard to collect the insurance money when he realized he would not be able to sell his disease-ravaged cargo for the anticipated profit when the ship arrived in the West Indies. For Baucom, *The Zong* massacre is a turning point in "a struggle between an empirical and a contractual, an evidentiary and a credible epistemology," which has resonance for our understanding of finance capital, race, and the slave narrative.[55] The recognition of the centrality of a racial logic advanced in new world slavery to the relations of contemporary finance capital, the phase of late-capitalism we are in now, sheds light on contemporary artists' augmentation of the visual dynamics inherent to the slave narrative form.

Racial slavery depended on a confluence of visual speculation, linguistic determination, and social performance, which resulted in a literal investment in racialized subjectivity increasingly articulated along the axis of the visual.[56] The slave narrative form reproduces racial division and black objectification in the conventions of authentication; however, ex-

slave narrators counter the racialist logic underlying the form through their production of representational static. Representational static serves two functions. First, it allows the ex-slave narrator to explicitly perform the authorizing gestures required by the form while implicitly undermining the notion that black humanity needs authorization; and second, it limits the symbolic power of representation: the power of literacy as a signifier of humanity and the power of blackness as a signifier of enslavement. In both nineteenth-century slave narratives and late-twentieth-century incarnations of the form in visual art, the "ex-slave" subject at the center contradicts the proposition that blackness and subjectivity are mutually exclusive by juxtaposing visual and literary racial codes.

More important, though the Benjaminian philosophy of history recovered by Baucom illustrates the portability of form through distinct historical epochs, his object is to trace a form that moves *with* history— a form that becomes the dominant organization of the social-material world. What are we to make of the recurrence of the slave narrative, a fundamentally negotiated form that both contains the logic of racialization (in the conventions of authentication) and resists that logic at the same time? The slave narrative's appearance in visual art suggests that the answer lies in the persistence of visual speculation, which has intensified along with the development of finance capital Baucom describes. Although the state's attempts to harness and control black labor took very different forms in slavery, Reconstruction, and the late twentieth century, the speculative gaze demarcating racial subjects has only grown stronger. As art historian Huey Copeland argues:

> [s]ince the 1960s, market forces have swept away symbolic and communal structures, conscripting black subjects to become complicit in their own commodification and devaluation within a glittering consumer culture. . . . the modern was hardly 'post' and history—despite claims of neoliberal ideologues to the contrary—was far from over: in fact, it mattered and structured more than ever with the putative ending of the Cold War and the emergence of a globalized spectacular culture, in which blackness circulates ever more widely.[57]

It is in this context that the visual tropes and metaphors within the original slave narratives, which interrupt the text's conventions of authentication, become the primary mode of the slave narrative at the end of the twentieth century. Visual art is in a unique position to recast the representations of black subjectivity advanced in the nineteenth-century slave narratives, which are constructed along, and limited by, the visual axis. Put differently, the historical disjunction of nineteenth-century literary

conventions represented in late-twentieth-century visual art exposes the limitations of both the discursive and iconic paradigms for representing black experience and black subjectivity. The ironic treatment of the conventions of authentication within late-twentieth-century visual art represents, then, the development of an element intrinsic to the form, rather than an anachronistic treatment of historical material. By restaging nineteenth-century narratives in the historical present with contemporary subjects, Glenn Ligon and his contemporaries expose the visual speculation of blackness that persists in the contemporary period.

This emphasis on what I call the visual cultures of text is the primary distinction between *Fugitive Testimony* and the growing body of research on African American visual culture and contemporary figurations of slavery with which it is engaged, including Arlene Keizer's literary and psychoanalytic account of "contemporary narratives of slavery" in *Black Subjects*, Daphne Brooks's deconstruction of the "ocular politics of race" in *Bodies in Dissent*, Michael Chaney's exploration of the "blind spots of representation" in *Fugitive Vision*, Ivy Wilson's examination of the "shadow realm" of African American art in *Specters of Democracy*, and Salamishah Tillet's identification of a "democratic aesthetic" in *Sites of Slavery*.[58] Like these works, *Fugitive Testimony* challenges the assumption that African Americans were passive objects of a dominant white gaze. However, this book departs from those works in two ways: first, in its focus on textual visuality rather than on the pictorial archive of photographs, images, or icons; and second, in its assertion that contemporary visual slave narratives and the literary slave narratives they reference are part of the same aesthetic trajectory, representing a persistent challenge to racial speculation that continues to impact the lives of African Americans. While many critics of contemporary visual slave narratives have read these works in the context of a "post-soul aesthetic," and therefore part of or only thinkable after the instantiation of what Trey Ellis has called the New Black Aesthetic, I show how they relate to and augment a much older representational strategy employed by eighteenth- and nineteenth-century slave narrators themselves.[59] This difference accounts for the book's unique methodology and unusual organization. Rather than tracing the historical markers of watershed moments of political enfranchisement, such as abolition or Civil Rights legislation, *Fugitive Testimony* is organized around the cultural and aesthetic flash points that provide the most ready access to African Americans' experience of racial speculation, which has remained remarkably stable over three hundred years despite these democratic advances.

Of course, the appearance of the slave narrative within visual art in the

1990s comes on the heels of a literary renaissance of the slave narrative a generation earlier. Largely out of print since the late nineteenth century, slave narratives regained popular currency in the 1960s and '70s as a result of social and political movements that prompted a return to primary historical documents and texts written from the perspective of the enslaved.[60] At the same time, fictional representations of slavery, such as Ishmael Reed's *Flight to Canada* and Toni Morrison's *Beloved*, emerged as an important genre within African American literature.[61] Both developments were the result of a desire to reclaim black experience from white interlocutors and were heavily invested in what has been called, in literary critical terms, "voice."[62] As Arlene Keizer argues, "[t]he contemporary narrative of slavery began to take shape at precisely the moment that the last of those who had experienced New World slavery first-hand passed away. The questions of who would be a witness to slavery and how it would be remembered became critical at the moment this first-hand experience disappeared from living memory."[63] As texts that both "mark the moment of a newly emergent black political subject" and act as a locus for individual and collective memory, contemporary narratives of slavery express the interior lives of the enslaved through narrative elements that depart from the template of the original slave narratives, often including everyday details and desires that were too small or idiosyncratic to fit the abolitionist frame of the original narratives, which were crafted for political expediency and designed to be generalizable.[64] Thus, an important aspect of contemporary narratives of slavery is their investment not just in slave testimony but also in the identities, or voice, of those who experienced slavery firsthand.

It is this investment in fleshing out fictive identities and providing richly textured interior lives for slaves and fugitives that distinguishes contemporary narratives of slavery from both the original literary slave narratives and contemporary visual slave narratives. In fact, contemporary visual slave narratives can be characterized by their avoidance of the subject, the simultaneous production and evacuation of a historical "voice." Although contemporary artists reconstruct and often speak from the subject position of the ex-slave, their object is to call attention to the spectacular (and voyeuristic) nature of early forms of black expression and attune the viewer to the possibility that we are not being granted access to the innermost thoughts and feelings of someone who has been enslaved in these texts, but rather to the expectations and desires of a white readership and an abolitionist movement that discounted the real political contributions of ex-slaves.[65] Rather than expressing the interiority of the black subject, contemporary visual slave narratives resolutely

reject interiority, instead creating a series of opaque and/or metaphorically reflective surfaces that call attention to the racial gaze directed at the black subject at the work's center. In this way, contemporary visual slave narratives return to the strategy ex-slaves used in the original narratives to overcome the constraints placed upon them: juxtaposing visual and literary discourse to reveal and unravel their power to fix the black subject in a racializing gaze.

While both contemporary narratives of slavery and contemporary visual slave narratives eschew notions of an essential black subject, they diverge in their deployment of visual discourse.[66] The primary rhetorical goal of contemporary visual slave narratives is not to restore the human complexity denied by the formal constraints of slave narration, but rather to use visual mediums to amplify those aspects of flattening and constraint that characterize the constitution of a "black voice." As Darby English argues, Walker's use of silhouette demonstrates this principle writ large: "The silhouette . . . indexes a flattening that routinely occurs in the social, eviscerating 'essential human depth.' Because 'the identities are purely relational' in this scenario, 'this is but another way of saying that there is no identity that can be fully constituted.'"[67] In Walker's tableaux, the figures can only be read as icons of racial identity through the viewer's engagement with racial discourse. In addition to questioning the persistence of visual precepts of race, which extend from the antebellum period to the contemporary moment, these artists' production of representational static interrupts the rhetorical coherence of the subject of the work and confounds any understanding of a self behind the conventions. The deliberate construction of a subject position inhabited by an empty or depersonalized subject makes the viewers' assumptions about race the focus of these works.

Using contemporary artwork as a lens onto the textual visuality of nineteenth-century slave narratives, this book works backward historically to excavate ex-slave narrators' challenge to authenticating conventions, and therefore their challenge to the assumptions motivating racial classification itself. Chapter 1 establishes and examines an archive of contemporary visual slave narratives. Analyzing works from Glenn Ligon's *Narratives* and *Runaways* series (1993), Kara Walker's *Slavery! Slavery!* (1997) and *Narratives of a Negress* (2003), and Ellen Driscoll's *The Loophole of Retreat* (1991), the chapter reframes critical debates on the slave narrative around the visual stakes of the form and advances a new model of reading the slave narrative founded on attention to the historical and

aesthetic dislocations and disjunctions accentuated in contemporary visual slave narratives. The chapter's signal contribution is its identification of representational static in both contemporary visual slave narratives and the original literary slave narratives. By setting historical and discursive paradigms of black expression against one another, ex-slave narrators and the artists who take up their voice reveal and unravel the power of those forms to fix the black subject in a racializing gaze. By analyzing these visual works within the framework of the slave narrative tradition—as opposed to expressions of a post-soul aesthetic—the chapter illuminates a rhetorical challenge to discourses of racial authenticity and "racial vision" sustained across historical periods and attributes a greater degree of aesthetic control to ex-slave narrators than has been previously recognized. Chapter 1 concludes with a reading of Frederick Douglass's 1845 *Narrative,* tracing the production of representational static to this classic and familiar slave narrative. Analyzing Douglass's deployment of visual metaphors, I argue that Douglass demonstrates the (racial) limits of political freedom, particularly with regard to the problems of an abolitionist movement that required evidence of black humanity. The turn to Douglass forecasts the analysis in subsequent chapters and demonstrates that representational static is not an innovation within these contemporary artists' work but is, rather, an extension and augmentation of a strategy developed by ex-slave narrators themselves to resist the slave narrative's formal emphasis on evidence and authenticity.

Chapter 2 turns to Keckly's 1868 postbellum narrative, *Behind the Scenes: Thirty Years a Slave and Four Years in the White House,* illustrating the way ex-slave narrators condense and juxtapose visual and textual forms to challenge prevailing modes of black representation codified in the slave narrative. Advancing a formal reading of the text, I show how *Behind the Scenes* undermines the ideological presumptions that link blackness with enslavement and whiteness with literacy and truth by inverting the racial protocols underlying those narrative gestures. In *Behind the Scenes* it is Keckly's letters that authenticate Mary Lincoln's version of events, Tad Lincoln's reading lesson that is included in place of her own, and the narrative gaze is primarily on the white bodies within the text as they take shape in her vocation, dressmaking. In overturning these race rituals, which rely on fixed notions of "black" and "white," Keckly challenges the racial protocols of the slave narrative and exposes how the form itself has been organized by the visual logic of racial slavery. Moreover, I argue that because of her vocation as a dressmaker, Keckly is well positioned to highlight the "constructedness" of what may appear to

be finished products. While other critics have acknowledged *Behind the Scenes* as an intervention into national iconography, I argue that Keckly's deployment of visual tropes and metaphors represents a fundamental refiguring of how we understand the visual world. Rather than a matter of perceiving fixed, observable objects, she presents sight as an inherently relational process: both the perceiving subject *and* the object perceived come into being through a process of differentiation that cannot be separated from its social context. This reading of *Behind the Scenes* reveals how African American writers in the nineteenth century engaged visual culture not only to counter an objectifying white gaze but also to subvert the symbolic function of literacy in the assessment of African American equality.

The third chapter reads William Craft's *Running a Thousand Miles for Freedom* (1860) as an emblematic text that depends upon a series of complex interactions between the Crafts' cultivation of their image and their use of distinct modes of dialogue and narration in different contexts. Using a strategy similar to that of Elizabeth Keckly, Craft shifts the traditional focus of the slave narrative from the black body to the white body; the difference, however, is that the white body under consideration is that of the enslaved Ellen Craft, in her successful performance as a white invalid planter traveling to Philadelphia with his slave. Examining how the visual image Ellen cultivates is juxtaposed with language within the narrative, the chapter argues that William Craft places the ambivalence of language and the ambivalent language of skin color side by side to unsettle popular notions of racial identity and identification. By producing the incongruent image of the fugitive slave speaking as the master, the narrative illustrates that phenotypical characteristics such as complexion are not facts with fixed meanings but, rather, are discursively defined social symbols that can be manipulated to various ends. Moreover, Craft's production of representational static reveals the discursive basis of visual assumptions of race. I argue that Craft turns this revelation back on the authenticating requirements of the slave narrative, offering recognition as a mode of visuality that counters the objectifying gaze of slavery. Just as *Running a Thousand Miles for Freedom* demonstrates that the appearance of white skin is only as "reliable" as the word of those who guarantee it, the authenticating strategies of slave narration are exposed as an elaborate social construct.

If Keckly's narrative demonstrates the usefulness of the slave narrative as a platform for anti-racist critique after abolition and the Crafts' narrative unsettles the authority of the speculative gaze, Northup's nar-

rative presents a critique of racial speculation outside of slavery's purported geographical bounds. Chapter 4 frames *Twelve Years a Slave* (1853) as a key example of the negotiation ex-slave narrators, their interlocutors, and readers engage in on formal terrain. As a narrative of kidnap rather than birth into slavery, the chapter argues that Northup's historical predicament dramatizes the rhetorical predicament of all ex-slave narrators. Northup is a free man who has been mistaken for a slave. This is, in existential terms, the condition of all ex-slave narrators: although they have been treated as objects, traded on the market, they must prove to their readers that this is a fundamental misrecognition, that they have been subjects all along. This rhetorical challenge is accentuated in Northup's case, as the process of restoring his legal freedom and the process of writing a slave narrative coalesce around the requirement that he provide documentary evidence to validate his claim to subjectivity: to regain his freedom, Northup must provide evidence of his free birth; additionally, to authenticate his narrative, Northup must provide documentary evidence of the truth of his narrative. Chapter 4 argues that Northup challenges the logic of racial speculation by producing two contradictory strains within his narrative: he meticulously executes the authenticating requirements that contribute to the restoration of his literal freedom and he fulfills the literary expectations of authentication; at the same time he evacuates those conventions of racial meaning through a series of visual metaphors and scenes of witnessing that reveal the absurdity of the racial logic motivating the conventions of authentication and the vacuousness of the category of citizenship for black Americans in the shadow of racial slavery. Employing a vocabulary of critical terms that avoids the binaries around which *Twelve Years a Slave* is structured, the chapter examines Northup's response to the fundamental contradictions of slave narration and suggests that the power of *Twelve Years a Slave* is its ability both to register the cultural vision which traps Northup in enslavement and to pierce its illusory nature.

Chapter 5 traces the various circuits—economic, narrative, and performative—that structure black abolitionist textual production, focusing particularly on Henry Box Brown's narrative and anti-slavery performances. In his texts, Brown provides an account of his traumatic experience of enslavement as well as his death-defying escape, which he accomplished by shipping himself by Adams Express Mail to abolitionist offices in Philadelphia. Using "boxing" as his mode of escape as well as his central narrative metaphor, Brown performs his own objectification in literal and symbolic terms in order to enact and reenact his freedom

by occasionally shipping himself to speaking engagements and emerging from the box to the surprise of his audiences. The chapter reads Brown's own narratives and performances alongside contemporary newspaper accounts of his engagements, arguing that both the highly negotiated form of the slave narrative and black abolitionist performance are examples of "fugitive performance," a category that challenges the ideological and rhetorical structures of constraint and control that are the context of black fugitive speech and narrative. Specifically, I argue that the performative or theatrical excess critics such as Daphne Brooks and Marcus Wood have identified in anti-slavery speech and theater (as opposed to narrative) must be viewed against the backdrop of Brown's white abolitionist contemporaries' concern that he was "keeping a careful eye on his own benefit," by which they meant that he was becoming more independent and exerting increasing control over the trajectory of his career as a speaker. Thus, rather than seeing black abolitionist speech and performance as containing more radical potential than text alone, as these critics have suggested, I suggest that we consider black abolitionist performance *in tandem* with narrative performance, arguing that ex-slave narrators utilize a *similar* recognition of the iconicity of the black body and visual savvy in their narrative performances as well as in their oratory and theatrical performances.

Meditating on the continued racial speculation on black bodies in our contemporary moment, the epilogue brings the link between racial violence, capitalism, and evidentiary epistemology into sharper focus. Drawing on Harriet Jacobs's insights into to the role racial violence-as-spectacle plays in the construction of wealth, the epilogue considers what ex-slave narrators bring to contemporary debates around racial violence, such as the debate over whether or not police body cameras will resolve or lessen unremitting episodes of police brutality on people of color. While the book opens with an analysis of contemporary visual slave narratives at the end of the twentieth century, the epilogue ends with a consideration of the slave narrative form in the twenty-first century, considering works that contribute to contemporary figurations of slavery but are not all strictly within the slave narrative tradition I have defined, including John Jones, Kerry James Marshall, and Kyle Baker. Each of these artists willingly and willfully adopts a set of formal constraints to examine and critique the operations of a speculative gaze founded in slavery and still operative in our contemporary moment. My reading of these twenty-first-century visual works unifies the economic and rhetorical strands of this book's argument, identifying the reproduction and subversion of various narratives of slavery as productive of representational static that

highlights the ways representations of black labor and black suffering authorize and legitimate a broader national and cultural vision.

As I noted at the beginning of this introduction, scholars have often interpreted the cultural work of contemporary visual artists against the work of ex-slave narrators who were no doubt working under more constraints, a division exacerbated by the critical habit of considering text and image as separate spheres. However, the recognition of representational static across the broad range of texts that have come to be known as slave narratives reveals that contemporary visual slave narratives are not, primarily, exposing the contradictions within slave narratives, but rather drawing on resistance strategies originally formulated in those nineteenth-century texts. The sustained logic of visual objectification—and African American cultural producers' resistance to it—embedded in the slave narrative form requires that we consider these works under the same analytic rubric. To get at those aspects of resistance to visual speculation of blackness that have been overlooked by a strict literary criticism, throughout the book I draw on language from visual studies and performance theory. Thus, I contend that we should consider the totality of these works, rather than their opposition to or competition with each other, as a kind of fugitive testimony, a multivalent term that emerges from Roland Barthes's *Camera Lucida*, which I use here both to name an archive and to indicate a line of inquiry.

With "fugitive" operating as both noun and adjective, fugitive testimony refers to the narrative, oratorical, and theatrical performances of fugitives from slavery—or those who take up their voice—and draws attention to the fugitive meanings within those performances (those aspects which contest, complicate, or are in excess of the editorial, theatrical, and political constraints which were the works' conditions of production), signifying on the conundrums of parallel claims to unmediated truth and authenticity in both the slave narrative and emergent "ways of seeing" ushered in by technologies of visual representation traceable to the nineteenth century but still operative today.[68] Literally the testimony of a fugitive, the slave narrative provides crucial eyewitness evidence for the abolitionist case against slavery. However, the slave narrative is also fugitive testimony in the sense that ex-slave narrators encode "fugitive" ideas within the narrative that remain unaccounted for and uncontained by the narrative's strict abolitionist frame, which requires that ex-slave narrators report, but do not reflect upon, their experiences of enslavement.[69]

Remarking on the "evidential power" of the photograph in *Camera Lucida*, Barthes insists that the photograph provides a kind of visual

certainty, calling it both a "guarantee of Being" and a "certificate of presence."[70] This, too, is the mandate of the slave narrative, which must certify the humanity of the ex-slave narrator by offering many proofs of existence and credibility for a skeptical readership. Yet, Barthes goes on to describe the visual certainty of the photograph as itself paradoxical, ultimately an expression of viewers' desires more than a characteristic of the photograph itself: "Since Photography . . . *authenticates* the existence of a certain being, I want to discover that being in the photograph completely . . . Here the Photograph's platitude becomes more painful, for it can correspond to my fond desire only by something inexpressible: evident (this is the law of the Photograph) yet improbable (I cannot prove it)."[71] As this passage shows, Barthes's rhetoric slips from what the photograph is and does to what he wants from it: rather than the truth of the photographic subject, which remains ultimately "inexpressible," the photograph authenticates the *viewer's* "pain" and "desire" upon encountering the absent subject of the photograph (*"there-she-is!"*). The fundamental improbability of the photograph causes Barthes to conclude, finally, that it is "a bizarre *medium*, a new form of hallucination: false on the level of perception, true on the level of time," by which he means that the temporality of the photograph is always past: *this-has-been*; what the photograph certifies—all it can certify—is the passage of time.[72]

In that vein, I offer that the ex-slave narrator's vexed relationship to evidence and authentication resonates with Roland Barthes's understanding of the photograph as a visual paradox, "certain but fugitive testimony" of *"what has been."*[73] As an object that marks an absent subject, the visual paradox of the photograph is an analogy for the visual paradox of the slave narrative. However, rather than a function of time—Barthes's argument about the photograph is that the person in front of the camera lens is no longer—the chimeric subject of the slave narrative is a function of the racial gaze. A white readership's skepticism toward black authors produces two competing aims within the slave narrative: the ex-slave narrator must make a case *against* slavery by describing the myriad ways enslaved people were brutalized and dehumanized, and the narrator must also make a case *for* the humanity of the enslaved. Although these aims may be politically coincident, they are often philosophically and rhetorically antithetical: the reader must be made to *see* the ex-slave narrator as simultaneously an object and a subject, a paradox played out and challenged in the form's conventions of authentication.[74] Yet both the visual paradox of the slave narrative and the visual paradox of the photograph are functions of the reader/viewer's desire for authentication. Adopting the absurd position of having to *authenticate* that which is self-evident,

the ex-slave narrator is in a unique position to critique the reader's desire for visual certainty.

In her comparison of Frederick Douglass's theory of photography with that of Barthes's in *Camera Lucida*, Laura Wexler demonstrates how one former slave understood and utilized the hallucinatory nature of the photograph-as-evidence to undermine the visual objectification of African Americans. In order to show how the visual objectification of black people conditioned Barthes's photographic gaze, Wexler analyzes his reading of a photograph of William Casby, a former slave:

> The question of slavery comes up explicitly in *Camera Lucida* only once, in connection with Richard Avedon's photograph of William Casby and its caption, "BORN A SLAVE, 1963." . . . Casby is an old man who incontestably *was born* a slave. Yet Barthes sees only frozen time in the present-day face of this man, ignoring the fact of a long life after slavery. It is for Barthes as if Casby is *still* a slave, wearing the mask of that social station. . . . [Moreover, Barthes] does not remark upon the tiny reflection of Avedon and his camera that the photograph reveals in Casby's eyes. . . . Casby aims his doubled lenses directly at the spectator, shooting back the objectifying gaze.[75]

As this analysis shows, Barthes's understanding of the photograph as "visual certainty" is actually an expression of his *desire for* visual certainty, which causes him to only see what he expects to see.[76] This case study exemplifies the fallacy that the photographic image produces visual certainty while simultaneously demonstrating how black subjects have often countered their objectification by doubling down on it, showing how— as Wexler says—"[m]aking another thing out of the making of a thing exposed the entire reifying process."[77] Ex-slave narrators and the contemporary artists under consideration use the logic of the slave narrative form against itself to expose and dismantle white desire for visual and racial certainty, refuting an evidentiary paradigm of visuality and offering a model of visuality as intersubjective recognition rather than objective division.

1 / Sight Unseen: Contemporary Visual Slave Narratives

The artist cannot and must not take anything for granted, but must drive to the heart of every answer and expose the question the answer hides.
—JAMES BALDWIN, "THE CREATIVE PROCESS," FROM *CREATIVE AMERICA*

In her field defining study of racial subjugation in the nineteenth century, Saidiya Hartman famously begins by refusing to reproduce the visual conventions of abolitionist literature: "I have chosen not to reproduce [Frederick] Douglass's account of the beating of Aunt Hester in order to call attention to the ease with which such scenes are usually reiterated, the casualness with which they are circulated, and the consequences of this routine display of the slave's ravaged body."[1] As Fred Moten argues, Hartman's critical repression of the scene of racial violence extends Douglass's own act of repression.[2] Just as Douglass's entrance through the "blood-stained gate" becomes a "primal scene" from which he must distance himself, so, too, does Hartman's repression become her critical point of departure. Instead of focusing on the "centrality of violence to the making of the slave," *Scenes of Subjection* focuses on the many ways that "the recognition of humanity and individuality acted to tether, bind, and oppress," arguing that "it was often the case that benevolent correctives and declarations of slave humanity intensified the brutal exercise of power upon the captive body rather than ameliorating the chattel condition."[3] The intimate relationship Hartman identifies between recitations of racial violence and declarations of slave humanity is manifest in the slave narrative, whose conventions of authentication are designed to simultaneously authenticate the truth of the brutality of slavery and the truth of black humanity. By calling attention to her readers' familiarity with such scenes of abuse, meant to provoke recognition of the slave's humanity and outrage over the vicious institution, Hartman highlights the reader's expectation

of—and desire for—such scenes and establishes them as an ambivalent mechanism for eliciting empathy or challenging slavery's objectification.

Hartman's evocation of an absent spectacle in *Scenes of Subjection*, published in 1997, coincides with a turn away from representing the body in work by a range of visual artists who take up the slave narrative in the 1990s. In one of the prints in Glenn Ligon's *Narratives* series, for example, "Black Rage; or How I Got Over; or Sketches of the Life and Labors of Glenn Ligon," Ligon skewers readers' and viewers' desire for scenes of racial violence with a parody of the marketing statements that often extended elaborate slave narrative titles. Underneath the tripartite title, the print boasts, "Containing a full and faithful account of his commodification of the horrors of black life into art objects for the public's enjoyment. WITH A PORTRAIT." Parodying the authenticity protocols of slave narratives, Ligon draws a direct line between the objectification of the visual conventions of slave narratives and the "commodification of the horrors of black life" in contemporary African American art. His refusal to provide what Lynn Casmier-Paz calls a "graphic point of reference"—while calling our attention to the convention—challenges the evidentiary function of conventions like the author portrait and implicates them in the continued objectification of black artists.[4] Although the prints in *Narratives* are richly intertextual and often reference visual mediums—quoting prominent film and theater critics such as bell hooks and Hilton Als, for example—there are no actual images in the series. Ligon avoids figuration and instead uses competing registers of text to frustrate the viewer's assumption of an essential black subject behind the representation and to call attention to our desire to *see* black suffering in what is often called 'black art.'[5]

Like the stencil paintings Ligon is perhaps best known for (such as "*I feel most colored when thrown against a sharp white background*" from Zora Neale Hurston's essay "How It Feels to Be Colored Me"), *Narratives* works by way of reference to canonical African American literature and continues his figural retreat.[6] Avoiding the dangers of reproducing the spectacle of the suffering black body while taking ironic aim at viewers' expectations of it, contemporary visual slave narratives both suggest and withhold images of the suffering black body to mark the perpetuation of a market for these images and disrupt their contemporary currency.[7] As Huey Copeland notes, "[h]istorically, visuality itself—thanks to its frequent denigration of the black image and its despotic manifestation in the white look—has been construed as the mastering conceit from which African Americans have sought refuge."[8] In addition to Ligon's *Narratives* and *Runaways* series (1993), Kara Walker's panoramic silhouette tableaux

throughout the 1990s, described by one critic as "life-size cutout silhouettes of imagined slave narratives," and Ellen Driscoll's installation *The Loophole of Retreat* (1991), also cannily combine nineteenth- and twentieth-century practices of visual representation with conventions of slave narration to question the historical threshold of legibility for the black subject.[9] Like Ligon, Walker often adopts the subject position of the ex-slave narrator in her work. Speaking as "an Emancipated Negress," she uses opaque, one-dimensional silhouettes to produce and confront the viewer's double vision so that both the historical subject and contemporary artist are simultaneously in view. Ellen Driscoll, a white artist best known for her installation and sculpture work, reinterprets a key chapter from Harriet Jacobs's *Incidents in the Life of a Slave Girl* in her installation of the same name, *The Loophole of Retreat*. Rather than speaking from the position of the fugitive, as Ligon and Walker do, Driscoll invites the viewer to briefly inhabit that position by entering a structure reminiscent of the crawlspace Jacobs occupied during her escape from slavery.

In addition to thematizing the negotiation that black cultural producers often engage in to get their works to the public, contemporary visual slave narratives translate the slave narrative from a primarily literary to a primarily visual medium to undermine the authenticating structures that so often fix black subjects in an objectifying gaze. As my reading of one of the prints in Ligon's *Narratives* series—which opens this book—shows, contemporary visual slave narratives exploit a series of historical dislocations to call attention to the continued traction of race rituals we feel we have moved beyond.[10] A central theme in contemporary visual slave narratives is the question of black authenticity, which has its formal roots in the conventions of authentication of the slave narrative. Rather than the expression of a singular life represented in all its unique particularity, slave narratives tell the story of race through a series of formal conventions the ex-slave narrator must negotiate with a skeptical (overwhelmingly white) reading public.[11] These conventions of authentication have the corollary effect of making race legible in text, the facet of slave narration on display (and under critique) in contemporary visual slave narratives. Commenting on the contemporary negotiations that take place between artist and viewer, Anne Wagner has described the experience of viewing Walker's silhouette tableaux in similar terms of negotiation and collaboration: "To tell a story about these figures is to decide who and what these figures are and do—as if that were an easy task. It is not. My narrative surely says as much about me and my history, as it does about Walker and hers. And so together artist and viewer conspire in telling the story of race."[12]

This chapter investigates the emergence of the slave narrative in visual

art at the end of the twentieth century. While extremely diverse in art historical terms, these artists' shared use of the slave narrative as a template calls for transhistorical analysis of the form and a reevaluation of the inaugural treatment of the visual logic of racial slavery in the original literary narratives. The central contradiction negotiated by the slave narrative—that the ex-slave author-narrator must be both object and subject of the narrative to provide an eye witness account of his or her own enslavement—is resurrected in contemporary visual slave narratives to reveal a consistent conceptual problem with race. Using popular nineteenth-century print and visual technologies, the artists under consideration juxtapose two paradigms of black subjectivity—the visual and the literary—through two historical paradigms—the mid-nineteenth century and the late twentieth century—to undermine visual fictions of race and notions of what it means to be an "authentically" black subject. I argue that both the ex-slave narrators and the artists that take up their subject position produce strategic moments of dissonance between multiple discourses of authenticity—representational static—to reveal the limits of each mode to express racialized experience, unsettling not only the equation of blackness with enslavement, but revealing blackness itself to be discursively produced. Placing readings of artworks by Ligon, Walker, and Driscoll alongside readings of Harriet Jacobs's 1861 *Incidents in the Life of a Slave Girl* and Frederick Douglass's 1845 *Narrative of the Life of Frederick Douglass, An American Slave, Written by Himself*, this chapter explores a sustained rhetorical strategy pursued by African American cultural producers to outwit the racial constraints that have been placed on them.

In identifying and analyzing an archive of contemporary visual slave narratives, this chapter offers new avenues of inquiry into the original literary slave narratives and illuminates a representational tradition in which black authors and artists use the fundamentally negotiated form of the slave narrative to launch a powerful critique of the visual objectification of blackness, which extends beyond both the historical bounds of racial slavery and the realm of the literary. In addition to making a case for an expanded notion of what has been called, alternately, the "neo-slave narrative" or "contemporary narrative of slavery" to include contemporary visual slave narratives, I argue that contemporary artists' use of representational static should be understood as an extension or amplification of the rhetorical strategies deployed by ex-slave narrators themselves to undermine the very conventions of authentication that structure the slave narrative form and that rely on fixed notions of "black" and "white."

"A Treacherous Site": Slave Narratives and Black Authenticity

The vexed question of authenticity as it has been unequally applied to black cultural producers throughout the nineteenth and twentieth centuries is central to Ligon's work. Although he is best known for his early text-based works, throughout the 1990s Ligon became increasingly ambivalent about using literary source material in his art, stating that literature has been "a treacherous site for black Americans because literary production has been so tied with the project of proving our humanity through the act of writing."[13] By juxtaposing incongruous fragments of stylized text, *Narratives* undermines the symbolic authority of text to signify black humanity and casts attention on the formal requirements of authentication. Rather than referencing specific narratives, *Narratives* targets the race rituals that structure slave narratives in general. By rigorously maintaining the structure of the conventions of authentication but supplying a contemporary subject and modern intertextual references, Ligon ironizes the slave narrative's authenticity protocols. For example, in "Black Like Me; or The Authentic Narrative of Glenn Ligon, A Black Man, To which is added testimonials from individuals and institutions on the veracity of his account" (Figure 2), Ligon includes a lengthy letter "To The Public" signed, "Yours, very truly, A WHITE PERSON." Although this formulation leaves the structural relationship of white authority/black legitimacy intact, it empties the categories of their meaning, "suggesting that it was the very category of whiteness, rather than the testimonial of any one abolitionist, that carried the power of legitimation"; it also reverses the roles of black objectivity and white subjectivity, as the artist is privileged as an individual (rather than a representative) while the white signatory is reduced to an anonymous type.[14] The sign off, "Yours, very truly," amplifies the elements of possession and authentication at play in the classic prefatory letter of support. Furthermore, where the original narratives would bear testimonials from white editors and abolitionists vouching for the truth of the account and the upstanding character of its fugitive narrator, the title pages of *Narratives* present quotations from black cultural producers and critics including bell hooks, Derek Walcott, Josephine Baker, and Hilton Als. Ligon's series fastidiously replicates the structure of authentication of the original literary slave narratives but upends the power relations they ratify by substituting black intellectuals, artists, and performers from the diaspora in place of the voices of white American and British abolitionists.

The traditional racial implications of the conventions of authentication are also troubled by Ligon's reference to John Howard Griffin's 1961

BLACK LIKE ME

OR

THE AUTHENTIC NARRATIVE

OF

GLENN LIGON

A BLACK MAN,

To which is added testimonials from individuals and
institutions on the veracity of his account

PREPARED FROM A STATEMENT OF FACTS
TAKEN FROM HIS OWN LIPS

To THE PUBLIC,

A coloured gentleman, Mr. Glenn Ligon, purposed to visit your
city for the purpose of exhibiting his splendid PANORAMA, or MIRROR
OF OPPRESSION. I have had the pleasure of seeing it, and am prepared
to say, from what I have myself seen, and known in times past, of
oppression, in my opinion, it is almost, if not quite, a perfect fac simile
of the workings of that horrible and fiendish system. The real *life-like*
scenes presented in this PANORAMA, are admirably calculated to make
an unfading impression upon the heart and memory, such as no lectures, books,
or colloquial correspondence can produce, especially on the minds of children
and young people. If you can spare the time to witness the exhibition, I am quite
certain you will feel yourselves amply rewarded. I know very well there are a
great many impostors and cheats going about through the country deceiving and
picking up the people's money, but *this* is of another class altogether.

Yours, very truly,
A WHITE PERSON

New York:
PRINTED FOR THE AUTHOR BY BURNET EDITIONS

1993

FIGURE 2. Print from Ligon's *Narratives* series. Courtesy of Regen Projects, Los Angeles, © Glenn Ligon. "Black Like Me; or The Authentic Narrative of Glenn Ligon, A Black Man, To which is added testimonials from individuals and institutions on the veracity of his account" (1993).

bestseller, *Black Like Me*, an account of a white journalist who traveled through the south passing as a black man.[15] By referencing a nonfiction account of passing, Ligon blurs the distinction between black and white figures upon which the conventions of authentication depend. The visual uncertainty of race conjured by the reference to *Black Like Me* also contradicts the protestations of authenticity in the second title. The nineteenth-century convention of joining two titles with an "or" is supposed to engender reader interest by providing *more* information about the story contained within the pages, but the switch from first to third

person in each title—"Black Like *Me*, or The Authentic Narrative of *Glenn Ligon*" (my emphasis)—confuses the claims of authenticity and raises the question of who can speak for black experience. The intertext implies that what the imagined reader or public viewer expects verified or authenticated is the truth of the subject's race, rather than the truth of the subject's narrative. Ligon's positioning of "race and the racial subject as mediated through the normative white voice" in *Narratives* is specifically emphasized through his reference to Griffin's text, which highlights the irony of the necessity for a white authority to "expose" racism.[16] In the representational static produced by Ligon's work, the viewer is confronted by and frustrated in his desire for visibly legible racial distinctions.

Manipulating the Gaze: Indexing an Idea

While much of Ligon's early work questions the discourse of authenticity through text, his other pieces—as well as almost all of Walker's silhouettes—directly address the way the visual image has been used to secure the authenticity of the so-called racial body. Ligon, Walker, and Driscoll use displaced nineteenth-century representations of blackness and the slave body to critique a notion of fixed, essential identity, revealing the ways blackness comes into being in the dynamic between economies of the visual and economies of literacy. As Lindon Barrett notes, racialization depends upon "foreclosing the mutability of the gaze."[17] Key to these artists' critique, then, is what Darby English calls their "terminal structural openness" and their use of visual technologies to direct and manage the viewers' gaze, disrupting the perspectival assumption of white subjects gazing on black objects.[18] For example, in some of his work Ligon exploits the "indexical medium" of photography to demonstrate that sight is a subjective function, while Walker uses silhouette to disassociate racial difference from actual bodies, and Driscoll uses a camera obscura to cast vision itself as a powerful narrative.[19] Rejecting the logic of the author portrait—supposed to vouchsafe the authentic race of the author/narrator—these artists use indexical mediums to index racism rather than the racial body, revealing visual representation to be as subjective as literary representation.

The medium each artist uses both produces and evacuates the meaning of black bodies even in their most "realisitic" presentations. Walker and Ligon take up overtly indexical mediums—photography and silhouette—to render "the indexicality of race incoherent."[20] In his analysis of indexicality, race, and photography, Nicholas Mirzoeff writes that "[c]aught between the desire to assert the obvious—that race is what is

visibly different—and the impossibility of sustaining such a position in the face of the always mixed population of the United States, discourses on race came to rely heavily on photographic representation"; similarly, silhouette was historically understood as a representational medium that transcribed Nature, most famously by the physionymist Johann Caspar Lavater, who wrote that silhouette was a "faithful" representation that "not even the most gifted artist could do freehand. No art . . . approaches a well-made silhouette in truth. . . . Physiognomy has no more irrefutable proof of its objective truth."[21] Lavater's understanding of silhouette as an unmediated index of truth is troubled by Walker's fantastical panoramas and Ligon's use of the captioned photograph, which he employs as a tool of misdirection, evacuating racial difference of its ontological status. Both artists produce work that requires the viewer to participate in the recognition of visual codes as indexes of racial difference in order to dispel the assumptions that make that interpretation possible.

While *Narratives* uses outmoded forms of representation to unsettle assumptions about a "real" body behind the representation and challenge presumptions about racial subjectivity and authenticity, Ligon produces a similar challenge to racial authenticity through his use of photography in his 1998 piece *Self-Portrait Exaggerating My Black Features* and *Self-Portrait Exaggerating My White Features* (Figure 3). The work is comprised of two identical ten-foot tall, black-and-white silk-screened photographic self-portraits underlined by the title captions. Signifying on Adrian Piper's drawing *Self-Portrait Exaggerating My Negroid Features* (1981), Ligon uses photographic technology to highlight the viewers' investment in seeing difference in identical images. In Piper's small drawing, she "heightened certain features often considered to be stereotypical of what a black person looks like."[22] By contrast, Ligon exactly reproduces a photograph of himself so that the viewer looks for imagined differences that are not there. The technological reproducibility of the photograph is the crux of the work's tension: the disharmony between contradictory captions for identical images. Had Ligon used painting or drawing as a medium, subtle differences in manual execution would reinforce the viability of sight as a function that reliably indexes difference and thereby reifies the connection between phenotypical distinction and racial identity, whereas his use of the "indexical medium" of photography challenges the notion of the body as an index of race.[23] Ligon exposes the phenotypical differences that have come to stand in for race—as race—as an inadequate visual shorthand that obviates how race is a product of complex social and political discourses. The work insinuates itself in what Robyn Wiegman calls an "economy of visibility" in order to interrogate the very

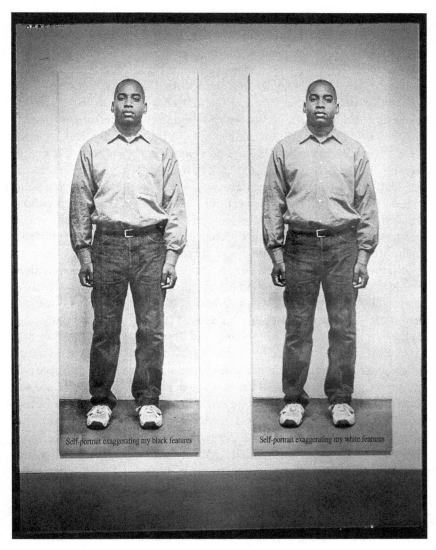

FIGURE 3. Glenn Ligon's *Self-Portrait Exaggerating My Black Features* and *Self-Portrait Exaggerating my White Features* (1998). Courtesy of Regen Projects, Los Angeles, © Glenn Ligon.

terms of the visible.[24] *Self-Portrait* locates race in the viewer's imagination rather than in the artist's body.

Ligon's mobilization of the visual image for the project of denaturalizing phenotypical difference is an example of representational static: the incompatibility of the visual image and the mutually exclusive captions expose

seemingly "real" differences—such as phenotypical characteristics—to be inextricable from their discursive context. Because the very same body is doubly legible as either exhibiting "white features" or "black features," it becomes a screen onto which viewers project their understanding of the racial phenotypes generically indicated in the captions. Because of the disjunction between the captions, the viewer is forced to "read" Ligon's image as a "bodily mark"; however, the moment of discerning ultimately dissolves into the recognition that the self-portraits are identical, at which point there is a reversal of object and subject as the subject of the photograph shifts from the body depicted in the photograph (Ligon's) to the speculative gaze of the viewer.[25] The image is ultimately no more reliable an index than the non-imagistic captions below. Ligon's use of representational static demonstrates how visuality is like a linguistic system, which registers and signifies through difference; both language and the visual image are discursively produced, not mirrors of truth.

Silhouette serves the same function for Walker as photography does for Ligon: Walker invests in the visual image as an index of race in order to evacuate its power from the inside out. As her figures are all monochromatic—usually black or brown against a solid white background—Walker's scenes of racialized violence and desire are achieved by her manipulation of paper into recognizably "black" and "white" forms. To read the disjunctive narratives in her panoramic scenes, viewers must participate in a racist interpretive tradition: the distinction between black and white figures is only legible if one reads them through a lexicon of racist imagery, which circulated in nineteenth-century postcards, romance novels, and minstrel fliers, including stock figures from Southern iconography such as the black-coded "mammy," her head in a kerchief, and the white-coded "lady," in hoopskirt and petticoats. Routing our vision through an older mythology, Walker subverts the indexical function of silhouette and reveals the contemporary currency of latent racist ideologies. As Darby English argues, her positioning of "slavery's representation within a present-day scheme of things . . . reveals fixed images of slavery as supplying a discourse of 'race relations' with an anachronous underlying order and a poignant lack of historical specificity."[26] Walker amplifies the viewers' complicity in these scenes by figuring her silhouettes as two-thirds life-scale and including "seemingly incidental specializing elements—trees, clouds, road signs, the implied ground, and perhaps most importantly, the plantation house—[which] rigorously structure the tableau as a landscape in which we stand."[27] In other words, we are not only *looking at* the scenes Walker has constructed, but we are *implicated in* them through a variety of formal mechanisms. In some works, such as

Insurrection! (Our Tools Were Rudimentary, yet We Pressed On), Walker even incorporates an overhead projector so that the viewer literally interrupts the projection stream and casts her own silhouette on the wall, becoming part of the scene.[28] While Walker uses silhouette in part *because* it was a form privileged for its utility by physionomers such as Lavater, thereby implicitly addressing the history of the racial gaze, her tableaux belie the privileged, empirical vantage of the scientist by situating her viewers as witness-participants, "facilitating the fantasy participation that is the precondition of looking this long."[29] Furthermore, her anachronistic and displaced use of silhouette—associated more with genteel parlors of the nineteenth century than with gallery walls of the late twentieth— operates as a "strategic presentism" which, like *Narratives*, keeps past and present discourses of race simultaneously on view.[30]

Ligon's and Walker's use of indexical mediums to reveal the phantasm of race subverts realist conventions associated with the slave narrative. Walker has stated that her interest in the term "negress" is specifically its ability to signify racial identity and the artifice of that identity at the same time: "The term 'negress' as a term that I apply to myself is a real and an artificial construct. Everything that I am doing is trying to scrape the line between fiction and reality."[31] Key to that project is the divestment of the visual image of its authenticating status. As both Augusta Rohrbach and Lynn Casmier-Paz have noted, author portraits affixed to slave narratives operate as paratextual elements, which work to secure or authorize the racial identity of the subject of the narrative: "the author portraits of slave narratives struggle to evidence multiple icons of realistic, biographical representation available to the period."[32] Claiming slave narratives as unrecognized precursors to a later (white) literary realism, Rohrbach argues that visual material appended to slave narratives served an indexical function and played an important role in both authenticating the narratives and bolstering their realist aura.[33] She notes that 58 percent of slave narratives published between 1845 and 1870 present an author's portrait, compared with zero portraits of white authors writing in the same social justice, realist mode.[34] She argues that the "textual element" of the portraits were employed for their supposedly greater power to refer outside the text to the "real" black body, as they "offered many proofs that the author was REAL and in this case that means: really black."[35] In Rohrbach's account, although the sight of the black body could not guarantee "textual authenticity," it was used to guarantee racial authenticity, to "locate the physical body" for its readership.[36] It is precisely the notion of the portrait as a reliable index of racial location that contemporary visual slave narratives disrupt, demonstrating that both the visual image and the literary

narrative are discursive productions. Ligon's hollow promise of "WITH A PORTRAIT" and Walker's opaque, monochromatic silhouettes are empty vessels that mark the expectation of visual evidence for racial authentication, but their works evacuate the evidentiary force of the visual.

In this way Ligon and Walker undermine not only the conventions of authentication that structure the slave narrative form, but also the conventions of authentication that structure the visual modes they appropriate, calling attention to the way these visual modes have been misunderstood as unmarked, neutral mediums, but which have instead served highly subjective functions inseparable from the social relations in which they were developed and continue to be used. To wit, Walker describes her use of silhouette as a kind of formal expedient to access a set of social relations: "The silhouette is the most concise way of summing up a number of interests. [It is a way] to try and uncover the often subtle and uncomfortable ways racism, and racist and sexist stereotypes influence and script our everyday lives."[37] For example, one of the vignettes in *Gone: An Historical Romance of a Civil War as It Occurred Between the Dusky Thighs of a Young Negress and Her Heart* (Figure 4) depicts a white plantation owner engaged in a sweet romantic moment with a white woman as the sword hanging from his belt sodomizes a small, black child dressed in ragged clothes. The white woman is implicated in the sexual abuse of the black child as much as the man, whose passive, distracted abuse is made possible by his active, attentive, proprietary engagement in heteronormative sexuality. Similarly, both the narrative form of romance and the visual form of silhouette are indicted in the broader challenge leveled by the tableau's title: *Gone*. Although slavery was an integral part of the daily workings of the plantation, the setting for the Southern "historical romance," its constitutive abuses of black people are often left out of the frame. Furthermore, Walker situates the "negress" and the contemporary black artist as parallel figures whose perspective is brought into focus when we see what has been cut away.

Rather than dismissing the narrative and visual modes from which they have been traditionally excluded, Ligon and Walker take up residence within those very structures of exclusion, challenging them from the inside. In this way my reading of Walker's and Ligon's use of the slave narrative is analogous to English's reading of Walker's tableaux as an appropriation and dismantling of the landscape tradition: "Treating landscape much as she does the silhouette, Walker turns it to her purposes not simply by evacuating its authenticating epistemologies, but by taking up a dissident position within them."[38] By challenging the authenticating strategies of the slave narrative as well as the authenticating epistemolo-

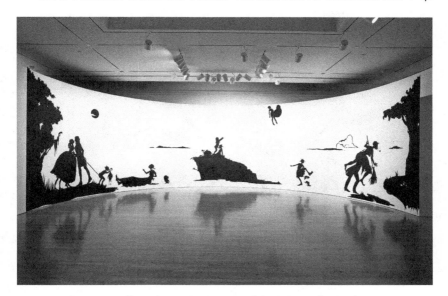

FIGURE 4. Kara Walker, *Gone, An Historical Romance of a Civil War as It Occurred between the Dusky Thighs of One Young Negress and Her Heart* (1994). Cut paper on wall. 180 × 600 inches (396.2 × 1524 cm). Installation view, *Kara Walker: My Complement, My Enemy, My Oppressor, My Love.* Hammer Museum, Los Angeles, 2008. Photo: Joshua White. Artwork © Kara Walker / Image courtesy of Sikkema Jenkins & Co., New York.

gies of landscape, in Walker's case, the artists under consideration take up a dissident position within the very structures that mark their exclusion in order to disrupt notions of visual certainty, resituating the gaze as a highly subjective function inseparable from its discursive context.

Slave Narrative as Camera Obscura: Inversions, Reversals, and Implications

If Ligon's and Walker's use of indexical mediums shift the focus of the gaze from the black subject of autobiography to the viewer herself, Ellen Driscoll's piece *The Loophole of Retreat* uses a pre-photographic medium to structurally invert the role of reader and narrator (Figure 5).[39] Driscoll figures a key chapter of Harriet Jacobs's *Incidents in the Life of a Slave Girl* as a camera obscura to address the complex power relations of looking and being looked at. In the piece, museumgoers enter a cramped structure at the room's center, evocative of Jacobs's hiding place, as objects of importance to Jacobs circle slowly outside on a motorized mobile, their

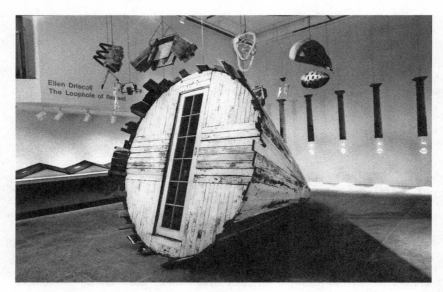

FIGURE 5. Ellen Driscoll, "The Loophole of Retreat" (1990–1992). Photo: George Hirose. Image courtesy of the artist.

inverted images itinerantly projected on the internal wall of the structure.[40] As Michael Chaney argues, Driscoll's transformation of the slave narrative into camera obscura extends Jacobs's own representation of the garret into a camera obscura, which he calls "a third space of representation" that "allows [her] to remain invisible while surveying the landscape that grounds her social and juridical subjection."[41] As a "third space" it offers a way for Jacobs to interrupt the easy binaries between slave and free, object and subject, such that "the distinctiveness of the categories it mediates break down."[42] While Chaney's goal is to articulate the ways Jacobs "registers her awareness of the possibilities in a counter-offensive of seeing," my goal is to situate this "counter-offensive" as a precursor to Driscoll's use of the slave narrative to unsettle the notion of sight as an objective, rather than subjective, function.[43]

In "The Loophole" chapter Jacobs powerfully contests the ways her life has been circumscribed by how she is seen, presenting a paradoxical relationship between her bodily constriction and the sense of freedom she achieves by her overturning of the optics of slavery. Prior to her escape, although theoretically she can move around relatively freely as a favored and sexually desired slave, her movements are actually controlled not only by the necessities of her workload but also her desire to elude the constant, lurid surveillance of Dr. Flint, which reduces her life almost entirely to a

series of defensive maneuvers and evasive actions. Conversely, during the period of her life where her body is most physically constrained, hidden in a crawl space in which she could hardly sit up, Jacobs exercises a much higher degree of control over her own life and that of Dr. Flint, directing him all over the country, for example, by arranging to have him sent letters postmarked from Northern locales—false clues to her whereabouts that he repeatedly chases after.[44]

Important for Driscoll, Jacobs moves from object to subject via the mechanics of sight. The constriction of her body is distilled into the constriction of her field of vision—a single hole through which she can see a portion of the yard—which, in turn, marks an expansion of her internal vision. "The Loophole of Retreat" chapter is the fulcrum of Jacobs's narrative: marking the turning point of her enslavement, what Jacobs can see from the attic profoundly overpowers how she is seen as a black woman.[45] Driscoll's installation reproduces this power reversal and revises the optics of the slave narrative more generally: instead of using the sight of the suffering black body as the primary route to empathy, which, as Hartman argues, runs the risk of objectifying black suffering, Driscoll's "Loophole" asks the museumgoer to become the subject, to see as Jacobs might have seen and to create their own narratives from the "flow of images" they encounter.[46]

The juxtaposition of visual, architectural, and narrative discourses is expanded in the installation's other main feature: a row of columns suspended between the ceiling and the ground. Light emanates from each of the seven columns—perhaps representing the seven years Jacobs spent in confinement—mediated by lenses that project indistinct images onto small piles of salt below.[47] The weathered columns recall the classical architecture of the plantation house; but significantly, the columns are either unfinished or decomposed, floating in midair, preempting their architectural function and significance as visual symbols of idyllic plantation life.[48] The instability of the plantation house, built on the exploited labor of enslaved people, is contrasted with the solidity of Jacobs's connection to her children, signified by her ability to look at them from her retreat. When Jacobs gets the idea to make a small aperture in the attic wall she says to herself, "Now I will have some light. Now I will see my children."[49] The durable and sustaining connection between enslaved mother and child signified by Jacobs's invisible line of sight is contrasted with the structurally unsound columns that fail to support the vision of Southern life they represent.

The salt beneath each column references another narrative of sight that turns on the drama of looking: the Biblical narrative of Lot's escape from

Sodom. Lot's wife, who cannot resist looking back, is turned into a pillar of salt. Thus the "pillars of salt" in Driscoll's "Loophole" emphasize the gender dynamics within Jacobs's account, as well as the depravity of racial slavery. Whereas male slaves, like her brother William, were able to escape when the opportunity presented itself, female slaves were often the sole caretakers of children or elders who would have no one to look after them in their absence. Determined that she was unwilling to escape without her children, Jacobs was forced to constantly look back, fixed in place for the moment, hiding within sight of her own personal Sodom.

Furthermore, this element of Driscoll's piece signifies the ambivalence to be mined from the original slave narrative form, in particular the ambivalence ex-slave narrators express about fulfilling the conventions of authentication which have the power to refix them in an objectifying gaze. The act of writing the narrative is to look back toward enslavement; however, despite the racial expectations encoded in the slave narrative form, ex-slave narrators often advance a powerful countervision within the narratives that challenges the speculative gaze of the abolitionist frame, "disturbing the conservative form of the narrative without displacing it" as Sekora would have it. For example, Chaney reads Jacobs's presentation of a particularly vicious beating of one of her fellow slaves as illustrative of her own circumvention of the speculative gaze of the narrative: "In satisfying the genre's conventional representation of the slave body as a spectacle of abject victimization" Jacobs describes the scene not as she *saw* it, but rather as she *heard* it, describing the slave's "piteous groans, and his 'O, pray don't, massa,'" which "rang in [her] ear for months afterwards."[50] Complying with the requirement that she provide examples of the brutal physical abuse enslaved people were subject to at the hands of irrational masters, Jacobs nevertheless refuses to expose the abused body to the gaze of the reader. Although she visually ratifies the scene by noting that she "went to the work house the next morning, and saw the cowhide still wet with blood, and the boards all covered with gore,"—a recognition of the importance of visual evidence to her readership—Chaney argues that "Jacobs's emphasis on hearing rather than seeing diverts the reader's gaze from the subjected captive body, allowing the tortured slave a measure of humanity commensurate with mind rather than body."[51] As a contest between the "eyewitness" and "earwitness," this is an excellent example of Jacobs's use of representational static to "probe, unconsciously and consciously, certain gaps in [narrative] conventions, certain disturbances in the surfaces of narrative" to evade the evidentiary requirements and speculative gaze formalized in the slave narrative.[52]

Driscoll expands Jacobs's own resistance to her literary confinement

by literalizing the cramped space of the attic as a cone of vision, thereby shifting the viewer's focus from the abused black body and presenting vision as a subjective, embodied function. Although Driscoll's attention to Jacobs's interiority—her psychological experience—distinguishes "Loophole" from other contemporary visual slave narratives, Driscoll's installation is ultimately interested not in Jacobs herself, but in the cramped architectural, social, and narrative forms she was compelled to inhabit. Where Ligon and Walker create a play of surfaces to evacuate the subject and ironize stereotypes of black subjectivity and assumptions of racial difference, Driscoll creates an installation characterized by depth to accomplish the same goals, literally inviting the museumgoer into the narrative to see from her perspective. By juxtaposing Jacobs's narrative of enslavement with the mechanics of visual representation, Driscoll discloses the true subject of the work: the racial dynamics of vision. The conical, makeshift camera obscura directs attention to perspective, pointing us to the embodied viewing subject and disrupting the model of visuality-as-authority, characterized by the surveillance economy of slavery and the privileged observer wielding a supposedly disembodied gaze over the enslaved person-as-object. Much like Ligon's *Narratives* and *Self-Portrait*, and Walker's silhouette tableaux, Driscoll's work forces the viewer to acknowledge her position vis-à-vis the subject. Moreover, although the viewer symbolically enters Jacobs's field of vision, that vision is entirely mediated through narrative. This instantiation of representational static, like those found in the slave narratives themselves, simultaneously confounds the notion of vision as an objective function operating outside of its discursive context and recovers the unseen affective and familial bonds between enslaved people by creating new lines of sight.

The Language of Visibility

In the crucible of the slave market the confluence of visual speculation, linguistic determination, and social performance resulted in a literal investment in racialized subjectivity increasingly articulated along the axis of the visual. As Walter Johnson shows in his study of antebellum slave markets, slave traders used language and the visual assumptions of their customers to produce an increasingly sophisticated lexicon of racial categories that then became "facts" in the market:

The traders' efforts to codify [a] strain of proximate whiteness produced the antebellum South's most detailed racial taxonomy. Whereas the categories of the United States census were limited to "black"

and "mulatto," the traders' detailed categories—"Negro," "Griffe," "Mulatto," "Quadroon," and so on—attempted much more precise measurement of imagined portions of "black" and "white" blood. And whereas the courts limited their own detailed investigations of blood quantum and behavior to drawing a legal line between "black" and "white," the traders' categories preserved a constant shifting tension between blackness and whiteness—a tension that was daily measured, packaged, and sold in the slave market.[53]

The black/white binary that was troubled by the proliferation of racial categories was also the essential fiction upon which race was based. Although Johnson indicates the traders' logic is founded on an unseen sexual economy of blood quantum, the language of the market fixates on—and attempts to fix—the external *appearance* of the slaves. This appearance, both relative and arbitrary, is then concretized in language, and visible attributes take on both discursive and literal value.

Ironically, this history demonstrates that it is through the stabilizing force of language that somatic characteristics come to seem objective. Conversely, as I discussed at the beginning of this chapter, visual adjuncts to the slave narrative such as the author portrait work to stabilize the text by authenticating the existence of the narrator and therefore the authenticity of the narrative.[54] Thus, by juxtaposing visual and literary paradigms of black subjectivity, Ligon, Walker, and Driscoll use the convergence of these registers to undermine visual fictions of race. In an interview at the time of his exhibition *Glenn Ligon: Un/becoming*, Ligon made the statement that he "wants to make language a physical thing, something that has real weight and force to it."[55] This statement is not without irony if we note, as Ligon does, that historically language has been used against black people with a tremendous amount of weight and force. In *Narratives* Ligon uses the absence of figural imagery to highlight the expectation readers and viewers have of *seeing* the black artist or author. "Black Rage; or, How I Got Over; or, Sketches of the Life and Labors of Glenn Ligon" exploits the double meaning of "sketches"—as both brief narrative accounts and a kind of visual shorthand—to emphasize the markedly visual nature of narrative presentations of black suffering in slave narratives. The oversized frontispiece boldly announces, "Containing a full and faithful account of his commodification of the horrors of black life into art objects for the public's enjoyment." Like all of the prints in *Narratives*, "Black Rage" trades on the salacious pleasure produced for some readers and viewers by representations of black suffering even while withholding that pleasure by refusing images where we most expect to

find them—in an art museum. In this way, Ligon engages debates about the representation of the black body and notions of racial authenticity while "sidestep[ping] figuration."[56] The empty announcement of "with a portrait" punctuates the print, diverting the viewer away from the representation of Ligon's actual body toward his or her expectation of the authentication of an author/narrator portrait calculated to demonstrate the dignity and humanity of the former slave as well as what has become the "routine display of the slave's ravaged body" within slave narration.[57]

Whether he uses figural representation, as in *Self-portrait*, or text-based representation, as in *Narratives* or his companion series *Runaways* (1993), Ligon's object is to unsettle the notion that images are more reliable indexes of race than language. *Runaways* in particular highlights the ways that language is implicated in the process of racialization, suggesting both the problematic nature of eye-witness testimony as well as the continued objectification of black men through racial profiling. To create the series, Ligon asked ten friends to "provide a verbal account of [him] as though reporting his disappearance to the police."[58] He then transcribed those descriptions into the form of runaway slave advertisements, replicating typographic conventions and including the stock images printers often ran with such announcements.[59] However, the descriptions in *Runaways* often contradict each other, evacuating the power of language to fix Ligon in a particular racial category and indicating the absurdity of such a project: one advertisement declares Ligon to be "pretty dark-skinned," while another identifies his complexion as "medium, (not 'light skinned' not 'dark skinned', slightly orange)." In addition to forwarding an argument about the similarities between racial slavery and our contemporary criminal justice system by asking friends to provide descriptions "as though they were reporting his disappearance to the police," the work brings out the subjective nature of sight, producing a moment of static to interrupt the discourses of accuracy and evidence in play. *Runaways* trades on the interplay between a real referent (the artist's body) and the contradictory visual and linguistic representations of that body. This particular strategy is common to all the artists under consideration, but it is important to recognize that this strategy has been part of the slave narrative from its inception.

Looking Back: Reassessing the Role of Visuality in the Original Slave Narratives

Although the original literary slave narrative, and particularly the classic slave narrative of the antebellum period that is later taken up by visual

artists, was circumscribed by the goals of abolition, there are moments of
visual incongruity—such as those described in Jacobs's *Incidents*—which
cannot be contained by the formulaic mold enforced by abolitionist
editors and sponsors. The "race rituals" that constitute the conventions of
authentication—which become the subject of Ligon's *Narratives*—record
a white racial anxiety over racial distinction that far outstrips questions
of black legal status, slave or free. Although Ligon has grown increas-
ingly leery of using literature within his art, his work opens the door to
understanding the way the ex-slave narrators themselves engaged this
"treacherous site." The discursive production of blackness through visual
iconography and literary subjectivity literally speak against one another
in the slave narrative form such that the illogic at the heart of racial con-
struction is exposed.

Contemporary artists' production of representational static through
the use of the slave narrative form occasions a reevaluation of the treat-
ment of the visual logic of racial slavery in the original literary slave nar-
ratives. As the foregoing reading of *Incidents* and the following reading
of *Narrative of the Life of Frederick Douglass* show, the use of represen-
tational static is not an innovation within current-day artists' work. Ex-
slave narrators themselves resisted the slave narrative's formal emphasis
on evidence and authenticity by highlighting—and challenging—the role
of visuality in codifying black subjectivity.

In Douglass's 1845 *Narrative*, the visual appears as a dissonant element
which limits the representative power of linguistic and visual discursive
modes to demarcate black experience. Even as he makes a strong case
for abolition, Douglass's deployment of visual metaphors demonstrates
the (racial) limits of political freedom. At the very moments Douglass is
expected to provide proof of his humanity, he casts rhetorical attention
on the idiosyncrasies of dominant discourses of authenticity by juxtapos-
ing literacy and the visual icon of the hyper-materialized black body. The
discrepant engagement of language and the visual image has two effects:
first, it reveals the fiction of race where it is instituted most powerfully—
in the visible; and second, it allows Douglass to explicitly perform the
self-authorizing gestures necessary to prove his humanity, while implic-
itly critiquing the system of racial classification that would place him out-
side of the category of human.

In the traditional reading of his *Narrative*, Douglass's acquisition of
literacy represents his transition from slave object to human subject. As
Lindon Barrett argues, literacy functions as a prohibition or exclusion
connected to systems of white power, but also as an entry-point into ab-
stract thought, a sign of freedom from embodiment.[60] By appropriating

literacy Douglass overturns the mind/body split, the exclusionary principle that casts blackness outside of Western notions of humanity. But while Douglass upholds reason as the constitutive element of humanity, he refuses the racial logic that posits blackness and reason as mutually exclusive, a notion that was used to justify and maintain racial slavery. Douglass's use of visual metaphors at key junctures in his narrative reveals the problem with racial slavery to be more than just a problem of enslavement, but a problem of racial speculation—specifically the objectification of blackness.[61] Attention to the visual codes in the text demonstrates the chiastic structure of witnessing within the narrative.[62] Furthermore, although he uses literacy to broker the transition between his object status as a slave and his subject status in freedom, it is at the nexus between literacy and embodiment that Douglass signals the racial limitations on the free black subject.

Early in his narrative Douglass describes many incidents of slave life from the perspective of a witness, a strategy that is reversed at the end; at the moment of escape, the moment we most expect a description of the slave body, his body literally disappears. Although born into slavery, Douglass marks his entrance through the "blood-stained gate" as his witnessing of the beating of his Aunt Hester, and he marks his "resurrection from the tomb of slavery" as his triumph over the slave-breaker Covey, long before his actual escape.[63] The scenes are connected by the chiasmus, "You have seen how a man was made a slave; you shall see how a slave was made a man."[64] In fact, the figure of chiasmus, a rhetorical crossing in which the words in the first clause are reversed in the second, is replicated in the larger narrative structure in which Douglass's experience of visibility, and therefore vulnerability in slavery, is reversed in the narrative's conclusion in which Douglass's body does not appear. Douglass emphasizes the spectacular nature of the beating of Hester by calling it a "horrible exhibition" and a "terrible spectacle."[65] He was "horror-stricken at the sight" and "had never seen any thing like it before."[66] His response is to hide himself in a closet; expecting to be next, his only defense was to physically remove himself from sight. Douglass attributes Hester's beating to her hyper-visibility as a sexual object in the eyes of Captain Anthony. He alludes to her objectification in a telling ellipsis followed by a description of her beauty: "Why master was so careful of her, may be safely left to conjecture. She was a woman of noble form, and of graceful proportions, having very few equals, and fewer superiors, in personal appearance, among the colored or white women of our neighborhood."[67] Hester's hyper-visibility is emphasized by her nakedness: "[Captain Anthony] took her into the kitchen, and stripped her from neck to waist,

leaving her neck, shoulders, and back, entirely naked."[68] Like Douglass, we are positioned as witness to this brutal scene.

This violent baptism into slavery is paralleled by another "bloody transaction" toward the end of the narrative—what Douglass calls the "turning point in [his] career as a slave"—his triumph over the slave-breaker Covey.[69] Describing being "broken" by Covey, Douglass writes, "I broke down; my strength failed me; I was seized with a violent aching of the head, attended with extreme dizziness; I trembled in every limb."[70] Shortly thereafter, though, his extreme physical vulnerability is replaced with the vulnerability, and visibility, of the white body. The last time Covey comes at Douglass, it is Covey who is seized by physical frailty in the face of Douglass's power; it is Covey who trembles at the hands, the fingers, of Douglass: "[A]t this moment—from whence came the spirit I don't know—I resolved to fight; . . . I seized Covey by the throat . . . He held on to me and I to him. My resistance was so entirely unexpected, that Covey seemed taken all aback. He trembled like a leaf. . . . I held him uneasy, causing the blood to run where I touched him with the ends of my fingers."[71] Rewriting the proposition of black and white physicality, Douglass describes himself as overcome by a "spirit" while Covey is reduced to the materiality of his body and its weakness. Throughout the rest of the narrative, Douglass's body virtually disappears. Where we expect an account of Douglass's escape from slavery, he demurs and substitutes the endangered slaveholder's body in a condition of moral and spiritual fugitivity: "Let [the slavecatcher] be left to feel his way in the dark; let darkness commensurate with his crime hover over him; and let him feel that at every step he takes, in pursuit of the flying bondman, he is running the frightful risk of having his hot brains dashed out by an invisible agency."[72] Douglass leaves white readers in intellectual darkness about the events and mode of his escape, concluding his narrative with the invisibility of the free black body—not only out of the grasp of the slaveholder, but also outside of representation.

Douglass's chiasmus, the turning point between his hyper-visibility and freedom from embodiment, is a key example of representational static. Douglass uses metaphors of sight to critique the visual objectification and racial speculation founded in racial slavery. When Douglass writes, "You have seen how a man was made a slave; you shall see how a slave was made a man," he tempers what would be a triumphant proclamation—his entrance into manhood—by containing it within the metaphorical frame of sight, which has been problematic throughout the narrative. The terms of the chiasmus present an insufficient claim on liberation precisely because it is how Douglass has been seen—as racially black—that has

put a lien on his freedom. Born into racial slavery, he was excluded from "Manhood." Thus, Douglass points the reader to a vacancy, an absence standing in for African American humanity denied by racial slavery. The visual is invoked as a limit to the symbolic power of literacy to transcend racial conditions. Douglass makes explicit that it is how slaves are seen that places them outside of humanity. Douglass's use of a visual metaphor to declare his entrance into manhood is, then, a cunning recognition of the ambivalent role of literacy within the slave narrative. On one hand, Douglass's invocation of sight demonstrates the (racial) limits of political freedom and signals the potential problems of an abolitionist movement that requires evidence of black humanity; on the other, Douglass's visual metaphor is a demonstration of his literary prowess, a triumphant declaration that his readers will no longer see him through the lens of his racial designation, but rather they will see him as he wants them to.[73]

By valorizing a sophisticated visual imaginary embedded in the narrative through language rather than image, this analysis shows how Douglass creates a disjunction between verbal and visual representations of the black body that undermines the logic of race understood as physical difference. Identifying representational static within contemporary visual slave narratives allows us to recognize previously overlooked rhetorical strategies of ex-slave narrators of the nineteenth century. Such recognition shows that even while reproducing a key trope of slave narration, the image of the denigrated black body for example, ex-slave narrators challenge the fixity of that image and reveal race to be a discursive construct irreducible to any single image authorized by the speculative gaze.

The Afterlife of the Slave Narrative

Twentieth-century artists' recovery of the publication conventions of nineteenth-century slave narratives advances a critique of the limits and expectations levied on African American cultural producers, which we can locate in the slave narratives themselves. Lamenting the ways works by black artists are often overdetermined by "the idea of black culture," English writes that "in this country, black artists' work seldom serves as the basis of rigorous, object-based debate. Instead, it is almost uniformly generalized, endlessly summoned to prove its representativeness (or defend its lack of the same) and contracted to show-and-tell on behalf of an abstract and unchanging 'culture of origin.'"[74] Although English's remarks refer to "black artists" at the turn of the twenty-first century, his statement could just as easily be applied to ex-slave narrators of the eighteenth and nineteenth centuries. It is exactly these parallels

that prompt Ligon, Walker, and Driscoll to use the slave narrative as a way of thematizing the extra-artistic forces that condition the production and reception of "black art" in contemporary museums and galleries. By adopting the conventions of an earlier generation of black cultural producers whose works bear the traces of the negotiations they undertook with white publishing institutions and readers, contemporary visual slave narratives highlight the similar negotiations the African American artist undertakes with contemporary art institutions and viewers, asking "what are the conditions under which works by black artists enter the museum? Do we enter only when our 'visible difference' is evident? Why do so many shows with works by colored people (and rarely whites) have titles that include 'race' and 'identity'? Who is my work for and what do different audiences demand of it?"[75]

By restaging nineteenth-century narratives in the present with contemporary subjects, Ligon, Walker, and Driscoll unhinge the realist narrative of race that persists in the contemporary period. The historical event of the slave markets conventionalized, naturalized, and solidified the sight of blackness into the symbolic capital of race that is still with us today. The ambivalent use of language surrounding the sale of slaves in the antebellum slave markets worked to fix blackness and whiteness in an oppressive binary system of signification. The black body was a site on which white fantasies were projected and concretized. Thus, visual art is in a unique position to recast and revise the experience of black subjectivity advanced in the nineteenth-century slave narrative as one that is constructed along, and limited by, the visual axis. Ligon, Walker, and Driscoll use the formal properties of nineteenth-century representations of blackness to create art that disaggregates the speculative white gaze. What they produce are canny, referential sites that use literary and visual paradigms of black representation to unfix blackness, and, in the case of Driscoll's piece, offer sight as a positive form of connection balanced against the damning vision of racial slavery. By creating visual sites in which the viewer participates in what Robyn Wiegman calls an "economy of the visible," Ligon, Walker, and Driscoll reflect and deflect the subjectivating gaze of whiteness onto the viewer, thereby undermining the reliability of sight as a mechanism for authenticating racial identity. Put differently, the historical disjunction of nineteenth-century literary conventions in late-twentieth-century visual art productions exposes the limitations of both literary and visual paradigms to represent black experience and black subjectivity.

It is right to be cautious about discussing two distinct historical periods under the same theoretical rubric, but the reemergence of the slave nar-

rative in contemporary art demands transhistorical analysis. Expressing his frustration over a backward-looking trend in black cultural criticism, Robert Reid-Pharr argues that "all too often students of Black American literature and culture reproduce notions of a stagnant Black American history by insisting that the anguished cries of the slave are ultimately indistinct from the complicated musings of the contemporary artist."[76] While I take Reid-Pharr's point that there must be room in contemporary cultural criticism to recognize and "reimagine the basic modes" of black culture outside of the paradigm of enslavement, analyzing contemporary artists' turn to the slave narrative allows us to see a greater degree of complexity in a genre that was valued at its inception for its perceived artlessness.[77] The deliberate and strategic conjunction of the formal properties of slave narratives with new modes of visual presentation provides an opportunity to reassess the goals and rhetorical strategies of formerly enslaved narrators working under highly compromised circumstances. Rather than reproducing a stagnant notion of blackness, contemporary visual artists' turn to the slave narrative provokes the viewer into questioning historical assumptions about blackness and the notions of racial legibility set forth in the original texts. Although the use of anachronism within the art distinguishes the contemporary visual slave narratives from their nineteenth-century literary counterparts, their shared use of representational static to interrupt fixed notions of blackness indicates a common experience of—and resistance to—racial speculation. The reassessment of the treatment of visuality within the original slave narratives makes it possible to evaluate the slave narrative form itself—from its literary origins in the late eighteenth century to its visual incarnation in the late twentieth century—as presenting a consistent challenge to racial speculation. By juxtaposing visual and textual discourse, ex-slave narrators and the artists who take up their subject position exploit the polyvocality and claims to authenticity of the slave narrative to reject the political and moral justifications for racial slavery and to thwart the speculative gaze directed at them by slaveholders, abolitionists, and museumgoers alike.

2 / *Behind the Scenes* and Inside Out: Elizabeth Keckly's Use of the Slave Narrative Form

Perhaps the most insidious and least understood form of segregation is that of the word.

—RALPH ELLISON, *SHADOW AND ACT*

In September of 1862 when Abraham Lincoln read a draft of what would become the Emancipation Proclamation, declaring that all slaves in Confederate states would be legally free on January 1, 1863, around four hundred recently escaped slaves were living homeless in Washington, D.C. By the end of the war, less than four years later, that number had risen to forty thousand.[1] Elizabeth Keckly, a former slave living in Washington, D.C., sympathized with the newly freed men and women who arrived daily in the city with little more than the clothes on their backs.[2] Since purchasing her own freedom in St. Louis, Keckly had established herself as a *modiste* to elite families in D.C. and was doing well enough to open her own shop and sustain a number of employees. It is from this vantage that in the summer of 1862, after observing fundraising campaigns organized for wounded white soldiers, she determined to make a similar appeal to the black community on behalf of newly emancipated slaves. Her narrative, *Behind the Scenes; or, Thirty Years a Slave and Four Years in the White House* (1868), describes the moment that she was struck by the idea: "If white people can give festivals to raise funds for the relief of suffering soldiers, why should not the well-to-do colored people go to work to do something for the benefit of suffering blacks?"[3] Within weeks, Keckly had organized and was serving as the president of the Contraband Relief Association, which provided material support to newly freed men and women establishing themselves in the North.

Keckly's intimate awareness of the precarious situation of emancipated slaves and her advocacy on their behalf provides a striking contrast to her discussion of Mary Lincoln's financial difficulties in her narrative. Al-

though she explicitly sympathizes with Mary Lincoln, and in fact states that her primary motive in writing the narrative is to clear Lincoln's name—"To defend myself I must defend the Lady that I have served"—the representation of Lincoln as a privileged woman forced to sell her couture dresses and live in less well-appointed guest rooms takes on an ironic cast when held up against Keckly's advocacy on the part of free men and women settling in makeshift encampments and struggling to acquire basic necessities.[4] As the Lincolns' personal tailor and confidante of Mary Lincoln, Keckly had a unique perspective on the First Lady's rise and fall in the eyes of public opinion, and her narrative offers, in its own words, to lay bare the "secret history of [Mary Lincoln's] transactions."[5] After Lincoln's assassination, when Mary's soaring debts came to light, she turned to Keckly for both emotional support and help selling her wardrobe to raise funds in a clandestine private auction; the scheme failed miserably and became the public debacle known as the Old Clothes Scandal. Newspapers of the time note that while curious about Lincoln's private life and financial predicament, the public had very little sympathy for her circumstance. According to Keckly, however, this was not the case within the black community. In the wake of the scandal Keckly marshaled her considerable contacts to raise money on Lincoln's behalf, noting "the colored people were surprised to hear of Mrs. Lincoln's poverty, and the news of her distress called forth strong sympathy from their warm, generous hearts. Rev. H. H. Garnet, of New York City, and Mr. Frederick Douglass, of Rochester, N.Y., proposed to lecture in behalf of the widow of the lamented President, and schemes were on foot to raise a large sum of money by contribution."[6] This disclosure, like many in the narrative, may surprise readers of the text. In 1867, when one might expect representatives of the government to be providing support and relief to newly emancipated slaves, many of those former slaves were taking up a collection for Mary Lincoln.[7]

This striking historical coincidence is emblematic of the structure of *Behind the Scenes* as a whole, which repeatedly confounds narrative expectations and reverses what Robert Stepto calls the "race rituals" that structure the classic slave narrative.[8] Although Keckly inscribes her text within the slave narrative tradition through her subtitle and the reproduction of key narrative tropes of slave experience—the scene of slave family separation, the female slave's vulnerability to sexual abuse, brutal beatings at the hands of white slaveholders—the majority of the narrative concentrates not on Keckly's experiences as a slave but on the Lincolns' experiences in the White House, observed from her perspective as Mary Lincoln's personal tailor. Because of this emphasis, critics have identified

the narrative as a departure from the traditional slave narrative genre, an assessment that, along with its postbellum publication, has kept it from receiving the widespread attention of other women's slave narratives, namely Harriet Jacobs's *Incidents in the Life of a Slave Girl* (1861), which is taken to be *the* representative account of a female experience of slavery.[9] Readers versed in the conventions of slave narratives expect that the primary subject of the narrative will be Keckly's experience of enslavement, an expectation that is both acknowledged and refused through the narrative's language of revelation. For example, recalling the language of Lydia Maria Child's Introduction to *Incidents*, in which Child takes responsibility for presenting the "monstrous features of slavery" with the "veil withdrawn," Keckly's self-penned Preface states that "the veil of mystery must be drawn aside; the origin of a fact must be brought to light with the naked fact itself."[10] However, the language of revelation and exposure is applied to Mary Lincoln's motivations in selling her old clothes, rather than to Keckly's experience of enslavement or the sexual vulnerability of black women to white men under the slave regime.[11] In light of Keckly's activist work on behalf of newly emancipated slaves, I argue that this reversal is a strategic choice designed to call attention to the ways traditional slave narration—with its attendant conventions of authentication—leaves certain racial assumptions intact.[12] Keckly's narrative, while seeming to avoid the black subject—causing Rafia Zafar to call the text a "black autobiography without African Americans"—actually dismantles the apparatus of racial authenticity, presenting a significant challenge to the persistence of a black/white racial binary in the postbellum period and drawing particular attention to the persistence of the visual logic of this binary, which continues to forcefully operate after Emancipation.[13]

Central to my argument is an understanding of the slave narrative as more than a version of autobiography, in which the singular perspective of a single subject is paramount, but rather as a form that comes into being as a response to the contradictions within western discourse that challenge the very notion of black subjectivity.[14] Although she moves quickly through the events of her life in slavery, Keckly's narrative is shaped by the formal requirements of slave narration throughout. The narrative responds to and revises the narrative elements that constitute the slave narrative's conventions of authentication: the variety of tropes, documents, and guarantees that confirm and cosign the black literary voice. *Behind the Scenes* includes a justificatory preface, documentary evidence, and a scene of literacy, but the racial convention underlying those narrative gestures—white authority legitimating black experience—is reversed. In *Behind the Scenes* it is Keckly's authority that underwrites the status and

actions of the white figures in her text: Keckly's letters authenticate Mary Lincoln's version of events, Tad Lincoln's reading lesson is included in place of her own, and the narrative gaze is primarily on the white bodies within the text as they take shape in her vocation, dressmaking. The authenticating documents integrated into *Behind the Scenes*, such as her emancipation papers and the letters between Keckly and Lincoln, are superseded by the dominance of Keckly's own editorial voice; Keckly offers or withholds information as *she* sees fit.[15] Because the conventions of slave narratives are so well known by 1868, Keckly's inversion of black and white figures within otherwise traditional authenticating elements casts attention on the racial expectations that motivate slave narrative construction, literally revising the notion of racial authenticity.

The novelty of my argument is its formal reading of *Behind the Scenes* as unified by its revision of the slave narrative conventions, which allows for an understanding of the text as a powerful rebuke of the racial logic extending from slavery into the postbellum period. Where other critics have understood the narrative as fundamentally ambivalent, riven by class divisions and Keckly's seemingly contradictory condemnatory and conciliatory stances on the role of slavery in both her own life and the life of the nation, attention to the narrative's formal elements reveals a sustained critique of white racism.[16] For example, a focus on these structural elements of the narrative belies the reading that Keckly exhibits "a strong desire to prove herself"; Keckly's inversion of black and white figures within the slave narrative's structures of authentication suggests not only that she feels she has nothing to prove, but also that she finds the requirement that she provide proof of the truth of her experiences absurd.[17] Similarly, I argue that the explicit class divisions within the text, such as the rhetorical distance Keckly adopts in her discussion of the mass of newly emancipated slaves arriving daily in D.C., are ultimately a rhetorical strategy Keckly uses to draw attention to the lack of care the newly reunited nation provides for its most vulnerable citizens.

Among those critics that have discussed *Behind the Scenes* within the slave narrative tradition, there has been a tendency to see Keckly as overly optimistic about the status of her freedom. Xiomara Santamarina, following Frances Smith Foster and Rafia Zafar, reads *Behind the Scenes* as Keckly's miscalculation that the working loyalty between black and white women would extend to the confidence and loyalty of a white readership, who roundly rejected the book: "[Keckley fails] to recognize how her subordinate status as a servant meant that her work-related attributes could only be narrated by her employer, not by herself."[18] While not going as far as to declare the narrative failed in this way, Jennifer Fleischner provides

a psychological account of the narrative's apparent inconsistencies, call-
ing them "strategies of unconscious repression or deliberate suppression,
substitutions, splitting, and inversions that seem intended to mask some
of the anger and sorrow associated with her experiences of racism and
slavery."[19] By contrast, I read *Behind the Scenes* as a successful activist text
that eschews the approval of her white audience and uses the persistence
of racial binaries against themselves.[20] Reading Keckly's narrative as uni-
fied by its revision of slave narrative conventions allows for an alternate
understanding of the text not as a *mis*calculation of interracial sentimental
female affiliation forged through work or an attempt to manage personal
feelings of loss and rage in the wake of slavery, but as a calculated reversal
designed to undermine the persistence of a pernicious racial divide.[21] The
success of Keckly's sharp-eyed critique might be measured by the vitriol
exhibited by the narrative's failed reception, which lays bare the ideologi-
cal assumptions about blackness her text targets through its revision of
the slave narrative form. Correctly perceiving *Behind the Scenes* as an at-
tack on the racial status quo, contemporary reviewers painted Keckly as
a servant "who had forgotten her place."[22] The narrative even engendered
a particularly virulent racist parody entitled *Behind the Seams*, which in-
advertently confirms Keckly's own analysis of racial ideology in so-called
free society through the caricature of Keckly as an illiterate, immodest,
ignorant slave named "Betsy Kickley" who must sign her name with an
"X."[23] Reading Keckly's narrative as unified by its revision of slave narra-
tive conventions claims a political unity of purpose for the text and sheds
new light on her interventions into literary and visual representations of
African Americans in the postwar period.

In addition to recalibrating our understanding of *Behind the Scenes* as
a major contribution to (rather than departure from) the slave narrative
tradition, recognizing Keckly's appropriation of the genre's authenticating
strategies exposes her sophisticated textual intervention into a visual cul-
ture quickly becoming the nineteenth century's dominant "mode of social
perception."[24] In overturning the race rituals performed by the conven-
tions of authentication, which rely on fixed notions of "black" and "white,"
Keckly undermines the ideological presumptions that link blackness with
enslavement and whiteness with literacy and truth. Moreover, through
her vocation as a dressmaker, Keckly is well positioned to highlight the
constructedness of what may appear to be finished products. While other
critics—particularly Elizabeth Young and Carme Manuel—have identi-
fied *Behind the Scenes* as an intervention into national iconography, I ar-
gue that Keckly's deployment of visual tropes and metaphors represents a
fundamental refiguring of how we understand the visual world.[25] Whereas

Manuel argues that "Keckley rewrites popular visual representations of blacks and restores their visibility in order to construct a new politics of historical truth," I argue that Keckly goes further than simply expanding the range of images admitted into the national archive and interrogates the values that construct that archive.[26] Writing against the assumption that "mechanically reproduced images carried the weight of truth and transparency," African American authors used their texts to scuttle the equation of visual evidence and truth.[27] Just as Keckly challenges the notion that her narrative requires authentication because of her racial status, so, too, does she challenge the idea that race is self-evident. Her strategy of inversion and juxtaposition pits textual and visual conventions of representation against one another to erode the aura of truth which obtains in each and challenges the notion that we "know something when we see it." During the scene depicting her whipping at the hands of a white man, for example, Keckly likens herself to a statue, invoking conventions of visual art to highlight the spectacular character of black suffering in traditional slave narration. Later, an image in Tad Lincoln's literacy primer impedes his reading lesson and becomes an occasion for Keckly to remark on the double standard of black and white illiteracy. These scenes, along with her substitution of Abraham Lincoln's spectacular vulnerability in place of the black slave's and her use of clothing as a narrative device—which both metonymically represents white flesh and highlights her role at the center of events of national importance—represent a profound challenge to the visual culture of her time. In *Behind the Scenes* visual details or metaphors intrude upon each of the expected slave narrative tropes and become the organizing principle of the text: conventions of authority and self-determination mapped onto black and white subjects are overturned in *Behind the Scenes* such that the racial logic expressed in the slave narrative's conventions of authentication is overturned. Despite writing her narrative with abolitionist editor James Redpath (who has no textual presence in the narrative), Keckly rejects the racial protocols of conventional slave narration, radicalizing the form.[28] In so doing, she establishes the slave narrative as a mode of cultural critique that exceeds the political mandates of abolition, as well as the historical moment of the antebellum, and intervenes in an epistemological conflict over race.

"A Black Autobiography without African Americans"

The rare appearance of Keckly's own body in her narrative and the corresponding focus on the white body represents a significant departure from the presentation of the suffering black body in classic slave

narratives.[29] Keckly includes a scene describing her own abuse, but it functions as a critique of what Saidiya Hartman calls the "inaugural moment in the formation of the enslaved"; her corollary shift in narrative focus to vulnerable white bodies—and specifically Abraham Lincoln's body—illustrates the unequal propositions of black and white materiality wherein blackness is seen as pure physicality and whiteness is understood as inherently meaningful, signifying beyond the contracted circle of matter that is the body.[30] Carol Henderson argues that the presentation of damaged black flesh was a representational strategy designed to make black humanity visible to readers: "the alliance between abolition and political action rested not only on *seeing* the body in pain but also on *being* the body in pain because it is this rhetorical use of pain that marks the slave body and makes it visible."[31] Hartman identifies the cost of this route to empathy: "[I]f the scene of beating readily lends itself to an identification with the enslaved, it does so at the risk of fixing and naturalizing this condition of pained embodiment and . . . increases the difficulty of beholding black suffering since the endeavor to bring pain close exploits the spectacle of the body in pain and oddly confirms the spectral character of suffering and the inability to witness the captive's pain."[32] Central to both Henderson's and Hartman's analysis is the re-inscription of a dominant visual paradigm. In Henderson, black flesh must be scarred to cross the threshold from invisibility to visibility; Hartman recognizes this mode of visibility as spectacle antithetical to empathy: "the elusiveness of black suffering can be attributed to a racist optics in which black flesh is itself identified as the source of opacity, the denial of black humanity, and the effacement of sentience integral to the wonton use of the captive body."[33] The presentation of the suffering black body is an ambivalent mechanism of self-authorization, potentially re-inscribing the invisibility/opacity of a fixed notion of blackness.[34] Keckly's narrative addresses this convention of authentication, implicated in a "denial of black humanity," by first acknowledging the spectacular character of the black body in pain, then shifting the narrative gaze to the spectacle of white physical vulnerability on a national scale—in the form of President Lincoln's assassination. By showcasing white vulnerability while she maintains a disembodied, editorial distance, Keckly implicitly critiques the association of blackness with embodiment, reversing what Hartman calls "racist optics."[35]

In the early part of her narrative Keckly, like Harriet Jacobs, demonstrates the link between physical vulnerability and sexual violation to which female slaves are susceptible. Although whipping usually appears under the guise of correction, Keckly emphasizes the sexual motivation often animating the abuse of female slaves. The beating Keckly describes

in the most detail—a whipping inflicted on her after she had grown into "strong, healthy womanhood"—reveals both sexual jealously (on the part of the mistress) and sexual desire (on the part of the master or master's proxy). At the time of the incident, Keckly was living with a relatively poor family, the Burwells, who were in charge of a small church in Hillsboro, North Carolina. Mrs. Burwell, who Keckly describes as "morbidly sensitive," constantly punished Keckly for unnamed offenses, a pattern that culminated in allowing a local schoolmaster, Mr. Bingham, to act as her proxy in punishing Keckly: "She whom I called mistress seemed to be desirous to wreak vengeance on me for something, and Bingham became her ready tool."[36] Sexual jealously is implied as the vague "something" that Keckly is guilty of, and Mrs. Burwell's suppressed jealously translates into the overtly sexual nature of the beating she receives from Mr. Bingham:

> It was Saturday evening, and while I was bending over the bed, watching the baby that I had just hushed into slumber, Mr. Bingham came to the door and asked me to go with him to his study. Wondering what he meant by this strange request, I followed him, and when we had entered the study he closed the door, and in his blunt way remarked: 'Lizzie, I am going to flog you.' I was thunderstruck, and tried to think if I had been remiss in anything. I could not recollect of doing anything to deserve punishment, and with surprise exclaimed: 'Whip me, Mr. Bingham! What for?'
>
> 'No matter,' he replied, 'I am going to whip you, so take down your dress this instant.'
>
> Recollect, I was eighteen years of age, was a woman fully developed, and yet this man coolly bade me take down my dress.[37]

Although Keckly refuses, Bingham tears her dress from her back and repeatedly wields the whip over her "quivering flesh."[38] Rather than suppressing what Hartman calls "the spectacular character of black suffering," Keckly emphasizes it by refusing to make any noise, likening herself to a statue. She prompts the reader to become a more immediate witness to the scene when she writes, "Oh God! I can feel the torture now—the terrible, excruciating agony of those moments. I did not scream; I was too proud to let my tormentor know what I was suffering. I closed my lips firmly, that not even a groan might escape from them, and I stood like a statue while the keen lash cut deep into my flesh."[39] Keckly expresses her subjectivity through her silence, refusing to acknowledge the pain that she knows would provide satisfaction to her tormentor.[40] But the scene also refuses the satisfaction anticipated by the white reader who expects the conventional display of black suffering in her narrative. Just before her

declaration to remain silent, Keckly describes the scene from the perspective of a witness at the time of her writing rather than participant during the original event. She writes "the rawhide descended upon *the* quivering flesh," forgoing the use of the possessive pronoun "my" and enhancing the scenic quality of her description.[41] At this most brutal moment of description she rhetorically distances herself, describing the scene from the perspective of an onlooker rather than from her perspective as the subject of the abuse. One effect of her adoption of rhetorical distance is to call our attention to the familiarity of the scene of whipping and the anonymity of the figure at the center. Although she exerts her individuality by refusing to make a sound, her flesh could be *any* black flesh in this canonical scene within slave narration. By highlighting the iconic (and routine) nature of the scene of abuse, a convention anticipated by the reader, Keckly refuses the conflation of her subjectivity with pain, rejecting the premise that to be seen as human the black subject must first be seen as damaged. Moreover, the scene discloses the less altruistic reasons motivating the convention of presenting black suffering to a primarily white readership; by likening herself to a statue, Keckly rebukes the aesthetic interests or even lurid pleasure that white readers may take in the spectacle of black suffering.

After this scene, Keckly's body rarely appears in *Behind the Scenes*. Instead, the narrative is organized around a spectacular instance of violence against a white body: the assassination of President Lincoln. The substitution of violence against a white figure, the head of state, for the routinized violence against black bodies reverses the conventional representational strategy of the slave narrative and serves to illustrate how black and white flesh have different symbolic functions within the nation and within slave narration. As Lindon Barrett argues, "Whereas the black body is understood in the redundant terms of its own materiality, the white body is understood as referential, in other words as significant and meaningful."[42] Keckly's reversal emphasizes the materiality and vulnerability of white flesh, but also reveals the social significance of whiteness: the white body is never understood in terms of its base materiality, even at its most inert and inanimate state—in death.

Written after his death, the narrative constantly foreshadows Lincoln's assassination. Although he is described in supernatural terms—"more like a demi-god than a man"—Lincoln is betrayed by his body, "crowned with the fleeting days of mortality."[43] After remarking on the bold and stately tableau made by Lincoln and Tad during one of Lincoln's addresses, the idea of his vulnerability intrudes on Keckly: "[A] sudden thought struck me, and I whispered to the friend at my side: 'What an easy matter would

it be to kill the President, as he stands there! He could be shot down from the crowd, and no one be able to tell who fired the shot.'"[44] The striking accuracy of Keckly's premonition transforms the tableau from an icon of national pride into a memento mori.

News of Lincoln's assassination comes during the Northern celebration of the fall of Fort Sumter. Keckly describes the whole of the nation as "transfixed" by the news: "[S]carcely had the fireworks ceased to play, and the lights been taken down from the windows, when the lightning flashed the most appalling news over the magnetic wires. 'The President has been murdered!' spoke the swift-winged messenger, and the loud huzza died upon the lips. A nation suddenly paused in the midst of festivity, and stood paralyzed with horror—transfixed with awe."[45] Unlike the spectacle of the suffering black slave, whose ability to inspire empathy rests on "fixing and naturalizing this condition of pained embodiment," the national spectacle of Lincoln's assassination arrests the bodies of the people in the crowd.[46] By substituting Lincoln's physical vulnerability for the rehearsal of black suffering, Keckly exploits "the inherent meaningfulness of white bodies . . . their legibility, their ability to stand in for terms and narratives that do not inhere in their physical presence," throwing into relief the unequal propositions of black and white embodiment.[47] Whereas black figures have to prove their humanity through a variety of symbolic gestures, including representing their experience of physical abuse, white figures are significant even in death. The representation of damaged black flesh is both what Douglass calls "the blood-stained gate, the entrance to the hell of slavery," and the mechanism by which readers of slave narratives come to recognize the humanity of the slave; by contrast, the spectacle of Lincoln's assassination registers as a singular tragedy unable to be exchanged in a representational market.

"Facts Which Float upon the Surface"

While Lincoln's assassination is the most dramatic example, Keckly's focus on the physicality of the white body—not under the lash, but as it takes shape under her needle—provides the most sustained critique of the race rituals governing slave narratives.[48] Characterized by weakness and fragility in contradistinction to her own disembodied presence as seamstress/editor/narrator, the measurements, outlines, irrational emotional reactions, even secretions of white bodies take center stage in *Behind the Scenes*. It is white flesh—often metonymically represented through clothing—which is on display, and whose signification Keckly manages in her everyday work as a seamstress. As Barrett argues, the treatment of "the

vexed African American body" is "the central textual dilemma for ex-slave narrators" and its management is a key strategy of authentication:

> In order to authenticate themselves as African Americans, [ex-slave] narrators must highlight the primary terms by which African American identity is construed—the body and the life of the body. Nevertheless, because the claims these narrators are making on the government and culture of the United States are based on denunciations of an enforced and spurious confinement to a life merely of the body . . . these narrators must not only recover their bodies within their narratives but also, more importantly remove their bodies from these narratives.[49]

Keckly uses clothing as a narrative device that allows her to emphasize her presence—as the clothing's fabricator—while removing her own body from view; further, by focusing on the literal "dirty laundry" of white figures in the text, Keckly continues to press her strategy of reversal, accentuating the materiality of white figures that would seem larger than life and overturning the cultural logic of race in the United States.

Keckly's treatment of the auction at the center of the Old Clothes Scandal is a good example of this. When put up for sale to raise money after Lincoln's assassination, Mary Lincoln's dresses become objects of curiosity and disgust, engendering a tremendous amount of public outrage and symbolizing the indecorous behavior of a former first lady. In a newspaper account included by Keckly, the author writes,

> The feeling of the majority of visitors is adverse to the course Mrs. Lincoln has thought proper to pursue, and the criticisms are as severe as the cavillings are persistent at the quality of some of the dresses. . . . Some of them, if not worn long, have been worn much; they are jagged under the arms and at the bottom of the skirt, stains are on the lining, and other objections present themselves to those who oscillate between the dresses and the dollars, 'notwithstanding they have been worn by Madam Lincoln,' as a lady who looked from behind a pair of gold spectacles remarked.[50]

It is this last "notwithstanding" that provides the prurient slant: it is the spectacle of Mary Lincoln's physical body that is on display through her used clothing. Instead of presenting the exposed black body on the auction block of the slave market, Keckly presents the white body on public display in the form of Mary Lincoln's clothing auction. The visual character of the scene is captured in the gold spectacles from behind which a lady gazes at the dresses. This reversal of the racial gaze interrupts the

readerly expectation of the slave narrative, but also illustrates the different treatment of black and white embodiment. While exposure of the black body is considered a necessary route to empathy and recognition in slave narration, exposure of the white body is considered unseemly.

Keckly's use of clothing to stand in for white bodies is central to her critique of postbellum racism: the history of emancipation and the history of clothing are often registered in a single garment. On the occasion of Lincoln's second inauguration, Keckly asks Mary Lincoln for the President's right-hand glove worn to the first public reception of his new term. To explain this strange request, Keckly tells Lincoln, "I shall cherish it as a precious memento of the second inauguration of the man who has done so much for my race. He has been a Jehovah to my people—has lifted them out of bondage, and directed their footsteps from darkness to light. I shall keep the glove, and hand it down to posterity."[51] Mary Lincoln finds this request rather distasteful: "You shall have it in welcome. It will be so filthy when he pulls it off, I shall be tempted to take the tongs and put it in the fire. I cannot imagine, Lizbeth, what you want with such a glove."[52] But Keckly's interest in the glove—a symbol of racial uplift—is directly tied to its filthiness as an index of white materiality. The day after the reception Keckly is delighted to pick up the "soiled glove . . . bearing the marks of the thousands of hands that grasped the honest hand of Mr. Lincoln on that eventful night."[53] Keckly specifically asks for the "right-hand glove," because it registers the "thousands of hands" that shook Lincoln's own. In addition to a congratulatory gesture, the handshake is a form of contract or recognition between equals; Keckly's request for the right-hand glove simultaneously emphasizes the material bodies of white figures and the compact that registers the symbolic entrance of black people into the national body.

Keckly's request for the soiled right-hand glove also demonstrates her awareness that material is never just that: imbued with meaning, clothing and bodies are represented as constructions steeped in power and consequence. Clothing represents the malleability of appearances, which is both a foil and an analogue for racial identity. In her preface, Keckly refers to writing her narrative as "bringing a solemn truth to the surface *as a truth*."[54] The unusual emphasis seems to indicate that truth can be distorted in its journey to the surface, or, at the very least, that surfaces and truth do not always correspond. It is in the conjunction between appearance (as it is constructed through clothing) and racial identity (as it is conferred by skin color) that Keckly locates her critique of postbellum racism. By showing how changing clothes changes white figures' reception in society, Keckly forwards the notion that appearance

is a matter of interpretation. As a seamstress Keckly is at the center of meaning-making; her work is vital to establishing the status of the figures she clothes.

In an echo of the slave narrative's conventions of authentication, Mary Lincoln's first question to Keckly when she interviews for the position of White House seamstress is about her references: "Mrs. Keckley, who have you worked for in the city?"[55] However, it is Keckly's influence as a tastemaker that authorizes her clients' entrance into society. Keckly's role in dressing and arranging their images is part of what constructs these ladies' social significance. Mary Lincoln is an outsider to Washington society and needs to secure a dressmaker who will confer the appropriate public image. Thus, Keckly's catalogue of what each of the Washington society women wore confirms her importance in constructing their public identities as much as it legitimates her own reputation: if they are considered to have good taste, it is because Keckly bestows good taste on them. For example, when the Lincolns leave for a vacation at the end of the social season, Keckly notes that she was employed by other significant ladies in Washington, including Mrs. Stephen Douglas, who "always dressed in deep mourning, with excellent taste, and several of the leading ladies of Washington society were extremely jealous of her superior attractions."[56] The jealously of Washington society ladies establishes Keckly's importance as a tastemaker. Mrs. Douglas's "excellent taste" is a reflection of Keckly's own, which controls the public image of these ladies at the center of the nation.

In Keckly's account, clothing is more than a superficial element: it— and through the clothes she makes, she—has the power to influence people's actions. For example, Keckly's first engagement for Mrs. Lincoln is to rework a rose-colored moiré-antique dress for her to wear to an upcoming Presidential levee. The event is of particular importance since it will be Lincoln's introduction to Washington society. When the time comes, Keckly brings the dress to the White House to find Mrs. Lincoln completely agitated. Upset that Keckly has come late, she throws a small tantrum, stating, "I will not dress, and go down-stairs. . . . I will stay in my room."[57] After a few rounds of Lincoln's anxious refusals and Keckly's gentle appeals, Lincoln consents to be dressed by Keckly. As soon as her hair is dressed and her clothes are arranged she is transformed. Keckly writes, simply, "[The dress] fitted nicely, and she was pleased."[58] Perhaps by way of explanation for Lincoln's indecorous behavior, Keckly describes her own expectations of Lincoln as a first lady. As the presidential party starts downstairs to meet the gathering below, Keckly notes,

I was surprised at her grace and composure. I had heard so much, in her current and malicious report, of her low life, of her ignorance and vulgarity, that I expected to see her embarrassed on this occasion. Report, I soon saw, was wrong. No queen, accustomed to the usages of royalty all her life, could have comported herself with more calmness and dignity than did the wife of the President, she was confident and self-possessed, and confidence always gives grace.[59]

Keckly's description of Lincoln's grace and composure contrasts with the description of her behavior only moments before. It is the clothing Keckly produced for her that confers "calmness and dignity" on the wife of the President. The transformation affected not by some magic of the clothing itself, but by Lincoln's security that she has on the "right clothes" provided by Keckly to present herself to Washington society.

Keckly's strategy of reversal—which allows her to focus on how she makes meaning, rather than how she is subject to meaning forced onto her—extends even to the interpretation of the Northern defeat of the Confederacy.[60] In one of the many bizarre coincidences that distinguish Keckly's life, she was a seamstress for the Davis family in Washington before taking her position with the Lincolns. Before the Davises move South, Mrs. Davis invites Keckly to go with them as their personal tailor. Although she considers the offer, Keckly decides to stay in Washington, but not before sending Mrs. Davis off with two chintz wrappers. The coda to this event is that while Keckly is in Chicago in 1865, not having seen the Davises since Southern secession, she attends a charity fair to raise money for the families of Union soldiers killed or wounded during the war and finds a wax figure of Jefferson Davis wearing one of the dresses she made for Mrs. Davis in the days before they left Washington:[61]

> In one part of the building was a wax figure of Jefferson Davis, wearing over his other garments the dress in which it was reported that he was captured. . . . I worked my way to the figure, and in examining the dress made the pleasing discovery that it was one of the chintz wrappers that I had made for Mrs. Davis, a short time before she departed from Washington for the South. When it was announced that I recognized the dress as one that I had made for the wife of the late Confederate President there was great cheering and excitement, and I at once became an object of the deepest curiosity. Great crowds followed me, and in order to escape from the embarrassing situation I left the building.[62]

Michelle Birnbaum argues that Keckly "uses her association with an object of clothing to turn *herself* into the object of interest," which she reads as "an effort to stitch together an identity based on associative connection, on the public investment on appearance and possibility, if not fact."[63] However, one could read the scene with a slightly different emphasis. Keckly's "pleasing discovery" renders her visible in a history in which she is otherwise invisible. In fact, I understand Keckly's project in *Behind the Scenes* to be an effort not to *trade* on "public investment on appearance and possibility," but to reveal it for what it is. Further, this scene is another key reversal: Keckly is at the center of national events, attending a fundraiser for Union soldiers, while Jefferson Davis is cast as a vulnerable fugitive, dressed in women's clothing, subject to fear and weakness.[64]

Although Keckly uses clothing to reverse the propositions of black and white embodiment, her ultimate goal is to critique the way a certain kind of racial vision has remained the same post-emancipation. In her preface, she explains that her motivation for writing was to exonerate Mrs. Lincoln's part in the Old Clothes Scandal. She writes, "The world have (sic) judged Mrs. Lincoln by *facts which float upon the surface*, and through her have partially judged me, and the only way to convince them that wrong was not meditated is to explain the motives that actuated us."[65] Though she claims the authority to remake the meaning of "facts which float upon the surface," she is all too aware of the ways in which the meanings of surfaces represent deeply entrenched ideological positions. This is nowhere more evident than in a curious passage in which an ex-slave making her way in the North confuses representatives of the United States government for slave masters on the plantation. In her relief work with newly freed slaves Keckly encounters an older woman who is shocked that the government fails to provide two undergarments a year, what she received as a slave in the South:

> "Why, Missus Keckley," said she to me one day, "I is been here eight months, and Missus Lingom an't even give me one shife. Bliss God, childen, if I had ar know dat de Government, and Mister and Missus Government, was going to do dat ar way, I neber would'ave comed here in God's wurld. My old missus us't gib me two shifes eber year."
>
> I could not restrain a laugh at the grave manner in which this good old woman entered her protest. Her idea of freedom was two or more old shifts every year. Northern readers may not fully recognize the pith of the joke. On the Southern plantation, the mistress, according to established custom, every year made a present of certain undergarments to her slaves, which articles were always anxiously looked

forward to, and thankfully received. The old woman had been in the habit of receiving annually two shifts from her mistress, and she thought the wife of the President of the United States very mean for overlooking this established custom of the plantation.[66]

Within the context of the narrative reversals and inversions Keckly undertakes, this "joke" operates as an ironic moment of instruction. The older woman's observations are included less to have a laugh at her expense than to show how easily race relations of the free North could be confused with those in the antebellum South.

Despite the chapter title, "Old Friends," attention to clothing also reveals a dark undercurrent in the scene of her reunion with her former masters in the South, undercutting readings of the narrative, which may overstate Keckly's positive disposition toward reconciliation.[67] As Keckly sits and talks with Mrs. Garland, her former mistress, Mrs. Garland remarks on "the peaceful feeling of this country."[68] While Keckly declines to include her response to Mrs. Garland's musings, the next paragraph suggests the continued solipsism of white Southerners even in this new "peaceful" climate. Keckly writes, "I had many long talks with Mrs. Garland, [and] in one of which I asked what had become of the only sister of my mother, formerly maid to Mrs. G.'s mother."[69] Garland responds bluntly: "She is dead, Lizzie. Has been dead for some years," and then launches into a memory of her mother's relationship with her "maid," intending to show their closeness, but revealing, instead, the inequalities that structured their relationship:

My mother was severe with her slaves in some respects, but then her heart was full of kindness. She had your aunt punished one day, and not liking her sorrowful look, she made two extravagant promises in order to effect a reconciliation, both of which were accepted. On condition that her maid would look cheerful, and be good and friendly with her, the mistress told her she might go to church the following Sunday, and that she would give her a silk dress to wear on the occasion. Now my mother had but one silk dress in the world, silk not being so plenty in those days as it is now, and yet she gave this dress to her maid to make friends with her. Two weeks afterward mother was sent for to spend the day at a neighbor's house, and on inspecting her wardrobe, discovered that she had no dress fit to wear in company. She had but one alternative, and that was to appeal to the generosity of your aunt Charlotte. Charlotte was summoned, and enlightened in regard to the situation; the maid proffered to loan the silk dress to her mistress for the occasion and the mistress was only too glad to accept.

She made her appearance at the social gathering, duly arrayed in the silk that her maid had worn to church on the preceding Sunday.[70]

Mrs. Garland's memory of this moment of "reconciliation," which she understands as great kindness on her mother's part, reverberates into the narrative present, suggesting that the moment of "reconciliation" between Keckly and the Garlands may be more superficial than Mrs. Garland can guess. If we read this scene as a parable of Reconstruction, as I think we are meant to, those in power make certain provisions for former slaves on the condition that they "look cheerful, and be good and friendly." Yet the provisions are quickly and easily revoked, much like the dress, at the whim of those in power. Once again the appearance of things does not always represent the structures of power operating behind the scenes.

Rather than painting a picture of sunny reconciliation, Keckly's portrait of reunion in "Old Friends" suggests the continuities rather than the distinctions between antebellum and postbellum race relations, a fact Keckly elegantly captures by linking metaphors of clothing with metaphors of enslavement. This symbolic condensation comes to a head in the chapter when, describing what she understands as the warm feelings between a mistress and her "maid," Mrs. Garland exclaims: "Ah! Love is too strong to be blown away like gossamer threads. The chain is strong enough to bind life even to the world beyond the grave."[71] Mrs. Garland's sentimental—and tone-deaf—language to describe the relationship between her mother and Charlotte is belied by the binding relations of coercion that structured the relationship between the women. Moreover, the frame of the anecdote reveals the disingenuousness of both white women's sentimental language. The story—purportedly about the uncommonly close relationship between Charlotte and Mrs. Garland's mother—is offered as a response to Keckly asking what has become of her only aunt on her mother's side. Mrs. Garland's blunt (and unfeeling) retort that she is dead, followed by a story she imagines flatters her mother, exhibits the same lack of empathy on her part toward Keckly that the story demonstrates between her mother and Charlotte. With Keckly's emphasis on the one-sided nature of the relationship, in which Mrs. Garland's mother just wants Charlotte to "look cheerful, and be good and friendly with her," the story parallels Mrs. Garland's need for Keckly to reassure her, asking "Do you always feel kindly towards me, Lizzie?"[72] Using clothing as a narrative device, Keckly recasts and controls the meaning of the white bodies within her realm of influence, but she is well aware that the social and political structures of power that fix the meaning of black bodies have outlived slavery.

"Don't I Know a Monkey When I See It?"

Keckly's most powerful revision of the conventions of authentication is her substitution of Tad Lincoln's reading lesson for her own. From early slave narratives featuring the trope of the talking book to Frederick Douglass's depiction of his first, aborted reading lesson, literacy has operated as a symbolic boundary within the slave narrative. Presented as a prohibition or exclusion connected to systems of white power, literacy is also characterized as an entry-point into abstract thought, a sign of freedom from embodiment.[73] In his 1845 *Narrative*, for example, Douglass calls literacy the "pathway from slavery to freedom" and represents his transition from object to subject within his narrative as a transformation from bodily existence to symbolic presence affected by his acquisition of literacy.[74] But as Valerie Smith has argued, literacy is an ambivalent mechanism of self-authorization in Afro-American narrative, which "pay[s] homage to the structures of discourse that so often contributed to the writer's oppression."[75] On the one hand, rehearsing the scene of literacy "grants [the narrators] significance and figurative power over their superordinates, [and by] their manipulation of received literary conventions they also engage with and challenge the dominant ideology."[76] On the other, the stress placed on the scene of literacy as the key to freedom has the counter-effect of suggesting that "without letters, slaves fail to understand the full meaning of their domination."[77] Smith reads the resolution of this dilemma in an expansion of our understanding of literacy to include oral culture, "the consciousness of the uses and problems of language, whether spoken or written. . . . In this view the unlettered person who can manipulate the meanings and nuances of the spoken word might also be considered literate."[78] However, the expansion of our critical understanding of literacy to include oral prowess leaves the structure and function of literacy as prohibition/arrival intact; by contrast, Keckly's revision of the scene of literacy with a white protagonist challenges the symbolic boundary literacy represents between black and white. More than simply inverting the racial conventions governing the scene of literacy established in the slave narrative genre, the content of Tad Lincoln's reading lesson, which features a conflict between an image and text, uses a visual icon to interrupt the symbolic authority of literacy. In *Behind the Scenes* literacy operates not as a neutral sign of reason that can be appropriated by white and black alike, but rather as a highly subjective discursive formation whose significance is shaped by the visual logic of race.

Shortly after Lincoln's assassination, Keckly accompanied Mary Lincoln and her surviving sons, Robert and Tad, to Hyde Park where Lincoln

attempted to create a new domestic routine. Tad, who had "never been made to go to school," was encouraged to begin daily lessons with his mother.[79] As Mary Lincoln opens the literacy primer to the first page, we are presented with a reading lesson very different from either Frederick Douglass's aborted lesson with Mrs. Auld or his "stolen" lessons from the street. Unlike Douglass, who hungers for literacy, Tad must be coaxed into his lesson. This reversal of racial position—white privileged protagonist in place of enslaved black protagonist—rewrites the stakes of literacy; literacy is presented, here, not as a "pathway to freedom," which the protagonist already possesses, but as an unstable foundation for establishing human authenticity. In fact, the analogy between Douglass and Tad Lincoln is interrupted by race. Tad's illiteracy is drawn as a function of his privilege: "Tad had always been much humored by his parents, especially his father," who had overlooked a speech impediment and never made him go to school.[80] His illiteracy has no effect on his social standing. He is considered "a bright boy, a son that will do honor to the genius and greatness of his father."[81] Tad Lincoln is socially legible through his familial relations—his whiteness is referential, significant. His individuality and social status exist in stark contrast to the anonymous, illiterate black boy Keckly invokes later in the scene as his foil, denied individual subjectivity and reduced to a symbol of the inferiority of his race.

Significantly, Keckly's critique begins with the non-correspondence between an image and a word. In the scene of the reading lesson, the first word in the primer is "Ape." Although Tad reads the letters correctly, when his mother asks him what "a-p-e" spells his immediate reply is "Monkey!" Instead of reading the word, or even "the sounds of the different letters," Tad "reads" the accompanying illustration: "The word was illustrated by a small wood-cut of an ape, which looked to Tad's eyes very much like a monkey; and his pronunciation was guided by the picture, and not by the sounds of the different letters."[82] The illustration, intended as a reading aid, supplants the word itself. Furthermore, it does so incorrectly. Tad interprets the picture of an ape as a picture of a monkey. His insistence that "A-p-e" spells monkey is based on his belief that he can accurately identify what he sees: "'An ape!' he cries incredulously, 'taint an ape. Don't I know a monkey when I see it?'"[83] As Mary Lincoln corrects him, the reading lesson devolves into a discussion of scientific empiricism and species differentiation: "Tad, listen to me. An Ape is a species of the monkey. It looks like a monkey, but it is not a monkey."[84] The potential discrepancy between an image of an ape and the letters "a-p-e" interrupts the pedagogic strategy of Tad's primer and suggests the damaging racial implications of a seemingly innocent misunderstanding. Tad's minor hysteria over the

notion that something can be different from what it looks like encapsulates mid–nineteenth-century racial anxiety, dominated by debates over what constitutes racial difference, species differentiation, and the rights of man.[85]

In her analysis of "the uncertain status of the body in slavery discourse," Shirley Samuels examines cultural objects such as the "topsy-turvy doll," which physically performs the racial reversal Keckly figuratively performs in *Behind the Scenes*: "Held one way the doll appears as a white woman with long skirts. Flipping over her skirts does not reveal her legs, but rather exposes another racial identity: the head of a black woman, whose long skirts now cover the head of the white woman."[86] Like the topsy-turvy doll, which "can be only one color at a time," Keckly's racial reversal in *Behind the Scenes* is a "double gesture [which] at once present[s] and refus[es] a reversibility of identity."[87] Samuels identifies the "problem of identity," on display in toys like the "topsy-turvy doll," to be a problem of "recognition."[88] In her subsequent analysis of pro- and anti-slavery rhetoric she identifies a shared rhetorical strategy in both: "the stark physicality of seeing conceived of as engraving impressions on the mind."[89] Although Tad is working with a literacy primer in the scene—not a political primer, such as the pro- and anti-slavery primers that Samuels discusses, which circulated in the years leading up to the Civil War—Keckly demonstrates how this "neutral" text becomes a flash point for the racial significance attributed to literacy via the presentation of a visual image.

Samuels juxtaposes the pedagogical strategy of abolitionist primers against the backlash registered in a prominent pro-slavery tract, *The Devil in America* (1859), to show that mid–nineteenth-century anxieties over the location of identity became lodged in a powerful desire to make internal characteristics visible—for both abolitionists and defenders of slavery. While not collapsing the antithetical rhetorical aims of *The Slave's Friend* and *The Devil in America*, Samuels's essay addresses the collapse in both between the "logic of miscegenation and the logic of sentimentality," which "involve the impression of, and mixing of, external and physical states in the interior state of the heart."[90] *The Devil in America* argues that the threat of abolition is its promotion of the unholy breakdown of all kinds of "natural" boundaries: "The Demon of Atheism, for instance, has been sent to use Philosophers and 'sons of science' to 'prove that men and monkeys are the same.'"[91] As both Thomas Gossett and Winthrop Jordan have pointed out, early-nineteenth-century scientific theories of polygenesis and species differentiation which labored to link African-derived people to apes and monkeys depended upon interpretations of external characteristics taken as indications of inherent inferiority.[92] By

rewriting the scene of literacy with a figure central to national domestic life, a President's son and former resident of the White House, Keckly interrupts the symbolic association of whiteness with reason and blackness with materiality. Tad's mistake, and his irrational attachment to it, raises the dehumanization of people of African descent considered by many defenders of slavery to be the evolutionary link between humans and apes; it also reveals this link to be an error of willful misrecognition.

Keckly asserts that her aim in including Tad's reading lesson is not to reflect on the intellect of "little Tad," but, rather, "[t]o say that some incidents are about as damaging to one side of the question as to the other. If a colored boy appears dull, so does a white boy sometimes; and if a whole race is judged by a single example of apparent dulness (sic), another race should be judged by a similar example."[93] Race, which Keckly obliquely refers to as "the question," is literally thrown into question by the discrepancy between what Tad believes he sees (a monkey) and what is written ("a-p-e"). In Tad's mind the word's meaning is deferred to the image, which is deferred to the minstrel-like performance of a monkey playing the organ, which Tad claims to have seen in the street. The racial valences of the example, which Keckly uses to undermine scientific debates about the place of African-derived people in the Chain of Being, are perversely confirmed by "Behind the Seams," the parody of Keckly's narrative, in which the author depicts Tad Lincoln's confusion over the illustration as explicitly racial. In the racist parody, Tad Lincoln proclaims, "Tain't an ape, . . . it's either a large monkey or a small nigger, I can't tell exactly because one is so much like both, I can't tell tother from which."[94] The word and the image, presented as seamless in the primer, actually reveal the discontinuity between image, word, and body (in this case, the body of the monkey in the street). The non-correspondence of image and text signifies beyond the singularity of Tad's illiteracy and implies the non-scientific, highly subjective nature of both written and visual discourse.

By casting doubt on both the self-evident nature of visible signs, in the form of letters, words, and images, Keckly casts doubt on systems of racial classification based on physical or visible signs such as blackness or whiteness. Keckly concludes the scene by commenting on the racial significance of literacy, revealing the scene itself to be an example of the non-correspondence of a visible sign (Tad's white skin) and its meaning: "Whenever I think of this incident I am tempted to laugh; and then it occurs to me that had Tad been a negro boy, not the son of a president, and so difficult to instruct, he would have been called thick-skulled, and would have been held up as an example of the inferiority of the race."[95] Keckly reveals not only that literacy is false evidence of white superiority,

but also that literacy itself is discursively produced. The misunderstanding that would be fodder for a joke is sobering when considered in the context of the real effects of the misrecognition of visible signs made into racial signifiers.

Keckly's inversion of black and white figures within the scene of the reading lesson presents a challenge to specifically visual presumptions about racial designation. Tad's rhetorical question—"Don't I know a monkey when I see it?"—must be answered with a resounding "No." Yet Keckly's inversion of black and white figures does not invert the social significance of black and white as racial categories productive of racial conditions. Despite his illiteracy, Tad is still privileged and significant as an individual, whereas an illiterate black boy would be seen as a symbol of the inferiority of the race.[96] What the inversion demonstrates, then, is that racial difference itself is discursively produced in the same way a word's meaning takes on significance. In his discussion of writing as a graphic representation of language, Ferdinand de Saussure contends that a written word's meaning is not self-evident, but rather "[t]he pronunciation of a word is determined, not by its spelling, but by its history."[97] In Tad Lincoln's reading lesson we see that the meaning of a word is produced through its difference from or likeness to other words or images, which is ultimately a social determination. In the example of the reading lesson the conflict between the word's likeness to an image and its difference from other letters—"M-o-n-k-e-y"—is a conflict magnified by the difference in interpretation between Tad and the adults in the room.

Keckly's revision thus offers the primer as another ironic tool of instruction: intended to instruct the student in literacy by providing mnemonic words and images corresponding to each letter, instead the primer instructs readers of *Behind the Scenes* in the possibilities for misunderstanding and misremembering. The distance between seeing and knowing is filled with the vagaries of perception. Keckly stages the discrepant engagement of the written word and the visual image to highlight the discursive production of race.

"Why Should I Not Be Permitted to Speak?"

Though her individual perspective was some years removed from slavery, Keckly's narrative captures a nation only very recently post-emancipation, and the national historical proximity to slavery directs her narrative throughout: details of her own life parallel events of national significance, and national milestones are narrated from her perspective as an intimate laborer inside the White House. Written during a period

of optimism among African American writers regarding the possibil-
ity of positive race relations in the newly reunited nation, the narrative's
condensation of Keckly's perspective with that of the nation nevertheless
marks an inconclusive liberation: slavery is no longer legal, but as her
narrative shows, the ideological propositions underlying racial hierar-
chies remain intact; as Keckly discusses, black citizens were turned away
from the second Inaugural Levee, a supposedly "open reception" at the
White House to celebrate President Lincoln's reelection in 1865.[98]

The unevenness of the narrative, what James Olney calls the "mixed
production" of *Behind the Scenes*, reflects these contradictions within the
nation; yet *Behind the Scenes* is unified by its strategic response to the
persistence of a black/white binary in post-emancipation America. In her
role as a dressmaker, narrator, and editor, Keckly redeploys visual tropes
to critique the generic proposition within the slave narrative that white
authority legitimates black experience. The formal reading I offer here
presents a different way of looking at Keckly's discursive choices. Ripping
the slave narrative apart at the seams and refashioning it, Keckly's literary
and material labors reconstruct how we see the scenes she puts before
us. By calling attention to the racial expectations of narrative structure,
coded in the slave narrative's conventions of authentication, Keckly forces
the reader to recognize the discursive production of race in place of the
icon of the black body.

The problem addressed by Keckly is shared by all ex-slave narrators:
blackness, which has been violently produced as a visual sign of enslave-
ment, must be wrested from this sociopolitical association and redeployed
in new terms. Though Keckly is not the first to challenge the stability of
racial categories in the context of the slave narrative—one thinks here of
the Crafts' narrative of passing in *Running a Thousand Miles for Freedom*
or Solomon Northup's narrative of kidnap in *Twelve Years a Slave*—she is
the first to completely invert the racial paradigm of the formal properties
of the slave narrative. In so doing she highlights the discursive production
of racial categories, rather than simply asserting a positive "black" image
or expanding the national archive to include images of black people at
the center of the nation. *Behind the Scenes* produces strategic moments of
dissonance between multiple discourses of authenticity to undermine the
very notion of racial or literary authenticity. In so doing, it advances the
rhetorical strategies of resistance employed by earlier ex-slave narrators
who remained bound by the political exigencies of abolition.

While the classic slave narrative is rhetorically calibrated toward aboli-
tion, Keckly's narrative is calibrated to reveal the ways a focus on abolition
left damaging racial binaries intact. Rather than departing from classic

slave narrative conventions, Keckly depends upon her readership's antici-pation of those conventions to create an ironic postbellum commentary on race relations in "free" society. Her canny revision of the racial proto-cols of the slave narrative reveals how the form itself has been organized in response to the visual logic of racial slavery. Thus, the rhetorical question she asks in her self-penned Preface, "why should I not be permitted to [speak]?" inaugurates her confrontation with the racial propositions her narrative overturns, radically addressing both those readers who doubt it is Keckly's role to "place Mrs. Lincoln in a better light before the world" and those readers who require that the black voice be contained in what John Sekora calls a "white envelope."[99] Her 1868 conjugation of the slave narrative form illustrates the continuation of a particular kind of racial vision in the postbellum period and challenges that vision by skewering the authenticity protocols of the genre.

Keckly's intervention into both visual culture and the slave narrative form is crystalized in her opening metaphor, in which she likens the pro-cess of writing her narrative to viewing a moving panorama:

> I am now on the shady side of forty, and as I sit alone in my room the brain is busy, and a rapidly moving panorama brings scene after scene before me, some pleasant and others sad; and when I thus greet old familiar faces, I often find myself wondering if I am not living the past over again. The visions are so terribly distinct that I almost imagine them to be real. Hour after hour I sit while the scenes are being shifted; and as I gaze upon the panorama of the past, I realize how crowded with incidents my life has been. Every day seems like a romance within itself, and the years grow into ponderous volumes.[100]

Casting her experience of memory in terms of a popular visual technol-ogy, Keckly both acknowledges and refutes the assumption that the slave narrative is an unmediated record of experience. In the decade before *Behind the Scenes* was published, anti-slavery panoramas such as Henry Box Brown's *Mirror of Slavery* (1850) and William Wells Brown's *Original Panoramic Views of Slavery* (1850), addressed more fully in Chapter 5, had gained popularity and were often discussed as offering viewers more im-mediate access to the experience of slavery. Writing about Brown's *Mirror*, for example, one reviewer contends, "The real *life-like* scenes presented in this PANORAMA, are admirably calculated to make an unfading impres-sion upon the heart and memory, such as no lectures, books, or colloquial correspondence can produce."[101] However, while Keckly acknowledges the near-reality of the panorama, she only provides access to its images in the form of her narrative. Declaring that "the visions are so terribly

distinct that [she] almost imagine[s] them to be real," Keckly disrupts the fetishization of the slave narrative as a presentation of "slavery as-it-is," dismissing the conceit that, as Olney puts it, the ex-slave narrator exercises a "clear-glass, neutral memory that is neither creative nor faulty," while emphasizing the reader's experience of these visions as necessarily mediated. Moreover, in this inaugural inversion, rather than positioning herself as the object of her reader's gaze, Keckly frames her narrative as the product of her own spectatorship. By situating herself as both the object and the subject of the narrative gaze, she refuses to provide the reader with the authenticating images he desires while deconstructing the prioritization of the visual over the textual we see in her treatment of Tad Lincoln's literacy primer. Addressing an abolitionist readership that needed to *see* the violence of slavery in order to be moved to act to end its injustices, Keckly demonstrates the interrelation and ultimately porousness of visual and textual material, presenting the narrative and the panorama as virtually indistinguishable, as the "scenes" of her memory "grow into ponderous volumes." Ultimately, the panorama she references is not for her readership; we cannot see its images. Thus she claims a visual authority unavailable to her readers.

3 / Optical Allusions: Textual Visuality in *Running a Thousand Miles for Freedom*

Between images and in the interstices of how we have been taught to see, there are so many necessary and invisible forms. As fiercely as we struggle to say things that are pictures, we must work to picture things that are not, the things inside the gaps in images, the content of spaces between time(s), the dynamic imperatives of power taking shape.

—RUBY C. TAPIA, *AMERICAN PIETÀS:*
VISIONS OF RACE, DEATH, AND THE MATERNAL

Anticipating Elizabeth Keckly's representational strategy in *Behind the Scenes*, William Craft's 1860 narrative, *Running a Thousand Miles for Freedom: The Escape of William and Ellen Craft from Slavery*, shifts the traditional focus of the slave narrative from black injury to white privilege, offering a perhaps surprising revelation: not only are these existential states constituted in dialectical opposition, but they are also simultaneously visible in the figure of his enslaved wife, Ellen Craft.[1] Describing Ellen's appearance at the beginning of the narrative, Craft writes, "[n]otwithstanding my wife being of African extraction on her mother's side, she is almost white—in fact, she is so nearly so that the tyrannical old lady to whom she first belonged became so annoyed, at finding her frequently mistaken for a child of the family, that she gave her when eleven years of age to a daughter, as a wedding present."[2] Like Harriet Jacobs's *Incidents in the Life of a Slave Girl* (published in 1861), this description of Ellen—placing her "almost white" features in the context of her ownership—appeals to white readers by revealing slavery's destructiveness to slaveholders' families as well as to the unrecognized families of the enslaved. Recalling the slaveholding law that "all children of slave mothers . . . follow their condition," Craft explicitly states "[m]y wife's first master was her father, and her mother his slave."[3] Thus Ellen's appearance both discloses the sexually exploitative conditions black women live under in slavery and places her in proximity to the white privilege that she is legally barred from accessing. But in addition to presenting the visual sign of Ellen's light skin as evidence of the illogic at the heart of racial slavery—that racial difference must be legislated where it supposedly naturally exists—Craft's

description shifts the focus from Ellen's body to the gaze upon her.[4] Highlighting the particularly visual character of the mistress's intolerance, the passage makes clear that her "annoyance"—and her desire to get Ellen out of sight—stems not from her concern over the exploitation of an enslaved woman in her house (or even her husband's violation of their marriage vows), but rather from her irritation that a racially black person could be "mistaken for a child of the family."

It is the potential for this visual "mistake" that the couple mobilizes to effect their escape across a thousand miles of hostile terrain from slavery in Georgia to freedom in Philadelphia in 1848, subsequently settling in England (outside of the reach of the Fugitive Slave law), where the narrative is first published twelve years later. Haunted by the fragility of their unrecognized marriage and the slaveholding law that any children they have while enslaved will also be designated slaves and will be, therefore, outside their protection, the couple formulates a plan to use Ellen's proximity to white privilege to gain their freedom.[5] In December of 1848 they decide that Ellen will dress up as an invalid male planter, the invented "Mr. Johnson," traveling with his slave to seek medical advice in Philadelphia.

Designated racially black by the law, William and Ellen have lived their lives subject to constant scrutiny and skepticism, required to produce documentation or written permission authorizing all of their movements outside the home. Marking the slippage between legal status and phenotypical appearance, William writes that "every coloured person's complexion is *primâ facie* evidence of his being a slave, and the lowest villain in the country, should he be a white man, has the legal power to arrest, and question, in the most inquisitorial and insulting manner, any coloured person, male or female, that he may find at large, particularly at night and on Sundays, without a written pass, signed by the master or some one in authority; or stamped free papers, certifying that the person is the rightful owner of himself."[6] So it is from this perspective, thinking as enslaved people, that before undertaking their journey north, the couple anticipates the various challenges and checkpoints they will encounter along the way and strategizes ways of overcoming likely obstacles. Disguising her unwhiskered femininity with a poultice tied around her face and wearing thick green glasses to discourage interaction and inhibit conversation with fellow travelers, Ellen also wears a sling to hide her illiteracy, giving Mr. Johnson an excuse for not registering his name in hotel books and at train stations. However, as Lindon Barrett has observed, Ellen's mobilization of her phenotypical whiteness through props and performance fundamentally transforms her relationship to the dynamics

of authentication.[7] As a white man, Mr. Johnson does not need to provide either evidence of his status or justification for his movements and actions. During their journey, the moments of crisis the couple encounters are characterized by the tension between "ensuring the mobility of privileged subjects and protecting private property," crises that are repeatedly resolved by the pressure the public exerts on various authority figures not to subject Mr. Johnson to such menial checks, deemed beneath him as a white man.[8]

By shifting the context in which Ellen's body is read, the couple both challenges race as an existential category and unsettles white readers' notions that—to paraphrase Tad Lincoln—they "know it when they see it."[9] Whereas in slavery the sight of Ellen's light skin offends her mistress and leaves her vulnerable to mistreatment and separation from her family, as Mr. Johnson her light skin and proximity to William make her freedom and mobility virtually unimpeachable. In fact, as Michael Chaney argues, the strategic vision of racial difference the couple cultivates is the most powerful legitimation of Mr. Johnson's identity: "Although the planter Ellen Craft pretends to be cannot write and thus cannot underwrite his presumed status through any means apart from the visual, the authenticating power of proximity to blackness nonetheless ensures Ellen's resemblance to patriarchy. The verifying power of blackness in proximity is precisely what threatens to dismantle the myth of white superiority, suggesting that racial privilege depends more upon difference and the appurtenances of domination than on essentiality."[10] Chaney's reading shows that the visual image the couple cultivates during their escape upends the traditional dynamics of authentication while seeming to satisfy them. Moreover, the Crafts' manipulation of the very assumptions of racial difference and visual certainty that give rise to the requirement that black mobility must be authorized by white authority works to expose the fallacy of these assumptions when their plan is revealed in the narrative. Strikingly, Craft uses the same sophisticated understanding of dominant visual culture demonstrated in the couple's escape to control his and Ellen's image throughout their written narrative, undermining the conventions of authentication that structure the slave narrative. In the most sustained example of representational static we have yet seen, William juxtaposes the visual image the couple cultivates as Mr. Johnson and his slave with ambivalent language within the narrative to further unsettle popular notions of racial identity and identification, and critique dominant visual paradigms. While the episode of Ellen's passing demonstrates that dominant modes of visuality are invested in vision as a function used to discern difference and, therefore, establish classification—such as black and

white or slave and free—Craft's narrative insists on a mode of vision that prioritizes recognition and intersubjective relationality.

As P. Gabrielle Foreman argues in her foundational essay on the narrative "Who's Your Mama?," Ellen's performance is an act of "passing *through*," rather than "passing *for*," whiteness, a distinction that recovers what she calls Ellen's expressed "racial will"—to identify with and preserve the black family.[11] Situating the narrative in the context of the development of early photography, Foreman refuses a reading that treats Ellen as solely the object of a gaze, linking the critical misunderstanding of Ellen's trauma as being primarily about "the disjunction between (the assumptions that accompany) her skin tone and (the assumptions about) her experience as a slave" to "an unreliable but pervasive optical model of identity" coincident with a burgeoning visual culture.[12] Writing that "[f]or those who wished to codify racial difference, the technological innovation and popularity of antebellum photography offered a way to resolve tensions between ontology and epistemology," she designates the text an "anti-passing narrative," observing that it is Ellen's investment in maternity and the black family—not whiteness—that drives her to "use [her] own bod[y] to challenge . . . constraints [upon her] by expressing a desire . . . for familial and juridical relations in which *partus sequitur ventrem* produces freedom rather than enslavement for African Americans, light and dark."[13] Recovering Ellen's "desire," Foreman's reading is essential in reframing the literary critical perspective that would unwittingly replicate abolitionist editors' jettisoning of the interior thoughts and feelings of enslaved people. However, this reading does not fully account for the visual interplay within the narrative itself: the double vision of Ellen that William Craft strategically cultivates, a strategy central to the sophisticated critique of vision that the narrative stages. By letting the reader in on the escape plan, Craft certainly makes Ellen's identification as a black woman visible to the reader in a way that it could not be during the couple's daring escape; however, his linguistic choices—his deliberate pronoun shift (addressing his wife as "he" and "my master" while narrating their escape), in combination with his frequent wordplay and double entendre, reminding the reader of the truth of his and Ellen's relationship to one another even while cultivating the image of Mr. Johnson and his slave in the reader's mind—keep her temporary whiteness in view. This duality counters the iconography of the couple that circulated in the years between their escape and the publication of their narrative in 1860. Foreman notes while "Ellen articulates her racial politics clearly," in both the narrative and in the rare letters that she wrote to newspapers such as the *London Daily News*, "there are no extant images of [William and Ellen]

together," a fact that she contends works to "contain . . . the threat of visually interracial (and/or) transgendered devotion" and to "further isolate her from the actual cause of her distress: her inability to choose a (black) husband and parent their children in freedom."[14] In this way the narrative accomplishes something that images of the Crafts would not have been able to convey: their commitment to one another and its expression in their construction of the image of Mr. Johnson, a solidarity that cannot be seen by slaveholders.

In this chapter, I argue that the narrative's insistence that we view Ellen simultaneously as Mr. Johnson, gentleman planter, and Ellen Craft, fugitive slave, repudiates the "resolution" offered by the ways of seeing that came to prominence with the advent of photography. By refusing to resolve Ellen's appearance into *either* black or white in accordance with the racial logic of the United States, the narrative refuses *any* singular vision of Ellen, thereby undermining the notion of sight as an objective function of discernment and classification while reasserting the importance of one's "racial will" in the construction of both what and how we see.

While there has been a great deal of contemporary scholarship addressing the narrative's intervention into mid–nineteenth-century visual culture, this research has been largely inter-artistic, focusing on the engraving of Ellen in her planter disguise and often addressing the question of whether the image or the narrative accords Ellen Craft a greater degree of agency. Chaney notes that while "it was not unusual for the publication of antebellum slave narratives to be preceded by illustrations of climactic aspects of the tale, no narrative received more widespread acclaim for a pre-publication illustration than *Running a Thousand Miles for Freedom*."[15] Analyzing the role that portraits of Ellen specifically played in "constructing her identity as a free and autonomous being," Barbara McCaskill situates the engraving of Ellen in her planter disguise in the context of the dual purposes of authentication and exhibition that engravings of the author or narrator conventionally performed on slave narrative frontispieces. Linking this convention to what Lerone Bennett and Houston Baker have termed the "Negro exhibit," McCaskill argues that Ellen's portrait operates as both proof and spectacle: "Her face reminds us of both the humanizing and sexualizing functions of visual 'text' or discourse in the narratives of the formerly enslaved. . . . To abolitionists, these engravings or pictorial texts authenticated Ellen's trauma and inaugurated written testimony of her escape in the same manner that male and female fugitives legitimized their pain and retorted detractors through . . . the 'Negro exhibit'—public displays of scars and signs of torture that escaped slaves, in silence, presented during their lectures to white Northern audiences."[16]

As McCaskill's reading shows, the introduction of visual material into the slave narrative is traditionally part of the authenticating architecture of the text, operating as evidence to secure the word of the ex-slave narrator, the logic being that while the audience may not trust the word of a black narrator or speaker, visual evidence such as scars on the body or even the dignified bearing of a former slave in an elegant portrait speaks for itself. However, the Crafts' narrative of escape makes clear that visual evidence never speaks for itself; it always comes to mean in a discursive context, one often established before the visual evidence itself ever arrives on the scene. If Ellen's body can be read in multiple ways, then images, too, are problematic bearers of uncontested, singular truth.

Many critics have reclaimed the frontispiece image of Ellen from this authenticating context, arguing that the portrait's gender-bending swagger offers Ellen a greater degree of agency than she is afforded in the narrative penned by William, which McCaskill argues, "muzzles or suffocates Ellen with the problematic discourse of true womanhood."[17] (See Figure 6.) Declaring that "[t]he engraving of Ellen finally can be read or decoded as a critique of the tenuous control she claimed on her own printed texts," McCaskill nevertheless argues that "Ellen's unmuffled mouth in the frontispiece likeness does not bespeak the fact that William's narrative snaps it shut. . . . He contrasts her frozen features in the frontispiece picture with the motion and momentum of his title on the opposite page."[18] Also noting that "closer scrutiny of the image uncovers a different set of priorities than in the narrative," Chaney argues that the likeness is a literal "pretext" for the narrative and that "William must . . . take control of the visual representation of Ellen that prefigures his narrative."[19] While McCaskill, Chaney, and Foreman analyze "the semantic interfaces of verbal and visual representation" between the engraving and the narrative, they nevertheless pit image against text in a way that suggests they are more separable than William Craft suggested himself. Directing attention to the textual visuality of the narrative, this chapter builds on these critics' work, identifying an emblematic structure to the text expressed in William's transcription and narration of the couple's ambivalent dialogue during their escape. Operating in tandem with Ellen's performance, like captions to a photograph, the dialogue keeps multiple interpretations of Ellen's body in view, refusing to resolve the "narrative crisis of knowing and seeing for those readers with racial power."[20]

Thus, the narrative addresses the dynamic of authentication on two levels, which we might designate the historical and the literary: on the historical level William and Ellen are enslaved people who require written permission to move through the world outside the home, while on the

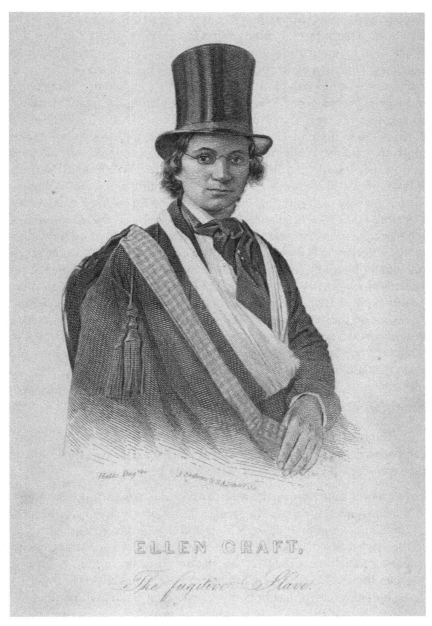

ELLEN CRAFT,
The fugitive Slave.

FIGURE 6. J. Andrews & S. A. Schiff, Ellen Craft, the fugitive slave. Manuscripts, Archives and Rare Books Division, Schomburg Center for Research in Black Culture, The New York Public Library, Astor, Lenox and Tilden Foundations.

literary level the account of their experience must be legitimated by white authority to reach print. In both cases it is their racial status that gives rise to the need for authentication, and in both cases the structure of authentication is governed by the principle that white institutional authority legitimates or authorizes black mobility or black experience. The couple overcomes both sets of constraints by manipulating dominant visual assumptions; William's rhetorical treatment of their historical experience extends the critique instantiated by Ellen's "passing through" whiteness to get to freedom. While there are key differences in the couple's actions during their escape and the choices Craft makes to represent those actions, both reveal the problematic nature of treating visual material as evidence, thereby undermining the authenticating function of iconography (including the image of Ellen in her planter disguise on the frontispiece of the narrative) and displacing the reader/viewer's illusion of masterful scientific objectivity, as well as the enslaved couple's presumed status as the perpetual object of that gaze. Exposing the fallacy of the equivalence between visual material and truth, on the level of historical experience, the couple exploits the public's belief that they can visually discern racial status, while on the literary level William Craft cultivates the reader's double vision to both reveal the ontological instability of readers' investment in whiteness and make visible the devoted relationship between him and Ellen that could not otherwise be seen.

Seeing Double

As Lindon Barrett argues, the treatment of "the vexed African American body" is "the central textual dilemma for ex-slave narrators" and its management is a key strategy of authentication:

> In order to authenticate themselves as African Americans, [ex-slave] narrators must highlight the primary terms by which African American identity is construed—the body and the life of the body. Nevertheless, because the claims these narrators are making on the government and culture of the United States are based on denunciations of an enforced and spurious confinement to a life merely of the body . . . these narrators must not only recover their bodies within their narratives but also, more importantly remove their bodies from these narratives.[21]

According to the cultural logic of race in the United States outlined by Barrett, the black body is understood in terms of "obdurate materiality," while the white body signifies beyond its substance, "attain[ing] its privi-

lege by seeming to replicate the dynamics, the functioning, of the symbolic itself."[22] By exploiting "the inherent meaningfulness of white bodies . . . their legibility, their ability to stand in for terms and narratives that do not inhere in their physical presence," the Crafts manage the gaze upon Ellen's body to outwit slaveholders' confidence in racial identification and visual discernment.[23] The black body simultaneously appears and disappears in *Running a Thousand Miles for Freedom* through Ellen Craft's successful performance as a white, invalid gentleman traveling to Philadelphia with his slave. However, because the success of the Crafts' escape depends on what Chaney calls "the convention of urban anonymity—of allowing white persons unimpeded mobility," Ellen's radical act of passing cannot actually be seen until the moment of narrative exposure—either in the Crafts' appearances on the abolitionist lecture circuit or in the narrative. Rather than presenting Ellen as either black or white, according to the cultural logic of race in the United States, Craft presents Ellen as simultaneously black and white, using language to emphasize not so much an objective racial identity, but rather the various ways she is simultaneously *seen* by others.

Somewhat curiously, Craft unfailingly refers to Ellen as "him" or "my master" while relating the details of their dramatic escape, as though to keep the image of Mr. Johnson intact for the reader. However, Craft's use of double entendre throughout the narrative refuses the resolution of Ellen's identity into a singular category. When Ellen first dons the disguise as Mr. Johnson, Craft still refers to her with the feminine pronoun: "Just before the time arrived, in the morning, for us to leave, I cut off my wife's hair square at the back of the head, and got her to dress in the disguise and stand out on the floor. I found that *she* made a most respectable looking gentleman."[24] It is not until the couple enters the public sphere that Craft announces his deliberate change in the language of his narration. Switching pronouns when the couple steps out of the cabin they share on the plantation and into public view, Craft signals that it is not Mr. Johnson's appearance that occasions the linguistic shift, but rather Craft's awareness of how Ellen appears to outsiders. Setting out from the cabin, William and Ellen take two different routes to the train station. William writes, "I took the nearest possible way to the train, for fear I should be recognized by some one, and got into the negro car in which I knew I should have to ride; but my *master* (as I will now call my wife) took a longer way round, and only arrived there with the bulk of the passengers."[25] In the eyes of the public, Ellen is a white gentleman free to move around as "he" pleases, while William is a "negro" under constant surveillance, his movements scrutinized and circumscribed. At the moment Craft begins to address

Ellen as "my master," he highlights the speculative gaze on his own black body and demonstrates how that gaze is responsible for limiting his range of movement.

At the same time, Craft's language plays on the conversational inter-changeability of Mr. Johnson's infirmity and William and Ellen's civic dis-ability to keep Ellen from "passing" in the narrative gaze of the reader and to keep the couple's true relationship to one another (as married) and their circumstance (as fugitive slaves) constantly in view. Mr. Johnson is purportedly suffering from a complication of physical ailments and is traveling to Philadelphia to consult a specialist, while William and Ellen are actually suffering from the legal disenfranchisement comprised by the chattel principle and are traveling to Philadelphia for relief. This extended irony is captured in frequent double entendre within the narrative. For example, when Mr. Johnson encounters a fellow passenger on a steamer bound for Charleston, South Carolina, who "urged my master not to go to the North for the restoration of his health, but to visit the Warm Springs in Arkansas," Craft writes that Mr. Johnson "said he thought the air of Philadelphia would suit his complaint best; and not only so, he thought he could get better advice there."[26] In another exchange Craft makes the joke explicit. When a gentleman on the train between Wilmington and Rich-mond asks William "what was the matter" with his master, William said "that he was suffering from a complication of complaints, and was going to Philadelphia, where he thought he could get more suitable advice than in Georgia."[27] When the gentleman concurs, saying he believes Mr. John-son "could obtain the very best advice" in Philadelphia, Craft writes, this "turned out to be quite correct, though he did not receive it from physi-cians, but from kind abolitionists who understood his case much better."[28]

Interestingly, during their escape, William and Ellen speak to each other and to those they encounter in such a way that both corroborates their cover story, but never strictly violates the truth of their relation-ship as devoted husband and wife nor the truth of their circumstance as fugitives from slavery. For example, when a slave-dealer on the train out of Savannah offers to buy William from Mr. Johnson for any price, Mr. Johnson replies, "I don't wish to sell, sir; I cannot get on well without him."[29] Mr. Johnson's answer accords with his cover story of illness and infirmity—William has just cut Mr. Johnson's meat for him as his arm is in a sling—but it also signifies on their situation as fugitives in the sense that Ellen and William are dependent upon one another for the success of their escape, to say nothing of the more enduring interdependence signified by their marriage. More literally, Ellen cannot "get on" in her journey to free territory without William's performance as Mr. Johnson's

attentive slave. Consequently, the reader, in on the escape, simultaneously "sees" Ellen as both black and white, a narrative strategy that "forestall[s] . . . expectation and a facile identification."[30] Deliberately emphasizing the multiple meanings of language in these scenes—"complaint" referring to both poor health and enslavement, "advice" referring to both medical and political intervention—William demonstrates that visual interpretation is conditioned by context, a point that he first makes at the beginning of the narrative with accounts of white people kidnapped into slavery.

William, too, speaks in such a way as to protect the visual image of master and slave the couple cultivates during their escape, while honoring the truth of their relationship to one another in the narrative. When a suspicious customhouse officer, guarding against abolitionists who might be transporting slaves from the South, fiercely demands, "'Boy, do you belong to that gentleman?'" William writes, "I quickly replied, 'Yes, sir' (which was quite correct)."[31] Similarly, when he is approached by a sympathetic conductor who encourages him to "'run away and leave that cripple, and have your liberty,'" William demurs, stating, "'I can't promise to do that.' 'Why not?' said the conductor, evidently much surprised; 'don't you want your liberty?' 'Yes, sir,' I replied; 'but I shall never run away from such a good master as I have at present.'"[32] Although his marriage to Ellen is not legally recognized, his responses demonstrate it to be a more important and more enduring relationship than the legally sanctioned one enforced between master and slave.

The double significance of this language interrupts the image of Mr. Johnson so carefully safeguarded during their escape. By letting the readers in on the plan and recording dialogue that reminds readers of the true relationship William and Ellen bear to one another as husband and wife, the narrative insists that—unlike the other passengers they encounter on the trip, who must only see Ellen as white for their plan to work—readers see Ellen as simultaneously black and white. In Foreman's analysis, "When the 'visibility of the apparatus of passing, the machinery that enables the performance,' was available, 'Mr. Johnson's' viewers could choose between locations: those in the know or those outside of it. Those who chose to identify as literate members, 'in-group' clairvoyants, unlike those duped in the narrative and during the escape, could reassert the connection between racial telling and knowing."[33] By contrast, I argue that William Craft's ambivalent language prevents readers from occupying the either/or position of insider/outsider. Making the "apparatus of passing" visible does not resolve Ellen's racial identity for the readers; rather it keeps it evermore in flux.

"Like a Book"

The success of Ellen's performance is indicated by the willingness of other white figures in the text to vouch for Mr. Johnson simply on the basis of his whiteness. While black people are required to produce written documentation to authorize their presence and their movements, Craft shows how a perception of white skin makes authentication unnecessary, as whiteness operates like writing in the sense that the "white body [is] understood within the play of 'differential structures from which [meaning, representation, and, indeed, writing] spring.'"[34] As mentioned earlier, anticipating that Mr. Johnson will be expected to sign the register books at hotels and the customhouse at Charleston, Ellen adopts a sling as part of her disguise to hide her illiteracy and provide a viable excuse for not registering "Mr. Johnson's" name in "his" own hand. Barrett argues it is the referentiality of whiteness that allows Ellen to counterintuitively emphasize the deficiency of illiteracy, through a physical marker—a sling.[35] When compounded with blackness, illiteracy is taken to be evidence of inferiority, proof of African American people's exclusion from a life of the mind; compounded with Ellen's white identity in her guise as a white planter, Ellen's solution "invokes the capacity of the white body to be read multiply, to be read in relation to other terms and narratives," in this case, the narratives of illness or infirmity.[36] When Ellen realizes her illiteracy could reveal her identity as a fugitive slave, she binds her writing hand, underscoring the impossibility of writing anything. Significantly, though, the plan depends upon the willingness of others not just to believe in Mr. Johnson, but to act on his behalf: "'I think I can make a poultice and bind up my right hand in a sling, and with propriety ask the officers to register my name for me.'"[37] Ellen's use of the word "propriety"—indicating both what is socially proper and the rights and expectations that are the "property" of whiteness—understands whiteness as a mechanism of social consolidation.[38] She rightly anticipates that when white figures see another white person in distress (signaled through the poultice and sling), they will extend themselves to help on the basis of what they imagine to be a shared racial identity.

As a matter of fact, the Crafts' actually *underestimate* the willingness of other travelers to extend themselves on behalf of Mr. Johnson. When an officer at the customhouse in Charleston refuses to register Mr. Johnson's name for him, skeptical not so much of his white identity but of his ownership of William, a virtual stranger steps in to guarantee Mr. Johnson's identity:

Just then the young military officer with whom my master travelled and conversed on the steamer from Savannah stepped in, somewhat the worse for brandy; he shook hands with my master, and pretended to know all about him. He said, 'I know his kin (friends) like a book'; and as the officer was known in Charleston, and was going to stop there with friends, the recognition was very much in my master's favour.[39]

Like with the double entendre keeping Ellen's simultaneous racial status in view, Craft's inclusion of the officer's specific dialogue works to underscore the different treatment of the same body when it is read as white versus when it is read as black. While William and Ellen are acutely aware of their need for written documentation to authorize their movements as black people, Mr. Johnson's whiteness places him beyond the need for authentication, an irony captured in the officer's claim to know Mr. Johnson's "kin (friends) *like a book.*" The visual identification of Mr. Johnson as white, and therefore "one of them," transcends the requirement for writing. It is the difference between vision as recognition (when the military officer looks at Mr. Johnson he recognizes him as *like* himself) and vision as discernment of difference. The recognition between white men literally overwrites the requirement that Mr. Johnson register his own name. Essentially the officer sees Mr. Johnson through the phantasmatic social connections his skin represents, "kin." Craft demonstrates that through the prism of "recognition," friendship, kinship, and identity are collapsed and translated into white solidarity. The credibility of the military officer in turn comes from his own recognizability—"the officer was known in Charleston." Furthermore, recognition is self-perpetuating. Once the captain of the steamer they are to board sees that the military officer "appeared to know" Mr. Johnson, he offers to vouch for him himself, stating, "'I will register the gentleman's name, and take the responsibility upon myself.'"[40]

Grateful that the moment of danger passes in their favor, Craft cannot help but comment on the absurdity of the military officer pretending to know Mr. Johnson on the basis of his whiteness: "When the gentleman finds out his mistake, he will, I have no doubt, be careful in future not to pretend to have an intimate acquaintance with an entire stranger."[41] The offhanded, drunken solidarity exhibited in the military officer's performance exists in contrast to the Crafts' own performance, upon which their lives depend. The Crafts' escape is dependent upon their public appearance as a planter traveling with his slave; however, Craft uses their story of escape to criticize the public investment in appearance-as-truth.

In a later conversation between Mr. Johnson and the captain, Craft plays up the irony of their situation at the customhouse by recounting the danger they encountered in the words of the captain:

> During the voyage the captain said, "It was rather sharp shooting this morning, Mr. Johnson. It was not out of any disrespect to you, sir; but they make it a rule to be very strict at Charleston. I have known families to be detained there with their slaves till reliable information could be received respecting them. If they were not very careful, any d—d abolitionist might take off a lot of valuable niggers."
>
> My master said, "I suppose so," and thanked him again for helping him over the difficulty.[42]

The captain and the Crafts' different experience of "the difficulty" of the morning—a white man inconvenienced by being unnecessarily detained versus two fugitive slaves in danger of recapture—is encapsulated in the ambivalence of the term "reliable information." From the Crafts' perspective, the moment of danger passes because *no* "reliable information" was offered regarding their true identities. By contrast, believing he can accurately identify what he sees, a white person, and therefore a trustworthy person, the self-assured captain takes the military officer's recognition *as* "reliable information," which resolves the dilemma. Craft uses the scene to direct attention to the emptiness of white authentication, in much the same way that Ligon's "Black Like Me" print in the *Narratives* series ironizes the convention of white testimonial letters as prefaces by a including a letter signed, "Yours very truly, A WHITE PERSON." The Crafts' escape demonstrates that, like language, which can be interpreted in multiple ways, but which always refers outside of itself, skin color is a signifier whose meaning is dependent on its context. Barrett takes this premise further, contending that skin color is not *like* language, but that the white body is itself linguistic, which is to say, "the white body has an associational power that leads elsewhere."[43] My argument here is that William Craft places the ambivalence of language and the ambivalent language of skin color side by side to expose the workings of visual assumptions of race.

The distinction between what people see when they look at Mr. Johnson and what people see when they look at William is a product of the different quality of the gaze upon each of them, a difference registered in the relationship of writing to either the black or white body. The equivalence of blackness and enslavement depends upon an understanding of the black body as illiterate, anonymous, outside of social signification, whereas whiteness is understood in terms of freedom, literacy, individ-

uality, and social significance. Mr. Johnson evades the requirement of registering his name in writing because his whiteness itself is a kind of writing. By contrast, the black body is understood as pure materiality, self-evident rather than referential, and therefore unable to signify beyond the confines of the material body: "[T]he black body functions as a widely accepted location of meaning, the end point of a chain of signification but never its point of initiation."[44] The steamer captain sees blackness in purely objective terms—he understands the stop at the customhouse in Charleston as preventing abolitionists from taking slaveholders' property. Both the object status of black people, as well as his visual powers of discernment, are so certain in his mind that it is inconceivable to him that fugitive slaves such as Ellen and William could "steal themselves." What the white officer believes he is guaranteeing by registering Mr. Johnson's name for him is the trustworthiness of another white man, not Mr. Johnson's whiteness, which, because he can see it for himself, is never in question.

The Crafts' escape demonstrates that whiteness is self-authorizing, whereas blackness requires white legitimation, often set forth in writing—itself a sign of the ability of white people to extend themselves symbolically. Craft's narrative demonstrates the double standard for white and black people as it gets encoded in the slave narrative form. Supplanting a scene of their own encounter with literacy, a convention of the slave narrative that operates as proof of the ex-slave narrator's humanity for a skeptical reading public, Craft offers the white officer's assessment that he knows Mr. Johnson's kin "like a book." Given the dynamics of authentication within the slave narrative form, well established by 1860, this literary choice aligns the reader with the officer by putting him in the position of both one who authenticates and one who assesses the status of the black subject. The reader literalizes the officer's attestation that he can read Ellen/Mr. Johnson "like a book," a collapse of metaphorical distance that both demonstrates the foolishness of racial assumptions and the fallacy of the ideological alignment of whiteness with literacy and blackness with the body. The particularly visual character of this ideological division of the properties of whiteness and blackness maps onto existing Western understandings of the mind/body split: "[F]or the 'enlightened' Western mind, no better justification for slavery or obfuscation of its economic motives can be found than one *visibly* grounded in nature and the 'natural' order."[45] Like Glenn Ligon's *Self-Portrait Exaggerating My Black Features* and *Self-Portrait Exaggerating My White Features* addressed in Chapter 1 of this book, the ambivalent dialogue William highlights demonstrates Ellen's ability to be read as simultaneously black and white,

which interrupts a presumptive racial binary and locates racial difference not in the body of the slave, but in the gaze of the viewer.

White Slavery

In addition to the racially ambivalent cipher of Ellen's body that both invites and disallows reader identification, Craft addresses incidents of white people kidnapped into slavery in *Running a Thousand Miles for Freedom*, announcing "I have myself conversed with several slaves who told me their parents were white and free; but they were stolen away from them and sold when quite young."[46] The purpose of these stories is to decouple skin color from racial designation or slave status:

> It may be remembered that slavery in America is not at all con-
> fined to persons of any particular complexion; there are a very large
> number of slaves as white as any one; but as the evidence of a slave is
> not admitted in court against a free white person, it is almost impos-
> sible for a white child, after having been kidnapped and sold into
> or reduced to slavery, in a part of the country where it is not known
> (as often is the case), ever to recover its freedom.[47]

Craft locates his critique of slavery in the vexed relationship between skin color and evidence. Although the narrative shows that dark skin color is taken as evidence of slave status, it also shows that white skin under the sign of slavery loses its privilege and is seen as "black." The same visual alchemy that allows Ellen Craft's "almost white" skin to be read as black while she is in slavery and read as white while she performs the role of slave master to effect their escape can transform the skin of a kidnapped white person into black, a status that denies the kidnap victim civic or legal recognition. Like the other slave narratives under consideration in this book, the Crafts' narrative challenges the visual logic of racial slavery; but rather than simply emptying sight of its positive evidentiary status, he offers it as a vehicle for interpersonal recognition. While the primary force of the story of Salomé Muller, Craft's most striking example of a white child sold into slavery, is that racial slavery does not respect the putative boundaries upon which it is based, Craft also demonstrates that vision as recognition provides a bulwark against the differentiating vision of slavery. In warning his white readership that "it is almost impossible for a white child, after having been kidnapped and sold into or reduced to slavery, *in a part of the country where it is not known*, ever to recover its freedom," Craft offers recognition—being known—as a visual operation counter to the avaricious gaze of racial slavery. As we see

in the officer's testimony on behalf of Mr. Johnson, mentioned earlier in this chapter, this type of recognition—an assessment of one as kin, for example—is freely offered amongst white people, but is denied to those perceived as black.

While the social significance of blackness and whiteness remains stable, the bodies considered either black or white shift unstably between racial categories, belying the notion that skin color is either evidence of enslavement or a stable visual sign. Citing the case of both a white boy kidnapped from Ohio whose story was pictured in George Bourne's *Picture of Slavery* and the case of Salomé Muller, Craft shows that an assessment of skin color often follows the designation of "slave," rather than the other way around.[48] Bourne "relates the case of a white boy who, at the age of seven, was stolen from his home in Ohio, tanned and stained in such a way that he could not be distinguished from a person of colour, and then sold as a slave in Virginia."[49] Muller, a white German immigrant sold into slavery after the death of her parents, comes by her color through the sun-exposure of plantation work:

> There was no trace of African descent in any feature of Salomé Muller. She had long, straight, black hair, hazel eyes, thin lips, and a Roman nose. The complexion of her face and neck was as dark as that of the darkest brunette. It appears, however, that during the twenty-five years of her servitude, she had been exposed to the sun's rays in the hot climate of Louisiana, with head and neck unsheltered, as is customary with the female slaves, while labouring in the cotton or the sugar field. Those parts of her person which had been shielded from the sun were comparatively white.[50]

By using the relative term "comparatively," Craft underscores the nonessential character of racial determination. As Ellen Weinauer argues, while Craft's inclusion of "white slavery" stories seems at first to reinscribe racial division, it actually exploits readers' potential identification with the victim to "contest slavery's assumption of natural binary difference," suggesting that "such difference itself is a construct. If white can be taken for black, and black, for white, the notion of discrete and meaningful racial categories becomes increasingly hollow."[51]

Providing a kind of précis of the traditional slave narrative, Salomé's entrance into slavery is marked by her disappearance, and her regaining of freedom is cast as a reappearance. While Salomé is a slave her body is visible, but her identity disappears; as Barrett argues, regaining her freedom is dependent upon making her body disappear so that her identity is visible: "Only when Muller's body is grafted to alternative narratives—that

is to say, when it is read in multiple ways that include family histories—is her membership in the realm of whiteness confirmed and made available to her."[52] When her relatives hear that Salomé's father has died, "they immediately [send] for [Salomé and her sister]; but they had disappeared, and the relatives, notwithstanding repeated and persevering inquiries and researches, could find no traces of them."[53] In a strange prefiguration of the scene of the Crafts' detention at the customhouse, what ultimately frees Salomé Muller is the gaze of recognition:

> In the summer of [1843] Madame Karl, a German woman who had come over in the same ship with the Mullers, was passing through a street in New Orleans, and accidentally saw Salomé in a wine-shop, belonging to Louis Belmonte, by whom she was held as a slave. Madame Karl recognized her at once, and carried her to the house of another German woman, Mrs. Shubert, who was Salomé's cousin and godmother, and who no sooner set eyes on her than, without having any intimation that the discovery had been previously made, she unhesitatingly exclaimed, "My God! here is the long-lost Salomé Muller."[54]

Barrett notes that the trial over her racial identity and her right to freedom depends upon the ability of the midwife who assisted at Salomé's birth to interpret "her body and its peculiar marks in terms of a personal and family history that dismisses the reading that would make her a slave."[55] On this testimony, the Supreme Court ultimately decides "'she was free and white, and therefore unlawfully held in bondage.'"[56] Since testimony presented to the courts also indicated that both John Miller, the plantation owner that first sold her into slavery, and the broker that negotiated the deal knew that Salomé was white and sold her anyway, the story illustrates that race is often an alibi for the economic motives of slavery, but most important for Craft, Muller's story demonstrates that race is anything but a fixed category that others can see and know by looking. However, he was also aware that looking as a mode of recognition challenges the objectifying gaze of slavery that makes one's identity—regardless of skin color—disappear.

William Johnson

The distinction in the way that white and black bodies signify under the logic of racial slavery can be read in the different identities that William and Ellen adopt to make their escape. Because slaves are not recognized as individuals, William's persona never requires an alternate name.

Although it is dangerous for William to travel under his own name as a fugitive, his identity is considered so inconsequential and interchangeable with other slaves that he never has the need to declare a pseudonym. The Crafts' cover story is tailored to a visual expectation: masters often traveled with their slaves. However, their play with names again disrupts the racial assumptions motivating the scene they construct, albeit in such a way that never increases the danger they are in.

Throughout the period of their escape William is most often referred to as "nigger" or "boy." Returning to the scene at the customhouse office at Charleston, the altercation begins when the officer asks Mr. Johnson to register both of their names: "'I wish you to register your name here, sir, and also the name of your nigger, and pay a dollar duty on him.'"[57] Mr. Johnson pays the dollar and, indicating the poultice, asks the officer to register his name for him. Although this ploy had worked perfectly throughout the trip so far, the South Carolinian ticket agent takes offense and declares loudly, "'I shan't do it.'" His refusal attracts the attention of the other passengers, including the military officer who rushes to vouch for Mr. Johnson. When the captain of the steamer finally intervenes by taking the responsibility on himself, Craft writes, "He asked my master's name. He said, 'William Johnson.' The names were put down, I think, 'Mr. Johnson and slave.'"[58] Although the customhouse officer had originally asked Mr. Johnson to register both his name and the name of his slave, the captain's entry reflects the inconsequentiality of William's identity from the perspective of white institutional authority; the only time the pair are asked to register a name for William, the requirement is satisfied with the generic entry, "a slave." Significantly, however, Mr. Johnson gives his own first name as "William." Although William's individuality is unrecognizable to the white officers and captain, Ellen ensures William's presence in the record by adopting his first name as Mr. Johnson's own. This verbal maneuver is decidedly safe for the pair, because the onlookers have no way of recognizing the connection between the two as anything other than "Mr. Johnson and slave." However, for readers who know the truth of their connection, Ellen's adoption of William's name is immediately recognizable and signals their unity in the performance of their division. While the onlookers at the customhouse see only what the official records show—Mr. Johnson and his slave—readers of *Running a Thousand Miles for Freedom* see William and Ellen Craft. By allowing the fugitive image of the Crafts to intrude upon the narrative illusion they construct for their escape, Craft exploits the reader's double vision to bring into focus what cannot be seen by slaveholders: the individuality of both the Crafts as well as the couple's connection and devotion to

one another. Consequently the slave narrative operates as an alternative visual record that corrects the customhouse declaration and the property ledgers of slavery.

In her analysis of Ellen Craft's performances on the anti-slavery lecture circuits in the United States and England, Teresa Zackodnik argues that Ellen Craft deliberately embodied the figure of the tragic mulatta to simultaneously court the audience's identification while making complete identification impossible. Working with William Wells Brown, the Crafts developed a routine in which Brown delivered philosophical remarks against slavery, followed by Craft giving an account of their escape, concluded by Ellen, often at the audience's urging, joining William on the stage as a visual symbol of the horrors of racial slavery. Zackodnik reads Ellen's consistent "decorous reluctance and embarrassment at appearing on the platform" as calculated performance rather than shy disinclination: "Craft's [silent] display positioned her as the site of her audience's empathic identification and horror, significantly referred to again and again as so nearly white that her enslavement embodied the lowest to which slavery would sink."[59] However, even while Ellen performed the tragic mulatta, "encod[ing] both the desire to conform to . . . standards of womanhood and her inability to do so as the 'white slave' on demand," the image of her dressed as Mr. Johnson circulated in the auditoriums.[60] Thus, Zackodnik contends that Ellen represented a deeply ambivalent figure who unsettled racial identification as much as she courted it:

> [T]he combination of Ellen Craft on stage as the 'white slave' so like her British countrywomen, in her audiences' imaginations as the tragic mulatta embodied, and in her engraving as the white Southern gentleman, Mr. Johnson, surely unsettled more than it comforted her audiences with the reassuringly familiar. This forestalling of expectation and a facile identification is significant, for it would enable Brown and the Crafts to direct their audiences' empathy away from the analogous—the white woman as slave, the white British working class as little better than slaves—and toward those who were quite literally enslaved in America.[61]

William Craft's use of representational static in *Running a Thousand Miles for Freedom* may have developed out of the Crafts' exploitation of their audiences' empathic identification and their simultaneous interruption of that identification in their anti-slavery performances; however, the textual visuality of the narrative makes possible new forms of vision and solidarity. By emphasizing the double significance of Ellen's body, which is simultaneously white and black, Craft undermines the traditional au-

thenticating strategy of the slave narrative form, unsettling the specifically visual assumptions of race upon which conventions of authentication rely and offering vision as the foundation of an intersubjective recognition that challenges the dominant mode of vision as scientific observation, sight as discernment, and imagery as self-evident.

"Re-Visioning" and Recognition

Before turning to his and Ellen's escape, Craft tells the story of another racially black person who temporarily appropriated whiteness to sustain the black family. Frank, the eldest son of "a very humane and wealthy gentleman that bought a woman, with whom he lived as his wife," "passes through" whiteness to reunite his family after they have been separated by a criminal taking advantage of exploitative slaveholding laws.[62] Frank's parents had five children, "among whom were three nearly white, well educated, and beautiful girls."[63] After his father's sudden death, without a will in place, the children are left "exposed" and the mother and five children make plans to leave their home for the North.[64] However, before they can do so a villainous figure, Mr. Slator, intervenes; claiming to be a "relative of the deceased," he puts the family up for auction for his own gain. The devastating outcomes of Slator's fraud reverberate through each of the family members' lives as well as those of their purchasers, both of whom die tragic, dissipated deaths. But there is one happy ending. Frank and Mary, the oldest siblings, are able to escape and ultimately succeed in reuniting the remaining family through an act of passing. Having kept track of where their surviving siblings were enslaved through a network of friends, once free in the North, Frank writes to their owners to purchase them and bring them to freedom, but their owners refuse to sell. Enacting a plan strikingly similar to that of the Crafts, though geographically inverted, Frank disguises himself as a white man by changing his styling and going South to recover his siblings: "After failing in several attempts to buy them, Frank cultivated large whiskers and moustachios, cut off his hair, put on a wig and glasses, and went down as a white man, and stopped in the neighborhood where his sister was; and after seeing her and also his little brother, arrangements were made for them to meet at a particular place on a Sunday, which they did, and got safely off."[65] However, there was one major hitch before their ultimate success: "Frank had so completely disguised or changed his appearance that his little sister did not know him, and would not speak till he showed their mother's likeness; the sight of which melted her to tears—for she knew the face."[66]

Craft offers the story as a parable that instructs the reader in cultivating a different relationship to visual material and the operation of sight, jettisoning the dominant understanding of sight as an objective process utilized to discern difference and reframing it as a subjective process that is the foundation of recognition. Although the story at first seems to affirm the evidentiary power of the visible—offering the likeness as a resolution to the crisis of identification (the sister's recognition of their mother in the form of her "likeness" confirms Frank's identity for her and, therefore, allows for the sentimental reunion of the family)—the crisis itself arises because Frank in disguise is unrecognizable to even his closest family members (undermining sight as a reliable gauge of truth). Much like Keckly's account of Tad's encounter with the literacy primer, the story slyly challenges the evidentiary force of visual material, even while gesturing toward it, ultimately rejecting images as self-evident bearers of certain, singular meaning and insisting that what we see is informed by the context in which we encounter it.

While it might be tempting to read Frank's proffering the image of their mother as "proof" of his relation to her, and therefore to his sister, the likeness does not in fact operate as evidence in this legal or rhetorical sense; theoretically, anyone could possess a picture and use it to cultivate fraudulent credibility. Rather, the likeness operates as a sentimental symbol of familial connection (like a photograph in a locket), enabling the sister to see and be seen.[67] At the very moment when the sister is most objectified—the point of sale, a circumstance created by the slaveholding law that the child follows the condition of the mother—Frank produces the likeness of their mother, which reintroduces her not as the source of their slave status, but as the source of their *family*, a set of relationships that are unseen or unrecognized by slaveholders. Their mother—and the connection the siblings have through her—is now responsible for the sister's *freedom*, rather than her continued enslavement. Frank's possession and proffering of the likeness does not so much verify his real identity as shift the context in which his sister sees him. The gesture of showing her the likeness only makes sense in light of his appreciation of what it will mean to her as a sentimental symbol of their familial connection, returning us to "the maternal nexus of a black mulatta genealogy," an emotional connection that slaveholders categorically deny and a bond they routinely sever.[68] We might recall, here, Michael Chaney's reading of William Craft's anguish when he is separated from his sister in his chapter on the narrative, "The Uses of Seeing."[69] As his sister is being taken away after having been sold, he falls to his knees and begs to have the "opportunity of bidding [her] farewell."[70] The auctioneer coldly denies

this request, returning, "Get up! You can do the wench no good; therefore there is no use in your seeing her."[71] The auctioneer cannot see the "use" in William's ability to see his sister one last time because he cannot see their sentimental connection.[72] It is a common refrain recorded in slave narratives, where spouses who are separated are sometimes told, as Elizabeth Keckly's mother is, "There are plenty more men about here, and if you want a husband so badly, stop your crying and go and find another."[73] For her part, the sister's outpouring of emotion comes because Frank's possession of the likeness, and the kindness and concern for her well-being that spurs him to show it to her to alleviate her fear, changes the context in which his physical features are read, reestablishing for her—and the reader—the black, matrilineal source of their relationship to one another. In other words, the likeness is not offered as proof, but rather as recognition, which is only possible in a relationship of reciprocity. In that sense the likeness establishes what Nicholas Mirzoeff deems "the right to look," which "begins at a personal level with the look into someone else's eyes to express friendship, solidarity, or love. That look must be mutual, each person inventing the other, or it fails. . . . It means requiring the recognition of the other in order to have a place from which to claim rights and to determine what is right."[74] Through the medium of the likeness, the siblings are able, once again, to see one another.

Craft uses the authenticating logic of the slave narrative—structured by the need to verify the existence, identity, and experience of the enslaved—to re-signify both the visual assumptions of race and the matrilineal genealogy of slavery. The personal significance of this re-signification is revealed at the end of the episode when Craft discloses that Frank and Mary are *his* family too, through his wife's matrilineal line: "Frank and Mary's mother was my wife's own dear aunt."[75] More than a likeness of the mother, the picture brings into view a family tree that is invisible in slavery.

More important, the reader has no access to the likeness; in other words, we cannot see the image. For Frank's sister, the picture vouchsafes the sentimental context of family, providing comfort and assurance that Frank sees her, which thus enables her to properly see him. But insofar as it legitimates Frank for his sister, it flouts the traditional dynamics of authentication not least because it bars the reader from the interaction. Unlike the frontispiece image of Ellen in her planter disguise, which exists and is deployed for the white reader's benefit—to satisfy curiosity, to judge the success of Ellen's disguise, to be shocked by the fact that someone with such light skin could be treated as a slave—the mother's likeness is not *for* the white reader.[76] It represents a circuit of recognition that

the reader is necessarily outside. Even if the image *were* included in the text, the reader would not have the necessary frame of reference for an encounter with it to resolve the crisis of identification which ultimately enables the family reunion. Offering a parable that signifies on the use of the likeness to authenticate or verify, but refusing to make it available for an external, objectifying, "legitimating," evaluative gaze, Craft denies the evidentiary status of the image and circumvents the authenticating investments of the slave narrative form.

In the epigraph for this chapter, Ruby Tapia calls for something like an inversion of ekphrasis, the literary description of a visual work of art, which until very recently has been the dominant analytic for thinking about the relationship between literature and visual culture. In addition to laboring to describe visual material ever more vividly and precisely, she suggests that we attend to "the gaps in images, the content of spaces between time(s), the dynamic imperatives of power taking shape."[77] Training our attention particularly on the nexus between history and representations of the racial violence of slavery, she writes of the "re-visioning" literature can accomplish, "pictur[ing] the materiality of many things ephemeral."[78] Tapia's invocation of the "necessary and invisible forms," which exist in "the interstices of how we have been taught to see," points the way toward what I have been calling textual visuality: the role language plays in conditioning how we see even those things deemed "self-evident," addressed in earlier chapters in the examples of Glenn Ligon's *Self-Portrait* and Elizabeth Keckly's rendition of Tad Lincoln's reading lesson. The Craft narrative offers a rich site for thinking about textual visuality, as William shows how language shapes the way Ellen is perceived during their escape, while consistently highlighting the way it can be used to preserve the legibility of their union, which can only be seen through the narrative expression of their escape.

4 / "The Shadow of the Cloud": Racial Speculation and Cultural Vision in Solomon Northup's *Twelve Years a Slave*

The boast of evidence . . . is that it limits and constrains the promiscuity of the imagination, weds imagination to a liturgy of facts, records, documented events. If to know is always, in part, to imagine, then evidence demands that imagination bind itself to the empirically demonstrable.

—IAN BAUCOM, SPECTERS OF THE ATLANTIC

Published in 1853 and written by Solomon Northup with white lawyer and writer David Wilson, *Twelve Years a Slave: Narrative of Solomon Northup, A Citizen of New-York, Kidnapped in Washington City in 1841, and Rescued in 1853, From a Cotton Plantation Near the Red River, in Louisiana*, has long been at the margins of slave narrative criticism.[1] Although it has received renewed attention with Steve McQueen's 2013 adaptation of it into a feature-length film, *12 Years a Slave*, the narrative has been in the somewhat unusual position of having been acknowledged and referenced by virtually all of the early literary criticism of the genre, but rarely treated as the primary subject of these works. One reason for this, as in the case with *The Narrative of the Life of Henry Box Brown* discussed in the next chapter, is because of Northup's reliance on an amanuensis, and in this case, Wilson, who was not affiliated with the anti-slavery movement. The difficulty of separating the narrative goals of Wilson and Northup has cast lingering suspicion on the usefulness of the text within literary studies. Sam Worley, one of the early critics to write on the importance of Northup's philosophical perspective in *Twelve Years a Slave*, asserts that the narrative's "value has been seen as one of fact or historical record and not, as in the case of the so-called classic narratives, a matter of imposing meaningful, interpretive form on its subject matter."[2] However, the notion that self-writing is "a matter of imposing meaningful, interpretive form on . . . subject matter" is borrowed from the European tradition of autobiography, a tradition I argue ex-slave narrators actively write against.[3] Rather than imposing form on subject matter as an expression of self, ex-slave narrators mobilize the racial logic of slave narrative form to call

attention to notions of subjectivity from which they are excluded. As I have been arguing, by manipulating or undermining the conventions of authentication that structure their texts, ex-slave narrators undercut the racial assumptions motivating that structure; specifically, ex-slave narrators challenge the notion of self-writing that understands the self as coterminous with the written word. Rather than addressing visual technologies or iconography such as frontispiece engravings, photographs, or the images, as in Tad's literacy primer, Northup's instantiation of representational static is the juxtaposition of two modes of seeing that are ultimately mutually exclusive: the objectifying gaze of racial slavery and the subjective look of recognition. The narrative works to unsettle essential notions of blackness by showing these mutually exclusive ways of seeing Northup that operate simultaneously.

If we place form at the center of our inquiry into the slave narrative, as this book does, *Twelve Years a Slave* is a key example of the negotiation ex-slave narrators, their interlocutors, and readers engage in on formal terrain. Like the Craft narrative, *Twelve Years a Slave* addresses the problem of authentication on both a historical and literary level. As the victim of a kidnapping, the drama of Northup's narrative is that he must provide evidence of his free status to overcome his designation as a slave and be returned to his rightful free status. Analogously, before his narrative can get to print, it must be authorized and legitimated by white institutional authority. In both cases, the "evidence" of his black skin must be overcome by written documentation. Thus Northup's historical circumstance mimics the rhetorical challenge all ex-slave narrators face: they must convince the reader of their rightful freedom even while compellingly documenting their experience of objectification in enslavement.

Northup's experience of enslavement as a consequence of kidnap rather than a circumstance of birth provides a unique opportunity to examine a literary response to the visual speculation of blackness as a problem that exceeds the institution of slavery geographically, socially, and politically. Rather than the traditional arc of object-to-subject, Northup's narrative begins in freedom, a fact registered in the many ways he is able to socially locate himself—as a son, husband, father, worker, and citizen of New York. However, if the presumption of blackness makes people vulnerable to kidnap even in free states, then the institution of slavery has established a *way of looking* at blackness that pervades free territory. Consequently, the narrative turns on the ways Northup is simultaneously seen as both free and a slave. The reader knows that Northup is a free man who has been criminally pressed into slavery; from this perspective the resolution of the narrative is Northup's rightful return to freedom.

However, because he was kidnapped into slavery, the reader must also see that the status of that freedom is perilously circumscribed and his return to "freedom" is thus compromised rather than triumphant. It is ultimately how Northup is seen that makes him susceptible to kidnap and transforms him from a man, with "all the same feelings and affections that find a place in the white man's breast," into a slave, an object to be traded on the market.[4] That very perspective is also the structuring principle of the slave narrative, crystallized in the authenticating requirements supposed to safeguard the anti-slavery work of the text. Through his relationship to evidence and authentication—specifically his account of the need to acquire "free papers"—Northup demonstrates that the perspective of the kidnappers is ultimately the national perspective: that black people are potential slaves.

In slavery, the skepticism directed toward enslaved people makes demonstrating his freedom nearly impossible. Northup was barred from providing legal testimony of the crimes committed against him.[5] Similarly, the authenticating gestures Northup integrates into his narrative are calculated to address the skepticism of a white Northern reading audience who questions the authenticity and veracity of a black speaker. In this way, Northup's rhetorical predicament is that of all ex-slave narrators: he must provide evidence to authenticate his narrative for a white audience while not acceding to their suggestion that his humanity is in question. Northup's response to this conundrum is to challenge the logic of racial speculation by producing two contradictory strains within his narrative: he meticulously executes the authenticating gestures, which both contribute to the restoration of his literal freedom as well as fulfill the literary expectations of authentication; at the same time, he evacuates those conventions of racial meaning through a series of visual metaphors and critiques that reveal the absurdity of the racial logic motivating the conventions of authentication.

Northup's narrative presents an effective case that both challenges the moral and political justifications for racial slavery and verifies his existence as a free man. But what does such a case mean in the context of his kidnapping? Although Northup describes the first thirty years of his life in the North in relatively idyllic terms, emphasizing that he did not understand himself in the reductive terms of "potential slave" during this period of his life, nevertheless his perspective at the time of the narrative—post-kidnap—is that of a man who now knows that the status of his freedom was always tenuous. This perspective intrudes on Northup's description of his early illusions and is captured in the before-and-after temporality of his account of this period, in which he discusses

aspects of his biography with a constant foreshadowing of what will become useful to him "afterward," meaning after his kidnapping. Thus the narrative's explicit interest in evidence and authenticity is belied by an implicit critique of the irrationality of the plantation system and United States' laws that effectively understand blackness as equivalent to enslavement. In other words, if a free black man can be kidnapped into slavery, then the authority of legal structures and written documentation is empty in the first place.

Although he overtly appeals to the authority of written documentation and legal procedure, his narrative questions the rationality of those systems by showing their dependence on context for interpretation. Even as he supplies the legal and literary evidence of his free status and his humanity, Northup evacuates the value of that evidence by showing its meaning to be dependent upon interpretation and perspective. Over and over in Northup's narrative we see that two people witnessing the same thing have different interpretations of what they have seen. The racial implications of the problem of witnessing are emphasized through Northup's use of visual tropes and metaphors. The power of *Twelve Years a Slave* is ultimately that it supplies evidence of the cruelty and immorality of racial slavery while framing a critique of an evidentiary model of subjectivity. Offering his own interiority—his memory, imagination, and sustaining fantasies of freedom—as a counternarrative to the documentation that ambivalently confirms his humanity, Northup marks the resolution of his traumatic enslavement not with his return to a dubious legal freedom, but with a look of mutual recognition between him and his partner-in-rescue, Henry B. Northup, which finally sets aside the documentation instrumental in securing his freedom and offers in its place the vision of the faces of all those whom he has loved and who have loved him.

A Matter of Public Record

The slave narrative's conventions of authentication, the formal elements that prove the humanity of the ex-slave narrator to the primarily white readership of the narrative, provide both the structure and subject of *Twelve Years a Slave*. On the surface the narrative appears to be both dependent upon evidence and evidentiary in nature. In addition to the authenticating elements that frame slave narratives generally—editorial preface, ex-slave's signature under the reproduction of his likeness, the reproduction of bills of sale, appendices with legal documents—much of Northup's story is *about* his attempt to demonstrate his legal freedom while he is enslaved. Thus the emphasis on what John Sekora calls factic-

ity, which is part of all slave narratives, is augmented and thematized in *Twelve Years a Slave*—much the same way that literacy is thematized in Frederick Douglass's 1845 narrative.[6]

Like other slave narratives, the text is filled with attestations of its truthfulness and authenticity. For example, Northup concludes a two-page description of the slave pen in which he was kept in Washington D.C. with an assertion of its accuracy: "Such is a correct description as it was in 1841, of Williams' slave pen in Washington, in one of the cellars of which I found myself so unaccountably confined."[7] In addition to an editor's preface, reproduction of his bill of sale, and appendices including letters instrumental in obtaining his freedom, Northup includes many details that have no narrative function except as factual markers his readers might use to verify the truth and accuracy of his account, such as who owned a particular boarding house at which he stayed, that a house he lived in was on the North side of the street, or that a particular plantation was "two and a half miles from Holmesville, eighteen from Marksville, and twelve from Cheneyville."[8] As Worley notes, "[s]o meticulous are most of [his] descriptions" of specific buildings and regions that he passes through "that one could easily produce a map or architectural drawing from them."[9] The inclusion of these details accords with the slave narrative's formal emphasis on facticity, but it also represents Northup's strategy of survival. Northup's eventual freedom (and his survival while in slavery) depended upon the accuracy of his memory, which preserved verifying (and sustaining) details of his life in the North as well as accurate descriptions of his location and circumstance in the South, information he would need to relay to friends in the North to secure his freedom.

Throughout the narrative Northup supports his memory of events with information he obtains from public records after his release from slavery, a narrative element that seemingly defers his authority to that of the written documents—public records that register his status as a salable object. Northup states in the beginning that his purpose is "to give a candid and truthful statement of facts: to repeat the story of [his] life without exaggeration."[10] However, the reader need not take Northup's word for it; his memory is constantly legitimated by information that can be verified by public records. For example, after noting that his master, William Ford, had to sell him to Tibeats because he became involved in debt, Northup helpfully offers, "The deed of myself from Freeman to Ford, as I ascertained from the public records in New Orleans on my return, was dated June 23rd, 1841."[11] This detail has the effect of verifying his testimony and incorporating annexed authenticating documents into the fabric of his narrative; the reproduction of the official record of this sale at the end of

his narrative confirms information Northup has already included in the body of his narrative as part of the plot.

It is the ease with which Northup integrates documentary evidence into his narrative that leads Robert Stepto to use *Twelve Years a Slave* as his example of what he calls an "integrated narrative," a phase in Stepto's account of slave narrative development in which "the various forms (letters, prefaces, guarantees, tales) and their accompanying voices become integrated in the slave narrative text."[12] Northup's ability to integrate, and therefore establish a degree of authorial control over, authenticating documents distinguishes *Twelve Years a Slave* from earlier phase narratives such as *The Narrative of the Life of Henry Bibb*, in which the narrator's voice is overpowered by ancillary authenticating documents, and later phase narratives such as *Narrative of the Life of Frederick Douglass, Written By Himself*, in which Douglass's authorial power and commanding narrative voice make authenticating documents secondary and unnecessary.

But despite incorporating authenticating material into the fabric of his narrative, Northup also reproduces the documents in an appendix, causing Stepto to qualify his designation, ultimately deeming *Twelve Years a Slave* an "integrated narrative unsure of itself."[13] According to Stepto, what prevents *Twelve Years a Slave* from being a more coherent autobiographical text is a problem of witnessing, the distinction between what he calls "Northup's eye and 'I'" controlling the narration.[14] Like many ex-slave narrators, Northup toggles between the individual and the representative; however, as an outsider to the institution, Northup's rhetorical distance and often anthropological tone is yet more disembodied than in traditional slave narration. For example, it is Northup's Northern perspective (including his familiarity with Northeast winters) and outsider status that seems to allow his assertion that "[t]here are few sights more pleasant to the eye, than a wide cotton field when it is in the bloom. It presents an appearance of purity, like an immaculate expanse of light, new-fallen snow."[15] For one who had been enslaved in Louisiana his whole life, the aspect of a cotton field in bloom would surely raise less pleasant associations; furthermore, one raised in Louisiana would have no frame of reference for how a field of new-fallen snow would appear. In the midst of one of the seemingly distanced and anthropological descriptions of slavery in Louisiana, Northup encodes a critique of visual evidence as a reliable indication of truth, situating it as a highly subjective and potentially occluding force.

Stepto identifies this perspectival divide as a problem for the autobiographical coherence of the narrative, noting that his "remarkable objec-

tive posture results directly from . . . assuming the role of participant-observer for authentication purposes," a role performed at the expense of presenting his own subjectivity in any depth.[16] However, my interest in *Twelve Years a Slave* is exactly the superficial position Northup is forced to take up as participant-observer. As a free man kidnapped into slavery he is an outside witness to slavery from the inside: he can speak of slavery as one who has experienced it personally but who has not grown up in its direct influence. Consequently, the role of authentication in his narrative is problematic. Rather than opening with the existential claim, "I was born . . . ," introducing his humanity to skeptical readers, Northup must present a life that was already in progress, a humanity lately denied. Northup is not in the position to write about slavery because he was born into it like most ex-slave narrators, but, rather, he is in the position to write about slavery because he was *mistaken* for a slave for twelve years. The presentation of facts supposed to ensure the reader that Northup was where he says he was, that he is who he says he is—Solomon Northup, a free man—is troubled by the fact that someone knew that and kidnapped him into slavery anyway. Northup's overproduction of facticity emphasizes the overriding force of visual speculation: his black skin is seen as equivalent to enslavement, which is to say that the fact of his blackness overshadows the documents supposed to vouchsafe his freedom.[17]

Northup as Participant-Observer

Northup's narrative voice is fractured by his dual inscription as both Solomon, a free citizen of New York, and Platt, a slave. While the name "Solomon Northup" represents a broad range of interracial social and familial connections elaborated in his first chapter (chiefly husband, father, independent contractor), the name "Platt" represents a closed circuit between name and outward appearance, a connection enforced through violence. The first time Northup hears the name "Platt," he is standing on the deck of the Orleans, the ship that takes him down the river to Louisiana. The slave trader Theophilus Freeman (his own name a stellar example of historical irony) reads out the name "Platt" from his cargo list. Getting no answer, Freeman calls the name again and again. After he has accounted for all the other slaves, Freeman looks at Northup and declares, "Your name is Platt—you answer my description."[18] Notably, although Freeman speaks as though he has a physical description in front of him that he is consulting, there is no physical description offered; Northup's sole "qualification" for his fitness as "Platt" is that he is a black man and there are no other black men remaining on the platform. This scene

echoes Northup's precipitous entry into slavery. When he first encounters Abram Hamilton and Merrill Brown, who entice him to follow them first to New York City then to Washington D.C. by stating that Northup was "just such a person as their business required," Northup believes they are referring to his skills as a violinist; however, the reader, who knows from the title page of the narrative that Northup is the victim of kidnapping, understands that they are speaking in a coded way about his appearance.[19] Both scenes demonstrate how slave status and individuality are mutually exclusive. From the trader's and kidnappers' perspective, a slave is a type, interchangeable with others who can visually fit the type, and is therefore denied the privilege of individual recognition. The violence inherent in this failure to recognize black individuality is manifested by Freeman on the Orleans. Though Northup states, "I informed him that was not my name; that I had never been called by it, but that I had no objection to it as I knew of," Freeman replies, "'Well, I will learn you your name . . . and so you won't forget it either by—!'"[20] The scene on the Orleans emphasizes the external perspective that conditions Northup's vulnerability to enslavement in the first place. Just as his only qualification for the slave name Platt is his appearance as black—"you answer my description"—his only susceptibility to kidnapping is his outward appearance and the kidnappers' perception of it, that he is "just such a person as their business required." The fullness of his life is reduced to the kidnappers' singular assessment of Northup as black and, therefore, as someone who "answers the description" of a slave.

As his two names suggest, Northup speaks from an impossible subject position in the narrative: the enslaved-free black man. The tension between maintaining his position as an outsider, a free man, while speaking from the position of an insider, a slave, creates some inconsistencies in the passages in which Northup describes slave life and slave consciousness. He asserts his identity as a free man by distinguishing himself *from* slaves who "have been brought up in fear and ignorance"; however, at times he endeavors to speak *for* slaves on account of his position among them, stating, "I have had the opportunity to know something of the feeling of which I speak."[21] Although he may *look like* other slaves, he describes himself as having different thoughts, feelings, and desires because he has "enjoyed the blessings of liberty in a free State."[22] Consequently, the narrative shifts often uncomfortably and sometimes unaccountably between passages in which Northup passionately defends the rights of slaves as one who is enslaved and passages in which he coolly distances himself from "them" as he describes slave life "as it came under [his] own observation."[23]

In talking about states of enslavement and freedom while inhabiting them both simultaneously, Northup shifts our attention away from the visible and toward internal characteristics that cannot be seen. He does this in two ways: first, he differentiates himself from other slaves based on internal states, insisting that what matters most when planning a slave rebellion or mutiny, for example, are qualities that cannot be seen; and second, he insists that regardless of the reader's perspective, which structurally mimics that of the kidnappers in requiring that he provide evidence of his authentic status before his freedom can be articulated, he makes clear that enslaved people understand their condition as fundamentally relational—a dynamic of power that must be constantly reiterated and maintained through violence.

Northup's account of his interiority is the primary way he distinguishes himself from other slaves during the period of his enslavement. Early in the narrative he relates his attempt to escape from the Orleans en route to the slave market. He shares his plan for rebellion with Arthur and Robert—two men who, like him, had been kidnapped into slavery, noting, "[t]here was not another slave we dared to trust. Brought up in fear and ignorance as they are, it can scarcely be conceived how servilely they will cringe before a white man's look."[24] Northup rhetorically distances himself from the position of slave, but importantly, the distinction he draws between himself and those brought up in slavery is their response to "a white man's look." For Northup the difference between a slave and a free man is not skin color, but rather the degree to which his personal hopes and expectations have been limited by racism, which he addresses synecdochally as "the white man's look."

The distinction in the way Northup addresses his own marriage to Anne Hampton and marriage between fellow slaves in Louisiana is an example of the tensions created by his effort to simultaneously identify with and differentiate himself from an enslaved position, what Stepto calls Northup's role as participant-observer. Northup sustains himself with the hope of escape and the hope of seeing his wife and children again, sometimes seeing visions of their faces and hearing their voices in his dreams. In contrast to Northup's enduring bond with his family, slave marriage is described in the following way, adopting the problematic anthropological tone noted earlier:

Marriage is frequently contracted during the holidays, if such an institution may be said to exist among them. The only ceremony required before entering into that "holy estate," is to obtain the consent of the respective owners. It is usually encouraged by the masters of

female slaves. Either party can have as many husbands or wives as the owner will permit, and either is at liberty to discard the other at pleasure. The law in relation to divorce, or to bigamy, and so forth is not applicable to property of course.[25]

Although Northup employs sarcasm to contest the notion of slaves as property, his account suggests that slaves themselves, following the law of the land, take marriage lightly. Unlike Northup's own marriage, sanctioned by God and the state, the "holy estate" of slave marriage must be sanctioned only by masters who desire to increase their property. Although Northup clearly lays the blame for the ephemeral nature of slave marriage on the chattel principle of slavery itself, he is notably dismissive of slaves' own commitments to one another, citing the example of Uncle Abram who lived seven miles away from his wife: "He had permission to visit her once a fortnight, but he was growing old, and . . . had latterly well nigh forgotten her. Uncle Abram had no time to spare from his meditations on General Jackson—connubial dalliance being well enough for the young and thoughtless, but unbecoming a grave and solemn philosopher like himself."[26] Northup's decidedly unsentimental tone regarding slave marriage differs from his own earnest declaration of love for his family in his first chapter, which he supplies for the benefit of readers who may doubt it:

From the time of my marriage to this day the love I have borne my wife has been sincere and unabated; and only those who have felt the tenderness a father cherishes for his offspring, can appreciate my affection for the beloved children which have since been born to us. This much I deem appropriate and necessary to say, in order that those who read these pages, may comprehend the poignancy of those sufferings I have been doomed to bear.[27]

Northup's posture of participant-observer likens him to the reader, who may assume slave marriage is less devoted than legally sanctioned marriage under God. He authenticates his own marriage to readers by naming the judge that married him and Anne Hampton on Christmas day, 1829, and by inscribing his feelings within the conventions of sentimental attachment denied to slaves.[28]

Northup's belief that the difference between slave and free is interior rather than exterior, a matter of feeling rather than a matter of skin color, distinguishes his position from the many white abolitionists who maintained a racist insistence on the ignorance of the enslaved. Even as Northup describes the affectionate relationship between his father and the

family that held him in bondage (the Northups), he notes that his father had "comprehended the system of Slavery, and dwelt with sorrow on the degradation of his race."[29] Despite the distance he maintains between himself and other slaves, Northup never wavers from his position that slaves know the conditions in which they live, and he often takes up the position of the translator or advocate for the slave:

> It is a mistaken opinion that prevails in some quarters, that the slave
> does not understand the term—does not comprehend the idea of
> freedom. Even on Bayou Boeuf, where I conceive slavery exists in
> its most abject and cruel form—where it exhibits features altogether
> unknown in more northern States—the most ignorant of them
> generally know full well its meaning. They understand the privileges
> and exemptions that belong to it—that it would bestow upon them
> the fruits of their own labors, and that it would secure to them the
> enjoyment of domestic happiness. They do not fail to observe the
> difference between their own condition and the meanest white man's,
> and to realize the injustice of the laws which place it in his power not
> only to appropriate the profits of their industry, but to subject them
> to unmerited, and unprovoked, punishment, without remedy, or the
> right to resist, or to remonstrate.[30]

As Worely notes, enslaved people's awareness of their condition is an aspect of authentication within the narrative. Rather than authenticating his own existence, this passage authenticates the civic presence of all slaves who recognize the value of the freedom they are denied: "Northup uses one undeniable and unavoidable aspect of slavery—its continuity with society—to refute another part of it, its relegation of slaves to a position outside of society."[31] Denied full membership in society, relegated to the margins of a community, slaves demonstrate their membership in that society by knowing the "privileges and exemptions" that belong to its membership: "Consequently, their knowledge of freedom, precisely because it comes about through their de facto membership in society, proves their right to freedom."[32]

In the previous passage Northup highlights enslaved people's awareness of the civic and legal injustice attendant on being enslaved. At another moment in the text, Northup focuses on enslaved people's knowledge of slaveholders' breach of more eternal laws, highlighting their awareness of the moral injustice of slavery:

> They are deceived who flatter themselves that the ignorant and
> debased slave has no conception of the magnitude of his wrongs.

They are deceived who imagine that he arises from his knees, with back lacerated and bleeding, cherishing only a spirit of meekness and forgiveness. A day may come—it *will* come, if his prayer is heard—a terrible day of vengeance, when the master in his turn will cry in vain for mercy.[33]

By placing the slave in the position of judgment, Northup aligns enslaved people with the laws of heaven, beyond the need for white authentication.[34] Moreover, this passage echoes Douglass's reversal of black and white vulnerability in his narrative in his description of the scene of the fugitive's escape, discussed in Chapter 1 of this book: "Let [the slave-catcher] be left to feel his way in the dark; let darkness commensurate with his crime hover over him; and let him feel that at every step he takes, in pursuit of the flying bondman, he is running the frightful risk of having his hot brains dashed out by an invisible agency."[35] Both Douglass and Northup employ religious rhetoric to convey the threat that awaits slaveholders who continue to flout the laws of heaven in favor of the earthly laws of greed. Both, too, place the fugitive slave in the position of godlike control—Douglass represents himself as a spirit no longer subject to physical vulnerability, having been "resurrected" after his fight with Covey, while Northup suggests that it is the wronged to whom the master must appeal for mercy. Although Northup's defense of slave consciousness comes at the price of his objectification and generalization of the position of "the slave," the distinction he posits between slave and free is structural: a function of immoral racial degradation sanctioned by law and perpetuated and superseded by visual speculation.

All of this is forecasted in Northup's opening move. Throughout the narrative Northup produces the authenticating requirements of the slave narrative while evacuating those conventions of racial meaning, a double gesture beginning on the opening page, in which Northup both appropriates and undermines a recognizable convention of the slave narrative: the first sentence declaring, "I was born." Northup distinguishes himself from the position of other ex-slave narrators through the grammar of his opening sentence: "*Having been born* a freeman. . . . "[36] Unlike the majority of ex-slave narrators, whose entrance into slavery was birth following "the condition of the mother," Northup was born a free man in New York and kidnapped into slavery as an adult. Northup's declension of the classic opening challenges both the assumption that racial identity and enslavement are inextricable and the notion that one comes into being through writing. Rather than the existential declaration, "I was born," we begin the narrative in medias res. Northup presents a self that is already

in existence both before the narrative and before his enslavement. As I argue in the introduction, the need to declare oneself and one's existence is one of the distinctions between traditional autobiography and the African American slave narrative. Not only has the ex-slave been treated as an object, and thus must announce his or her status as a subject before the narrative can begin, but the very existence of black narrators was consistently called into doubt. Discussing the traditional "I was born" opening in his essay by the same name, James Olney writes,

> We can see the necessity for this first and most basic assertion on the part of the ex-slave in the contrary situation of an autobiographer like Benjamin Franklin. While any reader was free to doubt the motives of Franklin's memoir, no one could doubt his existence, and so Franklin begins not with any claims or proofs that he was born and now really exists but with an explanation of why he has chosen to write such a document as the one in hand. With the ex-slave, however, it was his existence and his identity, not his reasons for writing, that were called into question: if the former could be established the latter would be obvious and the same from one narrative to another.[37]

Northup's opening distinguishes his experience from that of other ex-slave narrators, but it also reveals the rhetorical situation of all ex-slave narrators: they must answer for a racial identity that has been determined from without. Whatever geographic location, political status, or social connections one may have, blackness is reducible to enslavement in the United States. "Having been born a freeman," Northup is speaking out of the same putative void as narrators born into enslavement. What Northup's narrative presents, then, is blackness, and the interpretation of blackness, as the pretext for enslavement rather than a circumstance of birth. Yet from his first sentence, Northup's narrative holds out multiple interpretations of blackness revealing the fallacy of reducing black skin to a single interpretation—enslavement—through the logic of racial speculation.

The Shadow of the Cloud

Presenting the experience of slavery from the position of participant-observer, *Twelve Years a Slave* both registers the cultural vision that traps Northup in enslavement and suggests its illusory nature. One of Northup's primary strategies throughout the narrative is to represent slavery through visual metaphors that both capture and critique the opacity of blackness as it is perceived by white figures within—and readers of—the text. Deploying a series of metaphors of visual occlusion, Northup demonstrates

that even supposedly incontrovertible documentary evidence meant to protect him (free papers, for example) is often motivated and overwritten by vicious racial fantasies that structure racial speculation. Northup literally foreshadows his entrance into slavery with the metaphor of slavery as "the shadow of the cloud" that darkens the dreams he indulges in of his children's bright future. Describing his close relationship with his young family in the beginning of the narrative, Northup writes, "Many an airy castle did their mother and myself build for the little innocents."[38] Yet in the ensuing passage, the "airy castles" of the hopes and dreams he harbors for his children transform metonymically into his children's "clouded skins," a perspective that is finally linked to slavery, described as "the shadow of the cloud."[39] The fantastic "airy castles" he and his wife built for his children, signaling their dreams of a secure and successful future for them, recall the childhood activity of seeing shapes and forms in clouds in the sky. However, the metaphor soon shifts to acknowledge his children's social reality in a free state that nevertheless sees blackness as equivalent to enslavement. In a strange turn, acknowledging a hostile external gaze upon his children in the midst of a memory of an intimate family moment, Northup reveals how the way his children appear to others intrudes on the private sentimental dreams he shares with his wife. Recalling joyful family times before his kidnapping in which he would promenade with his children through the streets of Saratoga, Northup writes, "I clasped them to my bosom with as warm and tender love as if their clouded skins had been as white as snow."[40] Although he is recounting events in the period of innocence before his kidnapping, he can no longer think of the moment without reflecting on the ways his children are subject to the same objectifying gaze that provoked his trauma. It is, he reveals, the vision of slavery, cast as a racialized fantasy, which shuts out the light and joy of his life with his family, to which we were introduced in the narrative just moments before:

> [N]ow I had reached a turning point in my existence—reached the threshold of unutterable wrong, and sorrow, and despair. Now I had approached within the shadow of the cloud, into the thick darkness whereof I was soon to disappear, thenceforward to be hidden from the eyes of all my kindred, and shut out from the sweet light of liberty, for many a weary year.[41]

Northup describes his entrance into slavery as an entrance into invisibility, "hidden from the eyes of all [his] kindred." Forcibly removed from his life as a husband and father in the North, Northup's social and familial connections cannot be seen in slavery. Furthermore, his invisibility in

slavery is a result of his hypervisibility as a black man. As discussed earlier, Northup's own "clouded skin," a hostile gaze upon him captured by referring to himself as "an obscure colored man," is the singular characteristic visible to his kidnappers.[42] At this turning point in his narrative, Northup characterizes the problem he faces as not simply legal slavery, but as the racialist fantasy that sees black skin as equivalent to enslavement—a way of seeing that is not limited to the South. In the narrative the power of that fantasy is actually more important than the documentary evidence supposed to guarantee his freedom, a point he demonstrates by showing the uselessness of so-called free papers, which the kidnappers actually use in their ploy to entrap Northup in slavery.

To persuade him to come with them, Hamilton and Brown offer Northup work as their accompanist, telling him they need a musician to perform in their circus act on the way to New York and then Washington D.C. Interestingly, this cover story trades on Northup's similarity to the kidnappers rather than their difference. Like Northup, a talented violin player who supplements his income through occasional performances, Brown and Hamilton represent themselves as performers who have taken a trip North to see the country, "paying their expenses by an occasional exhibition."[43] Tellingly, their act consisted of "feats of ventriloquism and legerdemain"—literally "sleight of hand."[44] After it is too late, it becomes painfully clear to Northup that Hamilton's and Brown's real purpose was, in fact, a different kind of sleight of hand. Like magic, which often works through visual illusion, the kidnappers use the visual association between blackness and enslavement to transform Northup from a free man into a slave by moving him across the North-South divide.

Even before Northup is taken across the border into a slave state, where his free status is in the most jeopardy, the presumption of freedom he enjoys in the North is revealed to be illusory, a fact illustrated by the requirement that free black citizens obtain "free papers" to legitimate their free status. In order to gain his trust and signal their concern for his welfare, the kidnappers suggest that Northup secure free papers before leaving New York. That he would have to acquire legal documentation of his obvious freedom is a novel idea to Northup: "The idea struck me as a prudent one, though I think it would scarcely have occurred to me, had they not proposed it. . . . I thought at the time, I must confess, that the papers were scarcely worth the cost of obtaining them—the apprehension of danger to my personal safety never having suggested itself to me in the remotest manner."[45] Northup's remarks signal both the double significance of blackness, which operates simultaneously under a presumption of freedom (Northup's perspective) and a presumption of enslavement

(kidnappers' perspective), and the emptiness of documentation in that obtaining free papers is ironically part of the strategy the kidnappers use to defraud Northup of his rights. Northup signals the difference between his perspective and the kidnappers' by emphasizing how alien the notion of free papers is to him; he has never thought of himself in any context *other* than free. By contrast, the kidnappers see him as someone in need of free papers, which is to say, Northup's racial status is at the forefront of their mind. As this difference in perspective shows, the kidnappers' perspective is that of the nation: that black citizens exist under a presumption of slavery but for written documentation guaranteeing their freedom. Essentially, free papers signify the threat of enslavement, a threat that is borne out in Northup's actual experience.

Although Northup performs gestures of authentication throughout *Twelve Years a Slave*, his experience demonstrates that documentation can neither guarantee freedom nor secure recognition of his humanity. The visual logic of racial slavery supersedes legal protections for black citizens, a category constantly under erasure. To demonstrate the vacancy of legal protection for black citizens, it is important to return to Northup's representation of his life before enslavement, which serves as a counterpoint to his life in slavery. In New York Northup is well integrated into his community, maintains good relations with the white Northups who once held his father in slavery, is valued economically and socially for his work ethic and his talent as a violinist, and he is loved and loves in his role as husband and father. Northup's decision to include these details gives a sense of who he is before he is kidnapped, but it is also calculated to heighten the sense of identification and injustice on the part of the reader. As discussed earlier, he deems it "appropriate and necessary" to state his unyielding love for his family "in order that those who read these pages, may comprehend the poignancy of those sufferings I have been doomed to bear."[46] The authenticating function of including a statement of his love for his family is countered by the uselessness of such a statement in the face of racial speculation. Northup preemptively answers those readers who imagine black family life as less stable or valuable than white family life, but his kidnapping demonstrates that the real threat to black family life is the visual association of blackness and enslavement: the way of looking at blackness conditioned by slavery, or "clouded skin." As Northup notes, including a passage describing his love in universal terms—"only those who have felt the glowing tenderness a father cherishes for his offspring, can appreciate my affection for the beloved children which have . . . been born to us,"—is included to produce shock: even someone as well integrated into the community as Northup, someone whose work

and familial life is recognized by the civil society in which he lives, someone so much *like* the white reader, is vulnerable to kidnap simply because of the color of his skin.[47]

Northup's connection to the civic life of his community is demonstrated through his emphasis on the contract form in the early part of his narrative. His ability to enter into contractual agreements implies his status as a subject, in contrast to his objectification in slavery: "Having hired several efficient hands to assist me, I entered into contracts for the transportation of large rafts of timber from Lake Champlain to Troy. . . . Having completed my contracts on the canal satisfactorily to myself and to my employer, . . . I entered into another contract with Medad Gunn, to cut a large quantity of wood."[48] In his early life Northup is recognized as an individual who can hire employees and enter into contracts, in contrast to his experience as a slave in which Northup is the object of contracts, evidenced by the bill of sale annexed to the narrative. Northup's family life is also acknowledged by the state: "I was married to Anne Hampton, a colored girl then living in the vicinity of our residence. The ceremony was performed at Fort Edward, by Timothy Eddy, Esq., a magistrate of that town, and still a prominent citizen of the place."[49]

Although he provides these details for the benefit of the reader, Northup himself has lost faith in the authority of the state, an aspect of the narrative captured by his repeated use of the word "afterwards" when narrating the early civic, economic, and familial recognition he enjoyed, suggesting a radical break from the perspective he held in his early years to that which he holds now: these early events and autobiographical sketches are related from the perspective of traumatic aftermath. For example, discussing his experience as a contract worker transporting timber from Lake Champlain to Troy, Northup interrupts the account to relate that the knowledge he gained regarding navigating waterways and transporting lumber "afterwards enabled me to render profitable service to a worthy master."[50] Similarly, he notes that his knowledge of cities along the route from New York to Canada "was also of service to me afterwards," forecasting that this knowledge was key to enabling his eventual escape from slavery.[51] In addition to the perspectival split between Northup and his fellow slaves and Northup and kidnappers Hamilton and Brown, the narrative encodes a perspectival split within Northup himself: before and after. Northup exploits his early innocence—in which he is unaware of even the need for free papers—to present a powerful critique of a nation that requires such supplemental documentation of supposedly free citizens who are not free because they are seen under the visual sign of slavery. Rather than situating himself as naïve about racism or slavery,

Northup's insistence that it had never occurred to him to consider himself in danger of being kidnapped into slavery serves to demonstrate that it is only by investing in the logic of racial slavery that one would see black citizens as potential slaves.

Northup's loss of faith in the structure of law and the authority of the state are central to his understanding of his kidnapping not as an isolated incident, but as the logical consequence of a country that tolerates and maintains racial slavery within its borders. Northup links the cultural vision of racial slavery to the distorted U.S. ideals of life, liberty, and the pursuit of happiness through a series of visual images, including an ironic extension of his earlier metaphor of slavery as "the shadow of the cloud." His first night in the slave pen in Washington, Northup notes that "within plain sight of this same house, looking down from its commanding height upon it, was the Capitol. The voices of patriotic representatives boasting freedom and equality, and the rattling of the poor slave's chains, almost commingled. A slave pen within the very shadow of the Capitol!"[52] Northup blends the iconographic sights and sounds of national pride with the iconic sights and sounds of slavery—the rattling of slaves' chains and the image of the slave pen; but these iconic sights and sounds are contained within his very body. Northup is simultaneously within the shadow of the cloud of slavery and within the national shadow, which is to say he is simultaneously a slave and an American citizen subject to U.S. law. The irony is captured in the aural distinction between the political representatives' voices contrasted with the enslaved people's voiceless rattling of chains.

Northup's anger at the emptiness of national rhetoric of equality in the face of racial slavery is expressed in the visual proximity of the slave pen *within sight* of the Capitol. This image discloses that the state refuses to see what is right in front of it—the humanity of its black citizens. Northup sharpens his sarcastic tone when describing how he and the other slaves were transported from the pen in chains under the cover of darkness. As they file into the Washington night, Northup notes the reflected lights of Pennsylvania Avenue, the street that joins the Capitol and the White House, are visible in stark contrast to the state's willful blindness to the humanity of the enslaved: "So we passed, handcuffed and in silence, through the streets of Washington—through the Capitol of a nation, whose theory of government, we were told, rests on the foundation of a man's inalienable right to life, LIBERTY, and the pursuit of happiness! Hail! Columbia, happy land, indeed!"[53] The logic of racial slavery refuses the category of free black subjects, casting a shadow over all black citizens, a circumstance that intensifies during the period of Northup's enslavement.

Although he was kidnapped in 1841, he was not rescued until 1853, three years after the revision of the Fugitive Slave Law, which metaphorically extended the shadow of slavery over all U.S. terrain. As the Fugitive Slave Law and earlier laws including the property qualification for black suffrage demonstrate, the U.S. fails to recognize black citizenship as a natural category.[54] Whereas white citizenship is conferred at birth, equal black citizenship must be written into existence through legal emancipation, purchased through property qualification, or affirmed through free papers. However, as I argue earlier, Northup's experience demonstrates that racial speculation supersedes legal documentation.

The dominance of racial speculation over legal documentation is nowhere more evident than at Northup's release from slavery. Despite the legal documentation he is presented with, verifying Northup's identity and legal freedom, his last master, Edwin Epps, cannot see Northup as anything other than Platt, an illiterate slave. Even as Henry Northup reads Epps the affidavit attesting to Northup's freedom and true identity, Epps continues to refer to Northup as "Platt" and is incredulous that he could have written a letter to Henry Northup himself: "It seems there has been a letter written for you by somebody. Now who is it?"[55] Neither documentary evidence nor the authoritative agent of the state, the sheriff, can change his view; his reading of Northup's skin color supersedes his reading of the legal documents attesting to Northup's freedom. His perspective is drawn in sharp relief as Northup says his good-byes:

> "Good-bye, missis."
> "Good-bye, Platt," said Mrs. Epps, kindly.
> "Good-bye, master."
> "Ah, you d—d nigger," muttered Epps. . . .[56]

Mrs. Epps calls Northup Platt, the name arbitrarily given him in slavery. Mr. Epps puts a finer point on it. The slaveholders who have a stake in Northup as property either cannot or will not see nor admit the validity of documentary evidence and continue to have the same relationship to Northup as before the evidence was presented.

Significantly, Epps interprets the documentary evidence as manufactured because he cannot believe a slave could have written a letter on his own behalf: "[Epps's] whole manner and language exhibited a feeling of anger towards the unknown person who had written for me, and of fretfulness at losing so much property."[57] Epps imagines an "unknown person" who had written for Northup because slave literacy is inconceivable to him. This is particularly curious in that Epps *knows* that Northup

is literate, a fact which was one of Northup's primary barriers in making contact with friends in the North. Northup writes, "[s]oon after he purchased me, Epps asked me if I could write and read, and on being informed that I had received some instruction in those branches of education, he assured me, with emphasis, if he ever caught me with a book, or with a pen and ink, he would give me a hundred lashes."[58] Epps takes special care to deprive Northup of access to paper and pen; the letter which ultimately reaches his friends in the North is written on a pilfered piece of paper with ink made by "boiling white maple bark" for a pen manufactured from a feather plucked from the wing of a duck.[59] Believing that Northup wrote the letter would indicate his own failure to fully dominate his slaves, but slave literacy is also unthinkable to Epps, who sees black people as objects without history or interiority:

> He said he wanted me to understand that he bought "niggers" to work and not to educate. He never inquired a word of my past life, or from whence I came. The mistress, however, cross-examined me frequently about Washington, which she supposed was my native city, and more than once remarked that I did not talk nor act like the other 'niggers,' and she was sure I had seen more of the world than I admitted.[60]

The Mistress's suspicion that Northup "had . . . seen more of the world" than he admitted is the result of her comparison of him with the other enslaved people; her husband cannot even make such a comparison because, to him, "Platt" has no existence or identity outside that of his "answering the description of" a "slave." Epps's image of what a slave *is*—an illiterate object, a "nigger"—is so powerful it inhibits his ability to reconcile Solomon Northup and Platt. He literally does not see Solomon Northup. The irrational character of Epps's failure of vision signifies beyond his singularity as a slaveholder and indicates the cultural vision that, like Hamilton and Brown's "sleight of hand," can transform any black person into an object.

Manipulating the White Gaze

Northup's use of visual tropes such as shadows and clouds in his narrative is coupled with his manipulation of the white gaze while he is actually in slavery. Many times during his enslavement Northup turns the speculative gaze of his masters to enslaved people's advantage. After first arriving at the Epps' plantation, Northup notes Epps's ever-present gaze: "[W]hether actually in the field or not, [he] had his eyes pretty generally upon us. From the piazza, from behind some adjacent tree, or other

concealed point of observation, he was perpetually on the watch."[61] Epps's gaze was often on Patsey, in particular, a female slave who he singled out for sexual abuse:

> Patsey wept oftener, and suffered more, than any of her companions. She had been literally excoriated. Her back bore the scars of a thousand stripes; not because she was backward in her work, nor because she was of an unmindful and rebellious spirit, but because it had fallen her lot to be the slave of a licentious master and a jealous mistress. She shrank before the lustful eye of the one, and was in danger even of her life at the hands of the other, and between the two, she was indeed accursed.[62]

Patsey is literally marked by her location between the opposing gazes of her master and mistress. The mistress often forced Epps to severely beat Patsey to punish her "for an office of which he himself was the sole and irresistible cause."[63] One afternoon, after returning to the plantation drunk after a nearby shooting match, Epps stood at the edge of the field looking at Patsey, "motioning and grimacing, as was his habit when half-intoxicated. Aware of his lewd intentions, Patsey began to cry."[64] Keeping his own head down, Northup advises Patsey "not to look up, and to continue at her work, as if she had not observed him."[65] When Epps realizes Northup's intervention, he holds a knife to his neck, threatening to kill him. Northup escapes Epps's clutch and runs directly to the mistress, who was "watching . . . [their] maneuvers" from the piazza.[66] Northup tells her what has transpired to provoke her rage, a plan that works. When Epps reaches the house, "Mistress Epps began to berate him roundly, heaping upon him many rather disrespectful epithets, and demanding for what reason he had attempted to cut my throat."[67] Epps denies having spoken to Northup that day and "the affair was never after alluded to."[68] By skillfully manipulating Patsey's visibility to the master through her visibility to the mistress, Northup protects Patsey from sexual violation and himself from Epps's violence.

Similarly, in his role of slave driver, which he is pressed into on the Epps' plantation, Northup creates the image of slavery desired by his masters to evade real potential violence. On large plantations the role of driver is a position under that of the overseer. While the overseer, usually a white man, follows behind the slaves, "keeping a sharp lookout upon them all," the drivers under them are black and "in addition to the performance of their equal share of work, are compelled to do the whipping of their several gangs," with the goal of neutralizing potential leaders among the enslaved by positioning them against their fellow workers. "Whips

hang around [the drivers'] necks, and if they fail to use them thoroughly, are whipped themselves."[69] On the Epps' plantation, Epps himself is the overseer and Northup is compelled to be the driver. Northup writes, "I had to wear a whip about my neck in the field. If Epps was present, I dared not show any lenity."[70] However, Northup learns to use the constant surveillance he is subject to to the advantage of the enslaved. Epps is satisfied when he "see[s Northup] use the lash freely," so Northup pretends to satisfy Epps:

> "Practice makes perfect," truly; and during my eight years' experience as a driver I learned to handle my whip with marvelous dexterity and precision, throwing the lash within a hair's breadth of the back, the ear, the nose, without, however, touching either of them. If Epps was observed at a distance, or we had reason to apprehend he was sneaking somewhere in the vicinity, I would commence plying the lash vigorously, when, according to arrangement, [the slaves] would squirm and screech as if in agony, although not one of them had in fact been even grazed.[71]

By producing the spectacle of the tortured black body, Northup saved "[his] companions much suffering."[72] During his enslavement, Northup develops a sophisticated understanding of the speculative gaze on the black body; his literal manipulation of that gaze under slavery is reflected in his metaphoric manipulation of the white gaze in his narrative. Just as Northup produces the image of the suffering black body the slaveholder desires and expects to see, Northup produces the gestures of authentication that the white reader expects to see. In so doing, in both slavery and freedom Northup holds onto the subjectivity that exists outside of the speculative white gaze.

Dissolving Shadows

If Northup's narrative must be, on one level, evidence of his case as a free man, it also must be an assertion of his humanity beyond the threshold of the arbitrary law that designates some men human and some men objects. In order to work beyond the visual logic of slavery, which controls or overpowers the logic of authentication and citizenship, Northup manipulates the speculative gaze of slaveholders and white readers; however, he also presents glimpses of himself outside of the fixed image of the slave he is expected to conform to both in slavery and in his presentation of his experience in the slave narrative after the fact.

In the scene of his release from slavery the often contradictory aims of authentication and subjectivity are unified. Northup's rescuers determine that because Epps is likely to contest the documentation of Northup's free status, a local sheriff should pose Northup a series of questions designed to further verify the truth of his identity:

> [I]t . . . suggested itself to Mr. [Henry] Northup [the white lawyer who is a relative of his father's former master], that the testimony of the sheriff, describing my first meeting with the former, might perhaps become material on the trial.
>
> It was accordingly arranged . . . that before I had an opportunity of speaking to Mr. Northup, the sheriff should propound to me certain questions agreed upon, such as the number and names of my children, the name of my wife before marriage, of places I knew at the North, and so forth. If my answers corresponded with the statements given him, the evidence must necessarily be considered conclusive.[73]

Although it is "the testimony of the sheriff" that might become material in a trial, as black people were not allowed to provide testimony in court at this time, it is Northup's own voice which provides conclusive evidence of his true identity. Specifically, it is Northup's relationship to his family—the very bonds that have been denied in slavery—which authenticate his story of kidnapping to the master even over the authority of "the Judge's signature."[74] Interestingly, in order for this scheme to work, Northup must first confirm his slave identity. When the sheriff first approaches him in the field he asks, "Your name is Platt, is it?"[75] Northup replies, "Yes, master."[76] The sheriff continues, "'have you any other name than Platt?' . . . 'Solomon Northup is my name, Master,' I replied."[77] To prove that he has been objectified, he must first acknowledge essentially, "I am the object in question," an ambivalent statement that both confirms and denies the subject at its center. This scene captures not only the truth of Solomon Northup's experience of kidnap, but also the truth of all ex-slave narrators' experience of authentication: it is necessary to take a detour through the denial of one's existence ("I was born a slave") in order to prove the truth and presence of that existence.

In the triumphant moment of his release, the two identities Northup has had to maintain dissolve in an orgiastic experience of recognition in which visions of his past come rushing back to him as he looks upon the familiar face of Henry Northup, an experience that essentially returns him to himself. When the sheriff approaches Northup, he notes that during his time on the Bayou he had "become familiar with the face of every

planter within many miles; but this man was an utter stranger—certainly I had never seen him before."[78] By contrast, when the sheriff points to Henry B. Northup and asks Northup simply, "Do you know that man?," Northup is overwhelmed by recognition, and his mind is immediately filled with images from his life in freedom, which come flooding back to him:

> I looked in the direction indicated, and as my eyes rested on his countenance, a world of images thronged my brain; a multitude of well-known faces—Anne's and the dear children's, and my old dead father's; all the scenes and associations of my childhood and youth; all the friends of other and happier days, appeared and disappeared, flitting and floating like dissolving shadows before the vision of my imagination, until at last the perfect memory of the man recurred to me, and throwing up my hands towards Heaven, I exclaimed in a voice louder than I could utter in a less exciting moment—"*Henry B. Northup*! Thank God—Thank God!"[79]

Notably, it is not the moment in which legal documentation is presented that Northup offers as his triumphant return to freedom; it is this dramatic moment, brimming with visual discourse, in which Northup presents the mutual recognition between Henry Northup and himself as the end of his twelve-year ordeal. In the same way that the likeness of Frank's mother secures the familial connection between Frank and his sister, when Northup looks at Henry B. Northup he does see not Henry himself, but rather his connection to his loved ones and the man he was in his life in freedom. Significantly, the image of the "shadow of the cloud" that has been the controlling metaphor of slavery throughout the narrative is replaced by the "flitting and floating" images of family and friends, which appear "like dissolving shadows." The speculative gaze that objectifies Northup is countered—and overpowered—by the internal "vision of [his] imagination," which sees the fullness of his life and social existence denied for so long in slavery.

The passage is also significant in that, much like Douglass's distinction between the moment of his spiritual freedom and the acquisition of his legal freedom (after his confrontation with Covey Douglass declares, "however long I might remain a slave in form, the day had passed forever when I could be a slave in fact"), despite this watershed moment of recognition, Northup must still jump through authenticating hoops to reach freedom.[80] Cutting short Solomon's tearful reunion with Henry Northup to further question him, the sheriff interjects:

"Stop a moment," said he, "have you any other name than Platt?"

"Solomon Northup is my name, master," I replied.

"Have you a family?" he inquired.

"I had a wife and three children."

"What were your children's names?"

"Elizabeth, Margaret and Alonzo."

"And your wife's name before her marriage?"

"Anne Hampton."

"Who married you?"

"Timothy Eddy, of Fort Edward."[81]

The content provided by this series of questions is subordinated to the vision Northup has just had in the moment of recognition, rendering Northup's experience and internal thought process more important in the narrative than this series of questions designed to legally ensure Solomon Northup's free status. But more importantly, the scene mimics—and subverts—the authenticating structure of the slave narrative form, which requires that black experience be legitimated by white authority. Northup's first chapter, filled with so many details seemingly inconsequential to the drama of the narrative, provides the key to this moment of resolution. When the sheriff asks, for example, who married Solomon and Anne, the attentive reader already knows the answer is Timothy Eddy, of Fort Edward. Bringing together the historical and literary conventions of authentication at the dramatic resolution of the narrative, Northup shows how they are both secondary to the recognition he experiences when he sees Henry B. Northup approach him across the cotton field. In contrast to the vision of the black subject that requires authentication, the look of mutual recognition secures Northup's freedom and returns him to himself. The mutuality of the recognition is signified in Henry Northup's response, his use not only of Solomon's given name, but of an affectionate, familiar nickname. When Solomon finally pushes past the sheriff, "unable longer to restrain" himself, he writes, "I seized my old acquaintance by both hands. I could not speak. I could not refrain from tears. 'Sol,' he said at length, 'I'm glad to see you.'"[82]

5 / Gestures Against Movements: Henry Box Brown and Economies of Narrative Performance

[The black performer's] very words are action words. His interpretation of the English language is in terms of pictures.
—ZORA NEALE HURSTON, "CHARACTERISTICS OF NEGRO EXPRESSION"

Henry Box Brown emerged on the abolitionist stage at the New England Anti-Slavery Convention in Boston at the close of May 1849. Bringing together regional anti-slavery societies throughout the Northeast, the host institution, the Massachusetts Anti-Slavery Society, rented the Melodeon theater for the occasion.[1] While preparations for the convention were taking place in Boston, Henry Brown, an enslaved man working as a skilled laborer in his master's tobacco factory in Richmond, Virginia, was making anti-slavery plans of his own. In the wake of having his wife and children sold away from him, Brown had determined to escape. Enlisting the help of close friend James C. A. Smith, a free black man who owned a cake shop, and Samuel Smith, a local white shoemaker, Brown considered a number of potential modes of escape, dismissing each as too dangerous until he was struck with the inspiration that ultimately lead to success: boxing himself up and getting shipped via Adams Express mail to the Pennsylvania Anti-Slavery Offices in Philadelphia.

Describing that moment in his 1851 narrative, Brown emphasizes the visual dynamics of what he suggests was divine intervention: "I prayed fervently that he who seeth in secret and knew the inmost desires of my heart, would lend me his aid in bursting my fetters asunder and in restoring me to the possession of those rights, of which men had robbed me; when the idea suddenly flashed across my mind of shutting myself *up in a box*, and getting myself conveyed as dry goods to a free state."[2] Marshaling the tension between concealment and revelation, Brown casts his inspiration as a vision while juxtaposing the limitations of human sight with the boundless, all-knowing, "secret" sight of the divine.

Although the reader can only imagine what "flashed across" Brown's mind, images of the box and Brown emerging from it—depicting his "resurrection" from slavery—proliferated after his escape, becoming central to abolitionist iconography of the 1850s.[3] In addition to paradoxically enacting the objectification of slavery in order to secure his freedom, Daphne Brooks argues that Brown's use of the "legendary box"—in his escape as well as in his reproduction of an image of the box at the conclusion of his 1849 narrative—is a sophisticated performance that "symbolically communicated a decision to re-move [sic] himself from the visible world while still moving through it. In doing so, his traveling entrapment offered a signifying metaphor of physical resistance to the antebellum period's rigorous literal and figurative colonization of black bodies."[4] Similarly, in his analysis of Brown's intervention into what he calls the "rhetoric of the runaway," Marcus Wood argues that images of Brown's "resurrection" "gave abolition perhaps the most potent single metaphor it possessed for the displacement of the traditional image of the 'runaway' slave in the popular imagination."[5] Both Brooks and Wood understand the mass reproduction of images of the box as a turning point for antebellum visual culture and illustrative of "tensions between free-white and black-ex-fugitive approaches to the experience of bondage."[6] As a resistant performance, Brown's mobilization of the box as a mode of escape, an iconic metaphor, and ultimately a theatrical prop not only challenged the chattel principle of racial slavery by extending it to its absurd logical conclusion—Brown as "dry goods"—but also the logic of the white-controlled abolitionist movement that fetishized black transparency and understood fugitives primarily as evidence of slavery's wrong rather than strategic partners in a political project.

Although Brooks and Wood discuss the ambivalent uses to which iconography of Brown's escape was put, with Wood arguing that "Brown's escape was propagandistically reconstituted as an enormous mythological embodiment of national liberation," both read Brown's performances and deployment of the visual emblem the box and his triumphant emergence from it in Philadelphia as a response to the narrative containment of his story by Charles Stearns, the white abolitionist amanuensis of his first narrative, published in 1849. Advancing the representation of the box as "the most critical point of reversal in the *Narrative of Henry Box Brown*," Brooks posits the image as "[a] parting, ambivalent riddle of sorts, a symbolic and corporeal refusal . . . [which] signifies on the implicit suggestion inherent in the slave narrative genre that the text will operate as a transparent looking glass, free of artifice and exposing the ordeal of bondage."[7] Rich with opaque, excessive, and revisionary challenges to anti-slavery

rhetoric, Brown's 1850 panorama, the *Mirror of Slavery*, which he commissioned using the proceeds from his narrative, epically extends Brown's iconoclastic critique, constituting, Brooks argues, "a generic 'wildzone' outside of the conventional slave narrative."[8]

Both Brooks's and Wood's analyses capture the entangled nature of Brown's cultural productions, considering "[h]is (auto)biographies, panorama, and public exhibitions . . . as concatenate parts [of] a sprawling, epic text"; nevertheless, they chart the narrative of Brown's increasing independence—and his triumph over narrative constraint—through his mobilization of visual media, arguing that through these modes "Brown effectively transcended the discursive restrictions of the slave narrative and redirected the uses of the transatlantic body toward politically insurgent ends."[9] It is important to note that the discursive constraints on slave narratives are particularly acute in *The Narrative of Henry Box Brown*. Brown was illiterate at least into the early 1850s, and Stearns's overbearing presence in the 1849 narrative is "a casebook study of the erasure of black subjectivity in the fugitive slave narrative genre."[10] As John Ernest puts it, "Readers of Stearns's narrative will learn a great deal about Brown's life, but they will learn a great deal more about Stearns's views on slavery, government, and religion in America."[11] Putting a finer point on it, James Olney laments that "there is precious little of Box Brown (other than the representation of the box itself) that remains in the narrative."[12] Although all acknowledge that the 1851 version of Brown's narrative published in England, *The Narrative of the Life of Henry Box Brown, Written By Himself*, is "more directly Brown's expression than the 1849 *Narrative*," the titular "Written By Himself" is a hallmark of slave narrative form rather than a statement of authorship as it is traditionally understood; Brown biographer Jeffrey Ruggles observes that "Brown did not put the words on paper" and "the writer of the 1851 *Narrative* remains unidentified."[13]

However, if we understand racial negotiation to be the defining feature of the slave narrative and attend to the textual aspects of visual culture to which ex-slave narrators were particularly attuned, Brown's insurgent iconoclasm emerges to disrupt the "discursively claustrophobic tone and form" of even his most constrained 1849 narrative.[14] In addition to his interventions into abolitionist iconography, considering forms of textual visuality in Brown's narratives yields a profound challenge to antebellum understandings of the operation of sight as well as the iconicity of the black body. As Wood suggests, comparing the 1849 and the 1851 editions "provide[s] an opportunity to consider which linguistic and narrative elements Brown felt impelled to redevelop or introduce once he was composing his story away from the persuasive advisory presence of Stearns";

but rather than evaluating Brown's cultural productions in terms of the degree of his authorial control, critically privileging the cultural productions over which Brown has more direct control, I suggest a mode of reading alive to what Valerie Smith calls the "linguistic narrow spaces" negotiated by all ex-slave narrators, but which become the controlling metaphor of Brown's narrative.[15]

Building on Brooks's analysis of Brown's cultural work in particular, I argue in this chapter that we consider black abolitionist performance *in tandem* with what I call narrative performance: the unruly narrative gestures uncontained by the slave narrative form or the expectations of its primarily white readership. Starting from Brooks's suggestion that Brown's use of illustration and panorama allow us to read the slave narrative anew, I claim that ex-slave narrators utilized a *similar* recognition of the iconicity of the black body and visual savvy in their narrative performances as in their oratory and theatrical performances, producing moments that go against the grain and challenge the ideological containment of the slave narrative. Thus, rather than opposed to or in competition with each other, we might think of the collectivity of these forms as "fugitive performance," a multivalent term, which both names an archive and indicates a line of inquiry. Fugitive performance refers to the narrative, oratorical, and theatrical performances of fugitives from slavery; draws attention to the fugitive meanings within those performances, those aspects that contest, complicate, or are in excess of the editorial, theatrical, and political constraints that were the performances' conditions of production; and captures the ephemeral nature of performances that "by definition live in time and perish."[16] The shared rhetorical scene navigated by black abolitionist speakers and narrators enables this line of inquiry. Most slave narratives developed out of well-wrought anti-slavery lectures, and audiences at anti-slavery meetings swelled in response to speakers who had authored popular narratives. Ruggles contends that Brown's oral account is most likely "the ur-text for both [his] *Narratives*."[17] Furthermore, black abolitionist performers were watched and managed by the white-dominated anti-slavery movement in ways that parallel the control white anti-slavery editors and amanuenses exerted over individual ex-slave authors or narrators. Famously, Frederick Douglass writes in *My Bondage and My Freedom* that white abolitionists attempted to stage manage his appearances, encouraging him to "have a little of the plantation manner" in his speech, lest people not believe he was formerly enslaved, with white abolitionist John Collins admonishing, "Give us the facts, . . . we will take care of the philosophy."[18] In their review of the New England Anti-Slavery Meeting the *Christian Enquirer* noted that "[t]he ultra-abolitionists . . . understand

stage effect. This year they produced a 'sensation' by exhibiting fugitive slaves."[19] To conclude their review, they give by way of example, "without comment," the story of Henry Box Brown's escape, which in a matter of weeks had already passed from a story of individual heroism to a set piece of abolitionist theater.[20] As these cases show, fugitive speech and narrative shared certain performative expectations as well as similar functions within the abolitionist movement vis-à-vis claims of truth and authenticity. Contemporary newspaper accounts make clear that black abolitionist performance was often understood as an assertion of the humanity of the formerly enslaved, with the appearance and demeanor of the speaker designed to produce shock and horror in an audience incredulous that such a specimen of humanity as the speaker standing before them had ever been enslaved.[21]

Although Brown's innovative and prodigious speeches and theatrical performances throughout the U.K. successfully "engineer[ed] multiple ruptures in the cultural arm of midcentury transatlantic abolitionism," these performances were subject to an economy of abolitionist patronage as well as the assumptions and expectations of white audiences, which parallel the constraints negotiated by ex-slave narrators.[22] Thus, while what Brown's contemporary viewers termed "the pictorial mode of information" certainly represents distinct possibilities of form, I argue that we should understand his panorama and performances as an extension of the visual work Brown accomplishes in his narratives. The tension between confinement and flight, which Brooks so deftly shows characterizes black abolitionist performance, is resolved by the fugitive performer through the manipulation of visual assumptions of race, but not exclusively through manipulation of visual material—images, illustrations, prints, panorama, or even ekphrasis or the presentation of the black body in speech or performance.[23] Consequently, this chapter directs critical attention to the radical potential of Brown's narrative performances and textual visuality, with the caveat that the distinction between visual media and textual production was exceptionally porous for Brown. Moreover, the inextricability of Brown's visual and textual material has intensified in the twenty-first century, as we have only the textual residue of descriptions of what the *Mirror of Slavery* (and Brown's other panorama produced later in the decade) depicted in ephemeral images and performances.[24] Thus Henry Box Brown's narratives, panorama, and performances offer perhaps the best test case for what I have been arguing: the inextricability of visual and textual material and the ways ex-slave narrators juxtaposed visual and textual discourses of authenticity to reveal them as a racial fetish unequally imposed on black cultural producers. At the vanguard of

visual culture, Brown was the first in the U.S. to appropriate the popular visual technology of the panorama for anti-slavery purposes, but simultaneously wielded perhaps the least degree of control over his narrative in relation to the other narratives under consideration.[25] The visual work accomplished by Brown's narratives, then, reveals the problem with the schema Robert Stepto lays out in his seminal essay "I Rose and Found My Voice"—that the more control the narrator has, the more sophisticated (and worthy of literary attention) the narrative is.[26]

Taking seriously the multiple significations of the terms "movement"—as a political project; a physical action; a demographic shift—and "gesture" —a bodily sign; an indication; an action intended for effect—this chapter evaluates how the fugitive slave's gestures—both physical and rhetorical—respond to and challenge the ideological presumptions of the anti-slavery movement of which they are a part. Placing analyses of reviews of Brown's speaking engagements and panorama performances alongside those of his narrative performances, I show how he critiques not just the devastation wrought by slavery, but also the damaging effects of white abolitionists' ideological limitations. Specifically, Brown challenges white abolitionists' insistence that "seeing is believing," an evidentiary epistemology that had harmful parallels with the racialist gaze and surveillance economy of racial slavery.[27] Proffering a countervisuality that contests the very terms of the visible, Brown stymies the authority and objectification constituted by both the racialization of the plantation complex and the evidentiary epistemology of abolition.[28]

"Living Epistles"

Reading the narratives of Box Brown alongside contemporary newspaper accounts of his engagements indicates the varying degrees of constraint Brown negotiated as a writer, speaker, and performer while demonstrating the consistent ideological limitations he encountered from white audiences across media. Just two months after effecting his escape, Brown attended the Anti-Slavery Convention in Boston, appearing on stage each night of the three-day meeting. Although Brown's dramatic escape had captivated the small group of Northern abolitionists that had been directly involved in his escape—or who were close with those who had—the story had been kept relatively guarded to protect Brown from recapture and to keep that route of escape open for others still enslaved. However, by the time of the Boston meeting, Brown's co-conspirators Samuel Smith and James Smith had already attempted the scheme again, endeavoring to ship two more enslaved men from Virginia to Philadelphia

in the weeks after Brown's successful escape.[29] Detected by Southern authorities, the plan was thwarted and both Smiths arrested. Consequently, by May 29, 1849, that route of escape was effectively closed and abolitionists at the convention felt free to tell Brown's story, situating him—and his daring escape—as living proof against the pro-slavery claim that enslaved people were content in slavery.[30]

It was here that Henry Brown became Henry Box Brown and "took his first step toward becoming a public figure."[31] The first night of the convention, fellow fugitive William Wells Brown introduced Brown to the crowd. As Ruggles tells it, quoting from coverage in the *National Anti-Slavery Standard*, he "'jocularly termed' Henry Brown 'Boxer,' ... [and b]y the convention's end, William Wells Brown's concept had been resolved into Henry 'Box' Brown. As the official report of the convention put it, 'the middle name of Box, in honor of his method of escape, has been accorded by general assent.' It was a name that Brown accepted and kept."[32] Linguistically associating him forever with the visual icon of his escape, Brown's appropriation of the name inaugurates his sophisticated textual intervention into abolitionist visual culture in ways that continue to influence our understanding of the movement and its theory of visuality.

In his opening remarks at the convention, white abolitionist Samuel May first invoked Brown's story without using his name, telling the audience about "a brother man" who was "coffined and almost stifled in a scanty box."[33] With dripping sarcasm aimed at pro-slavery logic, May declared, "Thus bore he *his* witness to the *contentment* of the slave in his bondage, and his *reluctance* to leave it, even should a *good* chance of doing so offer!"[34] Though he positions Brown as a witness, May invites the audience to understand Brown's escape as damning evidence against slavery, insinuating that the act speaks for itself. Thus, when Brown is invited to the stage to tell his own story on the second night of the convention, his success as a speaker is nevertheless framed by white abolitionists in objectifying terms and ultimately appropriated as the property of the abolitionist movement. On the third and final night of the convention, for example, before again relating the particulars of Brown's escape and his own role as witness in the wake of Brown's "resurrection," Samuel May reflected on Brown's speech the previous night and on the role of fugitive speakers within the abolitionist movement more broadly: "Those who have attended the previous meetings of this Convention, have heard living epistles from the South that must have spoken to your hearts as no written words could have done."[35] May prioritizes speech over writing for its ability to move the audience, but nevertheless represents the black speaker in terms of a written form, referring to fugitives from slavery as

"living epistles," in a rhetorical act of containment. All too literally anticipating John Sekora's critique of the slave narrative as a "black message in a white envelope," May's metaphor unwittingly expresses the vexed relationship of the fugitive speaker in relation to the anti-slavery movement.[36] Bound by the ideological imperatives of the white-dominated anti-slavery movement and discouraged from making his or her own distinct claims, the fugitive speaker, like the ex-slave narrator, was often presented *as* evidence, rather than recognized as an activist, theoretician, moral guide, or political strategist in his or her own right. Performances in excess of this mandate produced discomfort within white anti-slavery ranks. May's metaphor consolidates the tension between the desire for expressivity and containment that was the stance of the movement toward both black speakers and authors.

But May goes further than simply advancing an objectifying metaphor; he appropriates Brown's story of escape as the community property of abolitionists: first positioning himself in proximity to the "resurrection," noting that he measured the box himself; then presenting Brown's story as the main content and culmination of his own speech, concluding the way Brown marked the end of his journey to freedom, quoting the song Brown sang upon his release from the box; and, most strikingly, expressing a conflicted desire to embody the fugitive's position himself.[37] After recalling Brown's feat for the audience, May addresses the hall in a conspiratorial tone, confiding, "Sir, I confess when I see such nobleness in a man of another hue than my own, I almost wish I could change my complexion for his."[38] Demarcating between white and black abolitionists, May expresses a desire to *be* the black speaker, rather than just a witness to his experience. His "confession" demonstrates an abiding interest in racial difference, reifying it even as he expresses a desire to transgress its putative boundary. It is an utterance symptomatic of the self-interested character of Garrisonian abolition, which understood anti-slavery as a project of "conver[ting] individual hearts and minds against slavery . . . , over the practical result of abolition."[39] In the same vein, then, as Wendell Phillips's pronouncement, "If we never free a slave, we have at least freed ourselves in the effort to emancipate our brother man," which in its opposition of "we" and "slave" advances a grammatical logic that cannot recognize enslaved people *as* abolitionists, May's disclosure reveals that abolition—which claims in the main to be primarily about securing enslaved people's freedom and welfare—is actually about achieving nobility oneself.[40] May's desire to appropriate Brown's nobility by "putting on" his skin tone at least momentarily supersedes his interest in the fugitive's experience or welfare.

In his zeal to convey to the audience how much he admires Brown, May exposes the curious visual logic of abolition, which imagines that to *look* like Brown is to *be* like Brown. Rather than expressing a desire to risk his life or undertake the actions that comprise Brown's nobility, May concentrates on Brown's external appearance. The first clause of his declaration uses "see" as a synonym for "recognize," a not necessarily visual apprehension of an inner quality—nobility; but he collapses apprehension with visual perception as he simultaneously "sees" that Brown's skin is "of another hue." Brown's nobility and his skin tone are fused for May, such that skin tone becomes a visual sign of nobility. By this reasoning, exchanging his own skin tone for that of Brown would confer nobility on him. Although May attempts, here, to re-signify the association of black skin with enslavement, degradation, and inferiority, he relies on the presumption that external traits signify internal qualities, or that nobility can be "seen." Furthermore, his failure to invest fully in his own project of re-signification is disclosed by the "almost," which negates his desire even as he names it. While May allows himself to momentarily fantasize about appropriating these speakers' nobility, he stops short of wanting to trade places with them, likely because he knows the negative associations that cling to the perception of black skin are not so easily dismissed. In fact, his view of blackness as nobility is belied by his assertion that to see this, one must look past Brown's inferiority, which he presents as indisputable. Addressing what he believes the crowd must see when they look at Brown, May asks rhetorically, "Is there a heart here, that can doubt that there must be in him not merely the heart and soul of a deteriorated man—a degraded, inferior man—but the heart and soul of a noble man?"[41] For May, Brown's inferiority and degradation are a priori, but he implores the audience to see past those "mere" qualities to the transcendent qualities of Brown's "heart and soul," which he then paradoxically suggests inheres in his complexion. May's speech unwittingly reveals the problem with an abolitionist theory of visuality that believes seeing and knowing (and being) are coterminus: that one can simultaneously understand black skin as a sign of nobility and inferiority demonstrates that visual signs are neither stable nor self-evident. Put differently, the problem is not that black skin is understood as inferiority rather than nobility, as May would have it, but the belief, rather, that black skin signifies anything at all. May's preoccupation with Brown's skin tone prevents him from seeing clearly.

The conflation of seeing and knowing promoted by May informs the abolitionist emphasis on the emotional impact of stage performance and the role of witnessing within the movement. Ironically, the eyewitness status of those in the audience is prioritized above the actual experience

of those who have been enslaved; fugitive speakers bring an essential authenticity and immediacy to the abolitionist movement, but they are positioned as in service to the movement rather than the other way around. Contemporary accounts of fugitive speakers in the abolitionist press stress the emotional immediacy and rhetorical power of black speech and black speakers over and above the possibilities of writing, but the treatment of fugitive speakers as themselves evidence works to contain their rhetorical power within the confines of abolitionist ideology. After reproducing transcriptions of the speeches given at Faneuil Hall the closing night of the Boston convention, for example, the *Liberator* writes that there is no substitute for the benefits of presence and immediacy experienced by those in attendance: "To those who were eye-witnesses and hearers, [this report will] seem to be but a faint representation of what transpired. . . . No pen can trace, no pencil portray, the electric glow and stirring enthusiasm of the occasion."[42] The *Liberator*'s reviews of Douglass's speech at the convention exemplify this dynamic. While marveling at his effectiveness as a public speaker, the authors follow references to his power and rhetorical control with expressions of disbelief that such a powerful speaker could ever have been treated as property, thereby translating what could be perceived as Douglass's threatening degree of control over a white audience into merely a specimen of what white abolitionists already believe: the immorality of the chattel principle. The review reprinted from the *Boston Republican* notes that "[m]any were there with the intention of interrupting [him], but with great tact and address, he held the meeting under the most perfect control. . . . It is, indeed, difficult to realize the fact that he was ever held as a piece of property."[43] Similarly, the review reprinted from the *Christian Enquirer* observes that he "appeared as the natural and most accomplished orator, holding in his power, and moving at his will, an audience many of whom were far from friendly; and proving that he, at least, stood up an entire confutation of the asserted natural inferiority of his race."[44] In both reviews, Douglass's dynamism is retrenched into a static "confutation" and his power is undercut by the specter of his objectification.

Reviews of Henry Box Brown's appearances most often remark on their "thrilling" nature, such as the *National Anti-Slavery Standard*, which reported that the "artless manner" in which he told his story at the convention had "exalted a thrill of sympathy and admiration in every one who listened"; but as with the previous examples regarding Douglass, reviewers often grounded the language of "thrill" with the language of "evidence." The *Boston Emancipator & Republican* reported that "[o]ne of the most thrilling events of the week was the appearance of the heroic man. Shame

on Virginia. She proudly claims to be the mother of statesmen and heroes, but no son of hers ever gave greater evidence of heroism than this poor despised son of hers."[45] The *Boston Chronotype* concluded, "What heroism, what self-denial, what energy of purpose are here manifested."[46]

Paradoxically, it is the more performative or theatrical elements of black speech and fugitive performance that produce the "thrill" the movement both craves and finds excessive and unsettling. A reviewer writing under the name "Practical Christian" in *The North Star* criticized Brown for exploiting the drama of performance during his presentation at an anti-slavery meeting at a Milford Methodist Church, writing that "[w]hen the incidents of a life in, and an escape from slavery are crowded into an hour's time, there must be some rather sudden passages from the pathetic to the ludicrous. There are several such passages in his narrative, and the audience answered accordingly; and at the close of his song the singer was greeted with a hearty round of clapping. These demonstrations on the part of the audience were a little annoying to some of the Methodist friends. There had been a funeral at the Church during the day, which of course rendered their minds more liable to be grieved by such matters than they would otherwise have been."[47] While "Practical Christian" praises Brown's story as "certainly a swift witness against what passes for Christianity in the land," he or she nevertheless identifies the theatrical aspects of Brown's performance to be offensive to the sober Methodist friends who find them unseemly: the narrative compression of his experience into an hour-long performance; the conclusion of the performance with song and applause; and the immediacy of the relationship between Brown and his audience, displayed by their collective applause.

White abolitionist transatlantic correspondence also exposes letter writers' discomfort with the popularity and theatricality of black abolitionist performance, positing it as a potential threat to white control of the movement's mission and goals. As Ruggles writes, "no matter how pure their antislavery credentials, [the Americans traveling on the British anti-slavery lecture circuit] risked alienating their friends if their behavior did not meet the reformers' standards."[48] Returning to Samuel May, in a letter of introduction he wrote to a friend in England on behalf of William Wells Brown, he expresses uneasiness with Brown's independence, ironically identifying Brown's abilities as a performer, in particular, as a threat to the anti-slavery cause: "He is a very good fellow, of very fair abilities, and has been quite true to the cause. But he likes to make popular and taking speeches, and keeps a careful eye on his own benefit. The Anti-slavery cause has been everything to him, in point of elevating and

educating him; and giving him a respectable position, etc. He owes much to it and ought to be true to it."[49] May's assertion that Wells Brown's success as an anti-slavery lecturer is evidence of his potential betrayal of the principles of the movement is counterintuitive, revealing the patronizing relationship leaders such as May had toward black speakers and performers. May's suggestion that Wells Brown's "keeping a careful eye on his own benefit" is in some way a betrayal of the anti-slavery cause begs the question of whom the anti-slavery cause is meant to benefit, if not former slaves such as himself. It also sheds light on the economic tensions between black speakers and white sponsors. May is most uncomfortable with the success of Wells Brown's speeches, both financial and in terms of influence, and understands them as a threat to the anti-slavery movement he claims possession over. His words curdle with the condescending implication that the anti-slavery cause has made Wells Brown what he is, rather than recognizing his contributions to or his work on behalf of the movement. The racial implications of this dynamic are yet more evident in a letter one of Wells Brown's British hosts wrote to an American correspondent in May, 1851. Decrying the tone of Wells Brown and the Crafts' marketing materials, Dr. John Bishop Estlin wrote that "we have been endeavouring to improve the tone of Brown and Crafts Exhibition altering their too *showman like* handbills"; elaborating in another letter, "they had kind, but not judicious, (& some vulgar) advisors in the North of England. . . . Some of their hand-bills have been headed 'Arrival of 3 Fugitive Slaves from America'!!! as if 3 monkeys had been imported, and their public appearance has been too often of the *exhibitive* kind."[50]

As scholars including Ruggles, Brooks, and Wood have argued, Box Brown's commission and presentation of the *Mirror of Slavery,* beginning in 1850—and his subsequent performances with it—capitalized on the more theatrical style he was already known for and were calibrated to establish financial, artistic, and political independence from white abolitionist sponsors and movement leaders. Catering to popular tastes and celebrating exactly the more "exhibitive" style that abolitionists such as Estlin denounced, Ruggles writes, "By its nature Brown's panorama always had more of the popular show about it than the usual forms of antislavery advocacy, and Brown's publicity now played like the brassiest of entertainments. His advertisement in the *Wolverhampton and Staffordshire Herald* promised an 'Unrivalled Treat!'" He goes on to note that while "Brown probably continued to lecture under religious or reform auspices when the opportunity arose[,] . . . [b]y not depending on such sponsors . . . he

remained unencumbered."[51] Brooks contextualizes Brown's construction of the panorama in the wider racial schisms of the abolitionist movement in the 1840s. She writes that at the time Brown was developing his panorama in 1849, black abolitionist culture had begun to develop a distinct political and aesthetic trajectory from white dominated antislavery societies: "Internal schisms within the transatlantic abolitionist movement made the concept of mounting an antislavery panorama especially appealing to African American antislavery activists. While Anglo abolitionists had weathered a number of conflicting ideals and 'crippling division(s)' resulting in the lack of any 'unified abolitionist movement' after 1840, black antislavery activists harbored their own discontent with white reform power structures throughout the decade and chafed at being forced to operate on the peripheries of the antislavery movement in relation to their white colleagues."[52]

Yet despite this political break and Brown's greater autonomy, contemporary reviews show that he was still contending with primarily white audiences who maintained surprisingly static demands on black cultural production, particularly with regard to what I am calling evidentiary epistemology. As with fugitive speeches, Brown's audiences understood the production of visual material—Ruggles usefully distinguishes between the *painted panorama* and the *performed panorama*—as more immediate, more impactful than the printed word, and considered the role of these cultural productions to be to make them witnesses to slavery through a representational appeal to the real, replicating May's sense of seeing as knowing.[53] For example, viscerally describing Brown's panorama as "painfully interesting," the reviewer for the *Bolton Chronicle* writes that the *Mirror of Slavery* "'conveyed through the eyes to the senses' such 'ideas of horror and suffering' as 'it would be impossible to receive from the perusal of a printed history.'"[54] Similarly, the *Leeds Mercury* touts the pedagogical value of panorama, writing, "the young especially should not neglect the opportunity, as they may derive more information from the impressive scenery than they can do from the perusal of many works written on the subject."[55] However, Brown himself rejected the sharp division between written and visual material, not only in that the production of his narratives and the panorama are intimately connected (Brown uses the proceeds from his 1849 narrative to commission his panorama, and uses his appearances with the panorama to support the revision and reissue of his 1851 narrative), but also in that he uses his narratives to question the visual assumptions of his audiences, whose insistence on "seeing as believing" had dangerous parallels with slaveholders' colonization of the visible as an exercise of dominance.

"The Mark of Bondage"

While it might at first seem paradoxical, although Brown had a greater degree of control over the 1851 version of his narrative, the text is more recognizable as a slave narrative, adopting or bringing to the fore many of the conventional and formulaic aspects of the genre. Simultaneously, the countervisuality of the narrative is sharpened and magnified in the 1851 edition. Comparison of the two versions reveals an intensification of visual language alongside the canonical hallmarks of slave narrative form. In addition to the inclusion of the titular tag "Written By Himself," for example, the 1851 Narrative trims the multi-paragraph preamble of the 1849 version (written in Brown's voice but showcasing Stearns's overwriting) to the simple, canonical first sentence beginning "I was born. . . ." Before getting to the corollary sentence in the earlier narrative—"I first drew the breath of life in Louisa County, Va. . . ."—the 1849 edition opens with what Brooks calls a "representational lack," a declaration of what the reader will not see, an assertion that this will not be a narrative "written in letters of blood": "I am not about to harrow the feelings of my readers by a terrific representation of the untold horrors of that fearful system of oppression, which for thirty-three long years entwined its snaky folds about my soul."[56] By contrast, the 1851 Narrative situates the text more squarely in the plainspoken mode characteristic of the slave narrative genre and uses the first paragraph to introduce a visual conundrum that does not appear in the earlier narrative. Brown observes, "I was born about forty-five miles from the city of Richmond, in Louisa County, in the year 1815. I entered the world a slave—in the midst of a country whose most honoured writings declare that all men have a right to liberty—but had imprinted upon my body no mark which could be made to signify that my destiny was to be that of a bondman."[57] Rejecting the logic of racial slavery that blackness serves as a visual mark of slavery, Brown nevertheless goes on to say that he is virtually marked—branded—by the violent negation of his rights by slaveholders: "[T]yrants—remorseless, destitute of religion and every principle of humanity—stood by the couch of my mother and as I entered into the world, before I had done anything to forfeit my right to liberty, and while my soul was yet undefiled by the commission of actual sin, stretched forth their bloody arms and branded me with the mark of bondage, and by such means I became their own property."[58] Presenting himself as simultaneously marked and unmarked, Brown rejects the proposition of racial slavery—that blackness is a visible marker of enslavement—offering in its place a metaphor, which makes visible the violence of the chattel principle that remains literally unseen.

In presenting "the mark of slavery" as metaphorical, Brown suggests that the visible markers of racial identity are themselves metaphors that have been dangerously literalized. In fact, the 1851 *Narrative* ends with a reflection on the myriad ways the *invisible* mark of slavery is made manifest through the violence of slavery, reprinting miscellaneous slaveholding laws that translate enslaved people's resistance to oppression into corporal punishment written on the body through whip scars or brands.[59] The last words of the 1851 *Narrative*—before "HENRY BOX BROWN. FINIS."—cite a law stipulating that "for riding or going abroad at night, without a written permission, a slave may be cropped or branded in the cheek, with the letter E."[60] On one level this rhetorical maneuver advances the ideological work of all slave narratives, shifting the stigma of slavery from the enslaved to the enslaver. Brown holds that there is a "mark of slavery," but it emanates from the "bloody arms" of the enslavers rather than the unmarked body of the enslaved. But on another, Brown presents a radical challenge to the visual paradigms of both slaveholders and abolitionists: slaveholders who put their faith in their ability to *see* the distinction between slave and free (belied by their need to further mark those who they deem a flight risk by branding their faces with an "E," presumably a reference to "escape"), and abolitionists who require visual evidence of maltreatment to *see* injustice. In the Preface to the 1851 *Narrative*, written in his own voice, Brown uses a tone of mock self-deprecation to challenge those readers who may have picked up his narrative expecting—hoping—to see a gory tale of brutality and suffering: "The tale of my own sufferings is not one of great interest to those who delight to read of hair-breadth adventures, of tragical occurrences, and scenes of blood: —my life, even in slavery, has been in many respects comparatively comfortable. . . . [B]ut though my body has escaped the lash of the whip, my mind has groaned under tortures which I believe will never be related, because language is inadequate to express them."[61] By framing the narrative with a meditation on the visibility (and invisibility) of slavery's violence, Brown links slaveholders' writing on the bodies of the enslaved to slave narratives' routine presentation of damaged black flesh and abolitionists' more general need for visual evidence of slavery's wrong. For Brown, violence may make the travesty of racial slavery visible, but there is violence in visibility itself.

As these passages show, language, and particularly writing, can be a form of violent visibility. Slaveholders' metaphorical and physical branding exists in contrast to what he deems the tortures of the mind that "will never be related, because language is too inadequate to express them."[62] This formulation forecasts the visual conundrum of the opening in which

Brown presents his body as entering the world in the midst of writing, yet antithetical to writing: "I . . . had *imprinted* upon my body no *mark* which could be made to *signify* that my destiny was to be that of a bondman."[63] The presentation of his body as unmarked, unwritten upon, is in contrast to the way he is perceived by slaveholders and abolitionists alike—as marked. The juxtaposition of his unmarked body with the "most honored writings" of American democracy, supposed to set forth universal freedom and equality but from which he is excluded, not only reveals American hypocrisy, but also that the "writing" of racial designation—the "mark of slavery"—supersedes the writing supposed to be the law of the land. In the Appendix to the 1851 *Narrative* Brown writes that "in the slave-holding states of America, there is a strong current of public opinion which the law is altogether incompetent to control. In many cases there are ideas of criminality, which are not by statute law attached to the commission of certain acts, but which are frequently found to exist under the title of 'Lynch law' either augmenting the punishment which the law requires, or awarding punishment to what the law does not recognize as crime."[64] In the vacuum created by the failure of the country's foundational documents to include him, his body becomes the document, written on by the slaveholding law that the child follows the condition of the mother, as well as "Lynch law," both of which alchemically transform an arbitrary designation into a racial status, a status that is perceived as visible evidence of enslavement, discernable by phenotypical markers.

While he suggests that physical violence is representable—and that representation itself does violence to experience—the familial bonds of the enslaved go unseen by slaveholders and the "internal pangs" of family separation are so traumatic that they cannot be comprehended through language.[65] Addressing abolitionists directly, he reminds the reader that the evidence of physical violence may heal, but the pain of family separation—which leaves no physical trace—only grows sharper with time: "This kind of torture is a thousand fold more cruel and barbarous than the use of the lash which lacerates the back; the gashes which the whip, or the cow skin makes may heal, and the place which was marked, in a little while, may cease to exhibit the signs of what it had endured, but the pangs which lacerate the soul in consequence of the forcible disruption of parent and the dearest family ties, only grow deeper and more piercing, as memory fetches from a greater distance the horrid acts by which they have been produced."[66] Even if visible markers such as scars and brands could represent the full devastation of slavery's operation (which they cannot), they are unstable evidence that can fade or heal. By focusing on

enslaved people's memory, Brown cordons off an aspect of his experience that is completely internal and cannot be reproduced as evidence for his audience. Memory cannot be corroborated and there is no visual residue of its operations. White abolitionists' emphasis on bodily injury is a symptom of their failure to credit the testimony of black people without visible signs indexing abuse. Whereas a physical scar marks violence to the body, we have only Brown's word to attest to the countless "internal pangs" or "lacerations of the soul" he has experienced.

The visual conundrum of the narrative's opening answers the authenticating testimonial letters, printed as preface to the 1851 narrative, which insist on the evidentiary value of Brown's narrative and panorama. After a short introduction indicting the hypocrisy of American democracy (simultaneously championing British superiority), English minister Thomas Gardner Lee reproduces a variety of letters endorsing Brown and verifying the authenticity of his story that demonstrate the intimate relationship between witnessing and authentication. If the primary role of the ex-slave narrator or fugitive speaker is to produce visual evidence of slavery's wrong, the primary role for the white abolitionist is to be a witness to it, with many of the testimonial letters urging the public to "go and witness this great mirror of slavery for themselves," contending that "[t]o appreciate fully the boldness and risk of the achievement [of Brown's escape], you ought to see the box and hear all the circumstances."[67] In his letter James Miller McKim, the member of the Philadelphia Anti-Slavery society that received Brown as freight in 1849, discusses the narrative as evidence which speaks for itself, noting "[f]acts of this kind illustrate, without comment, the cruelty of the slave system, the fitness of its victims for freedom, and, at the same time, the guilt of the nation that tolerates its existence."[68] Rehearsing the outlines of Brown's escape, McKim writes that it "is a tale scarcely to be believed on the most irresistible testimony," confessing, "if I had not myself been present at the opening of the box on its arrival, and had not witnessed with my own eyes, your resurrection from your living tomb, I should have been strongly disposed to question the truth of the story. As it was, however, seeing was believing, and believing was with me, at least, to be impressed with the diabolical character of American Slavery, and the obligation that rests upon every one to labour for its overthrow."[69] Framing his response to Brown's story—skepticism—as the proper response, McKim, with the notion that "seeing [is] believing," invites the readers to do the next best thing to seeing the escape with their own eyes: to be witnesses to it through his narrative. While he leaves it to the reader about whether believing Brown's story is necessarily to be anti-slavery—acknowledging that it was "with me, at least"—seeing itself

is presented as an operation offering uncomplicated access to singular truth and authenticity.

Other letter writers discuss Brown's panorama in similar terms but prioritize the verisimilitude of images over narrative. Jettisoning the aesthetic, ideological, or narrative work accomplished by the *Mirror of Slavery*, its principal value is attributed to its seemingly unmediated realism, therefore its ability to make viewers more immediate witnesses to slavery. Justin Spaulding's letter provides a representative example.[70] He writes "I have had the pleasure of seeing [the *Mirror of Slavery*], and am prepared to say, from what I have myself seen, and known in times past, of slavery and of the slave trade, in my opinion, it is almost, if not quite, a perfect *fac simile* of the workings of that horrible and fiendish system. The real *life-like* scenes presented in this PANORAMA, are admirably calculated to make an unfading impression upon the heart and memory, such as no lectures, books, or colloquial correspondence can produce."[71] To see the panorama, he suggests, is to witness slavery. Both McKim and Spaulding attest that they have seen the original events with their own eyes (Brown's emergence from the box and the "workings" of slavery, respectively), and their firsthand testimony makes possible the readers' witnessing once removed, via the narrative and panorama. Unlike Brown, their role as witnesses do not require authentication; we are to take them at their word that they have seen these things firsthand. By contrast, as an ex-slave and black man, Brown cannot *be* a witness to slavery; he is always the *object* of slavery, requiring the adjunct of white authorities to affirm the authenticity of his account. The fact that Lee includes Spaulding's letter, which prioritizes visual representation over written, as preface to the written narrative, demonstrates that the goal of the letters is not to market the narrative in particular, but to authenticate Brown. Therein lies the conceit of the abolitionist movement: because of their racial status, the "mark of slavery," formerly enslaved people provide the facts from which others will produce meaning, a premise that devalues former slaves as subjects, reducing them to evidence to be interpreted by others, rather than interpreters of their own experience. In fact, the reasoning goes, if the representation is a "mirror" of truth, then the particular medium hardly matters. Brown essentially enjoys the same status as the box—material evidence; thus when the testimonial letters insist that "to appreciate fully the boldness and risk of the achievement, you ought to see the box and hear all the circumstances," the box and Brown are treated in similar ways, each with their dimensions faithfully reproduced: "the box is in the clear three feet one inch long, two feet six inches deep, and two feet wide. . . . The man weighs 200 pounds, and is about five feet eight inches in height;

and is, as you will see, a noble looking fellow."[72] Brown's job—whether narratively or through visual media—is to make his experience visible so that readers and viewers can be witnesses to it.

While Brown explicitly submits to the authenticating requirements of the slave narrative, he implicitly critiques white abolitionists' notion of "seeing as believing" set forth in the testimonial letters through a series of narrative performances in the first chapter. Under the guise of impressing the reader with the depth of neglect of the religious education of the enslaved, Brown tells two stories about his childhood, which challenge abolitionists' operative visual theory. Invoking the language of testimony and evidence, which frame his narrative as a whole, Brown presents the first story as "a specimen of the religious knowledge of the slave," but offers, instead, a parable illustrating the dangers of taking visual evidence at face value:

> I may here state what were my impressions in regard to my master. . . . I really believed my old master was Almighty God, and that the young master was Jesus Christ! The reason of this error seems to have been that we were taught to believe thunder to be the voice of God, and when it was about to thunder my old master would approach us, if we were in the yard, and say, all you children run into the house now, for it is going to thunder; and after the thunder storm was over he would approach us smilingly and say, 'what a fine shower we have had,' and bidding us look at the flowers would observe how prettily they appeared; we children seeing this so frequently, could not avoid the idea that it was he that thundered and made the rain to fall, in order to make his flowers look beautiful, and I was nearly eight years of age before I got rid of this childish superstition.[73]

Cannily using the naïveté of enslaved children to surreptitiously confront the visual assumptions of white abolitionists, Brown portrays the notion of "seeing as believing" as "childish superstition." Showing how easily visual evidence can be distorted or misinterpreted, Brown's aim is not to refute all visual evidence, but, rather, to show how it comes to mean in a particular context, as a function of power.

Furthering his critique, Brown follows this story of his own religious misapprehension with the story of one of his sisters attempting to access the divine by manipulating visual signs herself: "anxious to have her soul converted . . . [she] had the hair cut from her head, because it is a notion which prevails amongst the slaves, that unless the hair be cut the soul cannot be converted."[74] Recalling Samuel May's desire to "change his complexion" to assume Brown's nobility, Brown's sister believes that internal

transformation follows from external appearance. Although the origin of this belief could very well be that cutting one's hair is a symbolic gesture renouncing a superficial investment in appearance and worldly concerns, his sister and the other slaves have overturned the causality and thereby negated the symbolism, instead investing in a literal, one-to-one relationship between appearance and truth.

In both cases, Brown's mother intervenes, instructing Brown "more fully in reference to the God in Heaven" and correcting his sister's belief that outward appearance is indicative of one's internal state: "My mother reproved her for this and told her that she must pray to God who dwelled in heaven, and who only could convert her soul; and said if she wished to renounce the sins of the world she should recollect that it was not by outside show, such as the cutting of the hair, that God measured the worthi- or unworthiness of his servants."[75] His mother's rejection of "outside show" as a sign of worthiness resonates with his own exhortation to the reader that the worst aspects of slavery leave no visual trace. Moreover, by including his mother's correction, Brown prohibits the reader from treating these stories as evidence of the inherent ignorance of the enslaved while keeping them available as parables instructing the reader to develop a different relationship toward the visible world.

Offering the experience of the enslaved as an epistemological intervention rather than static case facts, these passages discursively interrupt the transparency of the experience of the enslaved to the readers, operating as a textual analogue to the ways Brooks has read the opacity of the box at the end of the 1849 narrative. If the image of the box offers a "staged resistance to the gaze and presumed spectatorial authority of his readership," Brown's first parable reveals the fallacy of that spectatorial authority by likening it to the slaveholders' fraudulent authority, secured through the manipulation of visual evidence.[76] Brown asserts that the master "knew very well what superstitious notions we formed of him," yet he strategically directs the gaze of the children to foster their erroneous belief, using his legal authority to cultivate the more profound divine authority secured by controlling his slaves' worldview.[77] As Nicholas Mirzoeff writes, "visualized techniques were central to the operations of the Atlantic world formed by plantation slavery and its ordering of reality."[78] Citing Phillip Curtin, he argues that "'[t]he [slave] owner not only controlled his work force during working hours, he also had, at least de facto, some form of legal jurisdiction. His agents acted informally as policemen. They punished most minor criminals and settled most disputes without reference to higher authority.' Sovereign authority was thus delegated to the plantation, where it was managed in a system of visualized

surveillance."[79] Brown's parable demonstrates the sovereignty, indeed the virtual divinity of the slaveholder in his domain, but rather than focusing on the overtly authoritarian or disciplinary actions of his master, Brown instead focuses on his kindness in order to expose the unseen brutality of a system wherein the master's power extends not only to his control over the actions and labor of the enslaved through unchecked physical violence, but also to the right to dictate the very "ordering of reality" on the plantation: "Our master was uncommonly kind, (for even a slaveholder may be kind) and as he moved about in his dignity he seemed like a god to us"; Brown laments, "I had no means of acquiring proper conception of religion in a state of slavery."[80] Brown's narrative reveals the intimate relationship between surveillance and visibility that reiteratively constitute the master's authority. As Mirzoeff puts it, "If visuality had been the supplement to authority on the plantation, authority was now that light. Light is divine. Authority is thus visibly able to set things in motion and that is then felt to be right: it is aesthetic."[81] Through these parables Brown not only demonstrates the extent of the master's control, which has gone unrecognized by an abolitionist movement primarily interested in that which can be corroborated by visible evidence, but he also establishes an analogy between slavemasters and white abolitionists whose authority, whether seemingly benevolent or not, operates by dictating the terms of the visible.

Governed by both a logic of presentation and a discursive context, visual evidence never "speaks for itself." The naïveté of the children thus represents an interpretation that fits the pattern of facts presented but follows a corrupt logic derived from the surveillance economy of the plantation, a closed system where power is necessarily self-referential. Although the enslaved children misattribute the source of the thunder and rain, believing that the master is in control of the natural phenomenon on the plantation, they correctly identify his self-interested motivation— believing he caused the storm "to make his flowers look beautiful"—as well as his atmospheric power over their lives. Although he is not "the God of heaven" Brown later learns of from his mother, the master assumes control over the plantation environment by manipulating appearances for his own proprietary benefit. Again, an early lesson Brown receives from his mother provides an essential counterpoint to the false logic of slavery. Speaking of slaveholding power in metaphorical terms, she suggests that it operates as a naturalized element of the plantation environment, but she is careful to distinguish between the way slaveholders' power operates *like* the natural environment, but is *not* the natural environment: "She would take me upon her knee and, pointing to the forest trees which were then

being stripped of their foliage by the winds of autumn, would say to me, my son, as yonder leaves are stripped from off the trees of the forest, so are the children of the slaves swept away from them by the hands of cruel tyrants."[82] Portraying the seemingly inexorable power of slaveholders like the wind—invisible though its effects are not—Brown's mother maintains the analogical distance between the master and the wind, a distance missing from the children's interpretation, which collapses the slaveholders' power with the natural environment. The distinction between his and his mother's treatment of the visible provides the key to Brown's narrative performance: rather than taking the stories as evidence of the enslaved children's ignorance, they provide a metacommentary on the limitations of white abolitionists' theory of sight.

"Representational Unruliness" and Narrative Performance

In many ways, Henry Box Brown's originality and success as a performer are central to understanding his intervention into abolitionist culture. Likening Brown's cultural work to that of twentieth-century visual artists Marcel DuChamp and Joseph Beuys, Wood suggests that we might best understand "the didactic potential" of Brown's productions by the rubrics of "installation and performance art," while Brooks's chapter on Brown provides the most comprehensive reading of "Brown's use of performative strategies to transcend the corporeal as well as the discursive restrictions laid upon him as a fugitive slave."[83] In accordance with my argument here, Brooks understands Brown's "incorporation of performance as a strategy of renewal, transformation, and liberation for the fugitive" as a response to "an initial crisis in mounting visual proof of the fugitive slave's experiences."[84] Yet as I mentioned in the introduction to this chapter, both scholars focus on the traffic between performance, image, and text, locating the "representational crisis" Brown poses to "viewers who were seemingly tethered to narrow and troubling racial authenticity politics" in his mobilization of visual media, and specifically in his "intertextual engagement with [his] celebrated boxing (re)appearance and his panorama."[85] Brooks writes that Brown's "attendance to intertextuality permeates the structure of the 1851 edition of the *Narrative* . . . [and] creates a direct and fundamental dialogue with the *Mirror of Slavery*," a reading specific to Brown's singularity as a performer, which places the performative to some extent at odds with what we would consider the narrative proper—as an element that intermedially intrudes on, interrupts, or is in excess of what is traditionally considered the slave narrative.[86] But as I have been arguing throughout this book, even without recourse to

intertextual objects, images, iconography, or live performance, ex-slave narrators regularly used the negotiated form of the slave narrative to produce "representational unruliness," what I have been calling representational static, to unsettle the ideological containment of the abolitionist frame.[87]

In the same way that the contemporary artists under consideration in chapter one offer a lens to focus on the interplay between visual themes and the subversion of authentication tropes in nineteenth-century slave narratives, Brown's status as a performer (and his negotiation with abolitionist "stage managers") provides a unique lens on narrative performance in the slave narrative tradition. Moreover, I make a distinction, here, between descriptions of performances incorporated into the narratives, such as the choir performance Brown participates in or the acting that William and Ellen Craft undertake to effect their escape, and the narrative performances staged on the rhetorical level, such as Brown's parable or Keckly's presentation of Tad's reading lesson, which seem to simply be relating facts of a formerly enslaved person's life and experience, but which challenge racist presumptions framing the slave narrative as a literary form. Distinct from the "imbricated interplay of cultural work" Brooks identifies in Brown's 1851 *Narrative*, narrative performance is internal to the fabric of the narrative itself.[88] It is the wily, disruptive rhetorical gesture that, like Brown's parable, satisfies the white abolitionist audience's hunger for the experience of the enslaved, but simultaneously "disturbs without displacing" the very assumptions motivating their demand for pure experience.[89] Narrative performance is multidimensional: it operates at the level of historical experience, offering the raw material parlayed into evidence for the abolitionists' case against slavery, but it also operates at the level of literary form, presenting rhetorical, philosophical, and political challenges to the abolitionist movement's treatment of evidence, which constitutes the slave narrative's textual frame.

Mattie Jackson, whose story of approaching the Union arsenal in her bloodied clothes appears in this book's Introduction, offers another elegant example of narrative performance in her 1866 *The Story of Mattie J. Jackson*. Coming upon a switch that her mistress laid out for her master to use against her, Jackson bends the instrument of punishment into a "W," the first letter of her master's given name. Labeling the tool of violence with the master's identity, Jackson shifts the stigma of abuse from herself to the master—a gesture that resonates both in the moment she does it and in her narrative rehearsal of the action in 1866. Historically, Jackson's resistant performance renders the switch useless, saving her from that beating and announcing her symbolic triumph in that mo-

ment by redirecting attention from her vulnerability to the slaveholder's brutality; but by relating this incident in her narrative, Jackson knowingly intervenes in the literary expectations she is subject to as an ex-slave narrator, speaking back to the requirement that she demonstrate her literacy to authenticate herself. Jackson's narrative performance renders literacy and violence as parallel tools of control, problematizing both slaveholders' and abolitionists' ideological presuppositions about the enslaved. Applying Brooks's performance theory to the discursive terrain of the slave narrative itself, this chapter treats Brown's prowess as a performer and the extensiveness of his cultural production as an opportunity to examine narrative performance as a form of representational static and a critical category that applies more broadly to ex-slave narrators who may never have performed on the abolitionist lecture circuit themselves, but who are nevertheless acutely aware of the audiences they address and the expectations they must anticipate.[90]

Epilogue. Racial Violence, Racial Capitalism, and Reading Revolution: Harriet Jacobs, John Jones, Kerry James Marshall, and Kyle Baker

Our mourning, this mourning, is in time with our lives.
—CLAUDIA RANKINE, "'THE CONDITION OF BLACK LIFE IS ONE OF MOURNING'"

In his recent, epic counterhistory of visuality, Nicholas Mirzoeff offers what he calls "the right to look" as the instantiation of a political subjectivity and collectivity, which opposes and is opposed to the authority of visuality. Figuring the contest between these two modes through an encounter with the police, Mirzoeff writes, "The right to look confronts the police who say to us, 'Move on, there's nothing to see here.' Only there is, and we know it and so do they."[1] As the foregoing chapters contend, what ex-slave narrators show us through their engagement with the highly prescribed slave narrative form is that the right to dictate the terms of the visible is a function of power, but that those disenfranchised from the dominant gaze are nonetheless looking. Subject to an evidentiary epistemology of the visual that understands blackness through an objectifying gaze, ex-slave narrators have established their "right to look" by countering that gaze with an insistence on intersubjective recognition.

The contemporary artists considered in the first chapter show that the question of who has the right to dictate the terms of the visible is not merely historical. As I write this epilogue, the intersection between racial violence and visual evidence is perhaps the most vexed it has been since the abolitionist period. Although racism within the criminal justice system is not a new phenomenon, over the past few years incidents of state (or state-protected) violence and the Black Lives Matter movement—founded in response—have become a dominant feature of our national conversation. In a *New York Times* editorial written in the wake of a racially motivated mass shooting at Emanuel Methodist Episcopal Church in Charleston, South Carolina, in which an avowed white supremacist

killed nine black people attending a prayer group, Claudia Rankine con-
denses the ongoing history of the spectacle of violence against black
people into a waking fever dream that continues to shape our quotidian
experience:

> We live in a country where Americans assimilate corpses in their
> daily comings and goings. Dead blacks are a part of normal life here.
> Dying in ship hulls, tossed into the Atlantic, hanging from trees,
> beaten, shot in churches, gunned down by the police or warehoused
> in prisons: Historically, there is no quotidian without the enslaved,
> chained or dead black body to gaze upon or to hear about or to posi-
> tion a self against. When blacks become overwhelmed by our culture's
> disorder and protest . . . , the wrongheaded question that is asked is,
> What kind of savages are we? Rather than, What kind of country do
> we live in?[2]

The necessary shift of perspective Rankine calls for in those final ques-
tions is reflected in the contest over a national orientation to visual cul-
ture that has persisted since the period of racial slavery. In her ensuing
analysis, Rankine offers a powerful meditation on the ambivalent effects
the spectacle of the brutalized black body has in a culture saturated with
it, calling our attention to different relationships viewers have to mate-
rial so often discussed in terms of singular evidence. Marking Mamie Till
Mobley's decision to allow her son Emmett's body to be photographed in
an open-casket funeral after his lynching as a watershed moment in visu-
alizing racial violence in the U.S., Rankine argues that Mobley "create[d]
a new pathway" for thinking about black suffering and racial violence.
Mobilizing the evidentiary logic of race that understands blackness as
evidence of inferiority against the evidentiary paradigm of the criminal
justice system, Rankine writes that

> Mobley's refusal to keep private grief private allowed a body that
> meant nothing to the criminal-justice system to stand as evidence.
> By placing both herself and her son's corpse in positions of refusal
> relative to the etiquette of grief, she "disidentified" with the tradi-
> tion of the lynched figure left out in public view as a warning to the
> black community, thereby using the lynching tradition against itself.
> The spectacle of the black body, in her hands, publicized the injustice
> mapped onto her son's corpse. "Let the people see what I see," she said,
> adding, "I believe that the whole United States is mourning with me."[3]

Using photography to call attention to the two mutually exclusive
modes of seeing her son's body, Mobley's intervention is an instance of

representational static. Her resolution that the nation should look upon her son's damaged body is effective not because the image of a mutilated black body is something we have not seen before, but because her insistence on placing herself as a mourning mother in the visual frame engenders a perspectival shift from that of the dominant culture's objectifying gaze to that of her own, contextualizing Emmett's life and death in terms of his family connections and provoking "people [to] see what [she] sees." Rankine notes, "It's very unlikely that [Mobley's] belief in a national mourning was fully realized, but her desire to make mourning enter our day-to-day world was a new kind of logic. In refusing to look away from the flesh of our domestic murders, by insisting we look with her upon the dead, she reframed mourning as a method of acknowledgment that helped energize the civil rights movement in the 1950s and '60s."[4]

However, invoking Michael Brown's mother's experience in August 2014, Rankine demonstrates that despite the "new pathway" created by Mobley's decision, evidentiary epistemology remains the dominant visual culture's principal mode of addressing racial violence. In the aftermath of the shooting of her son Michael Brown, Lesley McSpadden

> was kept away from her son's body because it was evidence. She was denied the rights of a mother, a sad fact reminiscent of pre-Civil War times, when as a slave she would have had no legal claim to her offspring. McSpadden learned of her new identity as a mother of a dead son from bystanders: "There were some girls down there had recorded the whole thing," she told reporters. One girl, she said, "showed me a picture on her phone. She said, 'Isn't that your son?' I just bawled even harder. Just to see that, my son lying there lifeless, for no apparent reason." Circling the perimeter around her son's body, McSpadden tried to disperse the crowd: "All I want them to do is pick up my baby."[5]

Rankine's account of the actions of both Mobley and McSpadden insists on recognizing the impact the spectacle of racial violence has on black viewers, challenging the subordination of their experience to a dominant visual paradigm, which understands this spectacle solely through the rubric of evidence, asking "How must it feel to a family member for the deceased to be more important as evidence than as an individual to be buried and laid to rest?" However, the context of each woman's relationship to the spectacle discloses other relationships to visual material beyond perspective. While Mobley makes a decision to provoke others to see as she sees, reframing Emmett's death not as evidence of black criminality but as evidence of irrational white brutality and criminality, McSpadden

is confronted with the spectacle of her dead son and his body's status as state evidence, a fact, which rather than demonstrating her connection to her son as Mobley's decision does, demonstrates the state's failure to recognize her relationship to him in a meaningful way.

In the outcry over the unrelenting and unaccountable police shootings including Michael Brown's over the past year, public policy debate has centered—nearly obsessively—on the need to capture more visual evidence, and body cameras worn by police have been offered as a resolution to the problem of state-sanctioned racial violence. While there has been some discussion about the insufficiency of this as a response—a recognition that body cameras can only be one aspect of what must necessarily be a multipronged approach—the tenor of the conversation has maintained the usefulness of video evidence in curtailing police brutality. But if we take seriously ex-slave narrators' intervention into visual culture, as well as contemporary visual artists' augmentation of that work, we must recognize that the evidentiary epistemology out of which this call emerges is actually at odds with a model of visuality that privileges intersubjective recognition over objective discernment. As we see in slave narratives, including Frederick Douglass's account of slave songs in his 1845 *Narrative*, there can be no understanding of racial violence without understanding the experience of those subject to it. Analogously, Rankine concludes that it is "a lack of feeling for another that is our problem," writing, "there is no life outside of our reality here. Is this something that can be seen and known by parents of white children?"

The belief that visual evidence will ameliorate the problem of racial violence recalls the logic of nineteenth-century white abolitionist James Miller McKim, who asserted that to see is to believe, assuming the transparency of visual evidence and thereby dangerously flattening its interpretation to a singular plane. However, the history of lynching photography refutes this; the history of the auction block refutes this; the history of the Rodney King video refutes this.[6] History shows that different people see the spectacle of racial violence in very different ways. Visual images are neither unmediated nor speak for themselves. Moreover, this approach to visual material actually opposes forms of recognition that would prioritize experience and testimony, reestablishing an all-too-familiar dynamic in which black experience must be verified and legitimated by visual evidence and white institutional authority before black people are seen as worthy of the same protections afforded white citizens. As ex-slave narrators such as Mattie Jackson and theorists including Elizabeth Alexander and Saidiya Hartman show, the unending circulation of the spectacle of the damaged and suffering black body is an ambivalent route

to empathy, truth, or justice, and its ceaseless presentation runs the risk of re-objectifying the black body in a condition of "pained embodiment."[7]

As a final meditation on the ways that, as Ian Baucom says, "the present is more than just rhetorically haunted by the past," I want to end this book by looking both backward and forward to demonstrate that the interventions black cultural producers have made into visual culture disclose a profound and enduring understanding of the relationship between spectacular racial violence and racial capitalism.[8] In thinking about our present circumstances, in which racialization saturates the operations of state power, we must understand that our interpretation of visual culture relies not just on ideas of sight but, as ex-slave narrators such as Harriet Jacobs knew, on our understanding of the transfer of structures of wealth and power which condition the very terms of the visible. Looking back to Jacobs's narrative and forward to contemporary artists John Jones and Kerry James Marshall, I trace black cultural producers' response to the constitution of white wealth through racial violence. Finally, I conclude with an analysis of Kyle Baker's graphic novel, *Nat Turner*, which demonstrates the possibilities of a different way of seeing as a weapon of resistance to be wielded against the evidentiary and objectifying gaze of white supremacy.

In her 1861 narrative, *Incidents in the Life of a Slave Girl*, Harriet Jacobs challenges the visual politics of racial slavery through her narrative strategy of exposure.[9] Presenting a case against racial capitalism, Jacobs reveals slavery to be a system that protects and increases wealth for white families not only by violently extracting labor from a captive population, but also by sexually exploiting enslaved women and transforming their reproductive capacity into a means of production. At the center of her critique is the speculative gaze directed at enslaved women—a gaze that both sexually objectifies them and sees them as literal bearers of economic value for slaveholders through their reproductive capability. In the preface to the narrative, editor Lydia Maria Child famously writes, "This peculiar phase of Slavery has generally been kept veiled; but the public ought to be made acquainted with its monstrous features, and I willingly take the responsibility of presenting them with the veil withdrawn."[10] As a metaphor for bodily exposure, the withdrawal of the veil symbolizes Jacobs's larger narrative strategy: to expose her own body and sexual history to a potentially lurid public gaze in order to reveal the moral corruption at the heart of racial slavery. However, just as Jacobs takes control over her sexual agency to evade the advances of her master Dr. Flint, she also takes determinative narrative control over this strategy of exposure.

In a scene that encapsulates the logic of her challenge to racial capital-
ism, Jacobs describes the sale of her grandmother at a public auction.
Having been promised her freedom by her mistress, Aunt Marthy (as she
is generally known) is defrauded by Dr. Flint upon the mistress's death. As
the executor of her will he claims she must be sold to settle the estate. He
attempts to do so discreetly, suggesting that he is "unwilling to wound her
feelings by putting her up at auction, and that he would prefer to dispose
of her at private sale."[11] Although he is within his rights to sell her, he also
knows that Aunt Marthy is a well-respected member of the community—
among both its white and black members—and her mistress's promise
of freedom was well known. Understanding his true motives—to protect
his *own* reputation—Aunt Marthy insists on a public auction, calculating
that "if he was base enough to sell her, when her mistress intended she
should be free, she was determined the public should know it."[12] Trans-
forming the degraded and degrading position of the auction block into a
powerful social platform, Martha exposes her own body to the public to
expose Dr. Flint's perfidy: "When the day of the sale came, she took her
place among the chattels, and at the first call she sprang upon the auction-
block. Many voices called out, 'Shame! Shame! Who is going to sell you,
aunt Marthy?'"[13] Aunt Marthy's strategy successfully redirects the specu-
lative gaze aimed at her body onto the actions of Dr. Flint.

The scene is paradigmatic of Jacobs's overall narrative strategy.
Throughout the narrative Jacobs draws a direct correlation between slav-
ery's chattel principle and white consolidation of wealth through the laws
of inheritance, shifting the speculative gaze from enslaved women's bod-
ies and sexuality to the spectacle of the institutional culture that sanc-
tions this exploitation—aspects of racial slavery that collide in the scene
of her grandmother's auction. Jacobs reminds us that the primary laws
governing antebellum life were that "the child follows the condition of
the mother," ensuring that any child born to an enslaved woman would
also be enslaved, thereby increasing the masters' wealth, and that "a slave
being property, can *hold* no property."[14] These laws work in tandem to
consolidate wealth in the hands of those deemed racially white while di-
vesting it from those deemed racially black.

In a particularly dense sequence of scenes early in the narrative, Jacobs
appropriates the language of debt and inheritance to reveal the arbi-
trary and destructive workings of racial capitalism under slavery. After
the death of her master, Jacobs's grandmother's children are distributed
amongst his children. However, because she had five children, they could
not be equally distributed, so Jacobs's uncle Benjamin was sold "in order

that each heir might have an equal portion of dollars and cents."[15] Noting that her uncle Benjamin was "nearly white; for he inherited the complexion my grandmother had derived from Anglo-Saxon ancestors," Jacobs goes on to say that "[t]hough [he was] only ten years old, seven hundred and twenty dollars were paid for him."[16] Evoking the image of a visually white person on the auction block to shock white readers into empathy with the enslaved, Jacobs also uses the word "inheritance" ironically to show that the traditional conception of inheritance—wealth transferred from parents to children—is usurped by the law that the "child follows the condition of the mother." Rather than inheriting, Benjamin *is* the inheritance; his own "inheritance" from his mother is his designation as a slave. By applying the language of inheritance to Benjamin's "nearly white" skin, Jacobs offers it as a visual sign of the hypocrisy of the laws governing white inheritance and black disenfranchisement.

Jacobs sets both these examples of disenfranchisement—her grandmother's and Benjamin's sales to settle the masters' estate—against notions of familial debt and inheritance unrecognizable under racial slavery. Describing the condition of deprivation in which Dr. Flint keeps his slaves, Jacobs gratefully acknowledges the material and emotional support she receives from her grandmother, noting "I was indebted to *her* for all my comforts, spiritual or temporal. It was *her* labor that supplied my scanty wardrobe."[17] Jacobs's sense of indebtedness exists in stark contrast to the unrecognized debt masters owe to slaves. Moreover, by showing how slaves are distributed alongside other objects, such as family heirlooms, Jacobs reveals the workings of the chattel principle and the genealogical disavowal upon which racial slavery is based.

This contradiction is on display in the scene of Aunt Marthy's auction. Before she is sold, she appeals to Dr. Flint to be repaid for a debt incurred by her mistress before her death. Marthy had set aside $300 with the goal of raising enough to purchase her children. However, her mistress, finding out about this cache, borrowed the money and never returned it. Dr. Flint denies Marthy's request for repayment, saying that since "the estate was insolvent . . . the law prohibited payment."[18] Jacobs archly notes, "It did not, however, prohibit him from retaining the silver candelabra, which had been purchased with that money. I presume they will be handed down in the family, from generation to generation."[19] Jacobs's indictment of slavery exists in her emphasis of the contrast between the gravity of Aunt Marthy's plan for the money—to buy her children's freedom—and the frivolity of the mistress's purchase—an unnecessary luxury. Furthermore, the anecdote illustrates that white prosperity is a

FIGURES 7 and 7a. KERRY JAMES MARSHALL, *Heirlooms and Accessories* (triptych), 2002 ink-jet prints on paper in wooden artist's frames with rhinestones 51 × 46 inches each. © Kerry James Marshall. Courtesy of the artist and Jack Shainman Gallery, New York.

direct consequence of the destruction of the black family. Because of this, even seemingly neutral objects—such as a pair of silver candelabra—are symbolic bearers of the damaging ideology of racial superiority, which is also passed down generation to generation.

More than 130 years after the legal end of slavery in the U.S., visual artist Kerry James Marshall makes a similar observation and critique about the workings of racial capitalism in his 2002 photographic triptych "Heirlooms and Accessories" (Figure 7). Taking as his raw material a famous photograph of a double lynching that took place in Indiana in 1930, which circulated as a *carte de visite*, Marshall reduces the image of the men's hanging bodies to near-invisibility while isolating and keeping sharp three of the female witnesses' faces in the crowd, framing them each with a locket superimposed over the photograph. The superimposition of the locket onto a picture of a public lynching discloses the intimate, uncomfortable, and causal connection between the accumulation of white families' wealth and the literal destruction of black men and their families. The locket chain is a visual analogue to the hanging rope in the background illustrating the connection between the racial violence of the past and the operation of wealth and capital in the present (Figure 7a). In this way, Marshall addresses the visual dynamics that characterize what Saidiya Hartman calls the "afterlife of slavery." Like Harriet Jacobs's *Incidents*, "Heirlooms and Accessories" overturns the visual dynamics of the lynch mob—an analogue to the auction block in the slave narrative, deflecting attention away from the abused black body and training it on the spectacle of the culture of racial violence. But it also exploits a temporal aspect of sight—the images are not what they first appear to be. Giving the initial impression of traditional portraits vouchsafed in sentimental heirlooms, the triptych ultimately reveals the connection between racial violence and the consolidation of whiteness. In an interview about the work, Marshall notes that because lynching images provoke such a visceral, emotional response, it can be difficult to get people to think through the complexities and implications of such images of violence and brutality. To avoid this problem, he uses a technique similar to that of artist Ken Gonzales-Day, whose *Erased Lynching* series (2002–2011) reproduces lynching photographs with the victim and rope photoshopped out, focusing our attention on the practices and legacies of viewing racial violence. In both Marshall's and Gonzales-Day's works, one is struck by the contrast between the casualness of the images—and in Marshall's piece in particular, the women's calm expressions—and the scenes of racial violence they depict.

By titling his piece "Heirlooms and Accessories," Marshall correlates the spectacular nature of racial violence with the quotidian objects of family history, revealing—like Jacobs—that even the most seemingly neutral objects are the bearers of ideological as well as material value. At the moment the viewer recognizes the context of the photograph, both terms operate as double entendre. The locket is an "heirloom" in the sense that it is an object of material and sentimental value passed down through generations, but like the silver candelabra in *Incidents*, it is also the legacy of white supremacy and racial violence. Similarly, the locket is a sentimental accessory while the women represented inside are "accessories" to a double murder. The tension between the superfluous nature of wardrobe accessories and the shattering violence of vigilante killings recalls Jacobs's anecdote about the silver candelabra purchased instead of her aunts' and uncles' freedom. Marshall's play on "heirlooms" captures black Americans' paradoxical relationship to value; the scenes of racial violence framed by the lockets are both symbolic mementos of the past and literal bearers of value for the future, implicating private family keepsakes in a regime of racial terror.

In *Confederate Currency: The Color of Money, Images of Slavery in Confederate and Southern States Currency* (2002), artist John Jones presents perhaps the most literal connection between racial violence and the consolidation of whiteness. While working at a blueprint company in Charleston, North Carolina, Jones discovered a small scene of slaves doing field work on the face of an old Confederate bill he was enlarging for a customer. The result is a series of more than eighty acrylic paintings in which Jones reproduces the idyllic images of slave labor that appeared on Confederate money as the subject of his own paintings, highlighting the role of aesthetics in maintaining ideologies of white dominance (Figures 8 and 8a). As the series shows, not only were visual representations of the enslaved an inextricable part of a national narrative, but enslaved African American bodies were the literal currency on which the nation was founded.

In addition to confronting the racial violence that has underwritten a broader national and cultural vision, Jones's and Marshall's works tell us something about the temporality of racial capitalism itself. Taking up quotidian objects—family heirlooms and photographs for Marshall and paper money for Jones—these artists illuminate the ideological burden of form itself, and the ways in which particular forms have been used to maintain, circulate, and reproduce white supremacist ideology. Following Harriet Jacobs and Aunt Marthy, they also show how these same forms can strategically be used to dismantle that ideology. The shift from

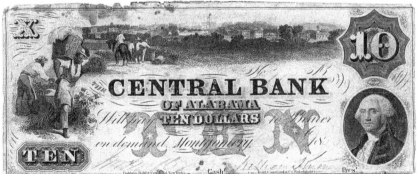

FIGURES 8 and 8a. Copyright John W. Jones, Artist and Author of the book and exhibition, *Confederate Currency: The Color of Money, Images of Slavery in Confederate and Southern States Currency*. www.colorsofmoney.com.

exchange value to anticipated or imagined value which is the basis of fi-
nance capital is bound up with modern notions of race which become
similarly abstracted from actual bodies and circulate as ideological val-
ues. If race and financial speculation are "technologies for constructing
the future," as Bruce Barnhart has argued, it might at first seem that debt
and indebtedness are ways of constructing the past. But in the hands of
Jacobs, Marshall, and Jones we see that debt is also future-oriented and
can be a way of describing a form of care and connection unacknowl-
edged by current matrices of finance capital. Debt, like speculation, binds
us to one another by borrowing on future possibility. In what may seem to
be black cultural producers' paradoxical return to images and narratives
of the past, we find an aesthetic and political strategy of constructing an
imaginative future. Jones's and Marshall's insistence on the actual, rather
than the abstract, value of black life in their works, sheds light on African
Americans' experience of racial speculation throughout history and sug-
gests new ways of appropriating aesthetic and financial forms in ways that
reject the chattel principle and simultaneously put us in each other's debt.

While Harriet Jacobs, John Jones, and Kerry James Marshall elucidate
the relationship between spectacles of racial violence and the mainte-
nance of racial capitalism, graphic novelist Kyle Baker instructs us in a
revolutionary mode of sight. In the introduction to this book I invoke
Stephen Best's lament that "[t]here are no visual equivalents of *Incidents
in the Life of a Slave Girl*" in order to challenge the critical separation of
the visual and the literary in the context of the slave narrative. Address-
ing the textual visuality of slave narratives, I have argued that ex-slave
narrators present textual responses to the problem of visual speculation,
utilizing representational static to undermine the conventions of au-
thentication that maintain the stark division between black and white.
Contemporary visual artists such as Kara Walker, Glenn Ligon, and Ellen
Driscoll amplify this aspect of slave narration by producing slave narra-
tives in the context of visual art, complicating the distinction between
image and word, object and subject, by translating literary conventions
into a primarily graphic medium. But perhaps the most direct example of
the slave narrative *as* visual culture is contemporary cartoonist and comic
book author Kyle Baker's 2008 graphic narrative *Nat Turner*, a "visual
equivalent" of Turner's *Confessions of Nat Turner*, originally published in
1831 by white amanuensis Thomas R. Gray. Presenting a conundrum as
to whether images or text have primacy as the most authoritative ver-
sion of the events of Turner's life, Baker productively intertwines ques-
tions of visual and literary distinction with questions of narrative control.

Baker's interventions are enabled by the graphic narrative form, which allows him to juxtapose text and image in such a way that the text's meaning is irreducible to either medium alone. Unlike many graphic novels or comic books, *Nat Turner* eschews the convention of presenting characters alongside descriptive text or dialogue bubbles, instead interspersing his own inventive graphic panels with text taken verbatim from *The Confessions of Nat Turner* (Turner's prison "confession" written down by Gray, in the days before his execution) and *The Memoir of Captain Theodore Canot, Twenty Years of an African Slaver* (1854).

Baker's original, largely wordless graphic panels retell the story of Nat Turner's early life, prophecies, rebellion, and execution in four chapters: Home, Education, Freedom, and Triumph. Notably, the texts that Baker draws on and includes conspicuously announce their antimony to the perspective of the enslaved, emphasizing that our access to Turner's story—and many narratives of enslavement—is compromised by the white amanuensis whose narrative goals sharply diverge from those of Turner himself. While this initially has the effect of keeping the reader off balance—as one critic puts it, "the reader is in a constant state of flux, trying to align the visual and verbal registers of the work. How do the pictures relate to the words? Are the pictures illustrative, supplementary, complementary, or contradictory?"—it ultimately highlights the power dynamics that go into publishing accounts of black experience and erodes our understanding of verbal and visual material as clearly bounded media distinct from one another.[20]

Baker's project of counter-reading—which he aligns with Turner's project of radical revolution—begins with the 1831 version of Turner's rebellion, written by white lawyer Thomas Gray. He reproduces that work's title page in gray-scale as the first image of Chapter 1, "Home," and it appears again in the hands of an enslaved woman in the narrative's final scenes in the section entitled "Triumph" (Figure 9). However, this framing device is ultimately deceptive, as Baker's narrative overspills the original literary narrative, written in Gray's voice, in every possible way: temporally, graphically, and ideologically.

While the original narrative begins as a response to a question posed by the white amanuensis (a question not included in the text), Baker's narrative opens with scenes of an African marketplace before European kidnappers arrive and violently conscript community members into slavery (Figure 10). If one tries to align the narrative content of the first chapter with the original *Confessions*, "Home" maps onto the final, single, vague clause of the sentence that inaugurates Turner's remarks to Gray: "Sir—You have asked me to give a history of the motives which induced

THE
CONFESSIONS
OF
NAT TURNER,
THE LEADER
OF
THE LATE INSURRECTION
IN SOUTHAMPTON, VA.

AS FULLY AND VOLUNTARILY MADE TO

THOMAS R. GRAY,

In the prison where he was confined, and acknowledged by him to be such
when read before the Court of Southampton: with the
certificate, under seal of the Court convened at
Jerusalem, Nov. 5, 1831, for his trial.

ALSO,

AN AUTHENTIC ACCOUNT

OF THE

WHOLE INSURRECTION,

WITH

Lists of the Whites who were Murdered,

AND OF THE

*Negroes brought before the Court of Southampton,
and there sentenced, &c.*

⸺

FIGURE 9. *The Confessions of Nat Turner* (1831). *Nat Turner* written and illustrated by Kyle Baker. Copyright © 2008. Used by permission of Abrams Books, an imprint of Harry N. Abrams, Inc., New York. All rights reserved.

me to undertake the late insurrection, as you call it—To do so I must go back to the days of my infancy, and even before I was born." Turner begins his narrative at a point long before Gray's question (and outside of his frame of reference) and registers his ideological distinction from Gray in this official record—"the late insurrection, *as you call it.*" Taking

FIGURE 10. African market scene, page 11, panel 1. *Nat Turner* written and illustrated by Kyle Baker. Copyright © 2008. Used by permission of Abrams Books, an imprint of Harry N. Abrams, Inc., New York. All rights reserved.

his cue from Turner's insistence that he start his narrative at the time "even before I was born," the scenes Baker conjures have no counterpoint in Gray's text and—purely pictorial—the story they tell is not dependent on literacy for its legibility. Staying true to Turner's assertion that he is explaining his motivation for rebellion, Baker's imaginative expansion augments Turner's strategy, displacing Gray as the controlling force of the narrative and re-centering the experience of the enslaved. Baker's rendering the first chapter pictorially—the only words in the first thirty-five pages are the onomatopoetic sounds of gunshots as kidnappers raid the marketplace—has the effect of linking the violence of colonial intrusion with the violence of white narrative control.

The first time Baker includes narrative text is, tellingly, when the captives arrive at the coast—the threshold between Africa and the West—and are branded and shaved as a way of being forcibly commodified and packaged for transport. Under a graphic panel depicting Turner's mother (before his birth) struggling against a captor who is holding her while another man shaves her head, a straight razor glints menacingly in the

FROM THE MEMOIR OF CAPTAIN THEODORE CANOT:
TWENTY YEARS OF AN AFRICAN SLAVER

"The head of every male and female is neatly shaved; and, if the cargo belongs to several owners, each man's brand is impressed on the body of his respective negro.... They are entirely stripped, so that women as well as men go out of Africa as they came into it—naked."

FIGURE 11. Woman prepared as cargo, page 36. *Nat Turner* written and illustrated by Kyle Baker. Copyright © 2008. Used by permission of Abrams Books, an imprint of Harry N. Abrams, Inc., New York. All rights reserved.

center of the image (Figure 11). Baker includes a passage from *The Memoir of Captain Theodore Canot*: "The head of every male and female is neatly shaved; and, if the cargo belongs to several owners, each man's brand is impressed on the body of his respective negro. . . . They are stripped, so that women as well as men go out of Africa as they came

into it—naked."[21] Baker exploits the contrast between the trauma depicted in the graphic panel—Turner's mother fighting for her life—and the dispassionate and cavalier tone of the slaver, referring to the Africans as "cargo" and making a subtle joke likening the process of transforming a person into a commodity to the natural processes of birth or death. The juxtaposition of the opposing perspectives of the graphic panel and the historical text enhance both—heightening the slaver's callousness in the face of this woman's trauma and the woman's trauma in the face of such callousness. While the text contradicts the picture on the level of experience and perspective, it also authenticates it, guaranteeing the historical truth of such practices within the inventive space of Baker's graphic portrayal. In this way, Baker mimics the authenticating conventions of the slave narrative—that black experience must be certified and legitimated by white documentary evidence—yet undermines its racist motivation. Rather than attesting to the humanity of the enslaved and the truth of his or her experiences, the inclusion of white documentary evidence certifies the *inhumanity* of the slavers, blind to the humanity of the Africans so manifestly evident.

The next inclusion of text further complicates the interrelationship Baker constructs between image and narrative. Positing the chapter we are currently reading as events that Turner relates that happened before he was born, Baker juxtaposes the text from *Confessions* with a graphic panel depicting Turner talking to fellow slaves, represented as a speech bubble containing pictures from the narrative we have already seen (Figure 12):

It is here necessary to relate this circumstance—trifling as it may seem, it was the commencement of that belief which has grown with time, and even now, sir, in this dungeon, helpless and forsaken as I am, I cannot divest myself of it. Being at play with other children, when three or four years old, I was telling them something which my mother, overhearing, said it had happened [*sic*] before I was born—I stuck to my story, however, and related some things which went, in her opinion to confirm it—others being called on were greatly astonished, knowing that these things had happened, and caused them to say in my hearing, I surely would be a prophet, as the Lord had shown me things that had happened before my birth.[22]

While Andrew Kunka reads this as a moment in which "image supersedes, or in this case, replaces, text in the work's hierarchy of meaning," as Turner's words are rendered graphically, it also situates the pictorial past Baker presents in the context of Gray's narrative, elaborating and authenticating Turner's assertion that he was prophetically able to know about

FROM THE CONFESSIONS OF NAT TURNER

"It is here necessary to relate this circumstance—trifling as it may seem, it was the commencement of that belief which has grown with time, and even now, sir, in this dungeon, helpless and forsaken as I am, I cannot divest myself of it. Being at play with other children, when three or four years old, I was telling them something which my mother, overhearing, said it had happened before I was born— I stuck to my story, however, and related some things which went, in her opinion, to confirm it—others being called on were greatly astonished, knowing that these things had happened, and caused them to say in my hearing, I surely would be a prophet, as the Lord had shown me things that had happened before my birth."

FIGURE 12. Nat remembers the past before he was born, page 57. *Nat Turner* written and illustrated by Kyle Baker. Copyright © 2008. Used by permission of Abrams Books, an imprint of Harry N. Abrams, Inc., New York. All rights reserved.

events that happened before he was born.[23] By filling in Turner's textual aporia—"I was telling them something . . . [that] had happened before I was born"—with the graphic specificity of the Middle Passage, Baker creates a broader historical condemnation of racial slavery than Gray's text allows for, and identifies Turner's motivations for historical rebellion as more than individual. Baker's canny use of the graphic narrative amplifies the production of representational static through inter-artistic juxtaposition in order to reclaim Turner's narrative from its white interlocutors.

While it might at first appear that Baker's rendering of the narrative as primarily imagistic is a corrective to the narrative control Gray exerts over the text, in Baker's text the images emerge from their relationship with the literary narrative and the literary narrative takes on distinct significance in relation to Baker's images. Rather than the one-to-one relationship a reader might expect between illustration and narrative, taken together the images and text of *Nat Turner* open up a space outside of the historical discourse of slavery and black rebellion, challenging the way each medium has been made historically to dominate and contain black experience—either through the tightly controlled publication conventions of slave narratives or the spectacularization of black suffering and black violence for an audience not fully convinced of the humanity of the enslaved (one might think here of the images of the slave ship *Brookes*).[24] Like contemporary visual slave narratives, Baker exploits what Michael Chaney calls an "intrinsic temporal duality"; rather than simply *representing* the past, Baker's *Turner* traffics between our present and Turner's.[25]

The radical potential of Baker's *Nat Turner* is in the call to arms he fashions out of the recognition that this moment is structured by and indebted to the past. The most stunning example of this is the visual epigraph on the book's frontispiece, a detail from the final graphic panel of the narrative: a slave woman holding the recently published *Confessions*, represented as a luminous book, with only her eyes and the book glowing in the dark (Figure 13). Presenting a striking image linking reading and revolution, the visual epigraph also collapses the historical distance between Turner's present and our own. Baker aligns the reader with the enslaved through the metaphoric consolidation of the luminous book, refocusing our attention on black audiences' and readers' adaptation and appropriation of texts that were not intended for them but that could be put to distinctly revolutionary aims. In his account of the publication history of *Nat Turner*, as he relates it in the Preface, Baker likens his successful self-publication of *Nat Turner* to what he considers to be Turner's self-emancipation, noting, "I liked that one of my first books as

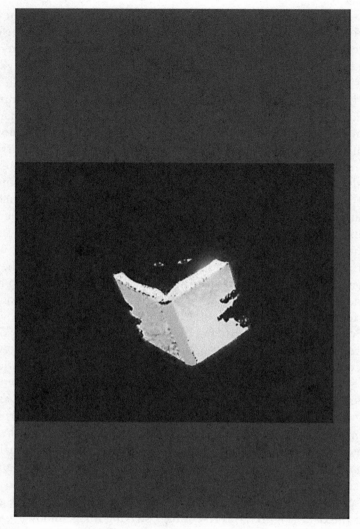

FIGURE 13. Girl holding *The Confessions of Nat Turner*, visual epigraph. *Nat Turner* written and illustrated by Kyle Baker. Copyright © 2008. Used by permission of Abrams Books, an imprint of Harry N. Abrams, Inc., New York. All rights reserved.

an independent publisher would be about a self-freed slave."[26] He states that the book was "so successful that one of my all-time favorite publishers, Harry N. Abrams, picked it up and published the lovely edition you are now holding."[27] Baker's reference to the reader's present echoes the visual epigraph, the book we now hold in our hands, aligning this *Nat*

Turner with the *Confessions of Nat Turner* and likening the reader to the slave "stealing" knowledge that was not meant for her. In this analogy, conveyed through inter-artistic juxtaposition—the image of the epigraph and the text of the Preface—the luminous book is an almost supernatural bearer of revolutionary spirit across medium and time, challenging the ideological darkness that characterizes both eras.

Acknowledgments

I am grateful to Lindon Barrett, whose course on African American Slave Narratives sparked a lifelong interest in the genre. His imprint is evident throughout the book and in the very structure of my thinking. Despite my losing him as an advisor and friend too early, his influence continues to shape the trajectory of my research and my life and serves as an intellectual model to which I aspire. I feel privileged that in the wake of his loss I have had the chance to get to know some of his family and friends inside and outside the academy. His parents, Dorothy and Leslie, have made it that much easier to see where the indefatigable spirit of community and humanity in Lindon's work comes from. The cultural studies reading group that he started at Irvine is a crystalline example of that spirit and continues to sustain me personally and professionally. Thank you to the members of that group—Bruce Barnhart, Mrinalini Chakravorty, Naomi Greyser, Ginger Hill, Linh Hua, Leila Neti, Arnold Pan, Amy Parsons, and Radha Radhakrishnan—scholars whom I look up to and, perhaps most important, friends who make life more fun.

I am very grateful for the institutional support provided by the University of California, Irvine. The faculty in English, Women's Studies, and African American Studies at U.C.I. gave me many opportunities: travel funds, teaching opportunities, and a solid intellectual foundation. I have tremendous gratitude for Gabriele Schwab, Rei Terada, and Arlene Keizer. Gaby, in particular, provided me with intellectual direction, inspiration, and, as the heart of an extended family of scholars in Irvine and beyond, she embodies, for me, the unlimited potential of what a scholar can be. My life in Irvine was further enriched by great friends, co-conspirators,

and interlocutors, including in order of appearance Qi Yuan Dai, Sam Steinberg, Margaux Cowden, Matt Nelson, Marcelle Cohen, Vanessa Osborne, Linh Hua, Randy Ontiveros, Anna Kornbluh, Mia McIver, Patricia Pierson, Larisa Castillo, Aaron Winter, Susannah Rosenblatt, Michelle Neely, and Emma Heaney. It was my honor to be in a writing group with Priya Shah and Susanne Hall. Dance parties with Jane Griffin and shopping or talking shop with I-Lien Tsay often saved the day. Their support still encourages me personally and professionally. Since leaving Irvine, I have continued to connect with fierce scholars from there, such as Selamawit Terrefe, who has been a friend, radical inspiration, and generous colleague.

The following scholars have provided support and encouragement at various stages of the project, although they had no institutional responsibility to do so: Teresa Goddu, Judith Madera, Koritha Mitchell, Britt Russert, and Shirley Samuels. I would like to thank the editors and anonymous readers at the following journals that were instrumental in advancing research and writing for this book: Martha Cutter, Maria Seger, and Shawn Michelle Smith, who edited a special issue of *MELUS* on Visual Culture and Race which published an earlier version of Chapter 1, Nathan Grant and Aileen Keenan at *African American Review*, who published a version of Chapter 2. I would also like to thank Hortense Spillers and the anonymous readers for the Issues in Critical Investigation Manuscript Competition who provided incisive and generous suggestions. My deepest thanks to Jennifer DeVere Brody for her brilliance, unwavering support, mentorship, and friendship. It should be noted that she also throws the best parties.

Hunter, CUNY, and PSC-CUNY have provided essential financial and institutional support for *Fugitive Testimony*. Thank you to Jennifer Raab, Hunter's President, and the Shuster Award, which provided resources at a critical moment in the book's production. Research and travel grants from the PSC-CUNY Research Foundation, the Hunter College Presidential Travel Award, the William Stewart Travel Award from the CUNY Academy, and the CUNY Faculty Fellowship Publication Program were essential to the book's development. Shelly Eversley's leadership of my FFPP group, in particular, as well as the work of my CUNY colleagues from that group—including Tyler Schmidt and Sean O'Toole—continues to guide me.

Less officially, I could not ask for a better group of colleagues and students than those I have at Hunter. They are intellectually rigorous, politically astute, and unfailingly generous. It has been my pleasure to work with exceptional students and research assistants, especially Maria Elizabeth

Rodriguez Beltran, Jennifer Garcon, Max Gottlieb, Maha Haroun, Marcella Leininger Kocolatos, Aime Salazar, Sam Simon, and Portia Seddon. Brandon Callender deserves special thanks for reading the whole manuscript and making suggestions that stunned me with their razor-sharp perception and precision. I only wish I could have incorporated them all. I work with truly exceptional teachers and scholars in the Hunter English Department who have enhanced the book in many ways. I am lucky to say that I feel the support of the whole department in all of my scholarly endeavors, but special mention must go to Cristina Alfar, Jeff Allred, Kelvin Black, Mark Bobrow, Sarah Chinn, Jeremy Glick, Marlene Hennessey, Gavin Hollis, Jan Heller Levi, Ramesh Mallipeddi, Mark Miller, Sonali Perera, Angie Reyes, Amy Robbins, and Barbara Webb, who have directly contributed to the thinking reflected in this book. Thom Taylor, Casandra Murray, Leah Light, Luz Ramirez, and Paul Fess smoothed the way for writing in a thousand visible and invisible ways. The connections I have with faculty beyond the English Department have enriched my time at Hunter immeasurably. Thank you to Mariann Weierich, Lydia Isaac, Cynthia Walley, Traci Warkentin, Philip Ewell, Michael Hoyt, and the rest of the stammtisch. Life at Hunter would be unimaginable without the exceptional smarts, friendship, and mentorship of Tanya Agathocleous.

The support and friendship of University of California, Santa Cruz friends—lifelong friends—Susan McCloskey, Rebecca Ponzio, Sarah Troy, Frank Dang, Jordan Stein, and Robert Chang continues to sustain me in ways that make the sometimes insular work of writing possible. Jordan, in particular, has been pressed into service as my unofficial mentor at every stage of my career. He has handled it manfully. Nicole and Josh Jackson, Laura Beadling, Russ Brickey, Amanda Tucker, and David Gillota encouraged and inspired me while I was teaching and writing in Wisconsin. New York friends Rebecca Goldberg, Sarah Blackwood, Kyla Schuller, and Sarah Davis have brightened my life. Julie Aviva Masarof provided support and laughter at precarious moments of this book's production.

Having a family that is close—emotionally if not geographically—is a constant source of encouragement and, when necessary, consolation. I am grateful every day for the smart, generous, loving family that has always encouraged me to learn more. My grandparents, Bob and Eileen Nicholson, provided an early example of how to intellectually engage with the world and their example continues to clarify what is really important. Thank you to Jack, Janice, Cathy, Bill, Katrina, Drew, Kyle, Tom, Tricia, Trinity, Jeff, Ivory, Tim and Catherine Parsons and the whole extended Parsons family, and Jan Sather. As the first doctor of philosophy in our family Colin Slim is a scholarly model who makes it look easy.

Singular thanks are reserved for Amy Parsons, who could always see the forest beyond the single tree I kept rewriting, and who has read every word I have written since the very beginning—those you see here and the million I have let go. Coral Leather has invigorated my sense of what is possible in the academy and has provided me with more encouragement and support than imaginable from across the Atlantic. I am unbelievably lucky to have parents and a sister who know exactly what it means to be an academic and have read and made suggestions for revision, financially supported me, and generally make my life better in every way. One can draw a direct line from debates we have around the dinner table to this book. Beth's boldness and outlook inspire me to take chances, as does her insistence that the bright side is the only side.

I would like to thank Richard Morrison, Eric Newman, and the editorial staff at Fordham University Press. Ruby Tapia and the second anonymous reader of the manuscript provided excellent recommendations for revision and it is a better book because of that. Richard has been an ideal editor and a joy to work with. His brilliance, vision, and commitment to racial justice are matched only by his kindness, efficiency, and publishing savvy. I am very thankful for his expertise and encouragement throughout this book's production.

Finally, I would like to thank the artists whose work is featured in the book as well as the archivists at their galleries who smoothed the process of obtaining permission to reproduce images of their works. Thank you to Kyle Baker, Ellen Driscoll, John Jones, Glenn Ligon, Kerry James Marshall, and Kara Walker.

Introduction: Representational Static

1. On the word "unvarnished" itself as an authenticating strategy, see James Olney, "'I Was Born a Slave': Slave Narratives, Their Status as Autobiography and as Literature," *Callaloo* 20 (Winter 1984): 46–73. Olney writes that white editors and amanuenses used the word, a reference to Shakespeare's Othello, to elevate and authenticate the nobility of the black narrator; as such, the reference to Othello is also a sign of white interlocutors' inability to think beyond the horizon of the narrators' race: "The Oxford English Dictionary will tell us . . . that Othello, another figure of 'dark-hued skin' but vastly heroic character, first used the word 'unvarnished,'" suggesting that white editors and amanuenses "were consciously evoking . . . Othello, the Noble Moor. . . . [B]ut no ex-slave that I have found who writes his own story calls it an 'unvarnished' tale: the phrase is specific to white editors, amanuenses, writers, and authenticators. . . . [I]t says much about the psychological relationship of white patron to black narrator that the former should invariably see the latter not as Hamlet, nor as Lear, not as Antony, or any other Shakespearean hero, but always and only as Othello," 62–63.

2. In an interview with Phyllis Rosenzweig in 1993, Ligon discusses the parallels between ex-slave narrators and current day black artists: "I recently became interested in slave narratives because their modes of address and the conditions under which they were written had certain parallels to my questions about audiences and cultural authority. The purpose of the narratives was twofold: first, to create consensus in the nation that slavery as an institution was immoral and should be opposed; and, second, to convince white people, by the very act of writing, that the author of the narrative and, by extension, the masses of enslaved black people were indeed human and worthy of freedom. I was interested in contemporary traces of the conditions under which former captives wrote their narratives. For example: what are the conditions under which works by black artists enter the museum? Do we enter only when our 'visible difference' is evident? Why do many shows with works by colored people (and rarely whites) have titles that include 'race' and 'identity'? Who is my work for and what do different audiences demand of it?" The interview is reprinted in Glenn Ligon, *Yourself*

in the World: Selected Writings and Interviews, ed. Scott Rothkopf (New Haven: Yale University Press, 2011), 75.

3. Representative works and exhibitions include Glenn Ligon, *Narratives*, 1993, prints, New York, Max Protetch Gallery, Fall 1993; Glenn Ligon, *Runaways*, 1993, prints, Max Protetch Gallery, Summer 2002; Kara Walker, *Slavery! Slavery!* 1997, New York, Whitney Museum of American Art; Walker's mid-career survey, *Kara Walker: My Complement, My Enemy, My Oppressor, My Love*, 2007, Minneapolis, The Walker Art Center; Lorna Simpson, *Suspended*, 1995, prints, Santa Fe, Museum of Fine Arts, as Part of SITE Santa Fe, Summer 1995; Fred Wilson, *Mining the Museum: An Installation*, Baltimore, Maryland Historical Society, 1992–1993, Reneé Green, *Bequest*, Worcester, Mass.: Worcester Art Museum, 1991; Fred Wilson, "Speak of Me as I Am," Venice Biennale, 2003; and the 2005–2007 group exhibition, *Legacies: Contemporary Artists Reflect on Slavery*, New York, The New York Historical Society. For a critical account of "the significance of transatlantic slavery within critical aesthetic practice at the close of the twentieth century," see Huey Copeland, *Bound to Appear: Art, Slavery, and the Site of Blackness in Multicultural America* (Chicago: University of Chicago Press, 2013).

4. As Michael Chaney notes, "properties of exchangeability [are] inherent to slave objectification"; see *Fugitive Vision: Slave Image and Black Identity in Antebellum Narrative* (Bloomington: Indiana University Press, 2008), 150. My discussion of the centrality of a series of exchanges to contemporary visual slave narratives is also informed by Fred Moten's study of the ex-slave narrator in terms of the exchange value of Marx's speaking commodity, which he argues exists "*before* exchange": "[i]t exists precisely as the capacity for exchange and the capacity for a literary, performative, phonographic disruption of the protocols of exchange. . . . To think the possibility of an (exchange-) value that is prior to exchange, and to think the reproductive and incantatory assertion of that possibility as the objection to exchange that is exchange's condition of possibility, is to put oneself in the way of an ongoing line of discovery, of coming upon, of invention," 10–11. Fred Moten, *In the Break: The Aesthetics of the Black Radical Tradition* (Minneapolis: University of Minnesota Press, 2003).

5. "Strategic presentism," Darby English, *How to See a Work of Art in Total Darkness* (Cambridge: MIT Press, 2007), 134. Writing specifically about Kara Walker's tableaux, English writes, "I have forced the issues of sentimentalism and landscape . . . for the exact reason that they bring [Walker's] project into view as a form of strategic presentism that can only achieve itself through a distancing of certain prior imperative forms in a practice that systematically disarticulates them" (134). It should be noted that this is different from Daylanne English's term "strategic presentism," which she defines as African American writers' "active participation in and contribution to the philosophies, aesthetics, and politics of their period: being in the world." *Each Hour Redeem: Time and Justice in African American Literature* (Minneapolis: University of Minnesota Press, 2013), 104. The way I use "strategic presentism" here is more akin to what Daylanne English calls "strategic anachronism": "African American writers' repetitive aesthetic forms as an expression of . . . injustice," 19–20. Robert Stepto also uses the term "race rituals" to refer to the variety of authenticating gestures which constitute the slave narrative in his essay "I Rose and Found My Voice: Narration, Authentication, and Authorial Control in Four Slave Narratives," in *The Slave's Narrative*, ed. Charles T. Davis and Henry Louis Gates, Jr. (New York: Oxford University Press, 1985), 225–241.

6. In this way, the subject of contemporary visual slave narratives is what Maurice Wallace has termed the spectragraphic—the racializing gaze rather than the racialized

body. Wallace defines *spectragraphia* as the "framework of the racialist gaze which suc-
ceeds by a camerical trompe l'oeil. . . . What racialists see gazing at the black male body
is a 'virtual *image*,' at once seen and unseen, spectacular and spectral, to [the] socially
conditioned eyes [of the racialist]. . . . Spectragraphia implies imperfect—indeed
illusory—cultural vision" (31).

7. Ligon quoted in Lauri Firstenberg, "Neo-Archival and Textual Modes of Produc-
tion: An Interview with Glenn Ligon," *Art Journal* 60.1 (Spring 2001): 43.

8. Mattie J. Jackson, *The Story of Mattie J. Jackson* (Lawrence, Mass.: Sentinel, 1866).
On the objectifying gaze in abolitionist literature (and particularly slave narratives), see
Saidiya Hartman, *Scenes of Subjection: Terror, Slavery, and Self-Making in Nineteenth-
Century America* (New York: Oxford University Press, 1997). Hartman asks, "Beyond
evidence of slavery's crime, what does this exposure of the suffering body of the bonds-
man yield? Does this not reinforce the 'thingly' quality of the captive by reducing the
body to evidence in the very effort to establish the humanity of the enslaved?" (19).

9. On the coincidence of "self-authorization and the most graphic representations
of the body," see Lindon Barrett, "African-American Slave Narratives: Literacy, the
Body, Authority," *American Literary History* 7.3 (Autumn 1995): 435. On the ambivalent
nature of reproducing black suffering in the slave's narrative, see Saidiya Hartman,
Scenes of Subjection. Identifying this convention as part of a "racist optics," Hartman
writes, "Why is pain the conduit of identification? . . . [I]f the scene of beating readily
lends itself to an identification with the enslaved, it does so at the risk of fixing and
naturalizing this condition of pained embodiment and . . . increases the difficulty of
beholding black suffering since the endeavor to bring pain close exploits the spectacle
of the body in pain and oddly confirms the spectral character of suffering and the in-
ability to witness the captive's pain. . . . Indeed, the elusiveness of black suffering can be
attributed to a racist optics in which black flesh is itself identified as the source of opac-
ity, the denial of black humanity, and the effacement of sentience integral to the wan-
ton use of the captive body," 20. I argue that ex-slave narrators such as Mattie J. Jackson
were aware of and made use of the ambivalent nature of displaying or representing the
black body in pain.

10. I use the term "speculative gaze" to capture the relationship between conjecture,
objectification, and value at work in a racializing gaze, a phenomenon intimately tied
to what I call throughout the book "racial speculation": the spectacularization of black-
ness tied to the anticipation of future value.

11. Hartman, *Scenes of Subjection*, 19.

12. See Ashraf Rushdy, *Neo-slave Narratives: Studies in the Social Logic of a Literary
Form* (New York: Oxford University Press, 1999) and Arlene Keizer, *Black Subjects:
Identity Formation in the Contemporary Narrative of Slavery* (Ithaca: Cornell University
Press, 2004). In his book *Everything but the Burden: What White People Are Tak-
ing from Black Culture* (New York: Broadway Books, 2003), 6, Greg Tate, referencing
Nelson George, writes that "the African-American equivalent of postmodernism" is
"post-Soul culture." Post-Soul overlaps with Glenn Ligon and curator Thelma Golden's
notion of "post-black" art (discussed more fully in note 59). According to Golden,
"For me, to approach a conversation about 'black art' ultimately meant embracing
and rejecting the notion of such a thing at the very same time. . . . ["Post-Black"] was
characterized by artists who were adamant about not being labeled as 'black' artists,
though their work was steeped, in fact deeply interested, in redefining complex notions
of blackness." Thelma Golden, *Freestyle* (New York: Studio Museum in Harlem, 2001),

14. On "post-soul aesthetics," see also the special issue of *African American Review* on "Theorizing the Post-Soul Aesthetic," particularly Bertram D. Ashe's introduction, "Theorizing the Post-Soul Aesthetic: An Introduction," *African American Review* 41.4 (Winter 2007): 609–623.

13. See Bridget R. Cooks, *Exhibiting Blackness: African Americans and the American Art Museum* (Amherst: University of Massachusetts Press, 2011). Cooks argues that American art museums have generally presented African American art using "the anthropological approach, which displays the difference of racial Blackness from the elevated White 'norm,' and the 'corrective' narrative, which aims to present the work of significant and overlooked African American artists to a mainstream audience" (1).

14. Anne Elizabeth Carroll, *Word, Image, and the New Negro: Representation and Identity in the Harlem Renaissance* (Bloomington: Indiana University Press, 2005), 28.

15. English, 208.

16. Ibid.

17. As William Andrews argues, with a few exceptions, "the narratives of former slaves published after 1865 have attracted relatively few readers" and, it may be said, a correlating lack of critical attention. *Slave Narratives After Slavery* (New York: Oxford University Press, 2011), viii.

18. Stephen Best, "Neither Lost nor Found: Slavery and the Visual Archive," New World Slavery and the Matter of the Visual. Spec. issue of *Representations* 113 (2011): 151.

19. On the expanding work on nineteenth-century black visual culture, see Sarah Blackwood's review, "Seeing Black," *American Quarterly* 65.4 (December 2013): 927–936. Blackwood examines Deborah Willis and Barbara Krauthamer's *Envisioning Emancipation: Black Americans and the End of Slavery* (Philadelphia: Temple University Press, 2013); Bridget Cooks's *Exhibiting Blackness*; Leigh Raiford's *Imprisoned in a Luminous Glare: Photography and the African American Freedom Struggle* (Chapel Hill: University of North Carolina Press, 2011); and Shawn Michelle Smith and Maurice O. Wallace, eds., *Pictures and Progress: Early Photography and the Making of African American Identity* (Durham: Duke University Press, 2012). See also Daphne Brooks, *Bodies in Dissent: Spectacular Performances of Race and Freedom, 1850–1910* (Durham: Duke University Press, 2006); Michael Chaney, *Fugitive Vision: Slave Image and Black Identity in Antebellum Narrative* (Bloomington: Indiana University Press, 2008); Celeste-Marie Bernier, *African American Visual Arts from Slavery to the Present* (Chapel Hill: University of North Carolina Press, 2008); Marcus Wood, *The Horrible Gift of Freedom: Atlantic Slavery and the Representation of Emancipation* (Athens: University of Georgia Press, 2010); Ivy Wilson, *Specters of Democracy: Blackness and the Aesthetics of Politics in the Antebellum U.S.* (New York: Oxford University Press, 2011); and Marcy J. Dinius, *The Camera and the Press: American Visual and Print Culture in the Age of Daguerreotype* (Philadelphia: University of Pennsylvania Press, 2012).

20. Blackwood, "Seeing Black," 934.

21. Dinius, 3.

22. Wallace, "Framing the Black Soldier: Image, Uplift, and the Duplicity of Pictures," in *Pictures and Progress*, 251–252.

23. P. Gabrielle Foreman, "Who's Your Mama? 'White' Mulatta Genealogies, Early Photography, and Anti-Passing Narratives of Slavery and Freedom," *American Literary History* 14.3, An ALH Forum: "Race and Antebellum Literature" (Autumn 2002): 505–539.

24. Reading ex-slave narrators' textual response to widespread belief that new technologies of visual reproduction provided greater access to authenticity and truth, the book responds to Foreman's assertion that "[t]he ways in which photography has been allied to anthropology are well-documented, yet when the authority of photography, representation, and indeterminacy in the nineteenth century are at play, there is still much more to be said about its production and disruption of racial (and gendered) 'truth'" (531).

25. Critical exceptions to this are Marcus Wood, *Blind Memory: Visual Representations of Slavery in England and America 1780–1865* (New York: Routledge, 2000), particularly his chapter "Rhetoric and the Runaway: The Iconography of Slave Escape in England and America," which discusses "the subversion of the rhetoric of the runaway in slave narrative," 118; Lynn Casmier-Paz, "Slave Narratives and the Rhetoric of Author Portraiture," *New Literary History*, 34.1 (Winter 2003): 91–116; and Sarah Blackwood, "Fugitive Obscura: Runaway Slave Portraiture and Early Photographic Technology," *American Literature* 81.1 (2009): 93–125. Wood, Casmier-Paz, and Blackwood present groundbreaking research on the relationship of slave narratives and visual culture; however, their focus is primarily on images and portraiture whereas my focus is on the textual aspects of visual culture which, I argue, are essential to fully understanding the context in which those images operated.

26. See William L. Andrews, *To Tell a Free Story: The First Century of Afro-American Autobiography, 1760–1865* (Chicago: University of Illinois Press, 1986); James Olney, "'I Was Born a Slave': Slave Narratives, Their Status as Autobiography and as Literature," *Callaloo* 20 (Winter 1984): 46–73; John Sekora, "Black Message/White Envelope: Genre, Authenticity, and Authority in the Antebellum Slave Narrative," *Callaloo* 32 (1987): 482–515; and Robert Stepto, "I Rose and Found My Voice: Narration, Authentication, and Authorial Control in Four Slave Narratives," in *The Slave's Narrative*, ed. Charles T. Davis and Henry Louis Gates, Jr. (New York: Oxford University Press, 1985), 225–241.

27. See Sekora.

28. I borrow the phrase "racial constraint" from Huey Copeland, who, writing about Glenn Ligon's work, identifies the overarching tension between the individual and the collective in African American cultural production, noting that "every discourse can become a site of racial constraint, particularly given the dialectic of 'I' and 'we' that can at once bolster possibilities for African American collective action and stifle the particularity of individual lived experiences." Copeland, "Glenn Ligon and Other Runaway Subjects," *Representations* 113.1 (Winter 2011): 73–110.

29. In a passage I have excerpted as my first epigraph, Sekora ends his essay with a prescription for future literary study, which calls for the identification and analysis of a variety of narrative devices within slave narratives that have the effect of evading, exceeding, or outwitting the "white envelope" in which they are contained, but he presents these devices as disparate elements deployed idiosyncratically: "Folk elements, superstitions, plays upon names and naming, images of exile and confinement and defilement all have the effect of disturbing the conservative form of the narrative without displacing it" (511). By contrast, I argue that ex-slave narrators develop a sustained and coherent rhetorical strategy of resistance to the slave narrative's conventions of authentication in their deployment of visual rhetoric. Many of the seemingly disparate rhetorical elements Sekora identifies can be read in combination as producing the singular effect of representational static when one addresses the narratives through a

comparative and interdisciplinary lens, paying special attention to visual tropes and discourse.

30. Sekora, 504.

31. In addition to the critics listed in note 23, see Valerie Smith, *Self-Discovery and Authority in Afro-American Narrative* (Cambridge: Harvard University Press, 1987); Harryette Mullen, "Runaway Tongue: Resistant Orality in *Uncle Tom's Cabin, Our Nig, Incidents in the Life of a Slave Girl*, and *Beloved*," in *The Culture of Sentiment: Race, Gender, and Sentimentality in Nineteenth-Century America*, ed. Shirley Samuels (New York: Oxford University Press, 1992); and Hazel Carby, "'Hear My Voice, Ye Careless Daughters': Narratives of Slave and Free Women before Emancipation," in *African American Autobiography: A Collection of Critical Essays*, ed. William L. Andrews (Upper Saddle River, N.J.: Prentice Hall, 1993), 59–76.

32. On the "trope of the talking book," see Henry Louis Gates, Jr., *The Signifying Monkey: A Theory of African-American Literary Criticism* (New York: Oxford University Press, 1988).

33. In her discussion of the status of literacy within the slave narrative and slave narrative criticism, Samira Kawash observes that the prioritization of literacy contributes to the ways "slave narrative is viewed as a political act that intervenes in the dominant discourse of race by countering the claim that the slave as subject is less rational or less human than the (white) nonslave." Yet she warns—as I do here—against transforming "[t]he descriptive relation between literacy, freedom, and subjectivity evidenced in some narratives" into an analytic horizon—"the normative standard of evaluation for all narratives" (30). Samira Kawash, *Dislocating the Color Line: Identity, Hybridity, and Singularity in African-American Literature* (Stanford: Stanford University Press, 1997).

34. See Lindon Barrett, "African-American Slave Narratives: Literacy, the Body, Authority," *American Literary History* 7.3 (Autumn 1995): 415–442.

35. See Barrett, "African-American Slave Narratives."

36. Douglass, 32.

37. Smith, *Self-Discovery and Authority*, 6.

38. Ibid., 2.

39. Ibid., 3.

40. Drawing on Robert Pattison, Smith writes, "literacy might be defined more broadly as the consciousness of the uses and problems of language, whether spoken or written. . . . In this view the unlettered person who can manipulate the meanings and nuances of the spoken word might also be considered literate" (4).

41. I have chosen to spell Keckly's name as she herself did, rather than the way her name is spelled in her published narrative. I thank Jennifer Fleischner for this historical restoration. In researching her book *Mrs. Lincoln and Mrs. Keckly: The Remarkable Story of the Friendship Between a First Lady and a Former Slave* (New York: Broadway Books, 2003), 7, Fleischner discovered Keckly's original signatures in her own hand on her application for a war pension after her son's death in the Civil War. I have kept the spelling "Keckley" in quotations from other scholars.

42. In *Scenes of Subjection*, Hartman reminds us that "acts of resistance exist within the context of relations of domination and are not external to them, [therefore] they acquire their character from these relations, and vice versa" (8). As for the visual character of this dynamic, Hartman's reading of slave songs in narratives, including Douglass's, is instructive: "Rather than consider black song as an index or mirror of the slave

condition, this examination emphasizes the significance of opacity as precisely that which enables something in excess of the orchestrated amusements of the enslaved and which similarly troubles distinctions between joy and sorrow and toil and leisure. For this opacity, the subterranean and veiled character of slave song must be considered in relation to the dominative imposition of transparency and the degrading hypervisibility of the enslaved, and therefore, by the same token, such concealment should be considered a form of resistance" (36). For a discussion of "spectacular opacity" in black performance see Brooks, 8. On the limits of a visual framework see Fred Moten's *In the Break: The Aesthetics of the Black Radical Tradition* (Minneapolis: University of Minnesota Press, 2003), particularly his introduction, "Resistance of the Object: Aunt Hester's Scream," 1–24.

43. Chaney, 11. Christopher Lukasik also uses the term "intermedial" to refer "to what Peter Wagner calls the intertextual use of one medium (such as painting) within another (such as fiction). Intermediality differs from comparative approaches to the arts in that it urges 'the reader not to give preference to one medium or the other but to consider both' (Wagner 18)." Lukasik, *Discerning Characters: The Culture of Appearance in Early America* (Philadelphia: University of Pennsylvania Press, 2011), 15. For more on intermediality see Irene Rajewsky, "Intermediality, Intertextuality, and Remediation: A Literary Perspective on Intermediality," *Intermédialitiés* 6 (Autumn 2005); and Peter Wagner, "Introduction: Ekphrasis, Iconotexts, and Intermediality—the State(s) of the Art(s)," in *Icons—Texts—Iconotexts: Essays on Ekphrasis and Intermediality*, ed. Peter Wagner (Berlin: Walter de Gruyter, 1996).

44. Chaney, 7, 5.

45. Robert Reid-Pharr, *Once You Go Black: Choice, Desire, and the Black American Intellectual* (New York: New York University Press, 2007), 16, 12.

46. In his introduction to a special issue of *J19: The Journal of Nineteenth-Century Americanists*, Lloyd Pratt notes that "the recognition of formal analogies across different areas of social (dis)enfranchisement has emerged in recent critique as the bête noir of efforts to think about how empowerment and disempowerment work in historically specific ways. . . . " See "Introduction: The Nature of Form," *J19: The Journal of Nineteenth-Century Americanists*, 1.2 (Fall 2013): 423–431, esp. 429.

47. Pratt, 429.

48. Raymond Hedin, "Strategies of Form in the American Slave Narrative," in *The Art of Slave Narrative: Original Essays in Criticism and Theory*, ed. John Sekora and Darwin T. Turner (Macomb: Western Illinois University, 1982), 24.

49. Stepto casts his "Three Phases of Narration" as developmental and teleological; the early phases, "eclectic" and "integrated," are characterized by "the former slave's ultimate lack of control over his own narrative, occasioned primarily by the demands of audience and authentication," while the latter "sophisticated narrative phase[s]" are characterized by greater authorial control and a recognizably generic form such as "history, fiction, essay, or autobiography" (226, 232).

50. Stepto, 232; Brooks, 73.

51. Another rubric for understanding the recursive nature of the slave narrative form is to think of them as aspects of popular culture at different historical moments. See Stuart Hall, "Notes on Deconstructing 'the Popular,'" in *Cultural Theory and Popular Culture: A Reader*, ed. John Storey (New York: Routledge, 2008). Following Hall's definition of "popular culture" as contested cultural terrain, I understand the slave narrative to be a cultural formation structured by influences and antagonisms

often outside the narrative frame. Hall offers three related but distinct definitions of 'the popular,' each of which has a particular resonance with the slave narrative. The first, which many cultural studies critics shy away from, is the 'market' or commercial definition: objects or cultural forms that "masses of people consume or enjoy to the full." This definition is incomplete or problematic according to Hall because it implies a top-down structure of cultural influence in which cultural products are considered "an up-dated form of the opium of the people" (232). The second definition Hall calls the 'descriptive' or 'anthropological' definition, that which is 'of the people.' The central distinction "of the people" and "not of the people" around which this definition is organized is unsatisfactory because culture is never a static catalogue; cultural objects and cultural forms are constantly re-signified, appropriated, or transformed such that popular forms become enhanced or decrease in cultural value over time. Something considered 'popular' in one instance can be 'elite' in the next and vice versa. The definition Hall settles on, then, is popular as a contested cultural terrain: a model or definition of the popular which looks at those forms and activities in a particular period which have their roots in the social and material conditions of particular classes and which have been embodied in popular traditions and practices (234–235).

52. Saidiya Hartman, *Lose Your Mother: A Journey Along the Atlantic Slave Route* (New York: Farrar, Straus and Giroux, 2007), 6.

53. Ian Baucom, *Specters of the Atlantic: Finance Capital, Slavery, and the Philosophy of History* (Durham: Duke University Press, 2005), 18.

54. Baucom, 18, 23.

55. Baucom, 16.

56. See Walter Johnson, *Soul by Soul: Life Inside the Antebellum Slave Market* (Cambridge: Harvard University Press, 1999), particularly his "Introduction: A Person with a Price" and Chapter 5, "Reading Bodies and Marking Race."

57. Huey Copeland, *Bound to Appear: Art, Slavery, and the Site of Blackness in Multicultural America* (Chicago: University of Chicago Press, 2013), 6–7.

58. Keizer, 4; Brooks, 20; Chaney, 7; Wilson, 9; Salamishah Tillet, *Sites of Slavery: Citizenship and Racial Democracy in the Post–Civil Rights Imagination* (Durham: Duke University Press, 2012), 3.

59. For example, in a review article in the *New York Times*, Orlando Patterson refers to Kara Walker as "a typical post-black artist," Patterson, "The Post-Black Condition," September 22, 2011. See also Touré, *Who's Afraid of Post-Blackness* (New York: Free Press, 2011), especially his second chapter, "Keep It Real Is a Prison." By all critical accounts, Glenn Ligon and curator Thelma Golden advanced the term "post-Blackness" to mark the contemporaneity of what they understood to be a new phase in black visual arts. According to Touré, "The concept of post-Blackness originated in the art world, articulated in the late nineties by Ligon and his close friend Thelma Golden, the curator of the Studio Museum of Harlem. They felt a new chapter in Black visual arts had been entered, a generational shift had occurred, but didn't know what to call it. 'Post-Black started,' Golden told me, 'as a sort of shorthand between Glenn and me to talk about how artists understood their content as related to their identity and to how they lived their lives as Black people. It seemed to us that what was a set of somewhat simple but incredibly freighted choices in the past were now sort of broken up in so many different ways. And for us that became a way to define things as being post-Black art. And the truth is, it was wildly misunderstood,'" 31. Discussing Kara Walker's work,

artist Kehinde Wiley asserts that it "shoots radically through Blackness by virtue of perversion. . . . It becomes post-Black by running directly toward Blackness," quoted in Touré, 36. See also Richard Schur, "Post-Soul Aesthetics in Contemporary African American Art," *African American Review* 41.4 (Winter 2007): 641–654 and W. Fitzhugh Brundage, "African American Artists Interpret the Civil War in a Post-Soul Age," *Remixing the Civil War: Reflections on the Sesquicentennial* (Baltimore: Johns Hopkins University Press, 2011): 156–179. Although Copeland does not use the term "post-soul," he gathers these artists "generationally and conceptually by a shared investment in critical artistic strategies developed since the 1960s, and their nearly simultaneous turn toward slavery in large-scale installations executed between 1991 and 1993" (Copeland, 4).

60. On the literary history of the slave narrative, see Charles Davis and Henry Louis Gates, Jr.'s *The Slave's Narrative*. On the historical turn to see history "from the bottom up," see Ashraf Rushdy's *Neo-Slave Narratives*.

61. Adapting Bernard Bell's term "neoslave narratives," Rushdy examines the strategic resonance of the slave narrative for a post–Civil Rights Black Power movement. Expanding the critical conversation begun by Bell and Rushdy, Arlene Keizer uses the term "contemporary narratives of slavery" to address figurations of slavery in contemporary African American and Anglophone-Caribbean literature. Like Rushdy, Keizer argues that contemporary narratives of slavery coincided with historiographic and political shifts of the 1960s, most notably the impetus to produce history "from the bottom up" (Keizer, 8); however, she understands the emergence of these narratives to mark more than the creation of a new black political subject and provides a psychological account of their emergence.

62. See Sekora, and Robert Stepto's "I Rose and Found My Voice."

63. Keizer, 5.

64. Rushdy, 7; Keizer, 10.

65. See, in particular, Sekora's "Black Message/White Envelope."

66. As Keizer notes, "black identity in the Americas, from slavery to the present, has never been a fixed essence, either biological or cultural, but instead consistently marked by fragmentation and differentiation" (11).

67. English, 89.

68. John Berger, *Ways of Seeing* (New York: Penguin Books, 1991). On the interrelationship between the slave narrative and early photography see Smith and Wallace's *Pictures and Progress* and Dinius's *The Camera and the Press*. In her essay for *Pictures and Progress*, "'A More Perfect Likeness': Frederick Douglass and the Image of the Nation," Laura Wexler writes that "During slavery, Douglass heard in the click of the shutter a promise of the shackle's release. If black people could appropriate by means of the camera the power of objectification that slavery wielded, photography would become an agent of radical social change" (Wexler, 18).

69. As Olney notes, the ex-slave narrator must "give a picture of 'slavery *as it is*' . . . maintain[ing] that he exercises a clear-glass, neutral memory that is neither creative nor faulty" (48). Downplaying his role in shaping or giving meaning to the events related in the narrative, the ex-slave narrator creates the illusion of unmediated truth.

70. Roland Barthes, *Camera Lucida: Reflections on Photography*, trans. Richard Howard (New York: Hill and Wang, 1980), 106.

71. Ibid., 106.

72. Ibid., 115.

73. Ibid., 93. In her essay in *Pictures and Progress*, Laura Wexler compares Frederick Douglass's thoughts on photography to Barthes's in *Camera Lucida*, arguing that "Douglass's ideas critique contemporary representations of death as the ultimate truth of the photographic image" (Wexler, 29).

74. Hartman also frames the presentation of black suffering, a staple of abolitionist argumentation, in visual terms, arguing that it participates in a "racist optics in which black flesh is itself identified as the source of opacity, the denial of black humanity, and the effacement of sentience integral to the wanton use of the captive body" (Hartman, 20).

75. Wexler, 31–32. For another excellent reading of Barthes's use of William Casby's portrait, see Enwezor Okwui and Octavio Zaya, "Colonial Imaginary, Tropes of Disruption: History, Culture, and Representation in the Works of African Photographers," in *In/Sight: African Photographers, 1940 to the Present* (New York: Solomon Guggenheim Foundation, 1996). Okwui and Zaya write that the caption of the photo, *William Casby, Born a Slave*, identifies this as "less a portrait than a sociological and anthropological study. The title points to the limitations of the photograph as a carrier of truth, for [it] needs the stabilizing factor of language employed not for clarification or as a source of knowledge but solely for the viewer's delectation," (25). I would disagree that the portrait is a "stabilizing factor" and read this, alternatively, as an example of the limits on *both* the image and the caption to convey truth.

76. Foreman also addresses the Avedon picture's limitations as a "truth-telling icon" in relation to her discussion of the engraving of Louisa Picquet in Mattison's *The Octoroon*: "Enwezor Okwui and Octavio Zaya's reading of Richard Avedon's photo 'William Casby, born a slave,' the important portrait reproduced in Roland Barthes's *Camera Lucida*, helps to clarify Mattison's process. They suggest that the 'important linguistic signifier,' the title 'William Casby, born a slave,' clearly announces this 'is less a portrait than a sociological and anthropological study. The title points to the limitations of the photograph as a carrier of truth, for [it] needs the stabilizing factor of language employed not for clarification or as a source of knowledge but solely for the viewer's delectation' (25)," 517.

77. Wexler, 31.

1 / Sight Unseen: Contemporary Visual Slave Narratives

1. Saidiya Hartman, *Scenes of Subjection: Terror, Slavery, and Self-Making in Nineteenth-Century America* (New York: Oxford University Press, 1997), 3.

2. Fred Moten, *In the Break: The Aesthetics of the Black Radical Tradition* (Minneapolis: University of Minnesota Press, 2003), 5.

3. Hartman, 5.

4. On the significance of author portraits in slave narratives see Lynn Casmier-Paz, "Slave Narratives and the Rhetoric of Author Portraiture," *New Literary History*, 34.1 (Winter 2003): 91–116, 91.

5. On the problematic nature of the category "black art" see Darby English, *How to See a Work of Art in Total Darkness* (Cambridge: MIT Press, 2007) and Huey Copeland, *Bound to Appear: Art, Slavery, and the Site of Blackness in Multicultural America* (Chicago: University of Chicago Press, 2013). Like English, I "refuse . . . the contention that 'African-American art [is] a distinct form of expression,' by isolating specific

practices, even specific aspects of them, where the engagement of conventions, themes, problems, and tactics derived from a variety of art historical and sociopolitical contexts does not simply embarrass claims of distinctness but, far more consequently, satisfies the representational demands of artists for whom the question of cultural position is not given, but historically and socially shaped and, to a degree, a matter of preference," (English, 7).

6. On Ligon's text paintings see English and Richard Meyer, "Borrowed Voices: Glenn Ligon and the Force of Language," in *Glenn Ligon: Un/becoming*, ed. Judith Tannenbaum (Philadelphia: Institute of Contemporary Art, 1997), 13–36; Huey Copeland, "Glenn Ligon and Other Runaway Subjects," *Representations* 113.1 (2011): 73–110; and Copeland's chapter on Ligon in *Bound to Appear*, 109–152. English writes that "For political subjects whose existence as pictures for others is a kind of general condition, not to mention a nauseating and often catastrophic one, the fetishization of surface, or indeed any aesthetics that prescribes its supervaluation, presents a serious problem. The text paintings forestall such a closure (to a degree) by withholding the kind of surface that stops an image at its borders and, by extension, seals off the viewer at hers" (English, 211). The stencil paintings, often called his "door paintings" because he initially painted them on doors before switching to canvas, transform both language and the body (suggested by the work's dimensions and textual referent) into abstractions.

7. Writing on the figural retreat within African American art, and Ligon's art in particular, English writes that "'authority . . . is connected with the privilege to suppress and protect the body and the reference to social constraints the body inevitably unleashes and all the more voluminously for black artists.' For Ligon, no such privilege existed, and this amounted to a social constraint that warranted referencing" (206).

8. Copeland, 129.

9. Hilarie M. Sheets, "Cut It Out!" *ARTnews*, 01 April 2002. Web. 30 August 2012. Touré also describes Walker's work as "fantasy and nightmare slave narratives," noting that "Walker says she sees herself as the master, her figures as her slaves, and her canvas as the plantation" in *Who's Afraid of Post-Blackness* (New York: Free Press, 2011), 34, 35. Walker amplifies this aspect of her work in interviews, using the term "slave narrative" to discuss features of her personal history, such as "gaining her artistic freedom by 'escaping North' [from suburban Atlanta] to graduate school in Providence" in Gwendolyn DuBois Shaw, *Seeing the Unspeakable: The Art of Kara Walker* (Durham: Duke University Press, 2004), 19; or describing her works as derived from her "inner plantation," in Darby English, *How to See a Work of Art in Total Darkness* (Cambridge: MIT Press, 2007), 97. Glenn Ligon, *Narratives*, 1993. Prints, Exhibited at Max Protetch Gallery, Fall 1993; Glenn Ligon, *Runaways*, 1993. Prints, Exhibited at Max Protetch Gallery, Summer 2002; Kara Walker, *Gone: An Historical Romance of a Civil War as It Occurred Between the Dusky Thighs of One Negress and Her Heart*, 1994. Cut Paper and adhesive on wall, 13 ' 50 feet, featured in *Selections Fall 1994: Installations*, September 10–October 22, at New York's Drawing Center; Ellen Driscoll, *The Loophole of Retreat*, Whitney Museum at Phillip Morris, 1991.

10. I borrow the term "race rituals" from Robert Stepto, "I Rose and Found My Voice: Narration, Authentication, and Authorial Control in Four Slave Narratives," in *The Slave's Narrative*, ed. Charles T. Davis and Henry Louis Gates, Jr. (New York: Oxford University Press, 1985): 225–241.

11. See John Sekora, "Black Message/White Envelope: Genre, Authenticity, and Authority in the Antebellum Slave Narrative," *Callaloo* 32 (1987), 482–515.

12. Anne Wagner, "Kara Walker: The Black-White Relations," 101, quoted in Ian Berry et al., *Kara Walker: Narratives of a Negress*, ed. Ian Berry et al. (Cambridge: MIT Press, 2002), 140–167.

13. Lauri Firstenberg, "Neo-Archival and Textual Modes of Production: An Interview with Glenn Ligon," *Art Journal* 60.1 (Spring 2001), 43.

14. Meyer, 15.

15. John Howard Griffin, *Black Like Me* (Boston: Houghton Mifflin, 1961).

16. Thelma Golden, "Everynight," in *Glenn Ligon: Un/becoming*, ed. Judith Tannenbaum (Philadelphia: Institute of Contemporary Art, 1997), 46.

17. Lindon Barrett, *Blackness and Value: Seeing Double* (New York: Cambridge University Press, 1999), 237.

18. Darby English, *How to See a Work of Art in Total Darkness* (Cambridge: MIT Press, 2007), 76. By "terminal structural openness" English means that the inherently dialogic structure of Walker's work in particular is an end in itself. Walker exploits silhouette's ambiguities to keep a variety of binaries in tension, rather leading us to some truth either about slavery or race relations in our contemporary moment.

19. For my understanding of the index and "indexical mediums" I am indebted to Nicholas Mirzoeff, "The Shadow and the Substance: Race, Photography, and the Index," in *Only Skin Deep: Changing Visions of the American Self*, ed. Coco Fusco and Brian Wallis (New York: International Center of Photography/Harry N. Abrams, Inc., 2003), 111–126. Mirzoeff writes "the index is a sign that designates a truly existing thing (in commonsense terms) in the way that a bullet-hole indicates the passing of a bullet" (111). His definition of the index is derived from Charles Sanders Peirce, who writes, "An index is a sign which would, at once, lose the character which makes it a sign if its object were removed, but would not lose that character if there were no interpretant. Such, for example, is a piece of mould with a bullet-hole in it as a sign of a shot; for without the shot there would have been no hole; but there is a hole there, whether anybody has the sense to attribute it to a shot or not." Mieke Bal and Norman Bryson, "Semiotics and Art History," *Art Bulletin* 73, no. 2 (June 1991): 189.

20. Mirzoeff, 112. Mirzoeff argues that contemporary artists may now be "in the best position" to deconstruct the notion of race as index. Mirzoeff takes his title from the caption of the portrait Sojourner Truth circulated at her speaking engagements. He argues that though the body cannot be an index because "there are no biological grounds to distinguish human beings into separate 'races,'" the racialized body nonetheless began to be treated as an index after abolition. While I agree with Mirzoeff that antebellum racism was "intensely ambivalent" about the role of phenotypical characteristics in determining racial designation, a number of antebellum slave narratives, including those by Solomon Northup and William Craft, demonstrate that the "desire to see racially" is not a postbellum invention. However, as the work of the artists under consideration shows, the assumption that race is fixed and visually discernable does not diminish after slavery's abolition.

21. Mirzoeff, 111; Johann Casper Lavater, *L'Art de connaitre les hommes par la physionomie*, Vol. 1, (Depelafol: Paris, 1820), 127, quoted in Lucia Moholy, *A Hundred Years of Photography, 1839–1939* (Harmondsworth, Middlesex: Penguin Books Limited, 1939), 21. It is worth noting here that Walker executes her silhouettes freehand.

22. Judith Tannenbaum, "Introduction," in *Glenn Ligon: Un/becoming*, ed. Judith Tannenbaum (Philadelphia: Institute of Contemporary Art, 1997), 11.

23. Mirzoeff, 111.

24. Robyn Wiegman, *American Anatomies: Theorizing Race and Gender* (Durham: Duke University Press, 1995), 3.

25. Wiegman, 25.

26. English, 88.

27. English, 96. He reads the plantation house as "a magnetizing presence in the formal and metaphoric structure of [Walker's] tableaux," noting that "the place of every other figure present in the scene will be determined by its location on the near side of an impassable rift between itself and that structure. In this way, the house is crucial for establishing the tableaux in the contemporaneity" (132).

28. Walker's interest in overhead projectors is their metonymic relationship to facts: "Overhead projectors are a didactic tool, they're a schoolroom tool. They are about conveying facts. The work that I do is about projecting fictions into those facts," Art in the Twenty-First Century "Stories: Kara Walker," *Art 21*, Season 2, September 2003.

29. English, 126.

30. On "strategic presentism," see English, 113. Although written about Walker's tableaux, English's interpretation of her "strategic presentism" could just as easily be applied to any of the contemporary visual slave narratives under consideration here: "The point, it seems, is to populate a picture of a past with events of subjectivity and desire and see what such a picture shows us about the present" (134).

31. Art in the Twenty-First Century "Stories," *Art 21*, 2:1, September 2003.

32. Casmier-Paz, 92.

33. Augusta Rohrbach, *Truth Stranger Than Fiction: Race, Realism, and the Literary Marketplace* (New York: Palgrave, 2002), xiv.

34. Ibid., 127 n.12.

35. Ibid., 31.

36. Ibid.

37. Kara Walker, interviewed by Hans-Ulrich Obrist, in *Kara Walker: Safety Curtain* 1998/99, exh. Cat. (Vienna: Art Pool, Museum-in-Progress, and Vienna State Opera, 1998), quoted in English, 85.

38. English, 96.

39. Commissioned by the Whitney Museum at Philip Morris (1990–92), the piece blends elements of sculpture and installation to create a site that recalls both the improvised structures of the homeless and the crawlspace inhabited by Harriet Jacobs during her escape from slavery. See Ellen Driscoll, "Ellen Driscoll: The Spokes of the Wheel, Art Work 1991–Present; Artist Statement," 2005. Web. 30 August 2012. http://www.ellendriscoll.net/update/artist_statement.htm.

40. Driscoll has said that "these objects refer to fragments in the text—a child's shirt, a book (because she later wrote one), etc . . . but most importantly they are sufficiently rough-hewn, open-ended, and representational but in varying degrees, crafted from detritus, that they act weirdly as Rorschach images—people project onto the black and white images inside the camera obscura, and start stitching together narratives of their own because the space is so . . . dreamlike and people lose their bearings. So—in a kind of parallel act to Jacobs, viewers engage in narrative-making of their own as they 'read' the flow of images, a reconstruction from scraps—rather than emerging with the Jacobs narrative clear and taut as she later wrote it." From private correspondence with the artist.

41. Michael Chaney, *Fugitive Vision: Slave Image and Black Identity in Antebellum Narrative* (Bloomington: Indiana University Press, 2008). See also Chaney's "Mulatta

Obscura: Camera Tactics and Linda Brent," in *Pictures and Progress: Early Photography and the Making of African American Identity*, ed. Maurice O. Wallace and Shawn Michelle Smith (Durham: Duke University Press, 2012), 109–131.

42. Chaney, *Fugitive Vision*, 173.

43. Ibid., 168.

44. On Jacobs's use of the metaphor of the "loophole of retreat" see Sarah Blackwood, "Fugitive Obscura: Runaway Slave Portraiture and Early Photographic Technology," *American Literature* 81.1 (2009): 93–125 and Franny Nudelman, "Harriet Jacobs and the Sentimental Politics of Female Suffering," *ELH* 59.4 (1992): 939–964.

45. Although it is important to note that she never figures her "peeping" as abstract or disembodied, but rather "an altered version of the camera obscura observer (the fugitive female slave) yields surprising reversals of the slave system by visually capturing her would-be captor," Chaney, 168.

46. See note 40 for full context for this citation, from private correspondence with the artist.

47. I thank Anna Marie Anastasi for this insight.

48. English writes that the plantation house is "[a]rguably the most durable and evocative synthetic icon in artistic and literary representations of slavery" (132).

49. Harriet Jacobs, *Incidents in the Life of a Slave Girl* (New York: Oxford University Press, 1988), 175.

50. Ibid., 15.

51. Ibid.; Chaney, *Fugitive Vision*, 155.

52. Sidonie Smith, "Resisting the Gaze of Embodiment: Women's Autobiography in the Nineteenth Century," in *American Women's Autobiography: Fea(s)ts of Memory*, ed. Margo Culley (Madison: University of Wisconsin Press: 1992), 75–110, quoted in Chaney, *Fugitive Vision*, 166. On the use of sound as a disruption of the visual priority within slave narratives see Fred Moten, "Resistance of the Object: Aunt Hester's Scream," in *In the Break: The Aesthetics of the Black Radical Tradition* (Minneapolis: University of Minnesota Press, 2003). Moten is "interested in the convergence of blackness and the irreducible sound of necessarily visual performance at the scene of objection" (Moten, 1).

53. Walter Johnson, *Soul By Soul: Life Inside the Antebellum Slave Market* (Cambridge: Harvard University Press, 1999), 150.

54. See Casmier-Paz and James Olney, "'I Was Born': Slave Narratives, Their Status as Autobiography and as Literature," *Callaloo* 20 (Winter, 1984), 46–73. Olney writes, "The portrait and the signature, . . . like the prefatory and appended letters, the titular tag 'Written by Himself,' and the standard opening 'I was born,' are intended to attest to the real existence of a narrator, the sense being that the status of the narrative will be continually called into doubt, so it cannot even begin, until the narrator's real existence is firmly established. Of course the argument of the slave narratives is that the events narrated are factual and truthful and that they all really happened to the narrator, but this is a second-stage argument; prior to the claim of truthfulness is the simple, existential claim: 'I exist'" (52).

55. Meyer, 13.

56. Glenn Ligon, Interview with Patricia Bickers, in *Yourself in the World: Selected Writings and Interviews*, ed. Scott Rothkopf (New York: Whitney Museum of Art, 2011), 168. On representation of the body in slave narratives see Lindon Barrett,

"African-American Slave Narratives: Literacy, the Body, Authority," *American Literary History* 7.3 (1995): 415–442. On Ligon's use of text in relation to debates on figural representation see his interview with Patricia Bickers, reprinted in Glenn Ligon, *Yourself in the World*.

57. Hartman, 3.

58. Meyer, 17.

59. On stock typographic images of runaways see Marcus Wood, *Blind Memory: Visual Representations of Slavery in England and America 1780–1865* (New York: Routledge, 2000).

60. See Barrett's essays "African-American Slave Narratives" and "Hand-Writing: Legibility and the White Body in *Running a Thousand Miles for Freedom*," *American Literature* 69.2 (1997): 315–336.

61. It is important to note that Douglass recognizes blackness as an ideological construct which contains a wide range of complexions, but which is legally enforced by the law that the child follows the condition of the mother, and socially and economically enforced through visual speculation: the visual assessment of slaves which results in a fixed racial identity and a particular value on the market. Rather than lessening their abuse, an assessment of lighter skin is read as a sign of the master's sexual misconduct and makes slaves more vulnerable to abuse and sale. Douglass emphasizes the role of sight in circumscribing these slaves' lives when he writes that a slaveholding mistress "is never better pleased than when she sees ['this class of slaves'] under the lash." If a master does not sell these slaves, he "must stand by and see one white son tie up his brother, of but few shades darker complexion than himself." See Frederick Douglass, *Narrative of the Life of Frederick Douglass, An American Slave, Written by Himself* (New Haven: Yale University Press, 2001), 15.

62. In his essay in *Pictures and Progress*, "Framing the Black Soldier: Image, Uplift, and the Duplicity of Pictures," Maurice O. Wallace reads the chiastic structure of early African American literature as parallel to and an extension of early African American visual culture. Offering a case study of two portraits of Hubbard Pryor, an enlisted former slave, Wallace argues that the calculated juxtaposition of Hubbard as "slave" and "soldier" "visually approximat[es] the verbal chiasmus, and its underlying logic of binary opposition, made famous in African American abolitionist discourse by Frederick Douglass" (251). He writes, "[w]hereas the terms *black* and *man* could hardly create a politically meaningful syntax together before emancipation, the black soldier portrait envisaged the possibility of a spectacular new grammar and social logic" (247). Wallace's case study provides an important historical counterpoint to what I argue Douglass accomplishes in his narrative. I claim that Douglass recognizes the potentially damaging implications of verbally and visually representing the transition from enslaved to free via the acquisition of literacy—specifically, he recognizes the problematic aspects of providing evidence of humanity where it should be self-evident—and that he uses visual rhetoric to interrupt and trouble the symbolic function of literacy, thereby implicitly challenging the chiastic structure of the narrative. In other words, even while Douglass fulfills the requirements of the slave narrative arc progressing from object to subject via the mechanics of literacy, his use of visual rhetoric suggests that he has not actually transformed, but rather that we now *see* him differently. Like Douglass's verbal chiasmus, the visual chiasmus identified by Wallace ultimately presents an insufficient claim on liberation because the photographs are read, in their

juxtaposition, in a manner dangerously detached from history, "misrepresenting the material reality from which they are extricated out of time and put '*in the service of specific vested interests*,'" (258).

63. Douglass, 16, 54.

64. Ibid., 50.

65. Ibid., 16.

66. Ibid., 17.

67. Ibid., 16.

68. Ibid. For an important theoretical exchange between Hartman and Moten on the visual/auditory significance of this scene to a black aesthetic tradition see Moten's *In the Break*.

69. Douglass, 54.

70. Ibid., 50.

71. Ibid., 53.

72. Ibid., 71.

73. In constructing the analogy of the chiastic structure of African American portraiture to that of abolitionist discourse, Wallace notes the similar tension between the image as evidence and the image as ideological production:

"while portraits of black soldiers were supposed to visually guarantee black citizenship, they were "visual propaganda" which ironically "hid not only the bodily violence of slavery and its unexpected extension into Union lines . . . but, more subtly, the political and legal disorder around the status of ex-slaves turned soldiers" (258).

"Although the desire of abolitionist audiences to hear the horrors of slavery firsthand was clearly in the interest of authenticating abolitionist claims about the wretchedness of life under the peculiar institution, the call for abolitionists to produce a 'real' slave to give evidence of slavery's inhumanity was also of a piece with the exhibition culture of freaks, missing links, and other human oddities put on view in circus and carnival sideshows" (253).

74. English, 7.

75. Ligon, 75.

76. Robert Reid-Pharr, *Once You Go Black: Choice, Desire, and the Black American Intellectual* (New York: New York University Press, 2007), 37.

77. Ibid., 13.

2 / *Behind the Scenes* and Inside Out: Elizabeth Keckly's Use of the Slave Narrative Form

1. *We Are Your Sisters: Black Women in the Nineteenth Century*, ed. Dorothy Sterling (New York: W. W. Norton, 1984), 245.

2. As I noted in the introduction to this book (note 41), I have chosen to spell Keckly's name as she herself did, rather than the way her name is spelled in her published narrative. I thank Jennifer Fleischner for this historical restoration. In researching her book *Mrs. Lincoln and Mrs. Keckly: The Remarkable Story of the Friendship Between a First Lady and a Former Slave* (New York: Broadway Books, 2003), Fleischner discovered Keckly's original signatures in her own hand on her application for a war pension after her son's death in the Civil War. See Fleischner, 7. I have kept the spelling "Keckley" in references to the published narrative and in quotations from other scholars.

3. Elizabeth Keckley, *Behind the Scenes. Or, Thirty Years a Slave, and Four Years in the White House* (New York: Oxford University Press, 1988), 113.

4. Ibid., xiv.

5. Ibid.

6. Ibid., 313–314.

7. On the significance of Keckly's activism in her narrative, see Lynn Domina, "I Was Re-Elected President: Elizabeth Keckley as Quintessential Patriot in *Behind the Scenes, Or, Thirty Years a Slave and Four Years in the White House*," in *Women's Life-Writing: Finding Voice/Building Community*, ed. Linda S. Coleman (Bowling Green, Ohio: Bowling Green State University Popular Press, 1997), 139–51; and Elizabeth Young, "Black Woman, White House: Race and Redress in Elizabeth Keckley's *Behind the Scenes*," in *Disarming the Nation: Women's Writing and the American Civil War* (Chicago: University of Chicago Press, 1999), 109–148. Domina argues that Keckly's discussion of her leadership of the Contraband Relief Association situates her as a figure parallel to Lincoln, with both being "re-elected President"—Keckly of the CRA and Lincoln of the country: "Writing in 1868, Elizabeth Keckley, a former slave who has become dressmaker to Washington's social elite, has out-Lincolned Lincoln, who had also been reelected but who had been assassinated early in his second term." See Domina, 139. Young also notes that "[s]yntactically and thematically," certain passages in the narrative "[align] Keckley with Lincoln, as parallel figures equally pulled to important locations by the needs of service." See Young, 121. As I will show in this chapter, rather than "out-Lincolning Lincoln," as Domina argues, I understand Keckly to be using a series of parallels, racial reversals, and inversions to show the disparity between black and white access to social power and the fixity of antebellum racial logic in the postbellum social landscape.

8. Robert Stepto, "I Rose and Found My Voice: Narration, Authentication, and Authorial Control in Four Slave Narratives," in *The Slave's Narrative*, ed. Charles T. Davis and Henry Louis Gates, Jr. (New York: Oxford University Press, 1985), 229.

9. On *Behind the Scenes* as a postbellum slave narrative, see William Andrews, "Reunion in the Postbellum Slave Narrative: Frederick Douglass and Elizabeth Keckley," *Black American Literature Forum* 23.1 (1989): 5–16; *Slave Narratives After Slavery*, ed. William Andrews (New York: Oxford University Press, 2011); Francis Smith Foster, "Autobiography After Emancipation: The Example of Elizabeth Keckley," in *Multicultural Autobiography: American Lives*, ed. James R. Payne (Knoxville: Tennessee University Press, 1992), 32–63; and Francis Smith Foster, *Written by Herself: Literary Production by African American Women, 1746–1892* (Bloomington: Indiana University Press, 1993). Andrews cites *Behind the Scenes* as an exception to the general rule that "the narratives of former slaves published after 1865 have attracted relatively few readers," viii. Despite its relative popularity, however, it has received only a fraction of the critical attention directed toward antebellum narratives, such as Harriet Jacobs's *Incidents in the Life of a Slave Girl*. I suggest, here, that one reason for this is its formal idiosyncrasy. While early critics of the narrative such as Andrews and Foster identify *Behind the Scenes* as a slave narrative and take up direct comparisons between it and *Incidents*—with Foster alternatively calling *Behind the Scenes* "autobiography after emancipation" ("Autobiography After Emancipation") and "postbellum slave narration" (*Written by Herself*, 117), and Andrews calling it a "postbellum slave narrative" ("Reunion in the Postbellum Slave Narrative")—more recent critics understand the narrative as a departure. In his introduction to the Schomburg edition of the text, James Olney writes

that "*Behind the Scenes* both is and is not what we might understand by the term slave narrative. Even when it rather briefly is in that mode, its perspective, from after four years in the White House, determines a very different story from one told by someone who has very recently escaped from slavery," xxx. Similarly, in her book *Mastering Slavery: Memory, Family, and Identity in Women's Slave Narratives* (New York: New York University Press, 1996), 93, Jennifer Fleischner cites the narrative's focus on Mary Lincoln as the prime reason for its "unsuitability as a representative text." Like Fleischner's, Domina's reading of the narrative rests on the signal reversal Keckly's text enacts, "revealing to the nation the secrets Mary Todd Lincoln has shared with her," rather than her own secrets; Domina argues that "[b]ecause Keckley published her narrative in 1868, when the concern of the nation was reunification (of white citizens) rather than abolition, she could not reasonably appeal to white readers by stressing either the horrors of slavery or continuing racial inequality. . . . [Thus,] Keckley . . . could not rely exclusively on the genre of slave narrative to create her audience" (140–141). In her discussion of Keckly's use of documentary materials in her narrative, Carme Manuel argues that Keckly's deliberate omission of a biographical sketch of her written by white journalist Mary Clemmer Ames is a direct result of her desire to distinguish the political project of her narrative from the slave narrative, noting Ames's article "mimics the dynamics of a dictated slave narrative." See Carme Manuel, "Elizabeth Keckley's *Behind the Scenes*; or, the "Colored Historian's" Resistance to the Technologies of Power in Postwar America," *African American Review* 44.1–2 (Spring-Summer 2011): 25–48, 38. The most comprehensive critical treatment of the narrative, Young's "Black Woman, White House," notes that "[t]he text has traditionally been discussed primarily for its biographical information about Abraham and Mary Todd Lincoln" and that it "conforms to no one genre, moving among war memoir, presidential biography, domestic novel, and slave narrative" (Young, 118, 125). While Young highlights highly circumscribed conditions of production of the text identical to those faced by ex-slave narrators—"a racist culture that denied not only civility but literary voice to African-Americans except in the most mediated of terms"—she understands *Behind the Scenes* to be first and foremost a Civil War narrative "on a continuum with other black women's texts of the Civil War era," including Mattie Jackson and Frances Rollin: "The Civil War frames internal conflicts in their texts, while the fracture of national identity creates an avenue of entry into national discourses that would otherwise exclude them" (111). By contrast, as this chapter will show, I understand *Behind the Scenes* to be a text unified by its sustained reversal of the race rituals structuring the classic slave narrative, thus staking the narrative as less ambiguous and more activist in its anti-racist position than earlier critical frameworks have allowed.

 10. Keckley, xiv. Andrews argues, compellingly, about the likelihood that Keckly read *Incidents*: "The narratives of Jacobs and Keckley were published only seven years apart by women who lived and worked in the Washington, D.C., area from 1862 to 1865, both of them active participants in relief efforts for the 'contrabands' from the South. The chances of their meeting each other or knowing about each other were more than slight. But even if the two women never met, it seems unlikely that Keckley would never have heard or taken notice of *Incidents*, given the publicity it received in the early 1860s, the public presence of its activist author in Keckley's hometown for three years, and, perhaps most important, the striking parallels between what Jacobs revealed about her slave past and what Keckley knew to be true about her own." See Andrews, "Changing Moral Discourse of Nineteenth-Century African American

Women's Autobiography," in *De-Colonizing the Subject: The Politics of Gender in Women's Autobiography*, eds. Sidonie Smith and Julia Watson (Minneapolis: University of Minnesota Press, 1992), 228. Young, drawing on Fleischner, cites this literary echo as a moment of usurpation and narrative inversion: "Adapting the language of the slave narrative, Keckley turns it against Mary Todd Lincoln. As Jennifer Fleischner argues, in Keckley's descriptions of the First Lady, a 'narrative inversion takes place, in which the 'mistress' comes to be cast in the role of the black slave as Other'" (Young, 136). Also, it should be noted that *Behind the Scenes* was written with white abolitionist amanuensis James Redpath, although his name does not appear anywhere in the publication; thus, when I refer to her "self-penned preface," I mean that the preface—like the narrative itself—is written from her first person perspective.

11. In *Mastering Slavery* Fleischner notes that, "With a title-page describing Mrs. Keckly as 'formerly a slave, but more recently modiste, and friend to Mrs. Lincoln,' *Behind the Scenes* takes as its subject 'the secret history' of Mrs. Lincoln's ill-fated 'old-clothes' sale of 1867, not the secret history of slavery" (93).

12. Narratives of passing or narratives that directly challenge racial constructions of bodily difference, such as William Craft's *Running a Thousand Miles for Freedom*, do not at first seem to fit into this paradigm. However, I argue that ex-slave narrators had to work against the formal requirements of the slave narrative—namely the race rituals performed in the conventions of authentication—which codify racial difference in what Sekora calls the "Black Message/White Envelope" structure of slave narratives. Thus, even a text like Craft's, which concentrates on escape rather than enslavement—representing passing as a way of undermining notions of racial difference—has to contend with the specifically visual assumptions of race upon which traditional conventions of authentication rely. Craft handles this by producing the incongruent image of the fugitive slave speaking as the master, illustrating (as I will show Keckly does) that phenotypical characteristics such as complexion are not facts with fixed meanings, but are constantly shifting social symbols that can be manipulated to various ends. Thus, *Behind the Scenes* represents an advancement of the challenges ex-slave narrators presented to the structures of racial difference codified in the negotiated form of the slave narrative, rather than a radical break from the genre.

13. Rafia Zafar, *We Wear the Mask: African Americans Write American Literature, 1760–1870* (New York: Columbia University Press, 1997), 152. While Keckly's narrative may present an extreme case, Young reminds us that her strategy of absenting her body fits into a pattern of black women's life writing during this period: "Overembodied in racist white culture, black women writers entered into national discourse from a position of rhetorical disembodiment. In contrast to the two-fisted Douglass, the hand of the black woman writer in the Civil War era was positioned as yet another phantom limb" (111).

14. As Olney establishes in both his introduction to Keckly's narrative and his foundational essay, "'I Was Born a Slave': Slave Narratives, Their Status as Autobiography and as Literature," *Callaloo* 20 (Winter 1984): 46–73, the conventions of authentication that structure the slave's narrative work to not only authenticate the veracity of the slave's account, in doubt because of the racial status of the author/narrator, but work to authenticate the very existence of the black subject at their center. That is, the ex-slave narrator must prove not only the truth of her experience of enslavement, but also the truth of the humanity of black subjects to white readers. Insofar as the slave narrative addresses the exclusion of black people from subjectivity, the literary narrative itself

functions as evidence of humanity where blackness is a putative void. Ironically, an assessment of blackness is both a precursor and an obstacle to establishing the veracity of the slave's narrative.

15. Although there is some debate over whether or not Keckly intended to include Mary Lincoln's letters in the narrative (some accounts indicate that editor/amanuensis James Redpath published them against her wishes), the way the letters are handled in the narrative signals Keckly's editorial control to her readership: "Mrs. Lincoln wrote me the incidents of the journey, and the letter describes the story more graphically than I could hope to do. I suppress many passages, as they are of too confidential a nature to be given to the public" (296). In *Behind the Scenes*, Keckly provides the authenticating voice and it is Mrs. Lincoln's character that is at stake: "If I have betrayed confidence in anything I have published, it has been to place Mrs. Lincoln in a better light before the world" (xiv).

16. In *Slave Narratives* Andrews marks the "many tensions and apparent contradictions in *Behind the Scenes*" as the aspect of the narrative that "make it one of the most intriguing and provocative personal narratives in nineteenth-century African American literature" (Andrews, 8). Young's analysis takes the reading of *Behind the Scenes* as a divided text the furthest, arguing that "we can see Keckley's oscillation between condemnation and apology—and the psychic 'splittings' that characterize her narrative as a whole—as a literary version of the Civil War 'border state.'" See Young, 124.

17. Andrews, "Changing Moral Discourse," 235. For readings of *Behind the Scenes* as Keckly's attempt to authorize herself, see Andrews ("Changing Moral Discourse"); Domina; Young; and Michelle Birnbaum, *Race, Work, and Desire in American Literature, 1860–1930* (Cambridge: Cambridge University Press, 2003). My argument differs from these readings in that I read Keckly as not only usurping the role of authenticator but also challenging the requirement of authentication through her racial inversion.

18. Xiomara Santamarina, *Belabored Professions: Narratives of African American Working Womanhood* (Chapel Hill: University of North Carolina Press, 2005), 159. Andrews also argues that "Keckley . . . banked on her reader's respect by recounting her career as a female entrepreneur dedicated not only to her own economic independence but to the advancement of her people." See Andrews, *Slave Narratives*, 7.

19. Fleischner, *Mastering Slavery*, 99.

20. While I argue that the text presents a successful challenge to racialist thinking, I am not arguing that the text was "successful" in terms of positive recognition or monetary compensation for Keckly. Fleischner and Andrews argue that though the narrative "was widely noticed and reviewed in the white press . . . Keckley came to regret the attention, most of it negative, some of it scurrilous, that *Behind the Scenes* received. Feeling betrayed by her white editor, the anti-slavery journalist James Redpath, and convinced that the Lincoln family had turned on her without justification, the author of the most important African American autobiography of the Reconstruction era watched her book fade from view within a few months of its sensational appearance. For the remainder of her thirty-nine years Keckley retreated from the public eye, becoming increasingly reclusive in her later years, partly because of ill health and poverty. She never again wrote for publication. She died in 1907, a resident of the National Home for Destitute Colored Women and Children in Washington, D.C." See Andrews, *Slave Narratives*, 4.

21. In addition to the formal reading I forward in this chapter, Keckly's membership in prominent and politically active black churches in Washington and her leadership in

vigilance societies, which culminated in her founding the Contraband Relief Association in 1862, provides historical evidence to suggest Keckly's political beliefs would not allow her to mistake her individual friendships for more broadly defined social equality.

22. Fleischner, *Mastering Slavery*, 95.

23. Appearing six months after the publication of *Behind the Scenes*, "Behind the Seams" was published anonymously but written by Southern apologist Daniel Ottolengul (sometimes printed as "Ottolengui"). Young also argues that the parody reveals the success of Keckly's critique, noting generally that the mimicry involved in the narrative strategies of parody "ironically intersect[s] with Keckley's own," and more specifically that "while the parody aims to nullify Keckley's text, it ultimately confirms the techniques of *Behind the Scenes*." See Young, 144.

24. Manuel, 27; in her analysis of the narrative's intervention into national iconography Manuel notes, "Daguerreotypes, photographs and cartoons were related to the emergence of new practices of observation and national identity formation."

25. Manuel calls *Behind the Scenes* "an act of black textual signifying on the visual world as created by white America." See Manuel, 27. Young writes that "[f]or black women writers excluded from national discourse by virtue of both race and gender, 'civil wars' involve battling not only the dominant national culture but also *alternative iconographies*—including those constructed by white women and African-American men—that would exclude them as well," (my emphasis); see Young, 111.

26. Ibid., 28.

27. Ibid. On the relationship of new visual technologies, language, and questions of truth see Alan Trachtenberg, "Photography: The Emergence of a Key Word," in *Photography in Nineteenth-Century America*, ed. Martha Sandweiss (New York: H. N. Abrams, 1991). Trachtenberg writes that photography emerged "not just as a practice of picture-making but as a word, a linguistic practice. It was not very long before 'daguerreotype' became a common verb that meant telling the literal truth of things. . . . The very words photography and daguerreotype provided a way of expressing ideas about how the world can be known—about truth and falseness, appearance and reality, accuracy, exactitude, and impartiality" (17).

28. To be clear, as I have been arguing, this is not to suggest that *Behind the Scenes* is a radical break from the slave narrative tradition, but rather that it is an extension or advancement of earlier narrators' strategies of resistance, calling attention to the way white racism is coded into the negotiated form of the slave narrative.

29. See Lindon Barrett, "African-American Slave Narrative: Literacy, the Body, Authority," *American Literary History* 7.3 Imagining a National Culture (1995): 363–374; Carol E. Henderson, *Scarring the Black Body: Race and Representation in African American Literature* (Columbia: University of Missouri Press, 2002); Saidiya Hartman, *Scenes of Subjection: Terror, Slavery, and Self-Making in Nineteenth-Century America* (New York: Oxford University Press, 1997; Robyn Wiegman, *American Anatomies: Theorizing Race and Gender* (Durham: Duke University Press, 1995); and Jeannine DeLombard, "'Eye-Witness to the Cruelty': Southern Violence and Northern Testimony in Frederick Douglass's 1845 *Narrative*," *American Literature* 73.2 (June 2001): 245–275.

30. Hartman, 3. On the unequal propositions of black and white embodiment also see Barrett, who, quoting Elaine Scarry, argues that "[t]he body, within the ideologies of the dominant American community, holds the ultimate terms of identity for African

Americans. As the dominant community would have it, the identity of African Americans is bound up primarily, if not exclusively, with 'the most contracted of spaces, the small circle of living matter'" (Barrett, 6).

31. Henderson, 39.

32. Hartman, 20.

33. Ibid., 20.

34. For example, DeLombard argues that Douglass's violent opening must be read in the context of a narrative trajectory in which he represents his transition from the "embodied subject . . . [of] an 'American slave'" to "the more universal [subject position] of American citizen," (253). Thus, Douglass's early accounts of witnessing violence to the slave body (Hester, Demby) are set against the acts of "testifying, physical autonomy, and Northern freedom" at the narrative's conclusion (253).

35. Hartman, 20.

36. Keckley, 32.

37. Ibid., 32–33.

38. Ibid., 34.

39. Ibid.

40. On silence as a strategy of black female slaves' resistance see Young, 113, 142. It should be noted that while the strategic silences discussed by Young represent one important strategy of resistance, Harryette Mullen claims "talking back" and a vibrant oral tradition are the core of a black female radical tradition extending from nineteenth-century black women's narratives including those by Harriet Jacobs and Harriet Wilson. See Mullen, "Runaway Tongue: Resistant Orality in *Uncle Tom's Cabin, Our Nig, Incidents in the Life of a Slave Girl*, and *Beloved*," in *The Culture of Sentiment: Race, Gender, and Sentimentality in Nineteenth-Century America*, ed. Shirley Samuels (New York: Oxford University Press, 1992). Although Keckly remains silent *during* her abuse, she is not silent *about* the abuse; furthermore, her narrative can and has been interpreted as a "tell-all." As noted earlier, Keckly's contemporary critics criticized her most harshly for speaking out about that which she was expected to remain silent. It is also worth noting, here, that this scene bears an interesting relationship to the account of Harriet Jacobs as an "earwitness" addressed in Chapter 1. Whereas Jacobs turns to aurality to refuse the spectacular logic of black suffering, Keckly remains silent. As my reading here shows, both strategies call attention to the reader's expectation of the spectacle of black suffering and are calculated to rebuke the potential satisfaction the reader anticipates from what Lerone Bennett and Houston A. Baker term the "Negro exhibit," "the public displays of scars and signs of torture that escaped slaves, in silence, presented during their lectures to white Northern audiences," discussed in Barbara McCaskill, "'Yours Very Truly': Ellen Craft—The Fugitive as Text and Artifact," *African American Review* 28.4 (Winter, 1994), 515.

41. Keckley, my emphasis, 34.

42. Barrett, 24.

43. Keckley, 177.

44. Ibid., 178.

45. Ibid., 184.

46. Hartman, 20.

47. Barrett, 325.

48. On the significance of sewing and clothing in *Behind the Scenes*, see also Young, 135; and Manuel, 29–30. Young argues that Keckly "conjoins needle and pen . . . in a

militarized mode of political critique," and Manuel argues that "Keckley did not want to be considered a simple dressmaker (i.e., skillful in her ability to control the mechanics of sewing), but rather a *modiste* (an artist who emphasized her special way of cutting, who could be an arbiter of tastes, etc.)." Young notes that "[i]n postwar America, it is the slaveholder, not the slave, whose state of undress brings humiliation" (134) and that "the sartorial circuitry of *Behind the Scenes* allows Elizabeth Keckley both to dress down her enemies and dress up herself" (135). I agree with this analysis, but read this reversal as part of the larger strategy of reversal Keckly pursues in her inversion of the race rituals of the slave narrative's conventions of authentication; as I have shown, representations of black embodiment constituted a key convention of slave narration that Keckly overturns. Furthermore, I understand Keckly's representation of clothing and her role as modiste not simply as a way of establishing her authority as a tastemaker, but as a way of highlighting the constructedness of visual icons.

49. Barrett, 315.

50. Keckley, 303–304.

51. Ibid., 154.

52. Ibid.

53. Ibid., 154–155.

54. Ibid., xiii, emphasis hers.

55. Ibid., 84.

56. Ibid., 90.

57. Ibid., 87.

58. Ibid., 88.

59. Ibid., 89.

60. In this assertion I am in agreement with Manuel, who in describing Keckly's intervention into visual culture argues that "what characterized the American postwar period in which photographic evidence emerged was a social and racial division 'between the power and privilege of *producing* and *possessing* and the burden of *being* meaning.' . . . *Behind the Scenes* revolts against 'the burden of *being* meaning'" (28).

61. Rumors circulated in the North that Davis had been apprehended in women's clothing attempting to escape capture by the Union army. See Barbara McCaskill, "Introduction: William and Ellen Craft in Transatlantic Literature and Life," in *Running a Thousand Miles for Freedom: The Escape of William and Ellen Craft from Slavery* (Athens, Georgia: University of Georgia Press, 1999), xviii. In her introduction to the Craft narrative McCaskill writes that images of a cross-dressed Davis were meant to denigrate southern masculinity: "When the Union's victory was imminent . . . northern papers lampooned southern men and attacked loyal southern women by depicting cartoons of Jefferson Davis, the President of the Confederacy, dressed in petticoats, and using his disguise to beat a permanent retreat from troops of the Grand Old Army." On rumors of Davis's cross-dressing see also Nina Silber, *The Romance of Reunion: Northerners and the South, 1865–1900* (Chapel Hill: University of North Carolina Press, 1993), 630. Silber argues that images of Davis in drag functioned as "the metaphorical unmanning of Southern aristocracy." For alternative readings of Keckly's incorporation of this scene into her narrative see Manuel, 35; and Young, 132–135.

62. Keckley, 74.

63. Birnbaum, 17.

64. Young, too, argues that "[t]he scene highlights Keckley's own power, placing her at the center of a drama of authentication in which she plays a starring role" (134).

65. Keckley, xiv, my emphasis.

66. Ibid., 141–142.

67. On African American perspectives on reunion and re-unification see Andrews, "Reunion in the Postbellum Slave Narrative."

68. Keckley, 254.

69. Ibid., 254.

70. Ibid., 256.

71. Ibid., 257.

72. Ibid.

73. On literacy and embodiment in the slave narrative see Barrett.

74. Frederick Douglass, *Narrative of the Life of Frederick Douglass, An American Slave, Written by Himself* (New Haven, Yale University Press, 2001), 32.

75. Valerie Smith, *Self-Discovery and Authority in Afro-American Narrative* (Cambridge: Harvard University Press, 1987), 6.

76. Ibid., 2.

77. Ibid., 3.

78. Ibid., 4.

79. Keckley, 217.

80. Ibid., 216.

81. Ibid., 220.

82. Ibid., 217.

83. Ibid., 218.

84. Ibid.

85. On this anxiety and its visual stakes see Shirley Samuels's discussion of pro- and anti-slavery discourse in Samuels, "The Identity of Slavery," in *The Culture of Sentiment: Race, Gender, and Sentimentality in 19th Century America*, ed. Shirley Samuels (New York: Oxford University Press, 1992) and Karen Halttunen on the antebellum world of "appearance" in *Confidence Men and Painted Women: A Study of Middle-class Culture in America, 1830–1870* (New Haven: Yale University Press, 1982).

86. Samuels, 157.

87. Samuels, 157. Young also discusses *Behind the Scenes* as "a world turned upside down" (133).

88. Samuels, 158.

89. Samuels, 163.

90. Samuels, 159.

91. *The Devil in America* (Philadelphia 1860), 23, quoted in Samuels, 158–159.

92. It is important to note that these pseudo-scientific theories were anything but marginal to the national conversation about citizenship, freedom and natural rights. See Clement Clark Moore, *Observations Upon Certain Passages in Mr. Jefferson's Notes on Virginia* (New York: University of Michigan Library, 1804), 20, quoted in Winthrop D. Jordan, *White Over Black: American Attitudes Toward the Negro, 1550–1812* (Chapel Hill: University of North Carolina Press, 1968), 504. Moore summarizes both the justification and implications of the placement of the African American in the Chain of Being as occupying a mediating position between humans (further differentiated by Jefferson into the Man of "rights of Man") and animals: "[T]he intellectual faculties of man were found to set him at such an immense distance from all other animals, that it was absolutely necessary to devise some scheme for filling up the chasm. The resemblance of the bodily structure of the orang-outang [*sic*] to that of the human

species, and the consequent similarity in many of its actions to those of men, were not overlooked; but every art was employed to prove that it was endued with reason, and that it ought to be reckoned a lower order of man. But as there was still a long jump from ape to a man, some happy geniuses bethought them of setting the Africans as a step that would make the transition perfectly easy. So that in the same proportion as the ape was raised above its proper sphere, the inoffensive negro was pulled down from his just rank in the creation."

93. Keckley, 220.

94. Betsey Kickley, (pseudonym), *Behind the Seams* (New York: National News Co., 1868), 17.

95. Keckley, 219.

96. The revised reading lesson highlights what Barrett calls "the spurious homology" between literacy/whiteness and illiteracy/blackness, expressed in Keckly's assertion that an illiterate black boy is understood as a symbol of the intellectual deficit of the whole race, whereas an illiterate white boy is understood in the specificity of his social and familial connections. Tad Lincoln is represented as an individual with social power despite his illiteracy, a circumstance Keckly parodies by addressing Tad as "Master Tad" to highlight the paradox of an illiterate white boy's status as her social superior. Although Tad is not her master, Keckly pointedly placates Tad with mock racial deference. Her address is ironic, but Tad responds in earnest, bowing his head to Keckly "in a patronizing way" (219).

97. Ferdinand de Saussure, *Course in General Linguistics* (New York: McGraw-Hill, 1966), 31.

98. As Keckly notes, Frederick Douglass was the exception eventually made to this rule barring black people from the reception, 158. On 1868 as a period of optimism in African American writing see Andrews's "Reunion in the Postbellum Slave Narrative," 8, in which he writes, "There can be little doubt that both Keckley and Douglass wrote their post–Civil War autobiographies in a mood of optimism and with a sincere desire to use their personal testimony as part of the national healing process that both hoped would follow the Civil War." The argument I have presented here suggests that Andrews overstates Keckly's optimism, despite her representation of an *apparently* rosy reunion with her former owners. On postbellum slave narratives more generally, see Andrews's *Slave Narratives After Slavery*.

99. Keckley, xiv.

100. Keckley, 17–18.

101. Justin Spaulding to Rev. Messrs. Pike and Brooks, Dover, 12 July 1850 in *The Narrative of the Life of Henry Box Brown, Written by Himself*, ed. John Ernest (Chapel Hill: University of North Carolina Press, 2008), 47–48.

3 / Optical Allusions: Textual Visuality in *Running a Thousand Miles for Freedom*

1. *Running a Thousand Miles for Freedom* was first published in London in 1860 by William Tweedie, one of the printers of the *London Anti-Slavery Advocate*, and was reprinted the following year. All quotations in this chapter will be drawn from William Craft, *Running a Thousand Miles for Freedom: The Escape of William and Ellen Craft from Slavery*, ed. R. J. M. Blackett (Baton Rouge: Louisiana State University Press, 1999).

2. Craft, 3–4.

3. Ibid., 10, 3.

4. In her essay "Who's Your Mama? 'White' Mulatta Genealogies, Early Photography, and Anti-Passing Narratives of Slavery and Freedom," *American Literary History* 14.3, An "ALH" Forum: "Race and Antebellum Literature" (Autumn, 2002): 505–539, esp. 522, P. Gabrielle Foreman states that "[c]ritics including [Barbara] McCaskill have noted that the white skin of some slaves acted as a visibly clear symbol of the wrongs of slavery that in itself made the moral suasionist argument without displaying the scars of what Lerone Bennett calls the 'Negro exhibit' of bodily exposure to abolitionist or potentially sympathetic audiences."

5. In the narrative it is William who first comes up with the couple's escape plan, though as Geoffrey Sanborn notes, published accounts of the Crafts' story vary on the degree of Ellen's agency, with some sources attributing the plan entirely to her inspiration. Sanborn, "The Plagiarist's Craft: Fugitivity and Theatricality in *Running a Thousand Miles for Freedom*," *PMLA* 128.4 (October, 2013): 907–922.

6. Craft, 19.

7. Lindon Barrett, "Hand-Writing: Legibility and the White Body in *Running a Thousand Miles for Freedom*," *American Literature* 69.2 (1997): 315–336.

8. Michael Chaney, *Fugitive Vision: Slave Image and Black Identity in Antebellum Narrative* (Bloomington: Indiana University Press, 2008), 109.

9. Elizabeth Keckley, *Behind the Scenes. Or, Thirty Years a Slave, and Four Years in the White House* (New York: Oxford University Press, 1988), 218. I discuss this passage in Chapter 2.

10. Chaney, 109.

11. Foreman, 508–509.

12. Ibid., 526; Amy Robinson, "It Takes One to Know One: Passing and Communities of Common Interest," *Critical Inquiry* 20, no. 4 (1994): 718, quoted in Foreman, 521.

13. Foreman, 527, 506, 508.

14. Ibid., 527.

15. Chaney, 80.

16. Barbara McCaskill, "'Yours Very Truly': Ellen Craft—The Fugitive as Text and Artifact," *African American Review* (Winter 1994): 515.

17. McCaskill, 520.

18. Ibid., 519, 521.

19. Chaney, 10, 85, 101.

20. Foreman, 509.

21. Barrett, 315.

22. Ibid., 315.

23. Ibid., 325.

24. Craft, 24, my emphasis.

25. Ibid., 28, emphasis in the original.

26. Ibid., 26.

27. Ibid., 29.

28. Ibid., 29.

29. Ibid., 32.

30. Teresa C. Zackodnik, *The Mulatta and the Politics of Race* (Jackson: University Press of Mississippi, 2004): 58.

31. Craft, 28.

32. Ibid., 38.

33. Foreman, 529.

34. Barbara Johnson, "Translator Introduction to Jacques Derrida in Dissemination," (Chicago: University of Chicago Press 1981), ix, quoted in Barrett, 325.

35. Barrett, 325.

36. Ibid., 325.

37. Craft, 19.

38. On whiteness as property see Cheryl I. Harris, "Whiteness as Property," *Harvard Law Review* 106.8 (1993), UCLA School of Law Research Paper No. 06–35.

39. Craft, 28–29.

40. Ibid., 29.

41. Ibid.

42. Ibid.

43. Barrett, 333.

44. Ibid., 329.

45. Ibid., 318.

46. Craft, 4.

47. Ibid.

48. George Bourne, *Picture of Slavery in the United States* (Middletown, CT: Edwin Hunt, 1834).

49. Craft, 5–6.

50. Ibid., 5.

51. Ellen M. Weinauer, "'A Most Respectable Looking Gentleman': Passing, Possession, and Transgression in *Running a Thousand Miles for Freedom*," in *Passing and the Fictions of Identity*, ed. Elaine K. Ginsberg (Durham: Duke University Press, 1996), 47.

52. Barrett, 322.

53. Craft, 4.

54. Ibid.

55. Barrett, 320.

56. Craft, 5.

57. Ibid., 28.

58. Ibid., 29.

59. Zackodnik, 51, 50.

60. Ibid., 54.

61. Ibid.

62. Craft, 10; Foreman, 508.

63. Ibid.

64. Ibid., 11.

65. Ibid., 15.

66. Craft, 15.

67. Foreman states explicitly that in slavery "maternity is not connected to sentimental affective desire," for slaveholders. See Foreman, 520.

68. Ibid.

69. Chaney, *Fugitive Vision*.

70. Craft, 8.

71. Ibid.

72. Chaney goes on to argue that when William later sells the engraving of Ellen in her planter disguise in order to raise funds to purchase his family members who

remain in slavery, William "takes the power the auctioneer deprives him of and reinvests the act of seeing with a contrapuntal use value calculated to win control over the legal, social, and physical position of his sister. For Craft the picture of Ellen is a retort to the charge that his seeing has no use." See Chaney, 90. In the reading I advance here, I am interested in the way William positions the likeness of Frank's mother as an internal sentimental symbol within his family that has no "use" for those outside the family circle, thereby circumventing the legitimating function of engravings that often accompany slave narratives, such as that of Ellen on the frontispiece of *Running*.

73. Keckley, *Behind the Scenes*, 24–25. Other examples can be found in Henry Box Brown's *The Narrative of the Life of Henry Box Brown, Written by Himself*; Charles Ball's *Slavery in the United States*; William Wells Brown's *Escape; or a Leap for Freedom*; and *Uncle Tom's Cabin*.

74. Nicholas Mirzoeff, *The Right to Look: A Counterhistory of Visuality* (Durham: Duke University Press, 2011), 1.

75. Craft, 15.

76. This resonates with Foreman's reading of the frontispiece engraving in Hiram Mattison's *Louisa Picquet: An Octoroon*, also published in 1861. Drawing on Enwezor Okwui and Octavio Zaya's reading of Richard Avedon's photo "William Casby, born a slave," which I also read in the introduction to this book, Foreman writes that "They suggest that the 'important linguistic signifier,' the title 'William Casby, born a slave,' clearly announces that this 'is less a portrait than a sociological and anthropological study. The title points to the limitations of the photograph as a carrier of truth, for [it] needs the stabilizing factor of language employed not for clarification or as a source of knowledge but solely for the viewer's delectation.' Likewise, rather than presenting Picquet's face as a truth-telling icon, Mattison's linguistic markers are meant to guide his readers/viewers back to his authority as the meaning-maker of the text," 517.

77. Ruby C. Tapia, *American Pietàs: Visions of Race, Death, and the Maternal* (Minneapolis: University of Minnesota Press, 2011): 131.

78. Ibid., 131–132.

4 / "The Shadow of the Cloud": Racial Speculation and Cultural Vision in Solomon Northup's *Twelve Years a Slave*

1. Solomon Northup, *Twelve Years a Slave. Narrative of Solomon Northup, A Citizen of New-York, Kidnapped in Washington City in 1841, and Rescued in 1853, from a Cotton Plantation Near the Red River in Louisiana* (New York: Penguin Books, 2012).

2. Sam Worely, "Solomon Northup and the Sly Philosophy of the Slave Pen," *Callaloo* 20.1 (1997): 243.

3. See James Olney, "'I Was Born': Slave Narratives, Their Status as Autobiography and as Literature," in *The Slave's Narrative*, ed. Charles T. Davis and Henry Louis Gates, Jr. (New York: Oxford University Press, 1985), 148–175; also Georges Gusdorf, "Conditions and Limits of Autobiography," in *Autobiography: Essays Theoretical and Practical*, ed. James Olney (Princeton: Princeton University Press, 1980), 29–48.

4. Northup, 10–11.

5. Northup informs his readers of the prohibition against black testimony in a sarcastic passage. After his first altercation with Tibeats, Northup's second master, the overseer Chapin, comes to tell Northup that he should sleep in the "great house" for the night. On the way to the protection of the house Chapin informs Northup that

Tibeats "intended to kill [Northup]—and that he did not mean he should do it without witnesses. Had he stabbed me to the heart in the presence of a hundred slaves, not one of them, by the laws of Louisiana, could have given evidence against him" (79–80).

6. John Sekora, "Black Message/White Envelope: Genre, Authenticity, and Authority in the Antebellum Slave Narrative," *Callaloo* 32 (1987): 482–515; and Robert Stepto, "I Rose and Found My Voice: Narration, Authentication, and Authorial Control in Four Slave Narratives," in *The Slave's Narrative*, ed. Charles T. Davis and Henry Louis Gates, Jr. (New York: Oxford University Press, 1985), 483. Writing about the full title of Douglass's narrative, Olney argues, "[t]here is much more to the phrase 'written by himself,' of course, than the mere laconic statement of a fact: it is literally a part of the narrative, becoming an important thematic element in the retelling of the life wherein literacy, identity, and a sense of freedom are all acquired simultaneously and without the first, according to Douglass, the latter two would never have been." See Olney, 54.

7. Northup, 22.

8. Northup, 107.

9. Worely, 10.

10. Ibid., 5.

11. Ibid., 67.

12. See Stepto, 225. Stepto identifies four different phases of slave narration differentiated by the degree to which the various forms of authenticating documents are integrated into the narrative: eclectic, integrated, generic, and authenticating narrative.

13. Ibid., 232.

14. Ibid., 237.

15. Northup, 109.

16. Stepto, 237.

17. I borrow the phrase "the fact of blackness," of course, from Frantz Fanon, *Black Skin, White Masks*, trans. Charles Lam Markmann (New York: Grove Press Inc., 1967).

18. Northup, 45.

19. Ibid., 12.

20. Ibid.

21. Ibid., 41, 164.

22. Ibid., 5.

23. Ibid.

24. Ibid., 41.

25. Ibid., 146.

26. Ibid.

27. Ibid., 8.

28. Ibid., 7.

29. Ibid.

30. Ibid., 173.

31. Worely, 255.

32. Ibid.

33. Northup, 165.

34. His more threatening tone, akin to certain passages in David Walker's *Appeal*, leaves the source of vengeance ambiguous—it is not clear whether the master will cry for mercy at the hands of slaves or at the hands of God. See David Walker, *David Walker's Appeal to the Colored Citizens of the World*, ed. Peter Hinks (Philadelphia: Pennsylvania State University Press, 2000).

35. Douglass, 71.
36. Northup, 5, my emphasis.
37. Olney, 155.
38. Northup, 11.
39. Ibid.
40. Ibid.
41. Ibid.
42. Ibid.
43. Ibid., 13.
44. Ibid., 14.
45. Ibid., 15.
46. Ibid., 8.
47. Ibid.
48. Ibid., 8–9.
49. Ibid., 7.
50. Ibid., 9.
51. Ibid.
52. Ibid., 21–22. It is worth noting that McQueen visualizes this moment, too, panning the camera up from the yard of the slave pen, where enslaved people are washing themselves in preparation for sale, to show the Capitol building dominating the city skyline.
53. Ibid., 31, emphasis in original.
54. The distinction between free white citizens and free black citizens in New York is illustrated by the property qualification imposed on black citizens, including Northup's father Mintus Northup who had acquired "a sufficient property qualification to entitle him to the right of suffrage," 6; Edgar J. McManus notes that until 1821 the property qualification for all voters in New York was $100; that year, however, the qualification rose to $250 for Negroes while it was eliminated for whites. McManus, *A History of Negro Slavery in New York* (Syracuse: Syracuse University Press, 1966), 187.
55. Northup, 206.
56. Ibid., 207.
57. Ibid., 206.
58. Ibid., 151.
59. Ibid., 152.
60. Ibid., 151.
61. Ibid., 149.
62. Ibid., 123.
63. Ibid., 129.
64. Ibid., 150.
65. Ibid.
66. Ibid.
67. Ibid., 151.
68. Ibid.
69. Northup, 147–148.
70. Northup, 149.
71. Ibid.
72. Ibid.
73. Ibid., 201.

74. Ibid.

75. Ibid., 202.

76. Ibid.

77. Ibid, 203.

78. Ibid, 202.

79. Ibid.

80. Frederick Douglass, *The Narrative of the Life of Frederick Douglass, An American Slave, Written by Himself* (New Haven: Yale University Press, 2001), 54.

81. Northup, 203.

82. Ibid.

5 / Gestures Against Movements: Henry Box Brown and Economies of Narrative Performance

1. Jeffrey Ruggles, *The Unboxing of Henry Brown* (Richmond: Library of Virginia, 2013), 48.

2. *Narrative of the Life of Henry Box Brown, Written by Himself*, ed. John Ernest (Chapel Hill: University of North Carolina Press, 2008), 84.

3. Marcus Wood notes that the lithographic print *The Resurrection of Henry Box Brown at Philadelphia* (Boston, January 1850) "became one of the most widely disseminated pictures in the abolition publications of the 1850s, on both sides of the Atlantic." See Wood, *Blind Memory: Visual Representations of Slavery in England and America* (New York: Routledge, 2000), 104. Jeffrey Ruggles provides important historical information about the print, determining that though unsigned, based on the visual style and his involvement in the production of Brown's panorama the *Mirror of Slavery*, it was likely the work of artist Samuel Rowse. See Ruggles, 80–83.

4. Daphne Brooks, *Bodies in Dissent: Spectacular Performances of Race and Freedom, 1850–1910* (Durham: Duke University Press, 2006), 67.

5. Wood, 103.

6. See note 3; Brooks argues that Brown's panorama (discussed later) is an extension of the box which closed the 1849 narrative and "provides an intervention in white abolitionist constrictions on black authorship and strategies of fugitive slave cultural and political expression." See Brooks, 77.

7. Brooks, 74.

8. Ibid., 101. To raise enough funds for the *Mirror of Slavery*, Brown supplemented the proceeds from his narrative with funds he solicited at his speaking engagements beginning December 1849. Ruggles notes that "six names—Brown, Smith, Stearns, Wolcott, Rowse, and Johnston—can be linked to some degree to the creation of the panorama." See Ruggles, 75. After facing jail time in Richmond for his role in aiding slaves' escape in Virginia, James Smith joined Brown in the North and traveled with him as a partner in his speaking tour, often conducting correspondence as he was literate and Brown was not (Ruggles, 73). While Wolcott is acknowledged to be the primary artist on the project, a Liverpool newspaper also named "Rouse and Johnson" as contributing artists; Ruggles has identified them as likely Samuel Worcester Rowse and David Claypoole Johnston (Ruggles, 74).

9. Brooks, 69, 68. It is worth noting that in the same chapter in which he discusses Brown, "The Rhetoric of the Runaway," Wood writes about the status of images in the *Narrative of the Life and Adventures of Henry Bibb, An American Slave, Written*

by Himself in the same way. Wood argues that "the deployment of pictures in slave narrative can resist, or recast, the established illustrational and graphic codes which permeate white abolition publication. . . . It is my contention that the peculiar status of the images used in Bibb's narrative violently challenges the audience, but that this challenge was not taken up by contemporary readers." See Wood, 118.

10. John Ernest writes that Stearns "speaks for Brown, and . . . uses his role as Brown to introduce his own essay." See Brooks, 73. On Stearns's edition as overwritten, constrained, etc., see Ruggles, 59–65; Brooks, 69–77; John Ernest, "Introduction," in *Narrative of the Life of Henry Box Brown, Written by Himself*, ed. John Ernest (Chapel Hill: University of North Carolina Press, 2008), 24–28. Ruggles contends, "Brown was not educated and his reading and writing skills probably never exceeded the rudimentary." See Ruggles, 173. While he was in partnership with Smith, Smith handled his correspondence.

11. Ernest, "Introduction," 26.

12. James Olney, "'I Was Born': Slave Narratives, Their Status as Autobiography and as Literature," in *The Slave's Narrative*, 161.

13. Ruggles, 129, 132.

14. Brooks, 71.

15. Wood, 105. Valerie Smith, "Loopholes of Retreat," in *Reading Black, Reading Feminist*, ed. Henry Louis Gates, Jr. (New York: Meridian, 1990), 212.

16. This valence of the term draws explicitly on theater studies. See T. J. Taylor, "Texting the Fugitive Performance," *Theatre Survey* 22.2 (November 1981): 177–183, 177.

17. Addressing the inextricable nature of Brown's speeches and narratives, and answering James Olney's speculation that there might have been an as-yet unidentified "ur-text lying behind both" the 1849 and 1851 versions of Brown's narrative, Ruggles writes that "[t]he text of the 1851 *Narrative* . . . was more likely a revision made in response to the criticisms of Charles Stearns's excesses in the 1849 edition. If there was an 'ur-text' for the two editions of Brown's *Narrative*, it was probably unwritten. The short time that Brown had been in the North, his activity during that time, and his illiteracy preclude a written ur-text from which Stearns could draw for the 1849 *Narrative*. . . . The ur-text for both *Narratives* was likely Brown's oral account," (Ruggles, 194–195 n. 52).

18. Frederick Douglass, *My Bondage and My Freedom*, ed. John David Smith (New York: Penguin Books, 2003), 266. In her essay "'Most Fitting Companions': Making Mixed-Race Bodies Visible in Antebellum Public Spaces," *Theatre Survey* 56.2 (May 2015): 138–165, Lisa Merrill writes that "[h]istorian William McFeely has described the relationships between white Bostonian abolitionists and black men in the abolitionist movement . . . as essentially analogous to that between a theatre director and a fledgling out-of-town actor, claiming that 'black anti-slavery speakers were always treated as visiting artists in a production of which the white Bostonians never dreamed of losing direction.'" See Merrill, 146. The essay goes on to present archival research revealing important departures from this dynamic, which I argue further demonstrates the analogy between fugitive speakers and ex-slave narrators, and the usefulness of a term such as "fugitive performance" to describe black speakers' and narrators' negotiations with structures of white abolitionist control in a variety of contexts.

19. Reprinted in the *Liberator*, 29 June 1849.

20. *Liberator*, 29 June 1849.

21. See Merrill on this.

22. Brooks, 69.

23. I take this terminology from Brooks, who argues that "Box Brown's narrative must be read as a living document *in struggle* and one which is (willfully) trapped in a repeating negotiation of confinement and bold flight." See Brooks, 77.

24. Not only does the *Mirror of Slavery* no longer exist, but "[u]nlike other black antislavery panorama exhibitions, no accompanying pamphlets, pictorial reproductions, or theatrical documents such as programs or posters remain from Box Brown's exhibition. Hence, the bulk of the information on the *Mirror of Slavery* has been culled from surviving newspaper advertisements, articles, reviews, and descriptions of the exhibition which surface in abolitionist epistolary exchanges." See Brooks, 86. *The Liberator* published a description of the scenes on May 3, 1850, which critics have used as a kind of key to infer what the panorama depicted.

25. Ruggles notes that "Henry Box Brown's *Mirror of Slavery* was the first anti-slavery panorama in the United States, but at least two others preceded it in Britain": white American Reverend W. H. Irwin's *Panoramic Exhibition of American Slavery*—produced in the U.S. and exhibited in the U.K.—and William Wells Brown's *Original Panoramic Views of the Scenes in the Life of an American Slave*, exhibited in the U.K., 119. For more on panorama in Britain, see Tanya Agathocleous, "The Sketch and the Panorama: Wordsworth, Dickens, and the Emergence of Cosmopolitan Realism," in *Urban Realism and the Cosmopolitan Imagination in the Nineteenth Century: Visible City, Invisible World* (New York: Cambridge University Press, 2013).

26. Robert Stepto, "I Rose and Found My Voice: Narration, Authentication, and Authorial Control in Four Slave Narratives," in *The Slave's Narrative*, ed. Charles T. Davis and Henry Louis Gates, Jr. (New York: Oxford University Press, 1985), 225–241.

27. Quote adapted from the prefatory letter by James Miller McKim introducing the 1851 *Narrative of the Life of Henry Box Brown, Written by Himself*, ed. John Ernest (Chapel Hill: University of North Carolina Press, 2008), 47. For the most in-depth account of "visuality as the supplement to authority" in slavery see Nicholas Mirzoeff, *The Right to Look: A Counterhistory of Visuality* (Durham: Duke University Press, 2011), 10.

28. I am using "countervisuality" in the way Mirzoeff does in *The Right to Look*. Rigorously historicizing "visuality," Mirzoeff provides "a critical genealogy for the resistance to the society of the spectacle and the image wars of recent decades" (xiv). He writes, "visuality is not the visible, or even the social fact of the visible, as many of us had long assumed" (iii). "*Visuality* is an old word for an old project. It is not a trendy theory word meaning the totality of all visual images and devices, but is in fact an early-nineteenth-century term meaning the visualization of history. . . . Visuality's first domains were the slave plantation, monitored by the surveillance of the overseer, operating as the surrogate of the sovereign" (2). Drawing on Rancière, Mirzoeff defines countervisuality, then, as "the dissensus with visuality, meaning 'a dispute over what is visible as an element of a situation, over which visible elements belong to what is common, over the capacity of subjects to designate this common and argue for it'" (24).

29. Ruggles, 40–46. On the debate over the wisdom of publicizing stories of escape, such as Brown's, see Ruggles, 54.

30. The focus of this chapter is on the ways the white-dominated abolitionist movement objectified fugitives and ex-slaves by treating them as evidence, but see Merrill

for an important account of how fugitive speakers'—and particularly mixed-race fugitives from slavery—used this positioning to their advantage in a variety of trans-atlantic abolitionist performance contexts. Merrill writes, "In Britain, [William and Ellen Craft], and [William Wells] Brown, made antislavery appeals and appeared in a range of public spaces and in private homes, where they presented themselves as living exhibits of the horrors of slavery" (141).

31. Ruggles, 49.

32. Ibid.

33. *Liberator*, 1 June 1849.

34. Ibid.

35. Reported in both the *Liberator*, 8 June 1849, and *The North Star*, 15 June 1849. In addition to Brown, William Wells Brown, Frederick Douglass, and William Craft—all fugitives from slavery—also spoke at the convention (Ruggles, 48). Although May was not at the Pennsylvania Anti-Slavery Office when Brown arrived in his box, thus not an immediate witness to Brown's "resurrection," he was staying at James and Lucretia Mott's house where Brown was taken to recuperate from his harrowing journey (Ruggles, 36–37). As he says in his speech, "I happened to be in the city of Philadelphia . . . in the midst of the excitement that was caused by the arrival of a man in a box" (*Liberator*, 8 June 1849).

36. John Sekora, "Black Message/White Envelope: Genre, Authenticity, and Authority in the Antebellum Slave Narrative," *Callaloo* 32 (1987): 482–515.

37. May's complete speech was reprinted in the *Liberator*, 8 June 1849.

38. *Liberator*, 8 June 1849.

39. Margot Minardi, *Making Slavery History: Abolitionism and the Politics of Memory in Massachusetts* (New York: Oxford University Press, 2010), 92.

40. Wendell Phillips to Elizabeth Pease, 29 August 1847, in Garrison Papers quoted by Jane and William Pease, *They Who Would Be Free* (Urbana: University of Illinois Press), 11.

41. *Liberator*, 8 June 1949.

42. Ibid.

43. *Liberator*, 29 June 1849.

44. Ibid.

45. *Boston Emancipator & Republican*, 7 June 1849.

46. Reprinted in *Boston Emancipator & Republican*, 7 June 1849, qtd. in Ruggles, 51 n. 192.

47. *Narrative of the Life of Henry Box Brown, Written by Himself*, ed. John Ernest (Chapel Hill: University of North Carolina Press, 2008), 153.

48. Ruggles, 124.

49. May to Joseph Estlin, 21 May 1849, quoted in Sekora, "Black Message/White Envelope," 505.

50. Ruggles, 122.

51. Ibid., 139–140.

52. Brooks, 78.

53. Ruggles, 93.

54. *Bolton Chronicle and South Lancashire Advertiser*, 8 February 1851, qtd. in Ruggles, 126.

55. *Leeds Mercury*, 19 April 1851, qtd. in Ruggles, 127.

56. Brown and Stearns, 14; Brooks, 71; Brown and Stearns, 11.

57. Brown, 51.

58. Ibid.

59. In his chapter on William Wells Brown and "Panoramic Bodies," Michael Chaney discusses Brown's strategies in similar terms. Specifically, he interprets Brown's inclusion of an iron slave collar shown at the end of the exhibition of his panorama, *Original Panoramic Views of the Scenes in the Life of an American Slave* (1850): "[William Wells] Brown combated white supremacist associations of degradation and blackness by highlighting the social conditions that erroneously confer upon those who are slaves the semblance of being essentially suited to slavery. In Brown's re-circuitry of the affective charge of slavery, revulsion is wired to the instruments of domination, as opposed to the visible difference of the dominated. To Brown, the chain and the collar, rather than black skin, are the proper emblems of the degradation that enslavement brings about" (Chaney, 146).

60. Brown, 96. This law could be drawn from the Maryland slave codes. See William Goodell, *The American Slave Code in Theory and Practice: Its Distinctive Features Shown by Its Statues, Judicial Decisions, and Illustrative Facts* (New York: American and Foreign Anti-Slavery Society, 1853): "By the law of Maryland, for 'rambling, riding, or going abroad in the night, or riding horses in the daytime without leave, a slave may be *whipt*, *cropped*, or *branded* on the cheek with the letter R, or otherwise punished, not extending to life, *or so as to unfit him for labor*'" (Goodell, 229).

61. Brown, 42. Many slave narratives express what Brooks calls the "crisis" that arises around "how to negotiate the void between the experience of slavery and its representation," (Brooks, 127); but it is worth highlighting the parallel between Brown and Henry Bibb in particular, as Ruggles has shown that Brown drew directly on the images included in Bibb's text for the constitution of his panorama. In the *Narrative of the Life and Adventures of Henry Bibb, An American Slave, Written by Himself*, Bibb writes, "Reader, believe me when I say that no tongue, nor pen, ever has or can express the horrors of American Slavery. Consequently I despair in finding language to express adequately the deep feeling of my soul, as I contemplate the past history of my life" (Bibb, 15).

62. Brown, 42.

63. Ibid., 51, my emphasis.

64. Ibid., 93.

65. Ibid., 42.

66. Ibid., 61.

67. Ibid., 45, 49.

68. Ibid., 46.

69. Ibid., 46–47.

70. Ernest notes that this is probably the "Reverend Justin Spaulding, a Methodist minister and missionary." See Ernest, 98 n. 10.

71. Brown 47–48.

72. Ibid., 45. The letter is signed by "M. McCroy," but Ernest verifies that it "was sent by James Miller McKim. . . . Most likely, the name here is changed to protect the Pennsylvania Anti-Slavery Society in its efforts to help fugitive slaves. Note that he leads into the next published letter, in which McKim's name is mentioned, by making it seem as though Brown came to McKim's attention only after 'the report of Mr. Brown's escape spread far and wide.'" See Ernest 97 n.7.

73. Brown, 53.

74. Ibid., 54.

75. Ibid., 54.

76. Brooks, 74.

77. Brown, 53.

78. Mirzoeff, 10.

79. Ibid.

80. Brown, 52–53.

81. Mirzoeff, 3.

82. Brown, 52. While critics have cited this passage as an example of the overblown language unlikely to be the authentic voice of the enslaved, Brown retains this wording from the 1849 narrative in the 1851 version.

83. Wood, 116; Brooks, 126.

84. Brooks, 128, 127.

85. Ibid., 127.

86. Brooks, 127.

87. Ibid., 94.

88. Ibid., 128

89. Sekora, 511.

90. Wood writes that "it is possible to argue that Brown is, artistically, the most forward-looking of all abolitionist propagandists. He had two big experiences, the loss of his family and his subsequent escape from slavery. In marketing this material in the context of abolition he used the full range of media available to him at the time: the panorama (and Brown's was one of the biggest), the lecture, the poetry and music of the plantations, nineteenth-century sentimental verse, prayer, hymns, stage performance, slave narrative, graphic satire, children's books, broadsides, woodcuts and lithographs, and the latest technology related to travel. His escape constituted an immediate metaphor that combined spiritual autobiography, resurrection narrative, travel narrative and farce." See Wood, 116.

Epilogue. Racial Violence, Racial Capitalism, and Reading Revolution: Harriet Jacobs, John Jones, Kerry James Marshall, and Kyle Baker

1. Nicholas Mirzoeff, *The Right to Look: A Counterhistory of Visuality* (Durham: Duke University Press, 2011), 1.

2. Claudia Rankine, "'The Condition of Black Life Is One of Mourning,'" *The New York Times*, 22 June 2015.

3. Ibid.

4. Ibid.

5. Ibid.

6. See Elizabeth Alexander, "'Can You Be BLACK and Look at This?': Reading the Rodney King Video(s)," in *The Black Interior* (Saint Paul: Graywolf Press, 2004), 175–205.

7. Saidiya Hartman, *Scenes of Subjection: Terror, Slavery, and Self-Making in Nineteenth-Century America* (New York: Oxford University Press, 1997), 20.

8. Ian Baucom, *Specters of the Atlantic: Finance Capital, Slavery, and the Philosophy of History* (Durham: Duke University Press, 2005): 18.

9. For foundational readings of *Incidents* and Jacobs, see Jean Fagan Yellin, *Harriet Jacobs: A Life* (Cambridge: Basic Civitas Books, 2004) and Hazel Carby, *Reconstructing*

Womanhood: The Emergence of the Afro-American Woman Novelist (New York: Oxford University Press, 1987), chapter 2.

10. Harriet Jacobs, *Incidents in the Life of a Slave Girl* (New York: Oxford University Press, 1988), 8.

11. Jacobs, 20.

12. Jacobs, 20–21.

13. Jacobs, 21.

14. Jacobs, 13.

15. Jacobs, 13.

16. Jacobs, 13.

17. Jacobs, 19.

18. Jacobs, 20.

19. Jacobs, 20.

20. Andrew Kunka, "Intertextuality and the Historical Graphic Narrative: Kyle Baker's *Nat Turner* and the Styron Controversy," *College Literature* 38.3 (Summer 2011): 168–193, 171.

21. Kyle Baker, *Nat Turner* (Abrams: New York, 2008), 36.

22. Baker, 57.

23. Kunka, 177.

24. On visual representations of the Middle Passage (and the slave ship Brookes) see Marcus Wood, "The Irrecoverable: Representing the 'Middle Passage,'" in *Blind Memory: Visual Representations of Slavery in England and America 1780–1865* (New York: Routledge, 2000). Baker includes one such image—"Cross-section of a slave ship, circa 1700s"—at the conclusion of *Nat Turner*, 202.

25. Michael Chaney, "Slave Memory Without Words in Kyle Baker's *Nat Turner*," *Callaloo* 36.2 (Spring 2013): 279–297, esp. 280.

26. Baker, 7.

27. Baker, 7.